# JASPER JOHNS

Fiona Donovan

# JASPER JOHNS

## Pictures within Pictures

## 1980–2015

Thames & Hudson

PAGES 2–3
*Untitled* (detail of fig. 60), 1983–84
Ink on plastic
28⅜ × 36¼ (72.1 × 92.1) sheet
26⅛ × 34½ (66.4 × 87.6) sight
Collection of the artist

PAGES 4–5
*Catenary (I Call to the Grave)* (detail of fig. 131), 1998
Encaustic on canvas with objects
78 × 118 (198.1 × 299.7)
Philadelphia Museum of Art

Frontispiece
Jasper Johns working at ULAE, 1990

NOTE
Dimensions of works are given in inches and
centimeters, height before width before depth.

*Jasper Johns: Pictures within Pictures 1980–2015*
© 2017 Thames & Hudson Ltd, London

Text © 2017 Fiona Donovan
All works by Jasper Johns © Jasper Johns/VAGA, New York/
DACS, London 2017, unless otherwise stated

First published in 2017 in the United States
of America by Thames & Hudson Inc., 500 Fifth Avenue,
New York, New York 10110

www.thamesandhudsonusa.com

Library of Congress Control Number 2017934759

ISBN 978-0-500-23971-1

Printed and bound in China by Imago

WHEN SOMETHING IS NEW TO US, WE TREAT
IT AS AN EXPERIENCE. WE FEEL THAT ALL OUR
SENSES ARE AWAKE AND CLEAR. WE ARE ALIVE.[1]

JASPER JOHNS, 1969

During the past thirty-five years, Jasper Johns has made some of his most inventive, mysterious, and, at times, strange pictures. Moving away from the more common iconography of his early flags, targets and numbers, Johns included in this new work imagery found in his studio or home, as well as appropriating pictures or fragments of works by artists he admires. *Racing Thoughts* (1983; fig. 52), for instance, features a photo puzzle of his long-time dealer Leo Castelli (fig. 4), a lithograph by the Abstract Expressionist artist Barnett Newman, and a decal based on the Mona Lisa, as well as a schematized tracing of a diseased demon from Matthias Grünewald's early sixteenth-century Isenheim altarpiece (figs. 48–50).

This book is a study of Johns's art from around 1980 to 2015. Although more has been written on Johns than on possibly any other living artist, there is no comprehensive text on his art of the late twentieth and early twenty-first-century; and while there have been exhibitions of this work, the scholarship around this period of his career is fragmentary.

Several museum exhibitions have been devoted to aspects of John's art of this period. Mark Rosenthal's cogent survey of his work from 1974 to 1987 was the American selection for the 43rd Venice Biennale in 1988, later traveling to the Philadelphia Museum of Art. The catalogue for that exhibition, completed while Johns was at work on the *Seasons* series of 1985–86, provides a thorough consideration of that thirteen-year period of Johns's work and a critical contemporary perspective. Another exhibition initiated in 1999 introduced the *Catenary* series that Johns began in 1997 (fig. 5). That catalogue includes important essays by three noted Johns scholars.[2] A third exhibition, originated in 2003, focused on the artist's pictures from 1983 to 2002, with a catalogue featuring three idiosyncratic texts.[3] In 2014, the Museum of Modern Art in New York exhibited *Jasper Johns: Regrets*, a show and catalogue featuring a cohesive group of two paintings, ten drawings and two prints Johns had created during the previous year and a half.[4] Yet another exhibition and catalogue explored the influence of the Norwegian expressionist painter Edvard Munch on Johns's later work.[5] It is surprising, given how well known much of Johns's art is, that there have not been more opportunities for the public to see this alluring and varied work.

Johns's few published texts and his sketchbook notes, along with his many published interviews, manifest his thoughtful engagement with those interested in his work. Johns is an astute and absorbed conversationalist on a wide variety of topics, including art and artists, movies, politics, gardening, the environment, food, and developments around the world. His understated sense of humor and hearty laugh inflect most exchanges. While Johns's remarks are for the most part open-ended, they provide key articulation of his ideas, while offering informative

1
*Untitled*, 1988
Encaustic on canvas
48⅜ × 60⅜ (123 × 153.4)
Anne and Joel Ehrenkranz

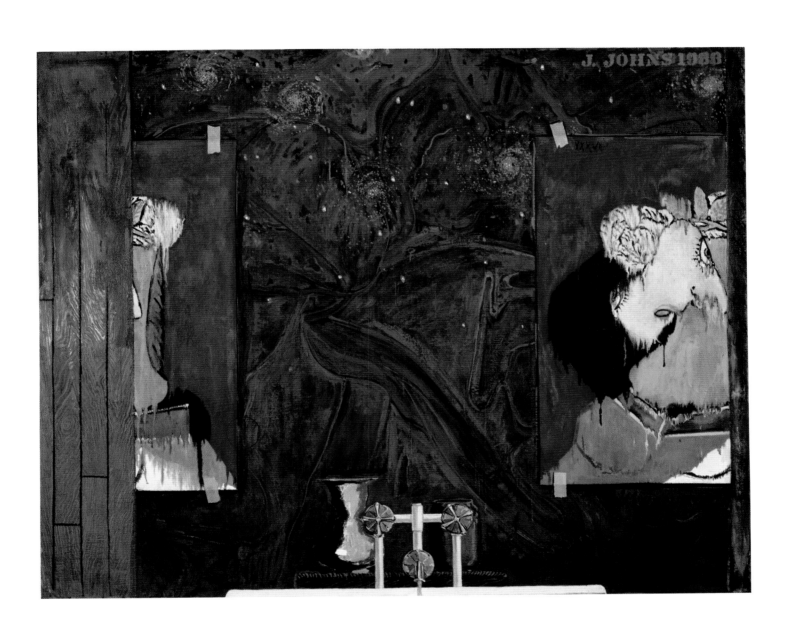

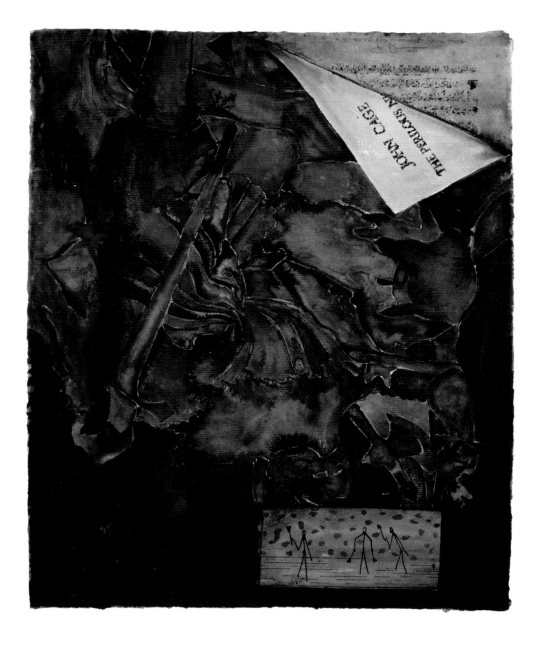

**2**
*Perilous Night*, 1990
Watercolor and ink on paper
31 × 22½ (78.7 × 57.2)
Collection of Margaret Leng Tan

**3**
*Untitled*, 1990
Watercolor and pencil on paper
30 × 22⅛ (76.2 × 56.2) sheet
26½ × 19 (66.4 × 48.3) sight
Private collection

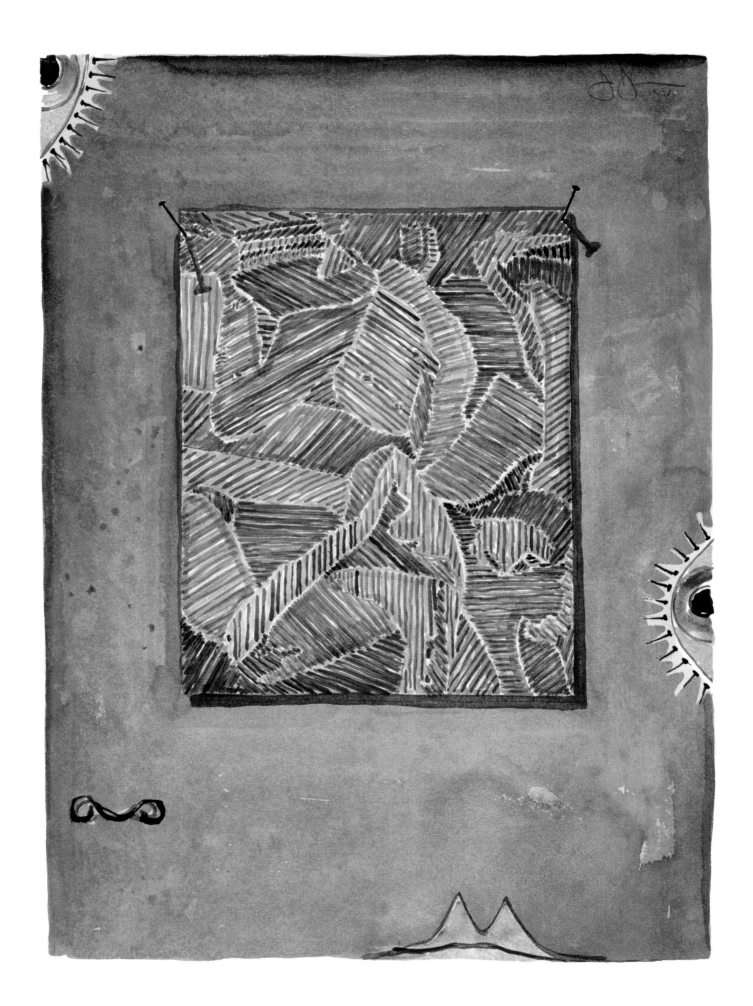

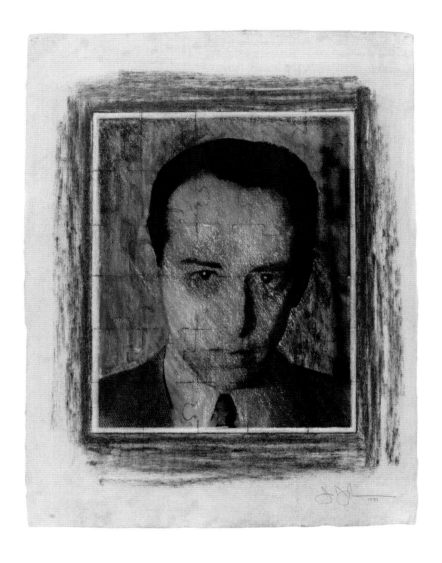

**4**
*Untitled (Leo Castelli)*, 1984
Oil, charcoal, pastel
and pencil on paper
20½ × 15½ (52.1 × 39.4) sheet
Collection of the artist

**5**
*Untitled (Halloween)*, 1998
Encaustic on canvas with objects
44 × 66 × 6 (111.8 × 167.64 × 15.2)
The Marguerite and
Robert Hoffman Collection

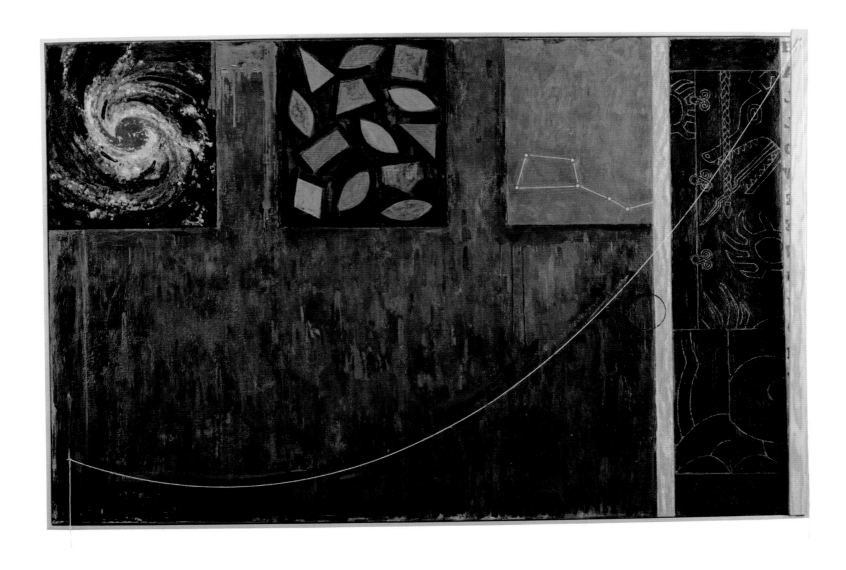

anecdotes about his art and life.[6] Compelled to experiment with a range of artistic practices and styles, Johns has provided a model for younger artists whose work blurs the boundaries between genres or who create simultaneously in a variety of forms and media.

Looking primarily at the artist's paintings and works on paper, with the benefit of his words and previous scholarship, this book aims to offer a broader context for his oeuvre from the early 1980s to 2015—a period when representational images began to emerge from the more purely formal crosshatch pictures of the 1970s and his work took on a new visual and iconographic complexity. The iconography in much of his art since the early 1980s has ranged from images that have some personal significance (as opposed to the collective subject matter of his earliest work), to a broader humanist discourse as he explores themes of suffering in the art of such precursors as Grünewald and Picasso. His absorption with appropriated and abstracted images—along with imagery from perceptual psychology and his immediate surroundings—springs from his enduring curiosity and accumulated experience. Over sixty years of making art, Johns's interest has consistently remained in "how we see and why we see the way we do."[7] During this time, he has painted in encaustic and oil, made works on paper and sculpture, mastered myriad methods of printmaking as well as sculptural casting, and worked with collage and assemblage.

Since 1982, the background in Johns's pictures is often figured as a wall, a nod to traditional painting as he investigates past art, his own, and that of others. Johns's work is best interpreted in classic art historical language: his attention to form, structure, and process; his sophistication as a colorist; and, of course, his iconography. Calvin Tomkins observed in 2006 that "not many young artists today seem influenced by Johns, in the way that so many used to be in the nineteen-sixties, and so many are still influenced by Rauschenberg and Warhol. Johns has become like an Old Master—but one whose work continues to change, double back on itself, contradict expectations, and disturb."[8] And yet, Johns's work has affected the artistic practice of a broad range of younger artists, from Carroll Dunham to Glenn Ligon, Elizabeth Murray, Kiki Smith, and many others.[9]

The connections Johns forges between the images in a given work allow for a range of readings. Meaning is embedded within Johns's layering and serial approach, in his repetitions and reinterpretations. From his fresh contemplation of space in *In the Studio* (1982; fig. 44), to the personal references and appropriation in *Racing Thoughts*, to an increased lyricism in the *Seasons* (1985-90; see figs. 74-77), followed by a return to a more abstract vocabulary in the *Catenary* series (1997-2000; see fig. 5), Johns's art of this era allows for a comprehensive exploration of the complex associations that impart meaning in his work. Taking into account the artists—from Leonardo da Vinci to Marcel Duchamp, Grünewald, Paul Cézanne, and Pablo Picasso—and other images that have influenced Johns and that he has made use of in varied ways, this book will consider his highly personal use of appropriation and why it has figured so significantly in his imagery. Like that of many American artists, Johns's work is rich in poetic symbolism and his deep, lifelong interest in poetry comes as no surprise. This volume will look at both specific and more general associations between poetry and Johns's art.

◆

Charged with the creative energy of youth, the radical elegance of Johns's early flags and targets also seems the work of an artist fully formed. Johns was twenty-four when he made his first flag in 1954–55 (fig. 6). In the mid-1950s, Johns's sophisticated intelligence and curiously inventive manner found a way beyond Abstract Expressionism. His tactile sensuality and iconographic restraint integrated the revolutionary refinement of early twentieth-century Parisian modernism with American literalism. The straightforward ease and common vocabulary of his early pictures spoke to a generation on the brink of challenging the middle-class stability of American society following the Second World War. This sense of agitation, particularly among American youth, sparked radical political activity, the civil rights movement, the sexual liberation of the 1960s, and the advent of feminism, environmental concerns, and opposition to the war in Vietnam. Johns's iconic images anticipated the American optimism of the 1960s that brought about the space program, the boom in advertising, and economic expansion, as well as a modish and freewheeling counterculture spirit. His first flags and targets distinguished him, but did not satisfy his relentless inclination to experiment again and again with new techniques, materials, and forms.

It was in the early 1980s that Johns's compositions became increasingly complex with a range of images and a mix of abstraction and representation. At this time, the artist expanded his single focus to multiple viewpoints that require shifts in attention, from direct experience to the infiltration of memory. The AIDS virus, first identified in the early 1980s, ushered in a period of illness and death, and of fear and misunderstanding. This era also saw the beginning of the increasing economic gap between rich and poor in the United States and, in the 1990s, the advent of the culture wars that polarized conservative and liberal politics and ideology over such issues as education, sexual orientation, abortion rights, gun control, and the separation of church and state. During the 1980s, the cult of celebrity was on the rise, with movie stars and others engaging in unabashed self-promotion through exposure of the most personal details of their lives. Throughout these years, while addressing abiding themes such as spirituality, life and death, and the ages of man, Johns found a way to make vulnerable and emotionally complex work. His art of the 1980s and 1990s has a dignified, timeless, interior character that suggests a corrective to the political moralizing and self-exposure rampant in the United States at that time.

In the early twenty-first century, Johns put aside painting for several years to focus on sculpture, some of it monumental (fig. 136). Johns started these reliefs working with cast wax, the same material that features in his encaustic paintings. Like Picasso, Johns finds ways to obscure definitions, his painting linked to a sculptural vision and vice versa. Such hybrid works, while incorporating traditional materials, blur the distinction between painting and sculpture. Then, starting in 2012, in two bodies of related work, Johns's imagery grew increasingly wistful (figs. 160 and 169). Each group was sparked by a different photograph of a dejected male figure. While mournful and at times haunting, these pictures pulse with a formal economy and a generative lyricism. Animated by a vital and engrossing current, they offer some meaning just beyond reach. Disenchantment and beauty coexist without the impulse to resolve the contradiction between them. There is an intensity in these works that results in a brooding clarity that ultimately reaffirms the significance for Johns of change

and growth over synthesis. This, rather than the photographs that triggered the works, becomes his subject.

Between the mid-1950s and early 1980s, Johns evolved from an ingenious, ruminative young artist to a more unpredictable, profound, and lyrical one. It was as if, as he grew older, he sought something more enigmatic and multifaceted than the basic, albeit undeniably complex, paradox of his early iconic imagery featuring flags, targets, and numbers. To seek meaning in Johns's later work—the period after 1980—requires us to approach it within our own frame of reference, rooted in our individual experience of life. To appreciate his art requires our willingness to forge connections between Johns's imagery and forces in our own lives. Without being didactic, Johns's art reminds us to pay attention and to look instead of to know. It offers an uncommon interpretive fluidity. Kirk Varnedoe acutely observed in the catalogue that accompanied Johns's 1996 retrospective at the Museum of Modern Art in New York that "from the outset [Johns] has seen art's goal as that of making life memorable—of impressing vividly on the mind things one might otherwise look at and forget."[10]

Throughout his practice, Johns has actively pursued experimental and technical refinement and invention. His work is abstract and representational, conceptual and sensual. In 1973 Johns described his work as

> in part concerned with the possibility of things being taken for one thing or another—with questionable areas of identification and usage and procedure—with thought rather than with secure things.[11]

It is perhaps the contradictions embodied in Johns's work that activate the viewer's response and that have been its most defining characteristic for over sixty years.

In 1977, the author Michael Crichton described Johns's character this way: "On the one hand, he is coldly rigorous, formal, adult, intellectual. On the other hand, he does not hesitate to be playful, punning, literal, even childish. He is detached, and he is emotional. He is calculating, and he is impetuous."[12] Thirty years later, critic Holland Cotter used these words to characterize the artist: "I would call him a metaphysical artist, in the way that the seventeenth-century English poet John Donne is a metaphysical poet. Like Donne's poetry, Mr. Johns's art is equally about body and mind, sensuality and reflection. It is unmystical, unromantic, unnostalgic but obsessed with transcendence and the reality of loss."[13] The paradoxes in Johns's work root its meaning in ambivalence and allow for varied associations and a range of interpretations.

◆

Starting with his earliest works, Johns returned painting to a more human scale, in some ways clearing the dense haze from the larger-than-life bravado of Abstract Expressionism. Beginning with the flag—not just a representation of a flag, but a painted object built up with torn newspaper and delicate, luminous layers of encaustic—he discovered a new way to examine the essential elements of the pictorial process, both in terms of describing forms and in our perception of images. He prompted us to look at everyday images anew. For more than half a century, his art—in its many guises—has been concerned with some of the most basic issues of our existence, and with the experience of what it is to be human.

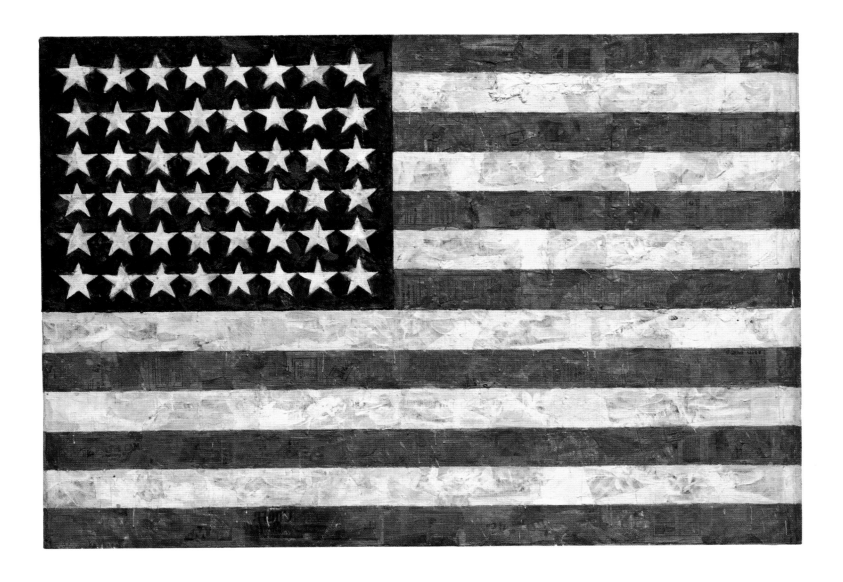

**6**

*Flag*, 1954–55
Encaustic, oil, and collage
on fabric mounted on wood
(3 panels)
42¼ × 60¾ (107.3 × 154.3)
The Museum of Modern Art,
New York

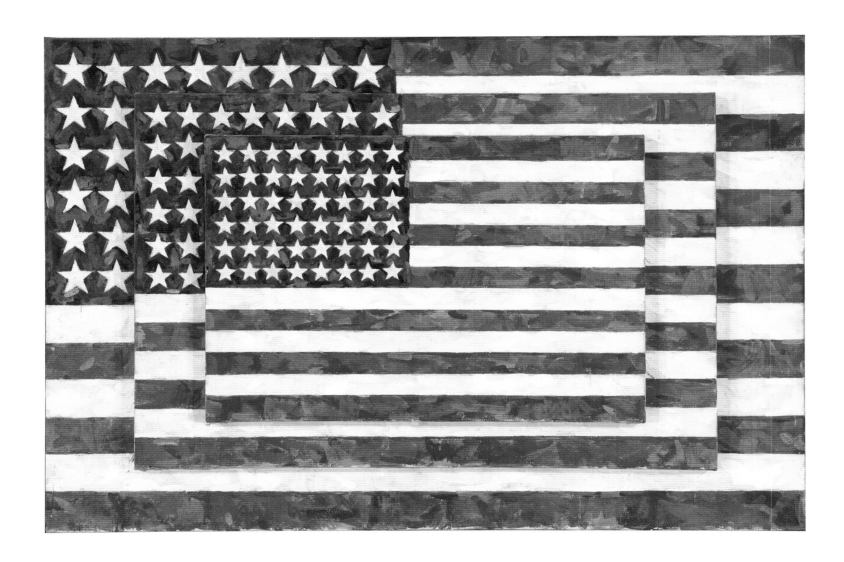

**7**
*Three Flags*, 1958
Encaustic on canvas (3 panels)
30⅝ × 45½ × 4⅝ (77.8 × 115.6 × 11.7)
overall
Whitney Museum of American Art,
New York

According to Johns, he began drawing when he was three and has not stopped since.[14] Born in Augusta, Georgia, in 1930, Johns was shuttled around to the homes of various relatives in South Carolina after his parents divorced when he was a small child. He developed interests in poetry and art early on, in part fostered by his aunt, who taught all grades in a two-room school called Climax in a small district named The Corner. Johns told critic Grace Glueck in 1977 of his early inclination to be an artist, describing impishly how

> no one in my immediate family was involved with art (I had a grandmother who painted, though I never knew her) but somehow the idea must have been conveyed to me that an artist is someone of interest in a society. I didn't know artists, but at an early age I realized that in order to be one I'd have to be somewhere else. I always had a tendency to try to be somewhere else.[15]

In 1948, after one and a half years of college, Johns moved to New York. He attended Parsons School of Design for the spring term in 1949, after which his money ran out and he worked briefly as a messenger and shipping clerk. During the Korean War, he was drafted and served in the army in South Carolina and in Japan from 1951 to 1953.

In 1954, Johns returned to New York, where he made the decision to commit himself to being an artist.[16] At that point, he destroyed all his artwork (except for a few pieces no longer in his possession) and shortly afterward made his first *Flag*. The imagery derived from a dream in which Johns saw himself painting a large American flag. He explained:

> Using the design of the American flag took care of a great deal for me because I didn't have to design it. So I went on to similar things like targets—things the mind already knows. That gave me room to work on other levels.[17]

In addition to targets, Johns also turned to the alphabet and numbers. In contrast to the flag image, these subjects are inherently more abstract. He added objects and words to his canvases over the next few years, questioning the traditional relationships intrinsic to painting: between figure and ground; and illusion versus reality. By taking a readymade object as its image, Johns's work urges the viewer to take notice of "things which are seen but not looked at, not examined."[18]

The pictures Johns made between 1954 and 1958 established the tone and conceptual concerns he has engaged with ever since. In these early pictures he explored issues that would become central not just to his own art, but also to key artistic developments of the 1960s, including Pop art, Minimalism and conceptual art. These include the synthesis of two modes until then considered largely incompatible: figuration and abstraction. Johns addressed the relationship between figure and ground by denying spatial illusion, carefully building up his picture surfaces with layered newsprint, encaustic, and a multitude of drawing and printmaking media. In probing whether or not his works were flags or targets, or images of them, he questioned the very nature of representation.

Johns experienced little formal art education but, once established in New York, he came into contact with a community of creative people, most significantly the composer John Cage, the choreographer and dancer Merce Cunningham and the artist Robert Rauschenberg.[19] Johns says he:

*Gray Alphabets*, 1956
Encaustic and collage on canvas
66⅛ × 48¾ (168 × 124)
The Menil Collection, Houston

thought of John [Cage] as a sort of teacher/preacher/soldier. His curiosity seemed wide-ranging and athletic, and he was able to connect his work to other fields of thought—to nature, philosophy, science, and what not. He was generous in his willingness to explain these connections.[20]

When asked later about Cage's influence on him, Johns responded:

> I don't usually think in terms of influence. I feel that only things one is insensitive to are not influences. John Cage had a serious concern for philosophical ideas and he was able to consider judiciously a number of complex ideas at the same time. From such practice, he seemed to gain abstract and practical insights which reinforced his music, his philosophy, his ambitions. Art and life structured by principle seemed the suggested norm.[21]

The generative nature of Johns's relationships with these friends and colleagues proved to be formidable.

In 1954, Johns moved into a loft on Pearl Street in New York. The next year, Robert Rauschenberg rented the loft upstairs from a mutual friend. According to Johns, Rauschenberg was "the first person I knew who was a real artist."[22] While they shared their southern backgrounds—Rauschenberg was from Texas—as well as their artistic ambitions, attitudes, and endeavors, in character they could hardly have been more different: Johns tended to be deliberate, precise, elegant, even diffident; Rauschenberg, five years older than Johns, was full of energy, provocative, and outwardly engaging. While providing encouragement to each other at a time when both lacked support from the art world, they—along with a pioneering community of visual artists living and working at nearby Coenties Slip, also experimenting with new forms and non-traditional media—developed beliefs that presented a contrast to the rhetoric of Abstract Expressionism. It was through Rauschenberg that Johns met Leo Castelli, who, in 1958, gave him his first one-man exhibition. The Museum of Modern Art in New York acquired three of Johns's paintings. Ironically, this was just as Abstract Expressionism was beginning to receive widespread attention. Already, however, Johns, along with Rauschenberg, was reshaping ideas about art. Both artists chose imagery from everyday life. Rauschenberg's "combines" and Johns's hybrid works broke down the traditional notions of artistic genres, erasing the boundaries between painting, sculpture, and print media.

Around 1960, when Johns turned from flags, targets, and numbers to an expanded iconography unconstrained by flat images and readymade compositions, his style became more fluid and gestural, allowing for a slight play of illusion. As if in response to his early success, Johns's paintings of 1959 and 1960 featured a new sense of expansive, penetrable space. Working in thick and sometimes drippy encaustic, and more often oil on canvas, in bright, varied primaries or shades of gray, Johns formed these vigorously worked pictures using carefully separated strokes of the brush, seemingly to call attention to the difference between his approach and the more random, allover execution of the Abstract Expressionist painters. Johns's increased use of oil paint in place of encaustic at this time suggests he sought a change from the wax medium's relief properties. These images were made in a less obviously cerebral vein than his earlier work (fig. 11).

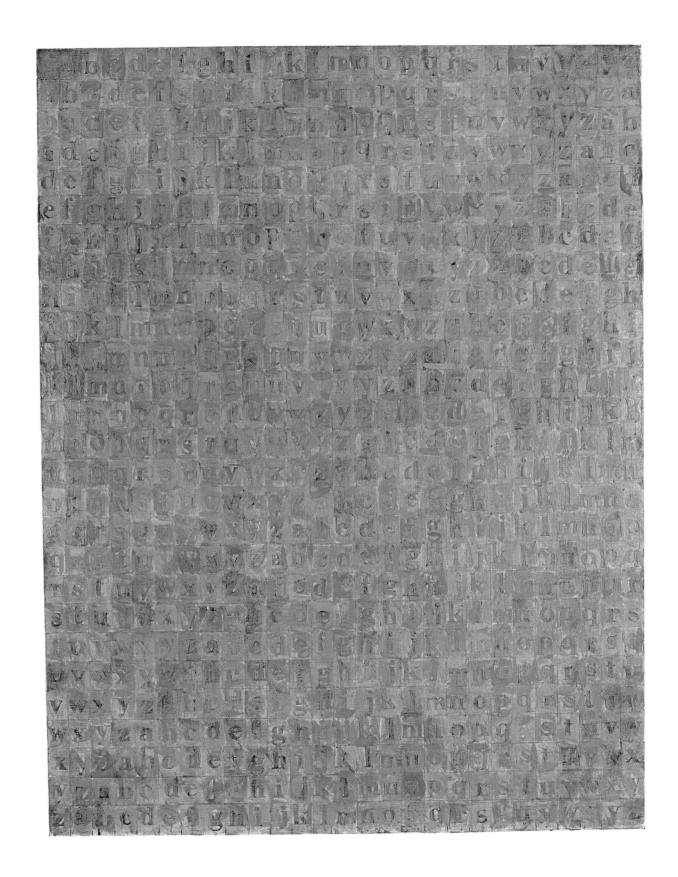

Generally, the dispersed and ambiguous iconography of this work differs from the iconic imagery that preceded it and is not easily decipherable. Some canvases have an agitated character. Where his earlier pictures had negated depth, volume is a key element of the new work, whether in common household objects, in metal letters attached to the canvas that jut out into the viewer's space, or in open, painterly passages. Johns incorporated stretcher bars or rulers, a thermometer, and eventually cutlery and other items in his canvases at this time (fig. 10). The picture-making process, and the structure itself, became both form and subject of these works. Instead of following the typical modernist trajectory from the depiction of some type of perspectival space to an increased emphasis on surface, Johns's development indicates a greater openness, with the possibility of variable viewpoints that take into account memory and experience, and impermanence and vulnerability. These pictures challenge viewers intent on determining particular associations, context, or even how the various objects, images, and styles in a given work relate to each other. Johns's use of language, whether in his poetically allusive titles or in stenciled words on his canvases, confounded viewers while enriching their interpretive experience. The associative lyricism of the mix of word or title and paint in paintings from the end of the 1950s such as *Out the Window* (1959), *Jubilee* (1959; fig. 135), and *False Start* (1959) must derive at least in part from the artist's longtime interest in poetry.

**9**
Robert Rauschenberg
*Jasper–Studio, N.Y.C.*, 1958
Gelatin silver print
15 × 15 (38.1 × 38.1)
San Francisco Museum
of Modern Art

While he explored new developments in his paintings, Johns continued to investigate the limits of realism in treating familiar imagery in sculpture and works on paper. Johns cast a flashlight, a can full of paint brushes, and two beer cans, among other objects, lending the bronze surfaces a handmade quality, with gestural brushstrokes and the imprint of the artist's fingers (see figs. 139, 15 and 70). Drawing and printmaking became key elements in Johns's practice, disrupting the conventional hierarchy between these traditionally humble art forms and the more assertive dynamic of painting.

Johns became familiar with the work of Marcel Duchamp in the late 1950s and met him in 1959.[23] In 1960, he first wrote about Duchamp, a review of the publication in English of Duchamp's notes from the *Green Box*. This was one of three short pieces Johns published on Duchamp, all in the 1960s. Johns's appreciation of Duchamp may have contributed to the increased ambiguity in his own pictures, as he considered the viewer's role in relation to his work, though it was not until 1969 that Johns wrote that Duchamp "was the first to see or say that the artist does not have full control of the aesthetic virtues of his work."[24]

From 1956 to 1958, while making paintings and sculpture, Johns also collaborated with Rauschenberg under the pseudonym Matson Jones to create window displays for Bonwit Teller and Tiffany and Co. He also made sets and costumes for several music, dance, and theater productions, most significantly, in the long term, for Merce Cunningham. From 1967 to 1978, Johns served as artistic advisor to the Merce Cunningham Dance Company. He encouraged other artists, among them Andy Warhol, Robert Morris, Bruce Nauman, and Neil Jenney, to make sets and costumes for the company's performances. In 1963, Johns was part of a small group that established the Foundation for Contemporary Performance Arts (now the Foundation for Contemporary Arts), which continues to support contemporary music/sound, dance, theater, and the visual arts.[25]

In 1960, at the invitation of print publisher and Universal Limited Art Editions's founder Tatyana Grosman, Johns made his first print, *Target*, a lithograph (fig. 17).[26] From this point on, his work in printmaking and drawing became a significant way for him to explore ideas first developed in paint. His early drawings and lithographs have a graphic freedom that distinguishes them from the more controlled encaustic and oil paintings (see figs. 16 and 18). In the winter of 1961, Johns purchased a house on the beach in Edisto Beach, South Carolina, south of Charleston. For several years he painted there and in New York. In June 1961 he had accompanied Leo Castelli to an opening of his work at a Paris gallery, his first trip to Europe.[27] The following year his close relationship with Robert Rauschenberg ended.[28]

There is a rough quality, heightened physicality, and dramatic intensity inherent in Johns's work of the early 1960s. While some pictures show Johns exploring a new type of suggested space (fig. 12), others have a broken-up aspect, both in the deep, dark, gloomy tonalities and the jumbled quality of the depicted letters. Johns's increasing complexity as a colorist became clear, while the use of stamping, rolling, and smeared forms added to the charged emotionalism of this work. Johns made his first large *Map* (1961; fig. 19) painting at this time,[29] as well as turning to more visceral and meditative, yet epic images such as the diving or crucified arms, legs, and feet of a lone figure in *Diver* (1962–63; fig. 21). The sensuality and spirituality of these works, and their larger scale, show Johns's deepening artistic resonance.

**10**
*Water Freezes*, 1961
Encaustic and collage on canvas
and wood with objects (2 panels)
31 × 25½ (78.7 × 64.8)
The Marguerite and
Robert Hoffman Collection

**11**
*False Start*, 1959
Oil on canvas
67½ × 53⅛ (171.5 × 135)
Private collection

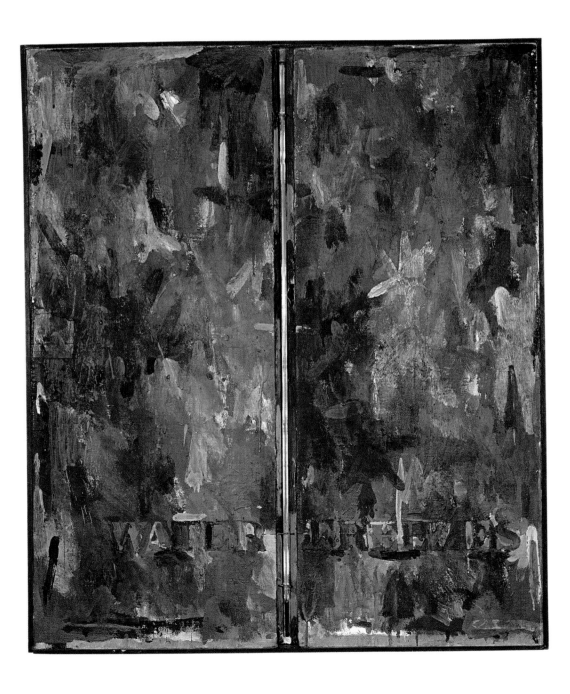

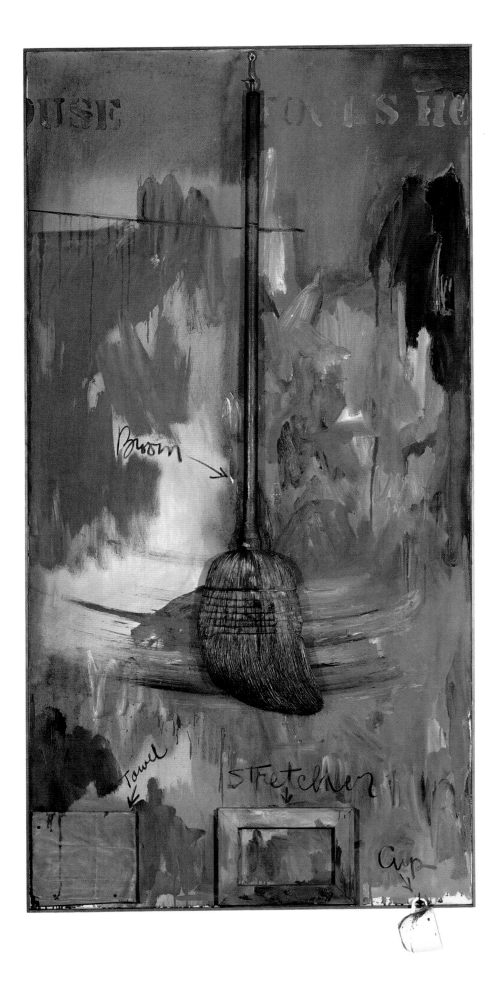

**12**
*Fool's House*, 1961–62
Oil, Sculp-metal, and charcoal
on canvas with objects
72 × 36 (182.8 × 91.4)
Collection of Jean-Christophe
Castelli, New York

**13**
*In Memory of My Feelings—*
*Frank O'Hara*, 1961
Oil on canvas with objects (2 panels)
40 × 59¾ (101.6 × 152)
Museum of Contemporary Art,
Chicago

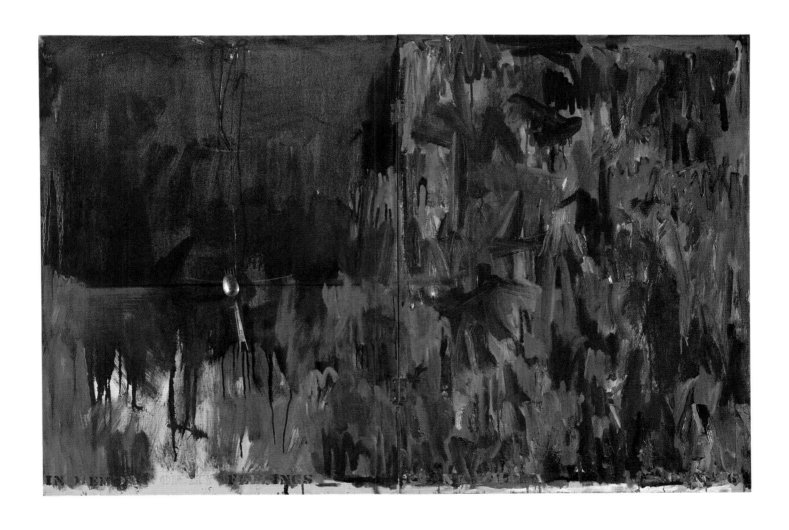

Johns had his first museum retrospective exhibition in 1964 at the Jewish Museum in New York. The flags and targets—bold, solitary images—as well as the numbers and alphabets, and his method of systematic reiteration, influenced myriad artists working in a variety of styles. What was evident even at this time, however, was that Johns's work would neither submit to any type of stylistic classification nor be allied with that of any particular group of artists. It was full of contradictory impulses: literal and abstract, intellectual and visceral, combining language with sensuously worked surfaces and sometimes body parts. In a brief statement in the Jewish Museum exhibition catalogue, John Cage remarked on these seeming polarities: "Looking closely helps, though the paint is applied so sensually that there is the danger of falling in love."[30]

The mid- to late 1960s and early 1970s were a period of formal and technical experimentation for Johns. He became an avid printmaker, trying out unfamiliar methods from photo reproduction and screenprinting to etching, while further exploring lithography (fig. 20). The screenprint's graphic look carried over into his painting style and in some of his canvases he used screens to apply the paint. The three-panel painting *Voice 2* (1967–1971; fig. 23) shows Johns further exploring his interest in serial imagery. The letters and single digit that spell out the title across the three canvases appear to slide down each panel without the benefit of gravity, the large stenciled letters and number tilting ominously and in some cases overlapping each other. Johns worked the paint through screens of varied sizes, resulting in an allover texture that permits almost no suggestion of depth. Instead, the letters stretch across the three panels, implying that they could wrap around and form a cylinder, as well as offering various permutations in the order in which they are hung. During this period, Johns also explored working in ink on plastic

**14**
Jasper Johns at Universal Limited Art Editions, 1962
Photograph by Hans Namuth

**15**
*Painted Bronze*, 1960
Bronze and oil paint
13½ × 8 (34.3 × 20.3) diameter
The Museum of Modern Art, New York

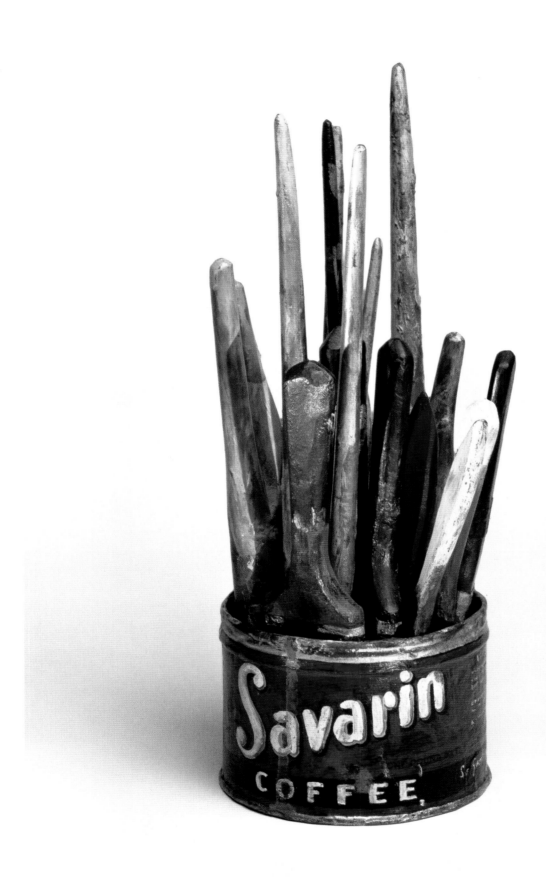

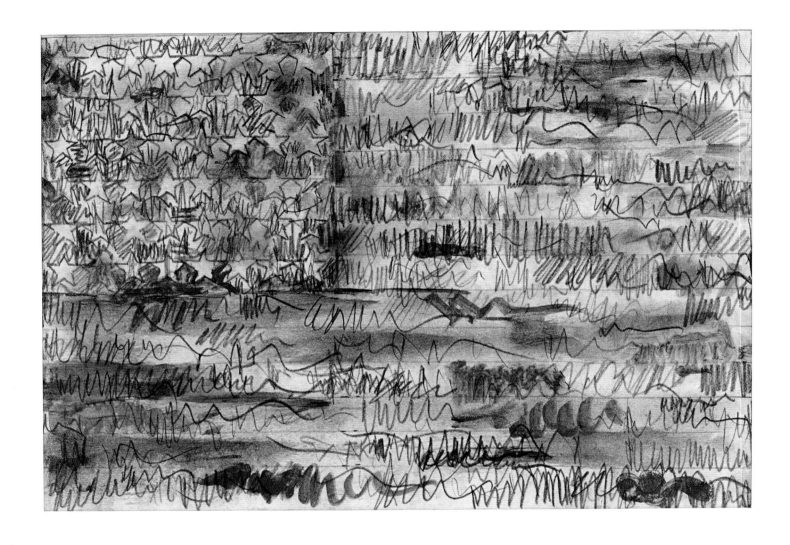

**17**

*Target*, 1960
Lithograph, edition of 30
22½ × 17½ (57.2 × 44.5)
Published by Universal
Limited Art Editions

**16**

*Flag*, 1958
Graphite pencil and
graphite wash on paper
9⅞ × 12 (25.1 × 30.5) sheet
7¼ × 10⅜ (18.4 × 26.4) sight
Collection of Barbara
Bertozzi Castelli

**18**

*White Target*, 1957
Encaustic and oil
on canvas
30 × 30 (76.2 × 76.2)
Whitney Museum of
American Art, New York

*Map*, 1961
Oil on canvas
78 × 123¼ (198.1 × 313)
The Museum of Modern Art,
New York

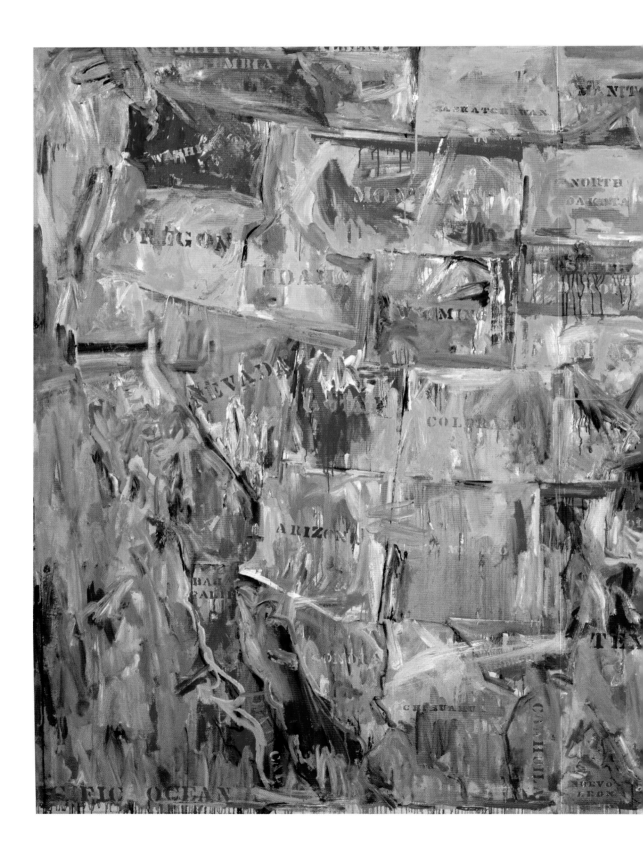

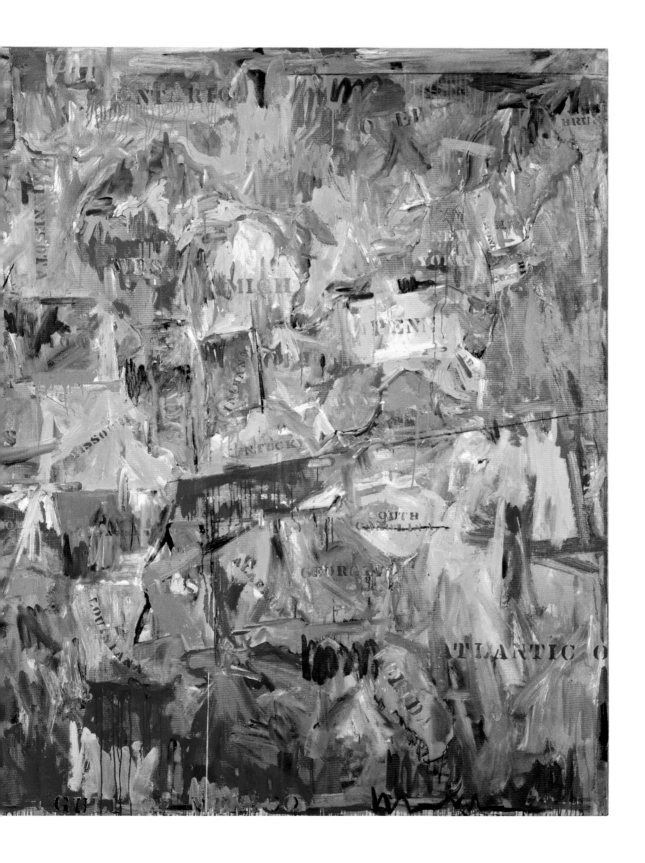

**20**
Ben Burns, Jasper Johns and
Tatyana Grosman at ULAE, 1966
Photograph by Ugo Mulas

**21**
*Diver*, 1962–63
Charcoal, pastel, and paint on paper
mounted on canvas (2 panels)
86½ × 71¾ (219.7 × 182.2)
The Museum of Modern Art,
New York

**22** OVERLEAF
*According to What*, 1964
Oil, charcoal, and graphite
on canvas with objects (6 panels)
88 × 191¾ (223.5 × 487)
Private collection

and made the largest, most complex assemblages of his career, such as *According to What* (1964; fig. 22).[31] These large works have no focal point but are composed of a variety of parts for the viewer to connect. Much of Johns's work at this time shows him considering the ideas of Marcel Duchamp, particularly as he sifted through Duchamp's *Green Box* (1934).

In 1967, while riding through Harlem in a taxi, Johns glimpsed a painted flagstone pattern on a small shop wall.[32] It stuck in his memory and provided a newfound element for his work, first seen in *Harlem Light* (1967). This flat stone-shaped motif and the opportunities it provided for repeated forms, reversed patterns, and the exploration of abstract systems would occupy a place in Johns's work over the years, right up to the present day. Later, beginning in 1973 and continuing for close to ten years, he steadfastly explored the crosshatch motif, another found image, which he had first seen on a passing car. As with his other imagery, as he worked with it and added evocative titles, it took on a variety of expressive guises and allowed for various interpretations (see fig. 28).

Beginning in 1982, with *In the Studio* and *Perilous Night*, Johns caught viewers off guard as he embarked on new formal and iconographic challenges. It was a speculative turn for an artist who had already been productive and successful for nearly thirty years. New imagery, such as pictures seen from the perspective of someone lying in the bath and a cycle of *Seasons* paintings, brought to the fore a sophisticated display of rich technical mastery and intellectual depth. Characterized by a more nuanced palette and a broader range of intense, rich color, these works also show a new sense of space, with the background often depicted as a wall layered with a carefully arranged gathering of objects, drawn from Johns's life, his art, and the archives of art history. This more traditional mode of spatial representation corresponded well with his inquiry into the formal, spiritual, and emotional elements in the work of older artists. Johns relentlessly explored this imagery in numerous works that reveal his virtuoso handling of his varied chosen materials:

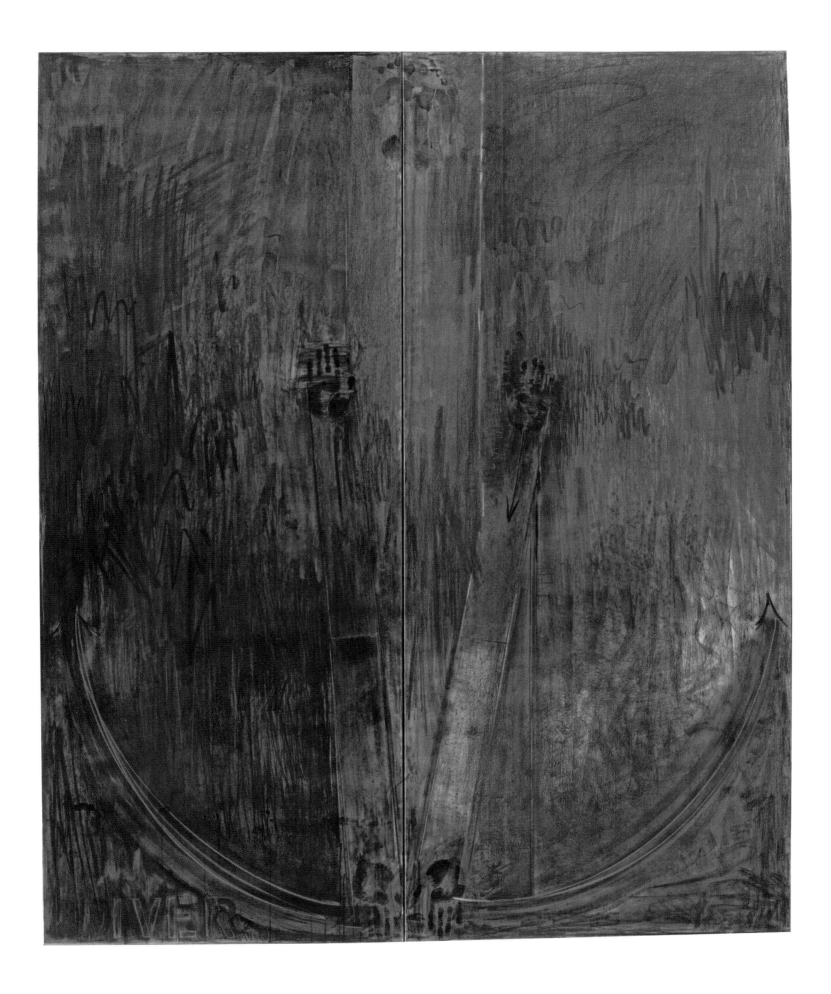

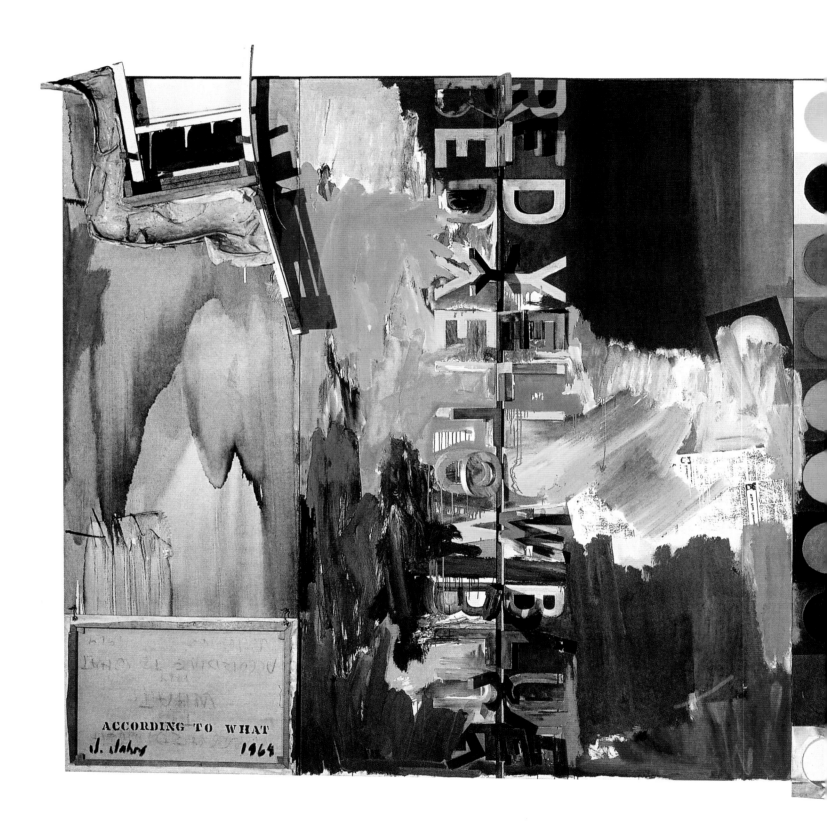

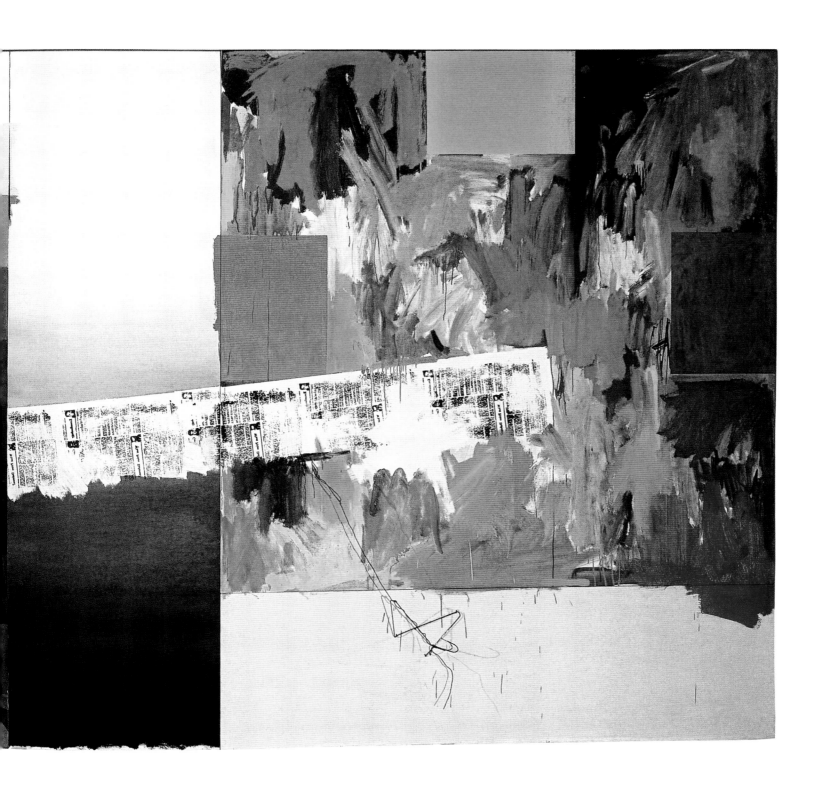

**23**
*Voice 2*, 1967–71
Oil and collage on canvas (3 panels)
72 × 50 (182.9 × 127) each panel
Kunstmuseum, Basel

in encaustic and in oil on canvas, sometimes with added objects or collage; in works on paper and plastic using ink, watercolor, pastel, gouache, crayon, charcoal, graphite, and collage; and in intaglio, lithography, aquatint, etching, carborundum, mezzotint, and monotype.

In the late 1980s and the 1990s, drawing deeply on images and recollections of his youth, and infused with the spirit of Grünewald and Picasso, Johns set to work on a group of pictures that brought into focus—albeit in his subtle and often obscure manner—the mysteries of universal themes: the passage of time, love, life, and death (fig. 26). At the same time, in a quirky cartoonish series (fig. 27), he drew on behavioral and perceptual psychology as well as his own memories, mining images of a distorted face from a 1936 Picasso portrait, a drawing made by a schizophrenic child, another that can be seen either as an old crone or a beautiful young woman, and a 1977 commemorative Silver Jubilee porcelain vase with profile portraits of Prince Philip and Queen Elizabeth II in its negative spaces. Trompe-l'oeil devices in the form of nails and masking tape 'fixing' objects to the background 'wall,' as well as painted wood grain, often feature in Johns's work of this period. The results—in flat expanses of creamy colors—are some of the most evocative compositions of his practice.

At the turn of the twenty-first century, in the *Catenary* series, Johns returned to making work in monochromatic gray tones built up with sensuously rendered atmospheric strokes of the brush. These works show a gravity and spaciousness that imply a more spiritual link between eternal truths and personal experience. He relinquished some sense of artistic control as he allowed gravity to create the curved form of a piece of string that falls through a screw eye and is attached at the picture's vertical sides. A range of sizes, these works are indeterminate in scale: they suggest both rain—in the masterfully streaked passages of encaustic mixed with sand—and boundless space. They are an expression of the doubt and hesitation we share about our place in the universe (fig. 5).

The critical response to Johns's shows during this period and beyond was mixed. It was clear that the artist's inventive spirit, which generated changing styles and approaches over the years, baffled some viewers. With his 1984 show, as Roberta Smith noted in her review, "Johns moves in the opposite direction [of the crosshatch], toward a trompe-l'oeil illusionism and a very specific, almost literary array of subjects." She continued, describing the "beautiful, if uneven, exhibition" and how "Johns simply but radically rearranged and shifted to different modes of depiction almost identical elements: the hand, the cross-hatch, the flagstone motifs—moving from working direct to working depictively and turning the surface of his paintings into the wall of a room." Her review ends with the following observation:

> Sometimes these paintings have a fingernail-on-chalkboard irritation to their precise beauty, particularly when first seen. Their gestures are so reined in; their painterliness is almost microscopic. Nothing is left to chance and every area of their subdivided surfaces makes a different spatial, depictive, painterly and/or autobiographical point, with the interconnections left to the viewer. If they are exhausting, they are also inexhaustible and among the most poetic, suggestive works Johns has yet created.[33]

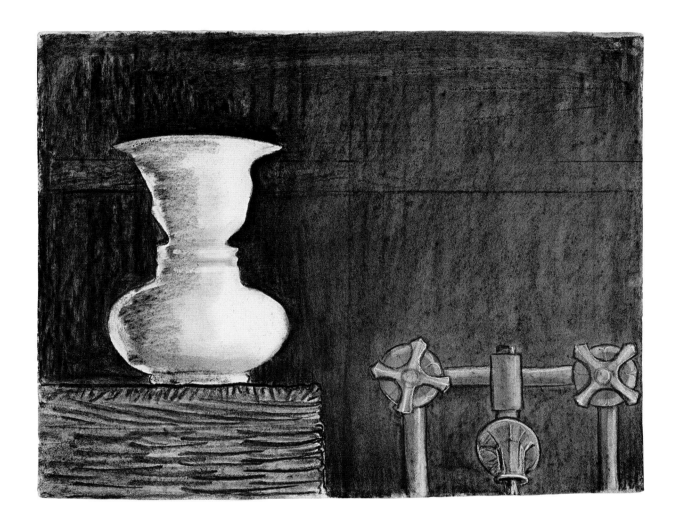

**24**
*Untitled*, 1983
Charcoal and pastel on paper
19¼ × 24¾ (48.9 × 62.9) sheet
Collection of Lenore and Bernard
Greenberg

**25**
*Untitled*, 1983
Ink on plastic
27⅝ × 36¼ (70.2 × 92.1) sheet
26¼ × 34½ (66.7 × 87.6) sight
Solomon R. Guggenheim Museum,
New York

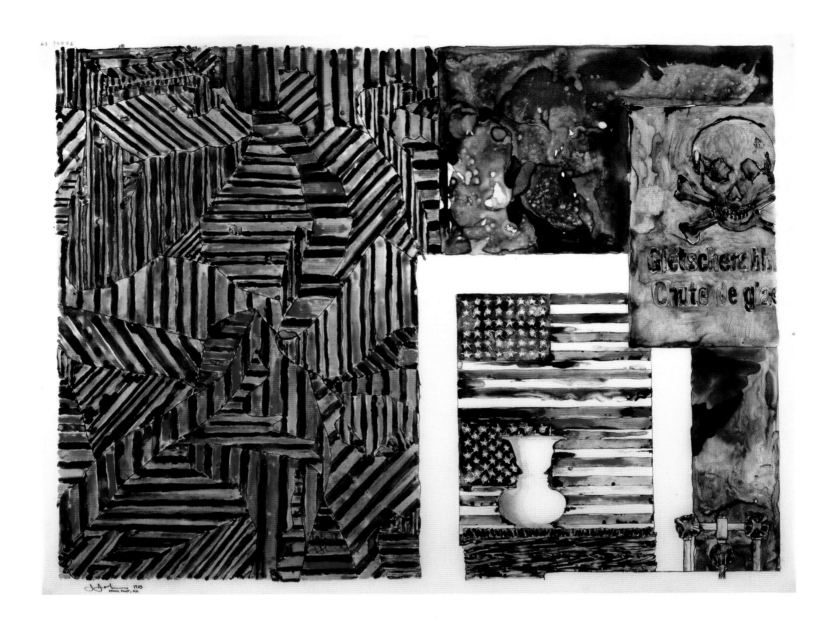

**26**
*Untitled*, 1998
Ink on paper glued to backing sheet
41 × 25¼ (104.1 × 64)
Collection of the artist

While Smith was receptive to Johns's new work—including, for instance, the "astoundingly painted" *Perilous Night*, with its ambiguous suggestion of spatial illusion, depicted imagery, and cast arms presented on a wall-like ground, or *Ventriloquist*, a tribute to nineteenth-century American inventiveness and craft—others were unsettled by what they saw as the artist's move away from his early formal and conceptual rigor.[34]

Again, in 2005, the critical response of several prominent art writers to Johns's exhibition of recent *Catenary* paintings at the Matthew Marks Gallery in New York created a stir among Johns enthusiasts. In the *New Yorker*, Peter Schjeldahl wrote that the pictures "bespeak self-imitative pastiche" and called them "undernourished and overthought." The *New York Times* reviewer Michael Kimmelman referred to Johns's work of the 1980s and 1990s as "clotted." While hailing the artist's formal fluency, Kimmelman found "the encoded mystery in the work...exhausting."[35] In spite of the undeniable attraction of parsing Johns's sophisticated iconographic references, the puzzled or irksome reactions seemed perpetuated by what viewers regarded as the obscure aspects of Johns's work as well as the abiding thematic and stylistic changes in his art over time. Some reviewers, taking into account Johns's long and successful career, suggested he had lost his critical edge, making work that appeared overly autobiographical and even sentimental. Others raised the question of whether or not the public still looked to Johns to produce concrete yet sensuously painted icons; "things the mind already knows," as he has referred to his early subjects.

Johns is galvanized by the cognitive challenges and experimentation with methods and materials that his work offers. From the beginning, his art has been distinguished by his viscerally sensual approach to materials and forms. Johns's absorption in his work and his reiterations can be seen as an affirmation of his fundamental commitment to see where these investigations take him. His upbringing may have predisposed him to this conduct. He has described how,

> as a child, I had a certain freedom; I was on my own a lot, so I could entertain myself. I had to find things to amuse myself. I grew up in the rural South during the Depression. There wasn't much available so I invented things.[36]

He claims not to be terribly disciplined and has maintained that

> [I am] fairly lazy, and have never taken any pleasure in compulsive work... I don't have any working habits. I work very erratically. It's most convenient that I be where my work is, so that at any moment I might do something, rather than having an idea that you go somewhere at a certain hour and spend so many hours there doing things.[37]

One wonders, then, how he has consistently remained as focused as his output suggests and how he is so prolific (and whether or not to believe him) when he unassumingly describes his practice:

> I work a little bit and then I go do something else, and then I come back and work a little bit more...I work in this broken fashion. But I rather like it, because the work mixes in with the rest of my life, whatever I'm doing, whether I'm swimming or gardening or driving the car...One thing

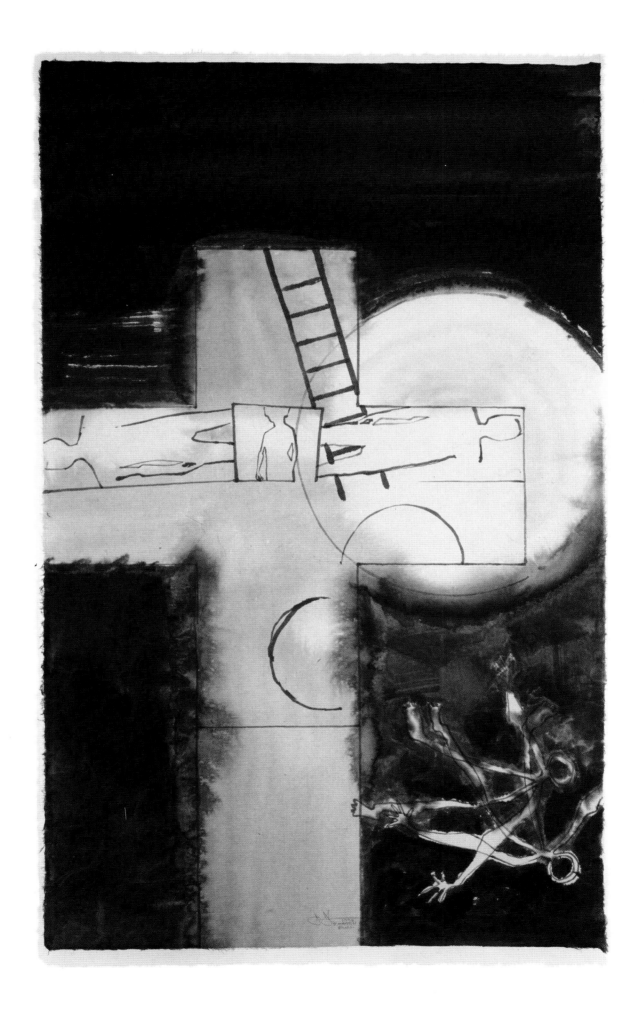

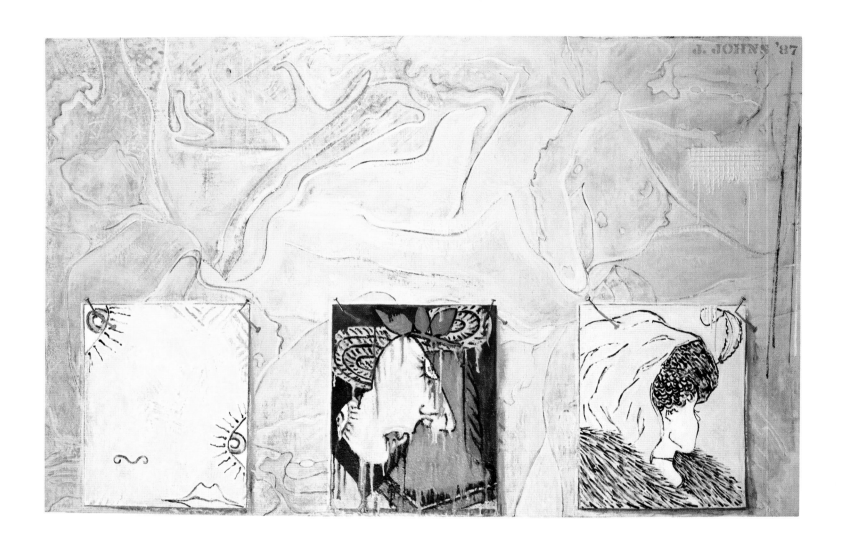

**27**
*Untitled*, 1987
Oil, encaustic, and charcoal on linen
50⅛ × 76⅛ (127.3 × 193.4)
Hirshhorn Museum and Sculpture
Garden, Smithsonian Institution,
Washington, DC

that seems to happen because of that kind of fragmentation is that a visual image of the work remains in the mind. As I go to sleep or wake up, some detail of a work in progress often seems to be in front of my eyes, so that I think I'm working even when I'm not.[38]

Johns has made a life of art. He tends to

devote a good deal of time to a painting, although much of it isn't actual working...Sometimes I resist working on a picture even though I know one of the best ways to work is to begin to work. Working itself creates ideas and tells you what to do.[39]

He appears to respond to the variety of operations his work demands. For him,

some things require tedious labor, some are different in their physical structure, while others are different in their spiritual structure. Some things come with a variety of uncertainty, clumsiness, gracefulness.[40]

Johns's art is grounded in the belief that habit can diminish our receptivity to the transformative potential of new perspectives and independent thought. He approaches his work with an open mind, while incorporating familiar elements that forge an endlessly evocative chain.

Johns has provided a model not only of originality and creativity—in his formal investigations, and in the ways he imparts meaning—but of how to live one's life as an artist. It would be difficult not to admire the persistence and integrity with which he approaches picture making. Johns's gentlemanly reticence about his art and his life is well known, and helps him to keep his distance from the commercial art world in which he is unavoidably entrenched. As the critic Vivian Raynor observed in 1973, "it is hard...to reconcile Johns's aura of sociability with the other impression of almost priestly apartness."[41]

Johns's art cannot easily be categorized. Since the earliest flags and targets, it has informed itself, grown on itself, and revealed its own humanity in that process of evolution. His art has never been static. It is complex and not easy to penetrate, though Johns never withholds from us the singular pleasure of his painterly finesse. Although it is not always evident in his work, Johns is not shy about articulating his self-professed pessimism. As he told Calvin Tomkins: "The basic question here is whether you think life is a wonderful condition, or not. I don't particularly. Amazingly enough, it's not entirely to my liking."[42] In spite of the artist's feelings of hesitation, doubt, and skepticism about the human condition—or perhaps because of them—during the period from 1980 to 2015, he made some of his most moving and challenging work, which is the subject of this book. To understand it requires a capacity to see the many ways he conveys meaning and a readiness to relish his methods. In retrospect, we may look at his early work in a new light, and acknowledge his career to be more fluid than we previously might have thought.

# THE CROSSHATCH AMPLIFIED

MY EARLY PAINTINGS WERE LARGELY ABOUT
ONE THING, ONE IMAGE. WHEN I SAW THIS WAS
THE CASE, I THOUGHT THAT PAINTING DIDN'T
HAVE TO BE LIKE THIS. MAYBE IT COULD
BE SOMETHING ELSE...EVENTUALLY, I PUSHED
THE BRUSHSTROKES FORWARD AND MADE
THEM THE SUBJECT OF THE PAINTING.[1]

JASPER JOHNS, 1988

The starting point for this study of the late work of Jasper Johns is a group of pictures that grew out of and developed the crosshatch motif he had first started using in 1972. Taking into account works such as the large drawing *Voice 2* and the three-panel encaustic *Between the Clock and the Bed*, this chapter traces the range of Johns's art from 1978 to 1983 and the new direction it followed. In the 1970s and early 1980s Johns broadened the formal and stylistic scope of his painting practice—setting aside his intense dedication to printmaking and experimentation with a variety of materials—to explore abstraction, before eventually returning to the independent rendering of representational objects. Between 1973 and 1982 the crosshatch motif provided Johns with his primary means of visual expression, both in encaustic and oil paintings and in works on paper. During this period his work engaged with formal issues of surface pattern, material, and structure, as well as the integrity of the picture plane and its limits.[2]

In an interview in 1988, Johns distinguished the more purely formal character of the crosshatchings, in which the brushstrokes became "the subject of the painting", from his earlier iconic pictures.[3] The crosshatch imagery sprung, however, from a motivation similar to that of the flags, targets, and numbers, all subjects that for Johns are "taken...not mine."[4] In a well-known anecdote, he explained how his idea for the crosshatchings came from a fleeting optical impression. He told the writer Michael Crichton that he

> was riding in a car, going out to the Hamptons for the weekend, when
> a car came in the opposite direction. It was covered with these marks,
> but I only saw it for a moment—then it was gone—just a brief glimpse.
> But I immediately thought I would use it for my next painting.[5]

Several years later, Johns described how the crosshatch "had all the qualities that interest me—literalness, repetitiveness, an obsessive quality, order with dumbness, and the possibility of complete lack of meaning."[6] He first incorporated hatch marks in the leftmost panel of the large four-part *Untitled* (1972; fig. 29). The following year he painted *Scent* (1973–74; fig. 28), his first allover crosshatch painting, and this and other paintings of the early 1970s ushered in an unfamiliar type of abstraction,

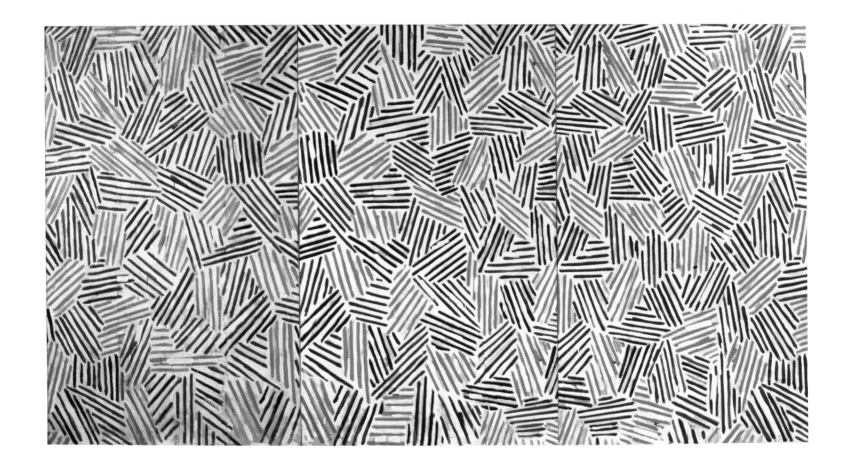

**28**
*Scent*, 1973-74
Oil and encaustic on canvas
(3 panels)
72 × 126¼ (182.9 × 320.7)
Ludwig Forum für
Internationale Kunst, Aachen

**29**
*Untitled*, 1972
Oil, encaustic, and collage
on canvas with objects (4 panels)
72 × 192 (182.9 × 487.7)
Museum Ludwig, Ludwig
Foundation, Cologne

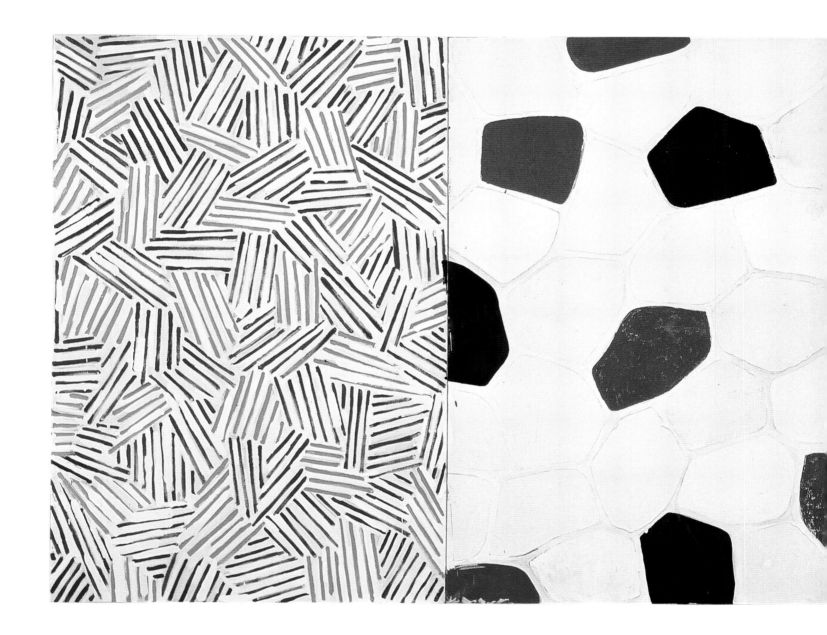

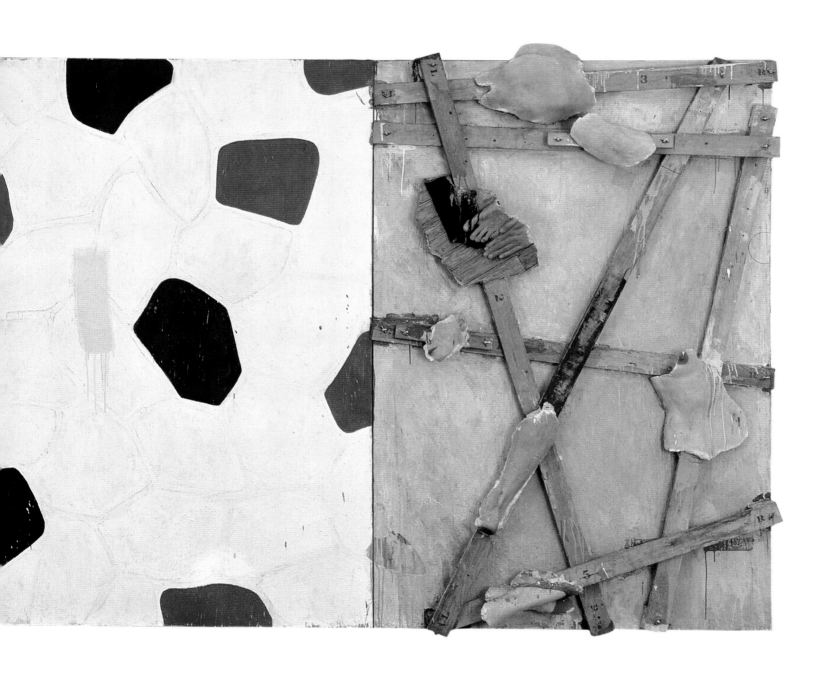

painterly without being expressive, schematic but not rigidly geometric, planar and volumetric.[7]

With the crosshatch form, Johns chose a technique that had been used by artists since the Renaissance to indicate shadow and three-dimensionality but that was for him, improbably, a found image. Johns was well aware, as the art historian Michael Fitzgerald has noted, of the patterns of short parallel lines—planes that unite figure and ground—in the final version of Pablo Picasso's *Women of Algiers* (1955), which hung with three others in the series in a red sitting room in the apartment of his friends (and serious collectors of both Picasso and Johns) Victor and Sally Ganz.[8] Although Picasso had interested Johns since his beginnings as an artist, it was during the 1970s that the older artist's significance for Johns came into focus, and not until the 1980s that Johns's own work showed his close and consistent study of Picasso.[9] Johns's crosshatch painting *Weeping Women* (1975; fig. 31) shares its title with Picasso's etching and aquatint, *La Femme qui pleure (Weeping Woman)* (1937; fig. 30), seen by Johns in a room at Atelier Crommelynck in Paris where he was working on the design and crosshatch etchings for his artist book collaboration with William Beckett, *Foirades/Fizzles* (1976). Some have taken the title *Weeping Women* literally and seen three abstracted figures embedded in the painting's hatchings. Others suggest that the imprints of irons in the middle panel derive from the triangular fingernails of Picasso's woman, or even from the pointed breasts of those in another work by Picasso that Johns would have seen at the Ganzs's home, *Woman in an Armchair* (1913).[10] Either way, the emotive character

**30**
Pablo Picasso
*La Femme qui pleure
(Weeping Woman)*, 1937
Etching and paper,
with aquatint ground
27¼ × 19½ (69.2 × 49.5)
Musée National Picasso, Paris

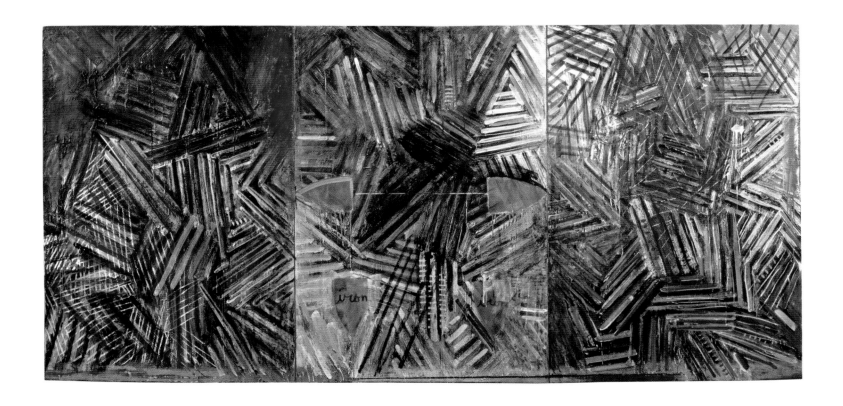

**31**
*Weeping Women*, 1975
Encaustic, charcoal, and collage
on canvas (3 panels)
50⅛ × 102⅜ (127.3 × 260)
Collection of David Geffen,
Los Angeles

**32**
*Usuyuki*, 1977–78
Encaustic and collage
on canvas (3 panels)
35⅛ × 56⅝ (89.2 × 143.8) overall,
including frame
The Cleveland Museum of Art

**33**
Jasper Johns at Gemini G.E.L.
while working on the Foundation
Print Project, October 1980

of Johns's *Weeping Women* does not appear as a subjective expression of the artist's own experience, but derives instead from the picture's association with Picasso's intensely affecting human portrayal.

In the crosshatch works, Johns arranged his hatch marks in clusters of patterns, some more regular, others less so, following predetermined configurations of repetition, mirroring or the transgression of boundaries. The complex arrangement of hatchings reached an apex in the late 1970s in the *Usuyuki* series, compositions that call to mind the swirling evanescence of flurrying snow (1977–78; fig. 32).[11] Distinguished by painterly units animated through expressive gestures, with drips, dabs, and raised dots of paint and encaustic as well as newsprint forming both mark and ground, *Usuyuki* represents a release from Minimalist restraint. Some of the expressive force of the crosshatch motif, however, stems from its association with the type of fragmentation and repetition of forms that runs throughout the history of modernism. The manner in which the crosshatchings fracture the picture plane originates from the same complex evocation of modern time and spirit addressed, for instance, in Degas's aggressive framing and odd compositional croppings that indicate a world seen on the fly and create a self-conscious abstract surface rhythm.[12] In 1979, discussing his re-use of plates or stones in producing his prints, Johns acknowledged that while this type of reworking is easier in printmaking,

> you see bits of it in other work. I think you see it in Rodin, for instance,
> with casts of body parts appearing over and over again in different
> works. You see it a lot now in contemporary music. Certain material
> is recycled in different pieces, different compositions: this material may
> be transformed in some way or may simply appear in a new combination

with other material. I thought it was striking in some of the music used in the Cunningham Dance Company's recent performances in New York.[13]

Johns's crosshatchings present a composite that fuses painterly facture with a highly planned geometric arrangement, simultaneously suggesting individual and type, and spontaneous form and given gesture. Just as early modernist works shared ideas with contemporaneous studies in science about flux and dynamism, as well as the fidelity of perception and the integrity of the universe, so Johns's hatched patterns acknowledge concomitant scientific developments that came with the birth of the microchip and new ways of analyzing the organizational principles underlying the apparent randomness of nature.[14] In studying and breaking apart organic structures such as a cauliflower or a fern frond and applying mathematical principles to nature, scientists discovered similar patterns at work, each part resembling the whole, only smaller. The fractured, seemingly random system of inflections in Johns's crosshatchings recognizes these contemporaneous advances in applied mathematics.[15] More specifically, Barbara Rose has suggested general links between Johns's crosshatch pattern and diagrams that illustrate theories of visual clustering published in the magazine *Scientific American*.[16]

◆

In 1982 Johns made *Voice 2* (fig. 34), a major three-part drawing on plastic, each of the three sheets separately framed, a reiteration of his earlier painting also called *Voice 2* (1967–71; fig. 23). Johns often reconsiders his earlier works—treating them as found images—and, characteristically, drawings and prints will follow a painting instead of the more conventional approach of developing a painting from a preliminary drawing. In 1982 and 1983, he made five lithographs also titled *Voice 2*.[17] The serial nature of Johns's reworkings, and the interdependence of his pictures, raises the significance of process for him. In his contradictory way, an image is never— yet always—unique. There is always the possibility that he will reinvent, reconsider, or remake an image in a different medium. At the same time, Johns's consistent method of working—his sheer persistence—becomes a metaphor for the churnings of his mind, as these variants come into being. Nothing is abandoned; everything remains available to be considered anew.

*Voice 2* (1982) is a virtuoso balance of structure and graphic freedom, linking it conceptually to the contemporaneous crosshatch works with their sensually rendered yet planned arrangement of hatched clusters. It shows Johns exploring a new expressive freedom. His use of multiple formats—possibly affected by his growing interest, discussed in more detail in Chapter Two, in the polyptych Isenheim altarpiece by the German Renaissance master Matthias Grünewald— would continue to develop in subsequent years. Like the earlier painting of the same title, *Voice 2* offers the possibility of variable hangings, with the three sheets displayed in any order. When arranged sequentially, the outer edges could, theoretically, be joined to form a cylinder. Johns had been interested in this type of imagined volumetric space as early as 1961–62 when he made *Fool's House* (fig. 12).

Johns drew a bisecting line with arrows at both ends through each of the three sheets in *Voice 2*, one vertically, one horizontally, and one diagonally, creating a linear structure that contrasts with the inky pools of vibrant yellow, blue, red, and

purple, and with the more organic scrawls of the overlying ink markings. The vivid gestures and allover character of the ink affirm Johns's fluidity and deftness with drawing and his relish for experimenting with unconventional materials. Paradoxically, the calculated composition is belied by the stirring nature of the inked surface. Each sheet has its own distinct character: while the one at far left relies on the yellow, blue, black, and white tones of the free-flowing wash, with relatively minimal and loosely applied overlying pen scrawls, the surface of the right sheet is worked in an allover fashion with the staccato markings of a razor-thin pen set off against the translucent yellow, purple, and gray brushed ink wash. These two poles are combined in the middle sheet, which is densely worked, with both crisp pen marks and more vigorous long vertical lines at the top, suggestive of a dense rain or thunderstorm, applied over red, green, black, and gray wash.

The strong, pellucid colors of the 1982 drawing contrast with the classic elegance of the gray painting produced over ten years before. In the earlier work, underpainting in red, white, blue, purple, yellow, and orange lightens the dense, somber tone, but its overall feel is one of stasis, not the relative cacophony of primary and secondary colors seen in the later drawing. This reflects the fact that Johns began to work with an increasing range of color during the early 1980s, eventually experimenting with more varied hues from creamy yellows and bubblegum pinks to rich, deep purples and dark nocturnal effects. Unlike in the earlier painted version, the gestural aspects of the 1982 drawing—the unconstrained, scrawled adaptation of the crosshatch marks and pools of ink—dominate. The letters that spell out the title across its three parts are full of resonant movement, either breaking apart or sliding off the page. The drawing's scale and its freedom are suggestive of a landscape with its own atmospheric conditions. Coming as it did at the end of a period when Johns concentrated on the visually compelling yet conceptually circumscribed crosshatchings, *Voice 2* may be seen as a transition, a move in a more free and expressive direction.

The fragmented body—represented here by the voice—has been a central element in Johns's work, in which various parts of his and other people's bodies appear countless times.[18] Johns's deadpan humor and sharp sense of irony can be seen in his decision to depict the voice as a written word. The title *Voice 2* looms large in both the painting and the drawing, but especially in the latter, taking up more than half the image. Speaking about the word 'voice', Johns told Christian Geelhaar:

> After the first *Voice*, I suppose there was something left over, some kind of anxiety, some question about the use of the word in the first painting. Perhaps its smallness in relation to the size of the painting led me to use the word in another way, to make it big, to distort it, bend it about a bit, split it up.[19]

The conflation of the visual and the verbal in *Voice 2* is characteristic of much of Johns's work, defying easy categorization in what Kirk Varnedoe—who wrote so intelligently about the ways in which Johns's pictures convey meaning—described as "nonabstract forms of abstraction."[20]

◆

Johns has said that one of the qualities that he favors in working with ink on plastic is its "independence, that it is difficult to tell from the finished drawing what gestures were used to produce it."[21] In the case of *Voice 2*, it is interesting then that he chose to overlay the translucent ink with a series of gestural pen strokes; the sharply drawn scribble maintains its autonomy as surface static, while the underlying inky pools develop tone. When worked on plastic, Johns's markings tend to adhere to the surface, creating a sense of life and movement that reminds us that Johns's art, in spite of its divergence from it, followed closely on the heels of Abstract Expressionism. *Voice 2* veers off from that earlier mode, however, in its rigorous structure and in the large careening stenciled letters and number of the work's title, "Voice 2," that unite the three sheets. The V begins on one sheet and is carried over onto another. Abstract echoing forms at the top balance the letters at the bottom. The "O," for instance, has an echoing semicircle above it; an irregularly shaped toast-like form balances the "E 2." It has been noted that this shape is similar to Johns's imprint of Marcel Duchamp's sculpture *Female Fig Leaf*—a bronze version of which Johns owns—in paintings from the early 1960s such as *No*, *Field Painting*, and *Arrive-Depart* (fig. 79), and points to the lasting significance of Duchamp's ideas for Johns.[22]

**34**
*Voice 2*, 1982
Ink on plastic (3 panels)
35⅛ × 23⅞ (89.2 × 60.6) each panel
Philadelphia Museum of Art

In the winter of 1984, Johns showed fourteen of his recent paintings in the airy loft-style space of the Leo Castelli Gallery on Greene Street in SoHo (fig. 35). While the fifty-three year old had had a major retrospective at the Whitney Museum of American Art in 1977 and had exhibited ten years of his drawings at Leo Castelli in 1981, Johns's last show of new paintings had been in 1976 at the Castelli Gallery on East 77th Street. This previous small exhibit of seven crosshatch paint and wax encaustics alongside a group of works on paper had affirmed his move in the direction of abstraction. In contrast, the works in the 1984 show were more expansive and less guided by a predetermined system of patterning. Some featured figurative elements and such indexical marks as handprints, as well as pieces of cutlery and representations of earlier artworks.

Like *Voice 2*, these latest paintings dating from 1978 to 1983 were not easily categorized, nor did they ally Johns with any particular group of artists. Some, such as *Between the Clock and the Bed* (1982–83; fig. 42), continued on from the abstract crosshatch works that he had begun in the early 1970s, although often in a more monumental and less obviously structured format. In other crosshatch works of this period, for example, the vertically compressed *Céline* (1978; fig. 37), representational elements began to mix with abstraction. At the same time, Johns slowly introduced subtle variations that, when taken together, represent significant changes: a new sense of shallow illusion, as well as an amplified range of color, from dark nocturnal to more lurid bright tonalities. As with *Voice 2*, the works in the 1984 exhibition demonstrated a greater compositional openness than the early crosshatch pictures, and a continuation of the associative possibilities evoked by Johns's choice of titles.

The new turns in Johns's work spurred a lively critical dialogue. Roberta Smith concluded:

> In a time when younger artists feel that paintings must be crammed with images and allusions, often randomly flung together, Johns is relatively sedate, even scholarly. He shows an alternate way to complication, knitting surfaces and images together with a deliberateness and concentration which is breathtaking but at times a trifle airless—as if someone's breath were really being taken.[23]

Looking back at the works in this show, one can see the considerable changes that took place in Johns's art at this time. Art historians agree on this point, while differing about which work definitively marked the turn. In fact, Johns tends to introduce new elements into his work in such a subtle manner—sometimes initially in a drawing, then reiterated in a painting or print or vice versa—that the viewer absorbs the shifts through a gradual process. The sculptor John Newman compares Johns's artistic evolution to the measured but significant way that unfamiliar words (slang, for instance) seem odd initially but then become part of our language, by which time the group (or, in this case, individual) who introduced them has typically moved onto an entirely new lingo.[24] Reviewing the 1984 exhibition, the poet and critic John Ashbery similarly remarked that Johns "has always changed his treatment gradually, so that one day we realize that his paintings are different without being able to point to the place where the change began."[25]

Prior to this, Johns's approach had been to focus on painting's essential elements of surface, structure, form, and color, invigorating them with a physicality

through his paint handling that, in the crosshatch works, elicited the organic energy of controlled chaos and invoked natural forces. As the crosshatchings became freer, in *Céline* and other works, they grew into handprints, signaling Johns's move away from the limitations of late modernism with its prohibition against illusion and represented imagery. What emerged from the increasingly free manner of Johns's use of the inherently abstract form of the crosshatch was an expanded notion of the referential possibilities of painting and a new sense of space. These painterly experiments coincided with those of other artists exploring organic abstraction concurrently, including Carroll Dunham, Bill Jensen, Elizabeth Murray, and Terry Winters.

In writing about Johns's earlier crosshatchings in 1977, Barbara Rose described them as revealing "the artist more distanced from his emotions and personal biography...than he has been since the targets and flags of 1955, which nevertheless were more intimate works with personal references buried in the wax-dipped fragments embedded in their wax crust..."[26] Perhaps in comparison to many of his paintings of the 1960s—whether the grave gray encaustics or assemblages with objects or body parts affixed to the canvas—the crosshatch pictures appear more distinctly determined by their preplanned structure than by the artist's own gesture, despite the fact that he altered the configuration of the hatch marks from picture to picture. As Johns's work with the crosshatch motif progressed, however, he allowed for the possibility of emotional referents, whether in titles, allusions to the figure, or references to the work of artists such as Edvard Munch and Picasso.[27]

There were also signs in his work that suggested Johns was considering representational modeling and new ways of depicting forms and space. In 1977,

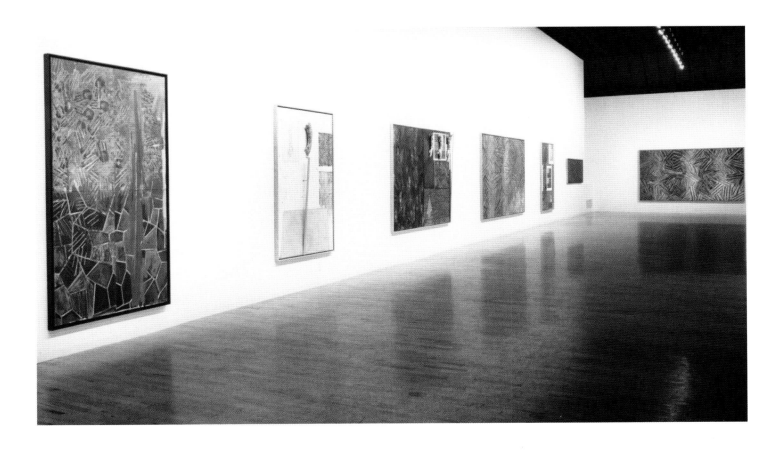

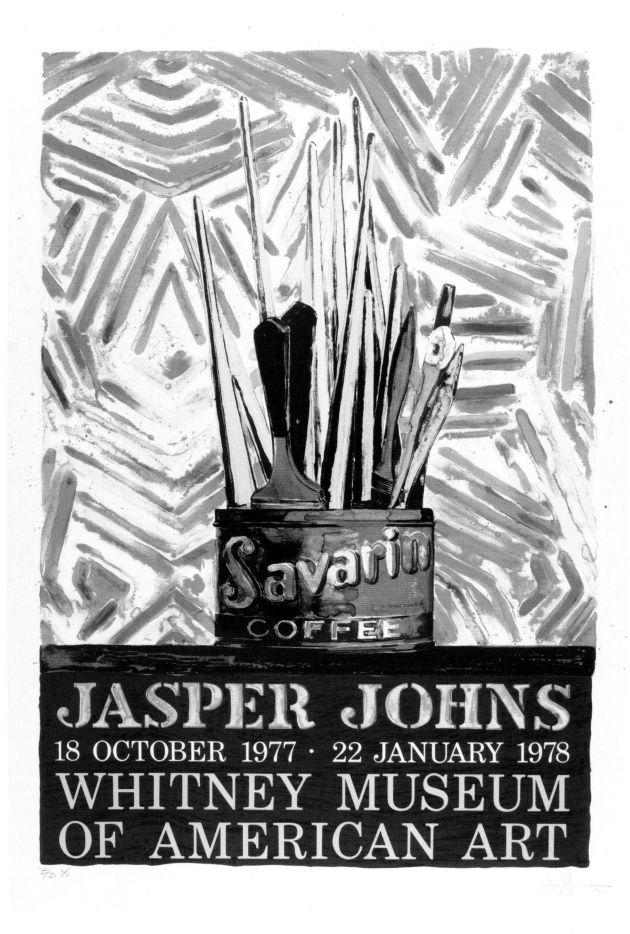

**36**

*Savarin*, 1977
Lithograph in 11 colors,
edition of 8
48 × 32 (121.9 × 81.2)
Published by Universal
Limited Art Editions

for instance, he designed the poster for his retrospective at the Whitney Museum of American Art (fig. 36). The resulting lithograph depicts his 1960 *Painted Bronze*, a bronze cast of a Savarin coffee can full of brushes, positioned on a plinth or shelf, projecting slightly forward into space. It is set against a magnified crosshatch field to indicate the span of the work included in the exhibition. The can with paintbrushes is a representational object, one that is generally considered a non-figurative self-portrait.[28] The poster provided Johns with the opportunity to rethink his more common indexical practice of casting, imprinting, tracing, or affixing objects in his pictures. As he said at the time, "In most of my work I respect the real size of objects, but here I've made a coffee can larger than life—I figured since it's advertising, I could do it."[29] In a group of monotypes based on the Savarin image that Johns made around this time, he turned the hatchings—which already at times bring to mind the fingers of a hand—into handprints and also dissolved them into fingerprints, the formal hatch mark morphing into a more distinctly human element.[30]

While continuing to explore the expanded formal possibilities of the crosshatch, Johns began to fracture the geometric arrangement of these clusters of lines, as seen in the painting *Céline*. A sense of dislocation derives from the slightly off-center vertical division of the canvas—also divided horizontally—as well as the mirroring of hatches and handprints in the upper half and partial repetition of the flagstone motif in the lower section. Forms do not quite meet in the middle and the flagstone and hatch patterns are broken up on the right side by two long vertical passages of paint that suggest a deep fissure, while also recalling the searching arm in *Land's End* (1963; fig. 38) and other pictures of that era. The character of the paint—scraped, smeared, and dripping—enhances the emotive effect of the handprints in its physical manifestation of distress. Painted in a range of grays with lurid orange, green, and purple in the upper half, the work evokes the bleak grit of the innovative twentieth-century French writer Louis Ferdinand Céline's best known novels, *Journey to the End of the Night* (1932) and *Death on the Installment Plan* (1936) which Johns read around this time.[31] The regular hatching and flagstone patterns of Johns's earlier crosshatchings have opened up in *Céline*, suggesting a wall-like format of the type that Johns would turn to four years later in *In the Studio* and subsequent works (fig. 44).

The eerie, unsettled *Céline* is one of the more desolately affecting of Johns's crosshatch works. In contrast, in *Dancers on a Plane* (1980; fig. 39), one of three painted versions from the same time, a lightness prevails (in spite of its smoky dark tonality), embodied in the groups of hatch marks that evoke rhythmic abstracted figures.[32] Speaking of a 1979 version with hatches in the primaries red, yellow, and blue as well as white, the artist explained in 1996 how it has "a symmetrical structure without any great variation in inflection." He continued:

> I had in mind that this might suggest the heroic mood that I was trying to indicate. Heroic or stoic, not involved in impulse. And while working, I began to think of a dancer on a stage. I thought of Merce Cunningham and how so often his work seems colored by a kind of unbalanced energy. In the second painting, with complementary colors, I tried to show that thought...One has the sense, I think of a force moving through the form, an inequality of stress.[33]

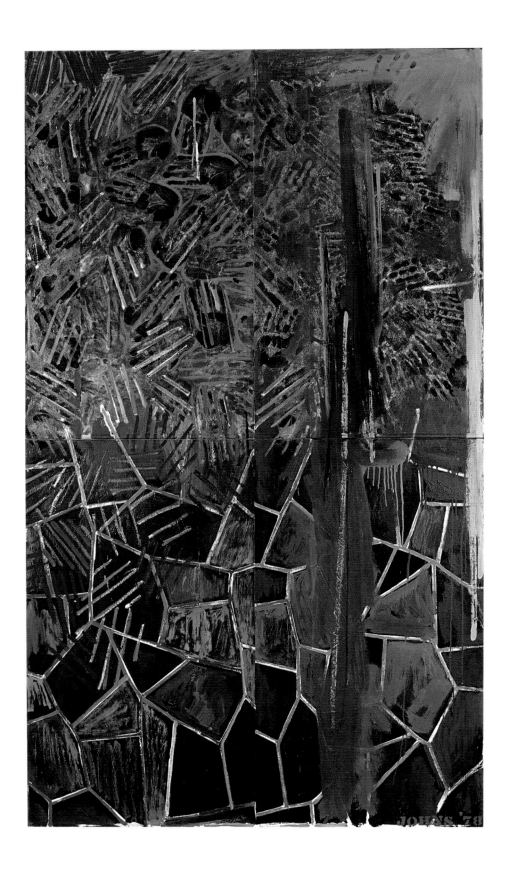

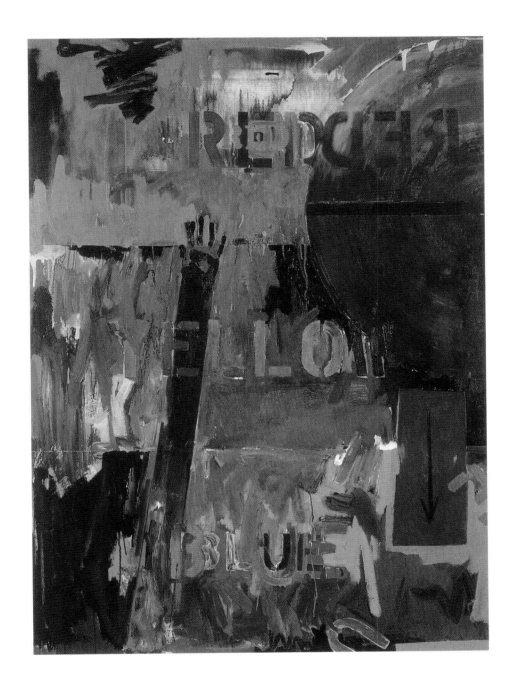

**37**
*Céline*, 1978
Oil on canvas (2 panels)
85⅝ × 48¼ (217.5 × 122.6)
Kunstmuseum Basel

**38**
*Land's End*, 1963
Oil on canvas with objects
67⅞ × 48⅛ (172.4 × 122.2)
San Francisco Museum
of Modern Art

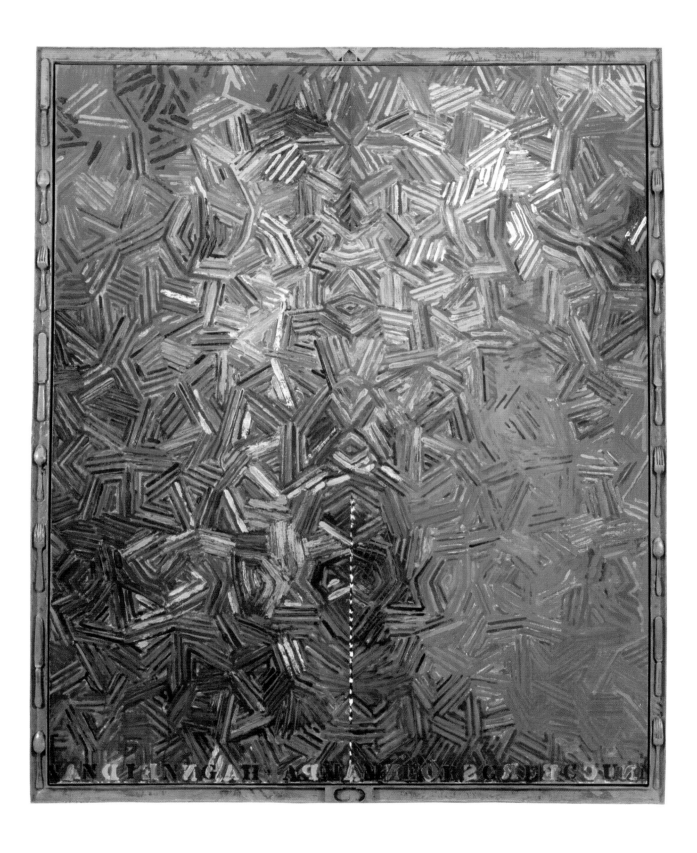

Johns further activated the canvas surface of the 1980 painting, affixing cutlery to it and embedding Tantric sexual imagery in the painted bronze frame, the first objects he had incorporated into a painting in seven years.

Then, in a group of three loosely painted, agitated, dark hatch oil paintings, all called *Tantric Detail* (fig. 41), the artist drew on images of sex and death from a seventeenth-century Nepalese painting, *The Mystical Form of Samvara with seventy-four arms embracing his sakti with twelve arms* (fig. 40).[34] The cartoonish testicles, skull and dotted line reminiscent of Tantric beads in all three of these pictures represent the first marked example of free drawing as opposed to casting, tracing, or printing in Johns's painting, not to mention a return to representational imagery after a ten-year exploration of abstraction.[35] In each one, testicles and a skull emerge from linear divisions in the canvas, creating a shallow sense of space amidst the hatching. From this period onward, Johns's manipulation of paint seems to embody both visual and tactile experience.

Speaking in 1990 of the crosshatch works, Johns described how "they become very complex, with the possibilities of gesture and the nuances that characterize the material—color, thickness, thinness—a large range of shadings that become emotionally interesting."[36] According to the artist, he was moving away from not wanting his work to be, as he said in a well-known statement in 1973, "an exposure of my feelings."[37] Over ten years later, in 1984, he elaborated:

"In my early work I tried to hide my personality, my psychological state, my emotions. This was partly to do with my feelings about myself and partly to do with my feelings about painting at the time. I sort of stuck to my guns for a while, but eventually it seemed like a losing battle. Finally, one must simply drop the reserve."[38]

Paradoxically, Johns's chosen motif—the inherently mechanical crosshatch—and the carefully premeditated manner in which he used it, ran counter to the freedom of expression that one might associate with lowering one's guard. This might account for the gradual move to a more expansive, expressive crosshatch style visible in his work by the early 1980s.

In 1980, after Johns had been absorbed with the crosshatch motif for seven years, a friend sent him a postcard of Edvard Munch's *Self-Portrait: Between the Clock and the Bed* (1940–42; fig. 43).[39] This late self-portrait (Munch was close to eighty and would die in 1944) shows the resigned artist standing impassively before open French doors leading into a bright studio with his paintings covering the walls. It is both emotionally resonant and formally compelling. Munch placed himself between a grandfather clock without hands, suggesting the passage of time and our inability to control it, and a small bed, alluding to solitude, as well as to birth, death, and sex. Significantly for Johns, the bed is covered with a bedspread depicted in a hatch motif similar to his own crosshatchings. While the depicted studio stands as a reminder of Munch's creative life, his senses seem to have shut down: his eyes are closed and his ears are concealed by red dabs of paint. Even the shiny, reflective paint surface of the floor suggests instability, as if the figure might slip away at any minute. It is a somber image ambiguously lightened, however, by the almost decorative manner in which it is painted.

Between 1980 and 1983 Johns made a number of crosshatch works stimulated by Munch's painting.[40] He began with two drawings in 1980, followed by two

**39**
*Dancers on a Plane*, 1980
Oil on canvas with painted bronze frame
78¾ × 63¾ (200 × 161.9)
Tate, London

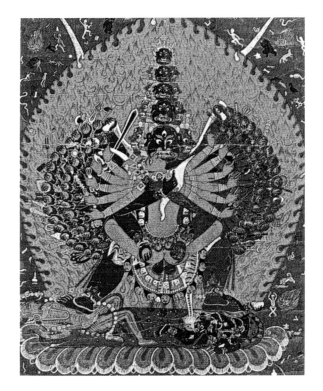

**40**
Artist unknown
*The Mystical Form of Samvara
with seventy-four arms embracing
his sakti with twelve arms*
Nepal, seventeenth century
Gouache on cloth
28 × 19 (71.1 × 48.3)

**41**
*Tantric Detail I*, 1980
Oil on canvas
50 × 34 (127 × 86.3)
Collection of Donald L. Bryant Jr.
and Marie-Josée and Henry R. Kravis

large paintings the next year, the second of which is the expansive three-panel grisaille encaustic *Between the Clock and the Bed* (1982–83; fig. 42). These works show Johns, then in his early fifties, turning to a more concentrated consideration of the fragility of life and human mortality.[41] In light of the direction his own work was headed, Johns's interest in Munch at this point is particularly revealing; Munch's art is a frank exploration of human emotion and an intense self-examination of the artist's own disturbed and agitated life, of his loneliness and pain, memories of his childhood and sexual awakening, as well as considerations of death.[42]

In Johns's painting, a variety of large-scale gray-toned hatches animate the surface of the canvas, highlighted by underpainting and by carefully placed thinner hatchings in gradations of pink, orange, blue, red, and yellow. Much smaller hatchings in purple, green, brown, red, and blue at the lower right and lower left, as well as at the bottom of the middle panel, refer to the quilt on the bed in Munch's painting. Through the spacing and colors of the lines that form the coverlet in his self-portrait, Munch suggested volume. This may have contributed to Johns's interest in similar concerns and the potentially cylindrical composition of the three panels that he had already explored in *Voice 2*.

Johns has said that in the crosshatch works he was creating "spaces that suggest a connection to physical presences."[43] Indeed, each of the panels in *Between the Clock and the Bed* alludes to one of the key components in Munch's painting: the clock on the left, the artist in the center, and the bed on the right. The groupings of parallel lines unite to form an allover surface characteristic of much abstract modernist painting, while at the same time creating planes reminiscent of cubist space. Johns manages incongruously to suggest both flat surface and depth and this spatial equivocation imparts emotional vibrancy. In a review of the exhibition of Johns's crosshatch pictures at the Leo Castelli Gallery in 1976, art historian

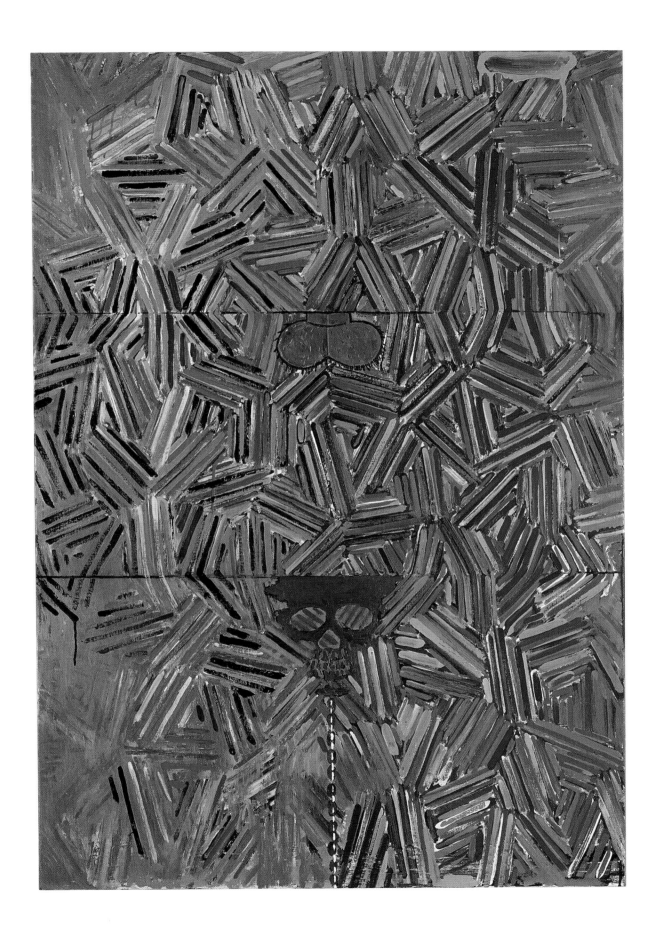

With its large vivid hatchings, this monumental work appears baroque in comparison to the more classic human scale and relatively restrained forms of earlier crosshatchings like *Scent* or *Usuyuki*. While multi-panel paintings figure prominently in Johns's oeuvre, his decision to work in such a large scale, combined with the triptych format that one associates with biblical painting since the early Renaissance, is intriguing. The three panels are unified by the strokes that cross from one to the next. The crosshatch patterns of the two outer panels mirror each other; the intervening middle one remains independent. While the hatching pattern is identical in the left and right panels, Johns's arresting brushwork renders each one distinctively. In the left canvas, the hatches coalesce, as the encaustic appears more blurred. The encaustic in the right panel is of a darker range of grays and each hatched line remains discrete. Within each of the three panels, the hatchings are more densely described at the edges with a thicker application of encaustic and added lines. The middle of each canvas is rendered in thin light gray paint, the hatchings sometimes appearing as brushstrokes over seemingly raw canvas. Encaustic drips enhance the work's rawness. It is an intense painting that recalls the gray and brown monochrome paintings of Picasso's analytical cubism, in which the depicted form can be seen from several simultaneous viewpoints.

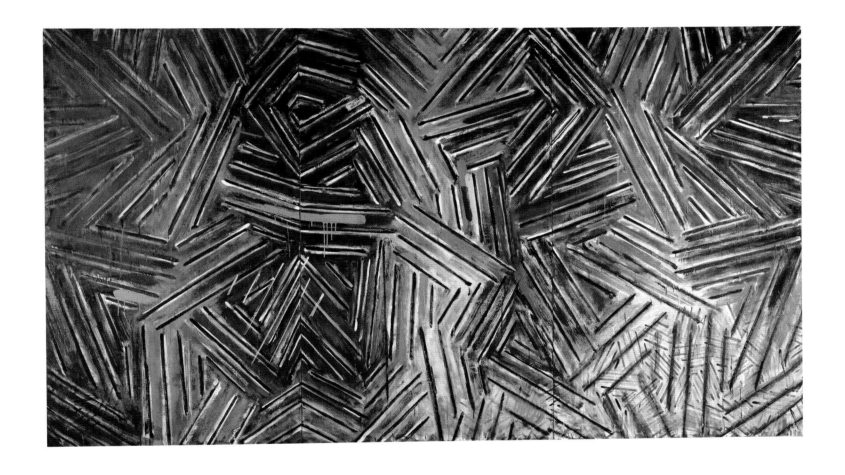

**42**
*Between the Clock
and the Bed*, 1982–83
Encaustic on canvas (3 panels)
72 × 126 (182.9 × 320)
Virginia Museum of Fine Arts,
Richmond

Joseph Mascheck had described the artist's "emotionalized conceptualism" and commented on the distinctions between Johns's delineation of space and that of his cubist precursors: "Cubism still dealt with axial revolution in space (extending the *posed* aspect of traditional figure and still-life painting), while Johns operates almost completely with rotations in the plane."[44]

For the artist Terry Winters, Johns's crosshatch images "quantified and measured the space that is in Pollock," in effect, breathing new life into the possibilities of abstraction.[45] While the formal characteristics of structure, pattern and repetition in these works dominated in much the same way as they had in the alphabet and number pictures of the 1950s, the crosshatch paintings—especially those of the late 1970s and early 1980s, infused with the spirit of the expressionist Munch (as well as Picasso)—assumed a new character. With *Between the Clock and the Bed*, Johns finished—at least for the time being—his vivid exploration of

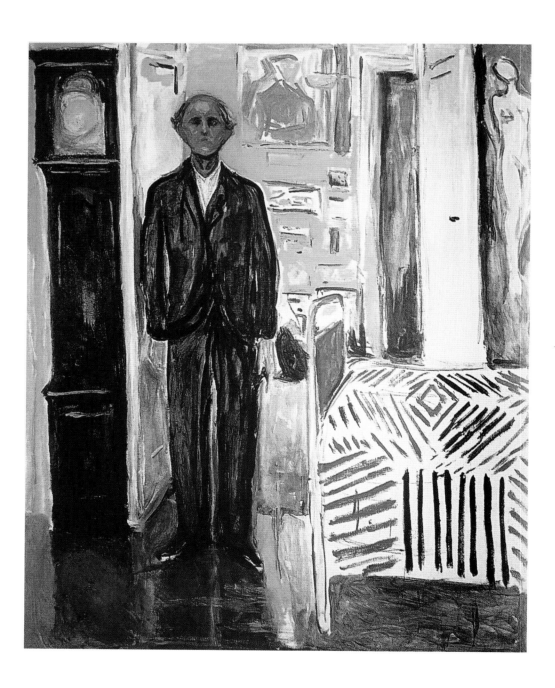

**43**
Edvard Munch
*Self-Portrait: Between the Clock and the Bed*, 1940-42
Oil on canvas
58¾ × 47½ (149.2 × 120.7)
Munch Museum, Oslo

the crosshatch, an intrinsically inexpressive form that he had taken to the limits of its expressive possibility. He achieved this with a highly intelligent and startlingly beautiful visual language, heightened by his use of evocative titles, which for most of the crosshatch pictures resonate with references to other artists (Jackson Pollock: *Scent*, Picasso: *Weeping Women*, Edvard Munch: *Between the Clock and the Bed*), writers (*Céline*), and natural as well as spiritual transformation (*Cicada*, *Tantric Detail*).[46] The allusive content that these titles provoke foreshadows the personal and art historical references in Johns's work of the 1980s and mid-1990s.

*Between the Clock and the Bed* can thus be seen as part of a transitional group of pictures, works that were becoming more concerned with a deepening expression in form and facture and a new attention to varieties of representation and abstraction. This did not escape the notice of contemporary critics. Writing about the crosshatch works, John Russell observed:

> It is a very promising last quarter of our century which begins with new pictures like the ones by Jasper Johns which are on view at the Leo Castelli Gallery…That the whole show is intelligent in the highest degree goes without saying; but one of the special things about Jasper Johns is that he allows for other things beside intelligence—for the intermittences of feeling, for instance, and the quirks and accidents and small exasperations which cannot be programmed out of human life.[47]

The early 1980s marked a pivotal period in Johns's practice, as he moved between abstract and representational modes and turned away from the crosshatch works to more open compositions. As formal issues concerning the art object and its physical properties, as well as the process of art making itself, continued to be significant characteristics of Johns's work, iconographic references also began to hold greater sway. Johns's art at this time begins to reveal a greater concern for the details of experience, a new subjectivity that allowed for a variety of open-ended meanings. He continued to transform and renew earlier imagery, such as in the 1982 reiteration of *Voice 2*. While conceptual elements remained significant, the works discussed in this chapter suggest that his pictures were becoming less contained, more visceral, and that meaning was accumulating through memory and subjective experience.

# RACING THOUGHTS

I'M INTERESTED IN THINGS WHICH SUGGEST THE
WORLD RATHER THAN SUGGEST THE PERSONALITY.
I'M INTERESTED IN THINGS WHICH SUGGEST
THINGS WHICH ARE, RATHER THAN IN JUDGMENTS.[1]

JASPER JOHNS, 1965

I ADMIT TO A SLIGHT LEANING TOWARD THE ESOTERIC,
AND AM PERHAPS NOT TO BE TAKEN SERIOUSLY. I AM
FOND OF THINGS OF GREAT FRAGILITY, AND ALSO AND
ESPECIALLY OF THE KIND OF POETRY JOHN DONNE
REPRESENTS, A DARK MUSKY, BROODING, SPECULATIVE
VINTAGE, AT ONCE SENSUAL AND SPIRITUAL, AND
SINGING RATHER THE BEAUTY OF EXPERIENCE
THAN INNOCENCE.[2]

HART CRANE, 1921

In 1982 Johns turned from the groups of hatch marks, the abstract patterns that had been his focus for much of the previous decade, to approach issues of representation and perception in canvases and works on paper that mix figurative imagery and abstract forms. Where the dense webs of crosshatchings had provided a thicket of lines on gridded or indistinct grounds, in his new work Johns employed shallow illusion and a layering of images and objects to suggest the pinboard wall of a studio or domestic interior. To some extent, and in very different ways, both the hatched patterns and the pinboard imagery Johns initiated in the 1980s probe embedded memory, fragmentation and transience. His new pictures, however, with their trompe-l'oeil devices and appropriations of his own art and that of other artists, as well as their varied cultural and personal associations, offered the opportunity for an expanded referential and emotive range.

With *Céline* (1978; fig. 37), as discussed in Chapter One, Johns started to break up the repetitive structure and pared down patterning of the crosshatch with agitated, free handprints. Then, in *In the Studio* (1982; fig. 44), in which a studio wall is depicted with only the slightest illusionistic depth, he reproduced parts of two of his hatched drawings apparently tacked to the wall with trompe-l'oeil nails. While Johns had not dismissed the crosshatch motif altogether, he adapted it and employed it in different ways, incorporating his own crosshatch works in this and other pictures such as *Perilous Night* (1982; fig. 47), as well as using free

hatched passages to represent abstracted appropriations of Matthias Grünewald's sixteenth-century Isenheim altarpiece in several works of this period. Johns's close study of Edvard Munch's late *Self-Portrait: Between the Clock and the Bed* (1940–42; fig. 43) may also have led him to consider new aspects of representation that took into account his own physical and psychic environments.

*In the Studio* initiated a new format and type of space in Johns's art. In this and numerous other works of the early 1980s that followed, including *Perilous Night*, *Racing Thoughts* (1983; fig. 52) and *Ventriloquist* (1983; fig. 53), the canvas surface became a studio or bathroom wall, the latter indicated by bathtub fixtures and the top of a wicker laundry hamper. *In the Studio* returns to a more obviously human orientation in comparison to some of the very large crosshatch canvases Johns was working on at the same time. In appropriating his own earlier pictures, he explores processes of transformation, repetition, and variation and how each new work is defined; one work recalls another, though each maintains its distinctive character. The new inevitably modifies our perception of the old, and reshapes the appropriated image's meaning through successive works.

While Johns included "personal" elements—objects that had some significance for him—in his work of the early 1980s, and such references increased throughout his pictures of the 1980s and 1990s, these pictures remain an incongruous enigma. They captivate without revealing anything in particular about the artist. And while some of them may have an autobiographical basis, they are not necessarily any more expressive of Johns's personal history than any of his other work. Johns has indicated about this imagery that he is "not even sure it's not *less* revealing. But I don't know. What is it that work reveals? Work reveals itself, really."[3] For Johns, there is a direct correlation between a painting's formal composition and its expressive content. Meaning is embedded in process more than in any deliberate expression on the part of the artist. Johns's art "doesn't just refer to things which are images," as he stated in 1989, "but ways of doing things, ways of painting."[4]

With its literal title, pared-down color scheme and formal rigor, *In the Studio* appears determinedly disciplined. The compositional format and spatial issues addressed in the work initiated an approach that Johns continued to investigate throughout the early 1980s and beyond, exploring the anomaly of representing the world on a flat canvas surface. The layering of forms that indicates shallow illusion is enigmatically challenged by the pictures and signs depicted in the paintings. It includes elements of painting, drawing and sculpture. Johns's own description of *In the Studio* affirms his straightforward investigation of artistic practice, of depicting various approaches to representation:

> I had seen an empty canvas propped against a painting in my studio, and that accounts for the sort of empty rectangle that goes in a slight perspective. I had some wax casts of an arm of a child; a three-dimensional object in relation to this representation of space in the canvas. It has a stick of wood that comes out from the painting. I was playing with that kind of thought on one level—of real things in space, and a suggestion of things in space, and within the studio setting the representation of paintings, at least one of which is melting. So in a kind of setting where there are just a few elements, there was the suggestion that something was happening, I thought.[5]

*In the Studio* shows a blank canvas leaning against a paint-spattered wall. Sharply delineated by a thin dark outline, the raw canvas at the picture's lower edge indicates a shallow spatial recession. The work is full of formal paradoxes: the picture surface suggests a flat wall while the painted picture creates a sense of space. A strip of wood attached just off center at the bottom of the canvas intrudes into the viewer's space, counteracting in real space the relief of the canvas within the painting. Hanging from a nail at the top edge of the work is the wax cast of a child's arm, patterned in red, yellow, and blue, recalling Picasso's lonely harlequin figure embedded in the wax. The shadows cast on the picture by the protruding stick and wax cast paradoxically reinforce the object quality of the canvas, as does the imprint of a circle fragment at its lower left edge. In contrast, across the top, a line made to resemble freehand drawing in charcoal or graphite also establishes the flatness of the canvas surface.

**44**
*In the Studio*, 1982
Encaustic, crayon, and collage
on canvas with objects
72 × 48 (182.9 × 121.9)
Collection of the artist

**45**

*Target with Four Faces*, 1955
Encaustic and collage on canvas
with objects
29¾ × 26 (75.6 × 66)
The Museum of Modern Art,
New York

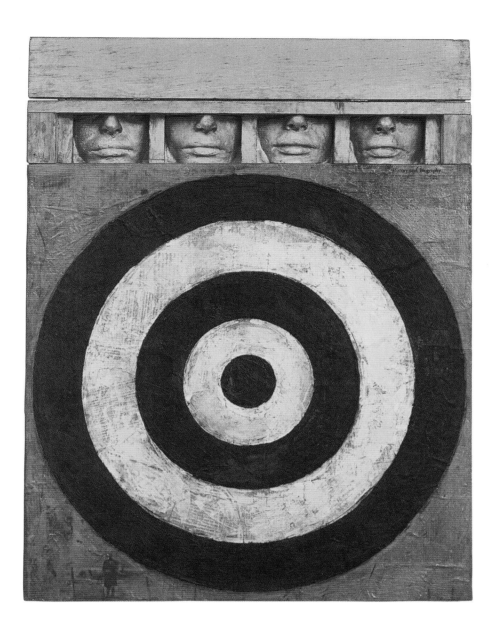

While indexical body fragments had appeared fairly consistently in Johns's work, no casts had featured since those in the multi-panel *Untitled* (1972; fig. 29) of ten years earlier, and never those of a child.[6] Johns said that initially, when he cast body parts in his first two target paintings of 1955 (see fig. 45), he "hoped to neutralize [the body parts'] more obvious psychological impact," while being well aware that

> there's a kind of automatic poignancy connected with the experience of such a thing. Any broken representation of the human physique is touching in some way; it's upsetting or provokes reactions that one can't quite account for. Maybe because one's image of one's own body is disturbed by it.[7]

Following his use of the solitary cast arm in *In the Studio*, Johns affixed three casts of the child's arm to the surface of *Perilous Night*, each one slightly larger than the one to its left, indicative of growth and evolution (1982; fig. 47).[8] These casts foreshadow the figure of the small boy in *Spring* of 1986, part of the *Seasons* series discussed in Chapter Four (fig. 74).

To the left of the cast arm in *In the Studio* is a drawing of it in reverse, illusionistically tacked to the surface by two painted nails. This may be the drawing Johns made in crayon and graphite pencil on plastic in 1982, to aid the process of creating the color pattern on the inside of the wax casts.[9] In the painting, the wax cast and its mirror-image drawing form a pair of arms that appear to reach for the end of the stick just beyond their grasp. As drawing and cast, they embody the fluidity with which Johns shifts between media and different ways of representing objects in space. The cast arm, stick, and various drawings, along with the blank canvas, suggest a spectrum of perceptual alternatives from the conceptual to the visual, and from figuration to abstraction.

On the right hand side of *In the Studio*, again pinned up with trompe-l'oeil tacks, is a representation of a two-part untitled crosshatch drawing executed by Johns in 1982 in ink on plastic in secondary colors of green, orange, and purple.[10] In the painting, the drawing is fragmented; we see only about two-thirds of it, the rest cut off by the right edge of the canvas. While the top sheet is intact, the lower half of the drawing appears to be melting, the encaustic loosely dripping down the canvas. It is ironic that Johns would use encaustic, a material that specifically allows for discrete marks, to create a drippy image. Johns frequently chooses to paint over the brushed-on, waxy surface of the encaustic in his paintings, an effect that can blur, drip or blend the image. The hatched pattern of the reproduced drawing in *In the Studio* has broken down, producing an unsettling instability. The systematic framework of the expressive hatchings seems here to morph into an image that requires of the viewer a more purely optical experience. In hindsight, it appears that Johns's exploration of a new pictorial mode coincided with the evisceration of the crosshatch motif.

With *In the Studio*, Johns's own practice becomes his subject. He had considered this idea previously in two pictures of the mid-1960s, *Studio* (1964) and *Studio II* (1966) and several other works of the period that address issues of picture making.[11] *Studio II*, a large-scale spare abstraction made in Johns's studio in Edisto Beach, South Carolina, shows a flat wall of windows, a grid structure constructed by repeated painting though a screen onto the canvas surface. Paint drips and areas of broadly brushed bright colors break up the white and gray tones. A handprint and painted ruler in the top right corner suggest the artist's presence.

The studio as a manifestation of the creative process is a significant theme for many artists, including Picasso, an artist whose work was increasingly informing Johns's own.[12] The spare, monochromatic tone of *In the Studio* recalls the earlier artist's airy, epigrammatic pictures of the late 1920s.[13] Picasso's *The Studio* (1928; The Solomon R. Guggenheim Foundation, Peggy Guggenheim Collection, Venice), for instance, shows an abstracted sculptural bust on the left facing an ideogrammatic image of a figure. Set in a gold frame, the picture leans against a red table similar to the propped canvas in Johns's painting. Picasso reduced his composition to a series of rectangles, circles, and variations of them, punctuated by discrete areas of color, playing with themes of representation and illusion and, like Johns, questioning how meaning is created through different approaches to making art.

Johns's *In the Studio* renews the pictorial language of *Fool's House* (1961–62; fig. 12) from twenty years before, in spite of the earlier work's gritty, emotive aspect.[14] While the broom attached to *Fool's House* (a household object now functioning as an artist's tool) mimics the painterly gesture of Abstract Expressionism, it foreshadows the

structure of the stick that bisects *In the Studio*. Though alluding to the artist in his studio, both works suggest more of a psychic space than a depicted environment. Johns maintained his consistent focus on process, his mix of the literal, the fictive, and the abstract in an attempt to understand in a concrete way the picture surface and the implied space around it or, put another way, the difference between what we see and what we know. For Johns, as Kirk Varnedoe noted in his detailed discussion of issues of space in the artist's work, the cognitive is grounded in the physical, and thus develops into metaphorical possibility.[15]

Beginning gradually with *In the Studio*, Johns's work of the early 1980s shows an increasing interest in the details of experience, a subjectivity that is not romantic, narrative, or sentimental, and that allows for open-ended interpretation. In the pictures of the following years, Johns continued to investigate the visual and iconographic possibilities of a constellation of images and objects in a hermetic representational space that appears as a wall fragment, but is perhaps more evocative of some inner state: a cognitive, spiritual, or psychic territory. After the nearly achromatic *In the Studio*, Johns's next paintings returned to the broader color range that characterized his final crosshatch works.

The richly hued but grave encaustic, *Perilous Night* (1982; fig. 47), incorporates images and objects like *In the Studio*, though it is no longer so clear that we are viewing a studio wall. A thin, broken-up gray blue line bisects the canvas vertically. Johns further developed the bipartite composition in several works that followed, including an ink on plastic version of *Perilous Night* (1982; fig. 46), a color and a grisaille version of *Racing Thoughts* (fig. 52) and the encaustic painting *Ventriloquist* (fig. 53). The space depicted in *Perilous Night* is of a darkly pensive dream. It exhibits the mysterious and exotic gloom and decay associated with macabre Gothic style. The somber atmosphere is articulated by deep jewel-toned imagery and passages of abstract encaustic. Johns affixed to the canvas the three graduated casts of the child's arm, each one decorated with green, orange, and violet patterns that look gray seen through the wax.[16] The casts' gradual evolution from left to right is suggestive of the three ages of man and prefigures Johns's treatment of the passage of time in the mid-1980s in the *Seasons* series.[17] Like the first body fragments Johns incorporated into his work in 1955, and the ones in the multi-panel *Untitled* (1972; fig. 29), these plaster casts evoke a dolorous trace of something lost or missing. *Perilous Night*, like *In the Studio*, includes at its right edge a long slat, possibly an artist's tool or measuring device. Beginning with *Device Circle* (1959) and *Thermometer* (1959), Johns has used measuring devices to explore what can or cannot rationally be measured, and how. In *Perilous Night*, the rigid wood strip seems alien amidst the more human creations on the wall. Attached at the bottom of the canvas, and in the middle with a screw eye, the stick protrudes from the painted canvas into the viewer's space, drawing us in.

A schematically rendered handkerchief nailed to the painted wood grain adds to the picture's grave mood. Johns may have been stimulated to include the handkerchief after seeing a Picasso print of a weeping woman (see fig. 30) that hung in the room of his Paris printer, Aldo Crommelynk, where they often had lunch.[18] Picasso worked on a series of *Weeping Woman* etchings around the same time he made the enormous mural *Guernica* (1937), in response to the civilian casualties following the horrific bombing of the Basque town of Guernica during the Spanish Civil War. The etchings have an emotional intensity and anguished quality, haunted

**46**
*Perilous Night*, 1982
Ink on plastic
31⅝ × 40⅞ (80.3 × 103.8)
The Art Institute of Chicago

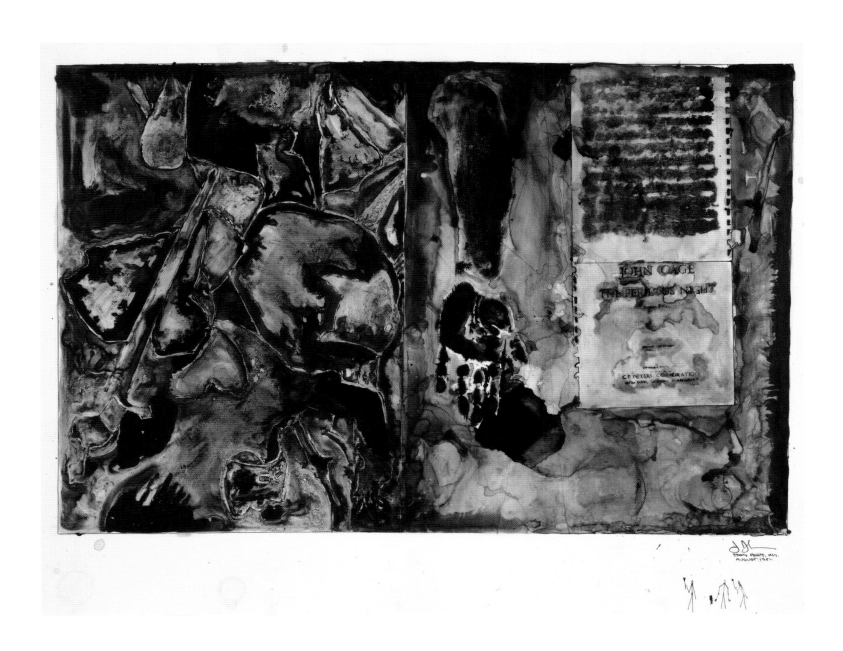

Screened on the canvas at the upper right, and partially covered by one of the cast arms, is a page of the score and partially obscured cover sheet for John Cage's six-movement suite for prepared piano, *The Perilous Night* (1943), which provided Johns with the name of his picture. According to Cage, the title for his early composition, written at the time his marriage was ending, came from the Irish myth or Grail legend of an enchanted or "perilous bed," on a floor of polished jasper.[19] Weapons and deadly animals assaulted any knight who lay on the bed; only by encasing himself in heavy armor would he survive. To Cage, the music tells a tale of the "dangers of an erotic life." Upon hearing a critic describe it as sounding like "a woodpecker in a belfry," the composer explained: "I had poured a great deal of emotion into the piece, and obviously I wasn't communicating this at all. Or else, I thought, if I *were* communicating, then all artists must be speaking a different language, and thus speaking only for themselves."[20] Johns, who had met Cage in 1954 and considered him a respected mentor, chose to represent in *Perilous Night* a score that signaled for the composer the difficulty of conveying intentional meaning in a work, of transmitting a specific emotion to a listener or viewer.[21]

To the left of Cage's score, also partially obscured by one of the arms, is tacked a crosshatch drawing—the top section of the 1982 untitled ink on plastic diptych that also appears in *In the Studio*. Johns rendered the area at the lower right of *Perilous Night* in purplish gray, with an exaggerated wood-grain effect. The painted shadows cast by the mock grain of the wood and the tacks, as with *In the Studio*, appear cartoonish, as if stressing their fictive nature rather than attempting the intended goal of trompe l'oeil to suggest illusion. They have a preposterous aspect that may have some basis in Surrealism. Such imagery in Johns's work focuses the attention, compelling us to look more closely.

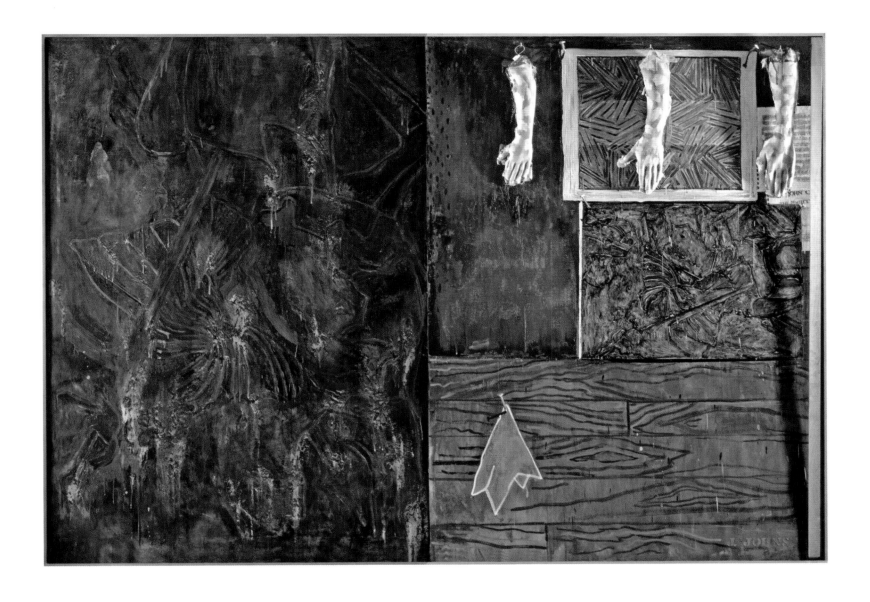

**47**
*Perilous Night*, 1982
Encaustic on canvas with objects
67¼ × 96⅛ (170.8 × 244.2)
National Gallery of Art,
Washington, DC

and threatening, that also infuses *Perilous Night*, as if the handkerchief alone could stand for the effect of the *Weeping Woman* iconography as a whole.

*Perilous Night*'s affective resonance thus depends partly on the visual and iconographic relationship Johns establishes with Picasso's emotive imagery by the inclusion of the somber handkerchief. *Perilous Night* is also an early example of Johns's concentrated interest in Matthias Grünewald's Isenheim altarpiece and his incorporation of traced figures from it in his own work. His experimentation with details from the Isenheim altarpiece in *Perilous Night* heightens its emotional tenor. Grünewald painted the enormous (10 feet high) and complex altarpiece around 1515 for the Antonite monastery at Isenheim in the Alsace. The Antonites ran a hospital for victims of a plague, known as St. Anthony's fire, which was virulent in the fifteenth century, particularly in France and Belgium.[22] Although it is a major work of Renaissance art, the Isenheim altarpiece is not well known, in part because, in the small town of Colmar in northeastern France, it is relatively inaccessible. Johns had, nevertheless, seen it twice in the 1970s, though he only began using its imagery after he was given a set of high quality black-and-white photographic reproductions of it in 1980.[23] The reduced tonalities of the photographs may have highlighted its schematic patterning. To Johns,

> looking at [the black-and-white details of the Isenheim altarpiece], I thought how moving it would be to extract the abstract quality of the work, its patterning, from the figurative meaning. So I started making these tracings. Some became illegible in terms of figuration, while in others I could not get rid of the figure…In all of them I was trying to uncover something else in the work, some other kind of meaning.[24]

Grünewald's monumental altarpiece features a range of poignant images from the life of Christ and St. Anthony (figs. 48–50). Though the panels are now installed separately in a museum setting, the polyptych had originally been conceived in three stages, each one open at different times in the religious calendar, but dependent for their meaning and compositional unity on the context of the other two. Johns may have found fresh motivation to work in his characteristic serial fashion through his study of the Isenheim altarpiece. With its multiple stages, shaped panels and predella, the complex polyptych perhaps informed his thinking as he explored the diptych format in his own work, as well as the depiction of forms in a shallow, illusionistic space.

*Perilous Night* exhibits some of the macabre character of Grünewald's Crucifixion, the central panel in the altarpiece's closed state. Set in a nocturnal landscape, Grünewald's is not a dignified, classic Italianate interpretation, but an anguished depiction, the figure of Christ elongated, emaciated, and covered with adhesions. It is a particularly human representation of suffering. The mottled cast arm fragments in *Perilous Night*, paint dripping down from the severed elbows, recall the suffering Christ's once muscular arms, now twisted in pain and ridden with pox in the Crucifixion panel and the Entombment scene on the predella below it (fig. 48). Countless fifteenth-century woodcuts devoted to St. Anthony and made contemporaneously with the Isenheim altarpiece depict hanging limbs as reminders of the healing power of faith (see fig. 51). This convention derived from the custom at Antonite monasteries of hanging diseased limbs at the entrance to announce the monks' role as healers.[25]

**48**
Matthias Grünewald
Isenheim altarpiece, first view
(from left): St. Sebastian;
Crucifixion; St. Anthony, c. 1510–15
Oil on wood
91⅜ × 29½ (232 × 75) side panels (each)
105⅞ × 120⅞ (269 × 307) central panel
29⅞ × 133⅞ (76 × 340) predella
Musée Unterlinden, Colmar, France

**49**
Matthias Grünewald
Isenheim altarpiece, second view
(from left): Annunciation;
Angel Concert; Virgin Mary
and Christ; Resurrection
105⅞ × 179⅞ (269 × 457) all panels, open

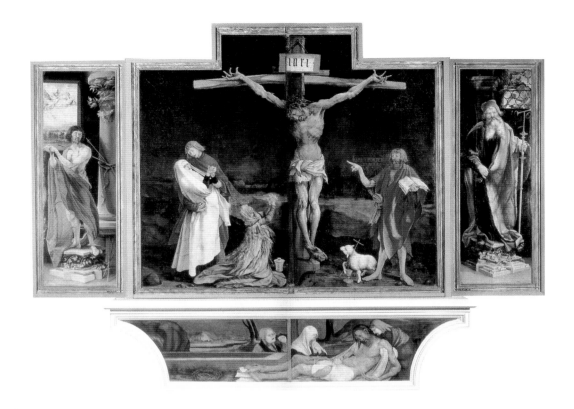

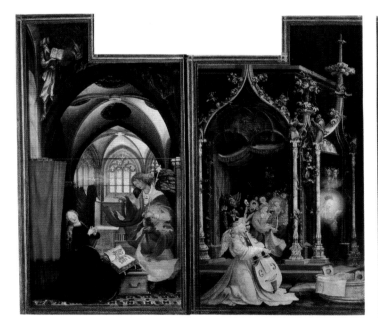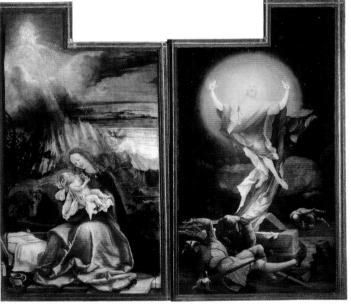

**50** BELOW
Matthias Grünewald
Isenheim altarpiece: Temptation of
St. Anthony (detail), *c.* 1510–15
Oil on wood
Musée Unterlinden, Colmar, France

**51** RIGHT
Artist unknown
*St. Anthony and victims*
*of Ignis Sacer*, 1440–50
Woodcut
14 × 10 (37.6 × 25.6)
Staatliche Graphische Sammlung,
Munich

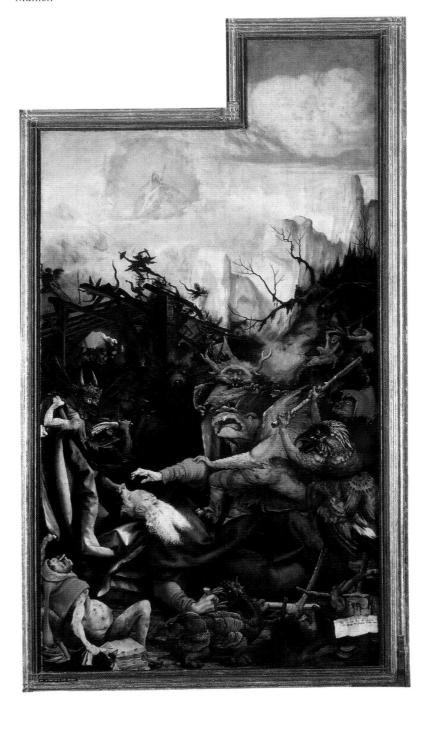

Between 1981 and 1989, Johns included details traced from the photographs of the Isenheim altarpiece in over seventy pictures. He returned most often to two of its details: the stricken demon in the scene depicting the Temptation of St. Anthony and the two astonished Roman soldiers in the Resurrection.[26] The Temptation of St. Anthony (the right side panel of the altarpiece in its most open state; fig. 50) shows a harrowing figure at the lower left, slumped with one knee bent, stomach swollen, covered with boils, his limbs distending into webbed hands and feet. Lost in misery, he has drifted off, unaware of the demons at right that beat St. Anthony to test his faith. This figure is echoed in both composition and form in the Resurrection, the right panel of the altarpiece's middle stage, by a Roman soldier turning away from the blinding light, struck down in awe at the sight of the risen Christ (fig. 49). In this dramatically lit nocturne with its ethereal depiction of Christ, light falls on the pleats in the soldier's tunic and in the drapery of Christ's robe. In each panel, these foreground figures appear as witnesses to the dramatic and transformative mystery taking place before them.[27] The diseased figure and soldiers are notably generalized, the demon a biomorphic decaying mass, the soldiers highly abstracted, defined by the textures and patterns of their tunics, chain mail, helmets, and visors, with their faces obscured.

Speaking of the fragments of imagery from other artists that he incorporates in his own work, Johns has said:

> I think it happens through a concern for parts and wholes and through
> seeing that anything that one thinks of as a whole can become a part, and
> that anything that one thinks of as a part can be treated as a whole...If the
> whole can become a detail, we see the mutability of the world, and shifts of
> meaning or of image or definition follow.[28]

So in Johns's work, these parts, as Nan Rosenthal also noted, can be seen to stand for the whole.[29] It might follow, therefore, that Johns's tracings of the demon and the Roman soldiers, however much he distills them, can be seen to embody the profound and varied emotions expressed in Grünewald's altarpiece. When asked about his interest in the Isenheim altarpiece, moreover, Johns's own response was characteristically literal:

> I was attracted to the qualities conveyed by the delineation of the forms
> and I wanted to see if this might be freed from the narrative. I hoped to
> bypass the expressiveness of the imagery, yet to retain the expressiveness
> of the structure.[30]

Through tracing, Johns explored several images in the reproductions of the Isenheim altarpiece before focusing on one that he incorporated into *Perilous Night*.[31] The left half of the work depicts a simplified and barely recognizable detail of the two awestruck soldiers in the Resurrection panel, in deep purple-red on a modulated dark bottle-green ground, rendered ashy with white smudges and streaks. John*s* reduced the image to a schematized pattern, turning it 90 degrees and reversing it. The event Johns—following Grünewald—depicts is unclear, even though apparently witnessed by the two soldiers. This episode, a central yet baffling moment in Christian iconography, as well as the enigmatic tracings in Johns's picture, raise questions regarding the distinction between seeing and knowing, the type of perceptual issue that seems to intrigue Johns.

The same image appears in grisaille on a smaller scale and in its original orientation "pinned" at the right of Johns's canvas. A white freehand line separates the smaller tracing from the inky green ground to the left. One of the defining characteristics of Johns's Isenheim interpretations is the experiential nature of his work as an artist—the transfers, traces, reversals, and reorientations that require a thorough awareness of scale, space, shape, illusion, and flatness and were likely informed by his deep-rooted exploration of printmaking. Such technical feats reflect Johns's appreciation for using his hands, in the labor and challenge of artistic practice.

This was a key period in Johns's consideration of the nature of pictorial illusion, one he explored further the following year in *Racing Thoughts* (1983; fig. 52) and subsequent works. He seemed particularly focused on spatial play, discontinuities in scale and form, trompe l'oeil, and traced imagery in various formats. When art historian Richard Shiff asked him what stimulated his work, Johns answered:

> Most of us have an underlying sense of helplessness, a necessity to make what we call our work...There is usually some combination of pleasure and anxiety connected to the activity: there are aspects of play, of control and trickery...[meaning] on the simplest level, the deliberate aspects in a work of art that are intended to cause the mind to wonder. Trompe l'oeil might contain some examples.[32]

From what one knows about Grünewald's altarpiece, it is tempting to seek metaphoric meaning in Johns's Isenheim tracings—and in all of his borrowings from earlier art, despite his admonition to resist interpretive strategies and to "avoid the sign of a puzzle to be solved."[33] Seeking to discover what has been transformed in Johns's pictures can lead to sustained and intense periods of looking. Grünewald depicted images of deep suffering, terror, transcendence, and hope in his expression of what it means to be human and in his confrontation with death. Whether or not we understand their derivation, some of this meaning seeps into Johns's Isenheim tracings in *Perilous Night*, affecting the painting's somber mood.

Johns's effective distancing of self while including deeply personal imagery in his art derives from the central role he assigns to process:

> I usually begin with some sort of an idea of what I want to do. Sometimes it is an image. I always want to see what it will make. Then, I actually start working. During the process I don't have any morality about changing my mind. In fact, I often find that having an idea in my head prevents me from doing something else. It can blind me. Working is therefore a way of getting rid of an idea...One's initial ideas may have little to do with chance, but as one continues, one watches and controls the effects.[34]

Johns initially surrenders himself, allowing the development of a work to assume a generative role. Johns's approach during the 1980s, while a tangible change from the common vocabulary of his early iconography to imagery that held some specific significance for him, nevertheless proceeded from similar and complex goals: to appreciate or experience something familiar in a new way; to alter one's perspective. While imbued with a healthy skepticism, Johns's pictures continue to induce what Kirk Varnedoe referred to as a "life-enhancing jolt," to stimulate our senses to

the experience of being alive, to heighten mindfulness instead of approaching life in a detached, incurious manner.[35]

With *In the Studio* and *Perilous Night*, Johns established an approach that grew in consistency in a group of works begun in 1983. In several of these, he pictured the closed door and wall of his bathroom in Stony Point, seen from the artist's viewpoint while soaking in the tub.[36] He maintained the diptych format of *Perilous Night* along with the shallow representational space first suggested in *In the Studio*. In *Racing Thoughts*, and other work from this period, he further articulated the encaustic surface with hatch patterning and abstract passages of color while amplifying the number of layered pictures and objects. The work is what Terry Winters described as a "vertical collage" that anticipates the overlapping windows and massing of images, as well the constant recycling of them, which we are now so familiar with on smart phones and computer screens.[37]

In spite of its title, suggestive of a churning imagination, *Racing Thoughts* has a stop-time meditative character.[38] This may be due in part to the encaustic and collage that gives each mark a discrete identity, downplaying physical gesture. Johns followed the same diptych format he had initiated in *Perilous Night*, the two sides of *Racing Thoughts* representing different pictorial styles. He expanded on this juxtaposition, with its study in contrasts, in 1984 when he made a grisaille version of *Racing Thoughts* in oil on canvas. In the earlier encaustic version, the bathroom door is covered in a vivid pattern of wood grain and hatchings. Embedded in the hatchings is the infected demon from the Isenheim Temptation of St. Anthony, turned upside down and reversed. The demon's black and blue hatched chest appears under the top of the pair of chinos hung on the door.[39] The bathroom wall is freely painted in large, distinct areas of red, green, and yellow, bisected by a faux-bois slat. The encaustic surface has a scumbled matte flatness different from the more layered encaustic collage in Johns's earlier compositions. Paint drips interrupt the linear patterning, as Johns contrasts two approaches to abstract picture making, one linear and the other painterly. The wax medium serves to temper the high-key coloration that became more prevalent in Johns's work in the early 1980s.

At the upper left, Johns signed and dated the painting in his trademark stencil: "J. Johns 1983." The painting's stenciled title appears to the left of an image of an untitled 1961 lithograph by the Abstract Expressionist painter Barnett Newman, though the letters disappear as they encounter it, so that only the "TH" is visible on this side. Layered under the Newman "zip" is a saturated red Swiss avalanche-warning sign in French and German (CHUTE DE GLACE and GLETSCHERABBRUCH) with skull and crossbones, the dark shading below it as well as the layering of words and image indicating pictorial depth. The stenciled words in *Racing Thoughts* reinforce ideas of implied cylindricality that Johns initially conceived in the early 1960s in *Fool's House*, and continued to explore over the years in many subsequent pictures, including *Voice 2* discussed in Chapter One. The picture title is severed by the Newman lithograph, so that "OUGHT" appears to its right, offering added implications; its last letter, "S", appears just to the right of the line dividing the canvas into two parts, implying repetitively cycling thoughts. The avalanche warning sign is fragmented at right but continues on the left side of the canvas, as if it were a continuous surface. Such strategies raise questions about the picture's physical structure and the nature of painting itself: is it flat or

The preexisting images and objects Johns included in this shallow perspectival space were all in his home or studio.[40] Pinned up to the left of the trousers is a small, enigmatic photographic puzzle portrait of a young Leo Castelli, in homage to Johns's long-time dealer, the man who had run the best-known gallery of the post-war period. Castelli's gallery was the first to show Johns's work in 1958; in the twenty-five years since then, the dealer had become a close friend and trusted mentor. On the right, taped to the wall, is a decal after Leonardo's Mona Lisa.[41] As if it were a poster hanging loosely on the wall, the iron-on transfer has a schematic flat simplicity, the right and lower edges darkened to indicate shadows. An untitled 1961 Barnett Newman lithograph hangs to the right of the Mona Lisa, exaggerated hatched lines to its left suggesting shading. A trompe-l'oeil nail protrudes from the wall to the left of the Newman, perhaps the remaining vestige of a work of art that had once hung there.

Only a small part of the front edge of the bathtub is visible, with taps and a faucet with running water. Two pots sit on a finely rendered wicker laundry hamper. The brown one on the left is by the early twentieth-century American ceramicist George Ohr, whose work Johns has long admired. To him, "there is something interesting about such a primitive way of making forms, something touching in its fragility. It is all about labor and skill."[42] The porcelain vase on the right, with its surreal blue shading, is a commemoration of Queen Elizabeth II's Silver Jubilee. Its negative spaces show profile portraits of Queen Elizabeth and Prince Philip. Johns is a serious art collector who has also traded works with artists he admires over the years. The images in *Racing Thoughts* embody these interests and suggest the importance to him of his ties to a creative community.

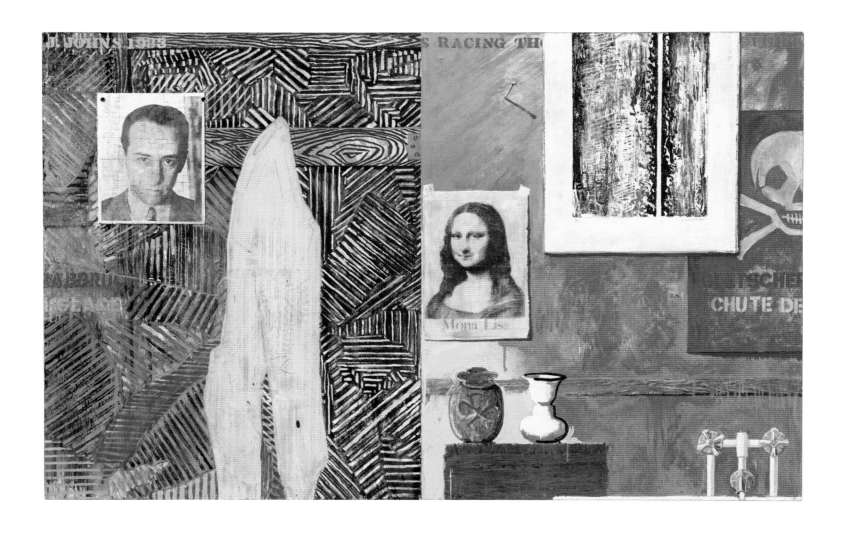

**52**
*Racing Thoughts*, 1983
Encaustic and collage on canvas
48⅛ × 75⅜ (122.1 × 191.5)
Whitney Museum of American Art,
New York

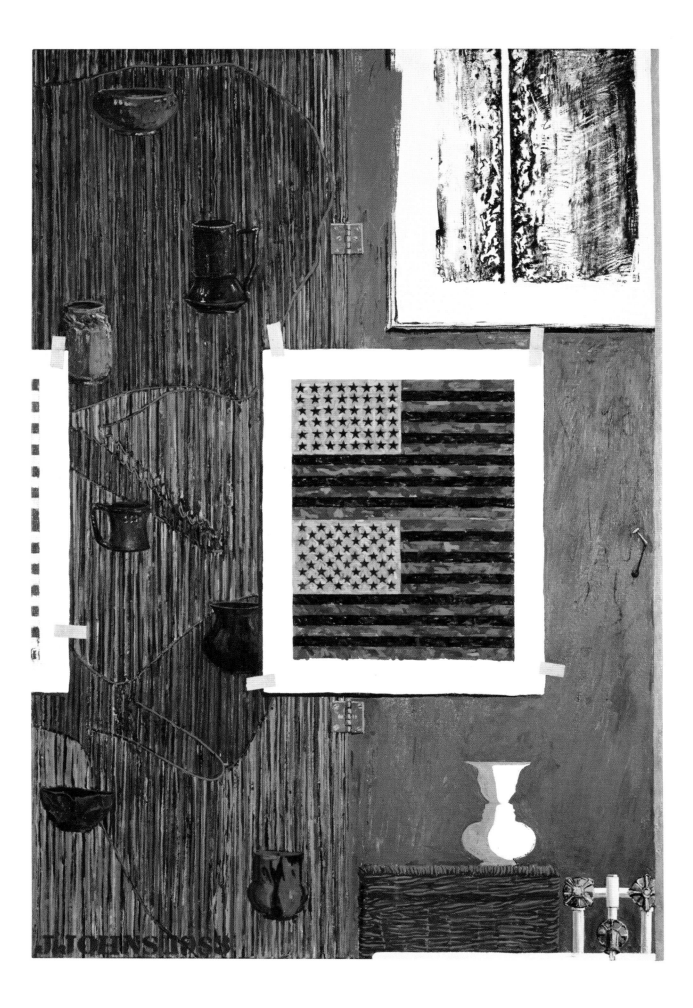

volumetric, illusionistic or two-dimensional? Does the Newman print retain its abstract nature or does Johns's reproduction of it as an actual object render it representational?

Johns's play with representation in *Racing Thoughts*, and his inventive focus on the nature of illusion, is nevertheless resolutely tied to the more expressive contemplation of human experience. While making notations that most likely relate to the crosshatch schema in his Sketchbook Notes around 1979, his musings on the nature of represented space are applicable also to *Racing Thoughts*:

> Two kinds of space can, in part, be one kind of space
>
> -------------------------------------------------------------
>
> 2 figure/ground systems
> In certain areas, one figure becomes the ground for
> the other figure[43]

Despite the stylistic variances, Johns clearly extended some of his ideas regarding figure/ground relationships from the crosshatch pictures to the representational ones that followed. Johns picked up and expanded these ideas regarding space and its referential possibilities several years later:

> Non-simultaneity in "a" space (or the idea of this)
> (could this be memory
> or a sense of time?)[44]

The space in *Racing Thoughts* can be read as both planar and three-dimensional. It is the kind of either/or situation Johns seems to seek out. This ambiguity associated with illusion is echoed in the Grünewald tracing at left, where the figure/ground distinction is diminished yet palpable. *Ventriloquist* (1984; fig. 53), with its diptych configuration, bobbing Ohr pots, and layered images and objects, has an equally disjunctive sense of space that resists a fixed solution.

The contemplative environment of the bathtub in *Racing Thoughts*, where the mind can wander and thoughts can be kindled, is akin to that of the studio. *Racing Thoughts* addresses this creative process, presenting different types of perceptual experience both for artist and viewer. Johns depicts diverse approaches to both making and displaying art: one image is framed, another taped; a nail stands ready to display a picture. There are tacks and hooks, elements of art installation commonly masked. Abstraction collides with representation, ceramics with painting, prints with sculpture. And, to create the work, the artist used silkscreen, collage, and encaustic paint. The restless mind becomes a metaphor for the creative process, for how ideas evolve and are endlessly replayed. Johns favors protean situations. Whether a target, an inherently abstract form that in Johns's hands becomes a representation, or a tracing of a representational work of art that he renders abstract, he values the resultant ambiguity. From early on, he maintained that:

> It is in the gray zone between...two extremes that I'm interested in...You can have a certain view of a thing at one time and a different view of it at another. This phenomenon interests me.[45]

53
*Ventriloquist*, 1983
Encaustic on canvas
74⅞ × 50⅛ (190.2 × 127.3)
The Museum of Fine Arts, Houston

Similarly he has also said, "there are no literal qualities to anything—everything is unstable."[46]

The vital character of Johns's work is embedded in this fluid situation. In some ways, it continues to reflect the legacy of Abstract Expressionism, whose viral, heady rhetoric—the spontaneous, emotive paint application, the performative act of painting, and the abandonment of representational subject matter—did little to arrest artists in continuing to address the relation of art to reality. Beginning with the flag, which had begged the question of whether it was a flag or a picture of one, Johns integrated expressive physicality with intellectual inquiry.

In the time between Johns painting his first flag in 1954, and 1983, when he made *Racing Thoughts*, modernist philosophy was called into question by relativist thinkers who insisted that the modernist belief in progress, reason and science was a fallacy; that an idea could not exist without interpretation.[47] Taking up these concepts, appropriation artists in the 1970s and 1980s questioned in their work whether or not invention was possible anymore. They critiqued representation, presentation, and the very idea of originality. Some artists focused on the commodity status of the art image while others considered the spectacle of consumerism. These emerging artists put aside the modernist belief in the artist as original author; for several of them, critical theory completely determined the visual character of their work.[48]

Johns's pictures have none of the ideological underpinnings that informed the work of these younger artists, though some of them, such as Julian Schnabel and David Salle, made dynamic pictures containing a proliferation of fragmentary images in ambiguous collations (fig. 54). While Johns has nearly always worked independently, not identified with any stylistic or philosophical group, neither has he remained unaware of artistic developments; in fact, there have been times when his work has been more or less in sync with that of younger artists, particularly during the early to mid-1980s. Johns's layering of references to self and past art in his work at this time results from his interest in the process of picture making more than theoretical philosophy. As he put it:

> A large part of the work is in the materials, in playing with the materials. Any idea that precedes the work is liable to change. The work is always different from the idea. The image is preestablished, but the realization of a work as a physical object shifts the meaning of it.[49]

Whether through encaustic layered over newspaper or through overlapping images, Johns's pictures have consistently manifested this type of formal complexity that is attached to deeper meanings. Its buried or concealed state fosters the viewer's curiosity.

Johns's grouping of at times seemingly unrelated objects—what Mark Rosenthal referred to as an "experienced environment"—is related to his earlier inclusion of household and studio objects such as brooms and cups in some work of the early 1960s, as in *Fool's House* (1961–62; fig. 12).[50] While offering viewers the possibility of more wide-ranging emotive references, Johns's work of the early 1980s falls within the tradition of Édouard Manet's compendium *Portrait of Émile Zola* (1868), in which the French author is shown at his desk before a bulletin board full of references to the roots of both his and Manet's own contemporary style.[51] *Racing Thoughts* and similar works also extend the spirit of Henri Matisse's

54
David Salle
*Miner*, 1985
Acrylic, oil, table, and fabric on canvas
96 × 162¼ (243.8 × 412.1)
The Philip Johnson Glass House,
Connecticut

many paintings of interiors, including *Harmony in Red* (1908), themselves inspired by seventeenth-century Dutch genre scenes of harmonious domestic comfort.[52] In Matisse's interiors, the picture space becomes more like a wall; expressive color and line more than conventional perspective serve to define space. The painter Elizabeth Murray's poignant description of *Racing Thoughts*, however, powerfully articulates Johns's more visceral approach. Murray found Johns's bath scenes among the "saddest images I've ever seen," as they imply the artist lying in the tub alone and naked, "reviewing everything about fears and hopes and failures."[53]

The viewpoint of *Racing Thoughts*, from the perspective of the artist soaking in the bath, pondering personal objects and familiar images, suggests it can be read as a self-portrait, though admittedly one that is difficult to decode. Why has the artist drawn us into this private space? In an untitled encaustic of 1983 (fig. 56) with the same diptych arrangement and presentation of related objects and images seen in *Racing Thoughts*, Johns included an altered version of his *Savarin* lithograph (1981; fig. 55) that incorporates *Painted Bronze* (1960; fig. 15), his sculpture widely acknowledged to be a non-figurative self-portrait.[54] In *Racing Thoughts*, instead of the *Savarin* print he included the photo puzzle of Leo Castelli and the Mona Lisa decal, male and female figures with the timeless, benevolent stares one might associate with the watchful gaze of parents. Johns, in middle age, may have been considering his artistic legacy as well as his own mortality.

*Racing Thoughts* acts as a visual parallel to the point of view Johns sometimes adopts in conversation, particularly when speaking philosophically, one that suggests he is observing himself from a distance. When asked a question about his pictorial practice he may respond using the third-person indefinite pronoun "one": "One wants from painting a sense of life," or, in speaking of human flaws: "I'm aware of my own morbidity, my feelings of shortcoming. One senses these things in oneself, a whole range of things to be overcome, that one doesn't in

55

*Savarin*, 1981
Lithograph, edition of 60
50 × 38 (127 × 96.5)
Published by Universal Limited
Art Editions

56

*Untitled*, 1983
Encaustic and collage
on canvas with objects
48⅛ × 75⅛ (122.2 × 190.8)
Kravis Collection

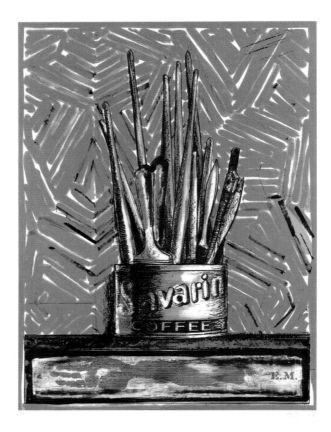

other people."[55] It is an inclusive, if formal, tone that acknowledges our common experience as humans.

In spite of its title, *Racing Thoughts* is simultaneously intimate and universally timeless. It invites contemplation in a manner foreign to that of the active patterns of Johns's previous crosshatch pictures. *Racing Thoughts* advocates the rich life of the imagination and memory, its radiant yearning suggesting that only a tender strand links these qualities to reality. In including more directly personal iconography in his work beginning in 1982—and taking the bold risk of verging on nostalgic sentiment—Johns opened the way for a type of art that could have a deeply subjective character while establishing a more universal poignancy regarding the mutability of life.[56] Johns's work has always been rooted in life with its inevitable linear chronology, but memory operates more fugitively; brief events can haunt us for life while years of our lives can pass virtually forgotten. In *Racing Thoughts* we see memory stirring.

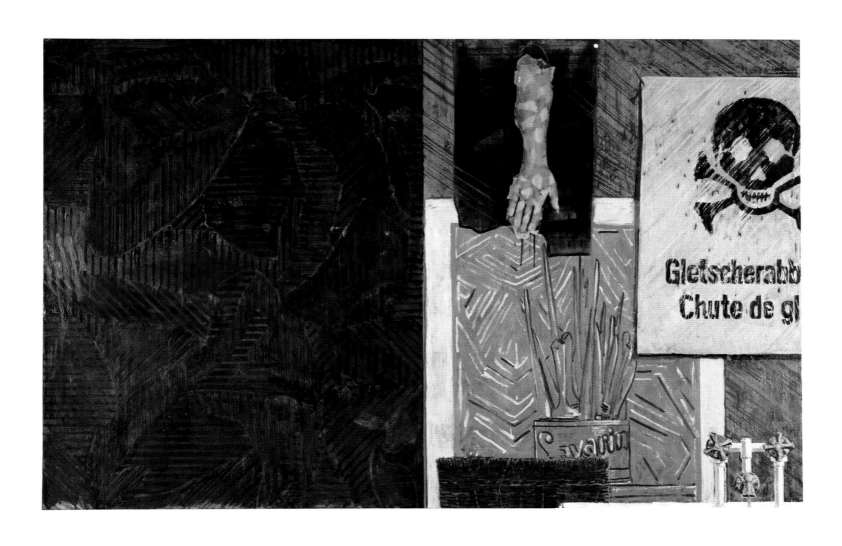

# PERCEPTUAL PLAY
## AND PICASSOID EYES

SURREALISM WAS FOR ME A VERY IMPORTANT
MOVEMENT; IT CONFIRMED ONE'S IDEAS THAT
THERE WERE OTHER WORLDS. FACED WITH
SURREALIST IMAGERY, THE PEOPLE I GREW UP
WITH WOULD HAVE THOUGHT IT WAS CRAZY.
FOR ME, IT WAS AN OPENING OF DOORS.[1]

JASPER JOHNS, 2012

As he has done frequently over the course of his long career, in the 1980s Johns changed course, not once, but several times. He gradually moved away from the images that featured a mental or invented picture of a wall in the bathroom of his Hudson River Valley home in Stony Point, in upstate New York. These works had occupied Johns intensively from late 1983 through 1988, alongside other aspects of his practice.[2] During these years, the artist began exploring two fundamentally different types of picture making. One (see fig. 57) was a series of surreal rectangular faces, featuring a child's drawing and a trick perceptual illustration that drew on Johns's playful nature, as well as his interest in issues of perception, and, to some extent, his early childhood memories. This imagery first appeared in late 1984 in a colored graphite drawing with a lightened palette (fig. 58), followed by several paintings, drawings, and prints made over the next seven years. The other main strand was the *Seasons* series, an epic cycle of four paintings and a large number of prints and drawings that Johns began in 1985. This series addressed the classical theme of the ages of man (as well as, in Johns's case, a move to a new house and studio), a subject with a long legacy in the history of art.

In both groups of work Johns included references to himself—his shadow, among other things, in the *Seasons*, and allusions to his childhood in the rectangular faces—in a way that took viewers by surprise, even considering the suggestions of autobiography seen already in the bathtub imagery of the same period. Johns also turned his attention in a more concerted manner to Pablo Picasso, in much the same way he had earlier delved (and continued to) into the work of Marcel Duchamp and Paul Cézanne. While these two series show Johns exploring similar concerns, they are distinct in composition, tone, and feeling and merit separate discussion. This chapter will treat the series of faces and related works, while Chapter Four will focus on the *Seasons*.

During the 1980s, Johns worked in studios in three or four venues (both within the United States and further afield) and moved between them regularly. A broad Johns chronology of the 1980s and 1990s suggests a busy life at mid-career,

**57**
*Untitled (A Dream)*, 1985
Oil on canvas
75 × 50 (190.5 × 127)
Collection of Robert and
Jane Meyerhoff

in addition to his peripatetic studio and house moves. New and older work was presented in a variety of group shows worldwide. In 1990, he received the National Medal of Arts, presented by President George H. W. Bush.[3] Paintings by Johns featured in three Biennial exhibitions at the Whitney Museum of American Art during this period, in 1983, 1985, and 1991.[4]

In 1988 and 1993, Johns helped organize the 25th and 30th anniversary exhibitions to benefit the Foundation for Contemporary Performance Arts (now the Foundation for Contemporary Arts).[5] Johns formed this organization with John Cage in 1963 to provide a vehicle for visual artists to support pioneering work in dance, music, performance, poetry, and the visual arts by donating artwork for grants, emergencies, and unexpected opportunities.[6] Not insignificantly, this was also a period when the price of Johns's paintings steadily escalated, beginning with the Whitney Museum of American Art's 1980 purchase of *Three Flags* (1958) for $1 million, then the highest price ever paid for the work of a living American artist.[7]

Johns was in his early fifties when he first used the imagery of a rectangular stretched face. In 1984, he made four transitional untitled paintings—two in encaustic and two in oil on canvas—cropped, distilled variations on the bathtub or pinboard wall imagery. While perhaps visually more open and uncluttered than the work that preceded them, these new pictures were also less introspective. Each one followed the vertical format of *Ventriloquist* (1983; fig. 53) and, compositionally, they are quite similar. In one of the oil paintings (fig. 59), a highly abstracted hatched detail of the plague victim from the Temptation of St. Anthony panel of Matthias Grünewald's Isenheim altarpiece forms the ground. If the Isenheim imagery seemed nebulous in Johns's work before, it was now largely obscured. Ground and figure are virtually indistinguishable. Where the demon was clearly outlined in previous work—even when it might be presented upside down or reversed—now its form was indistinct, the ambiguity heightened by Johns's use of a fleshy pink ground covered with striated patterns of hatching in blue, green, white, and red. Johns later explained that what drew him to such close study, via black-and-white reproductions, of the imagery in Grünewald's altarpiece was the desire to uncover some meaning within it beyond its narrative content, an abstract quality in which the figure might, at times, become unrecognizable.[8]

On the Grünewald ground in this 1984 untitled painting, the artist depicted fragments of just two images and relegated these to the outer right and left edges of the work. Taped in trompe-l'oeil fashion at its upper and lower right edge—treated as a work of art tacked to the surface—is the right side of a Johns *Two Flags* print. Taped opposite, is the left side, including most of the face of the illustrator W. E. Hill's 1915 visual illusion of "My wife and my mother-in-law," in which one can see either a beautiful young woman with a ribbon tied around her neck or an old lady with a prominent nose and bulging chin, but not both at the same time.[9] Paint from the Grünewald traced ground drips over the upper edge of the airy purple Hill image and over a painted nail protruding from the lower left of the Grünewald ground and its looming shadow. Why does Johns choose to include fragments of the flag and the Hill image? The thought process or imaginative leap required to see them whole affirms his interests in the relationship between part and whole, perception and cognition, as the process of completing the image in our minds—particularly the flag—prods our memory of Johns's many flag pictures. Nan Rosenthal aptly suggested that in his varied ways of picturing the flag,

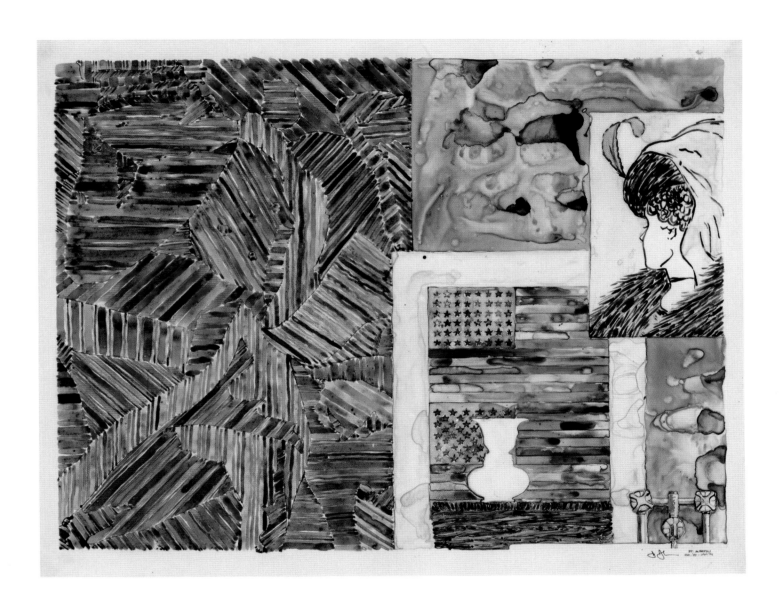

**59** OPPOSITE

*Untitled*, 1984
Oil on canvas
75 × 50 (190.5 × 127)
Milwaukee Art Museum

**60** ABOVE

*Untitled*, 1983–84
Ink on plastic
28⅜ × 36¼ (72.1 × 92.1) sheet
26⅛ × 34½ (66.4 × 87.6) sight
Collection of the artist

splitting it into two parts at either edge of a canvas, painting two flags one over the other or three flags superimposed, "Johns shows its uses for rethinking issues of space in contemporary art."[10] To Johns, "space is a main concern of artists, as they manipulate our perception of space; our ideas of space are constantly mutating."[11]

Johns's compositional organization encourages the viewer to compare the different picture types he depicts: the flag fragment, a fluid abstract passage of blue and green stripes of oil paint worked in a modulated manner to resemble watercolor, with the more narrative Hill illustration. If one considers the flag fragment and Hill's wife/mother-in-law in the context of the schematized Grünewald image, the result is a compendium of varied iconography and styles from the history of art. There is a figurative image that has been rendered abstract, a fragment of a flag that also appears as a linear abstraction due to the absence of stars, and a portion of the Hill illustration, which is more difficult to read due to its fragmented nature. The whole image is informed by the mental processes or decisions Johns made in the midst of creating a new picture.

Hill's illustration had first appeared in Johns's work in a 1983–84 ink on plastic drawing and a 1984 painting, showing the wall of his bathroom in Stony Point (figs. 60 and 61). Johns initially worked out the composition for the drawing and related works in a 1983 sketch (fig. 62). In the later drawing, however, the abstracted Grünewald tracing replaces an area of hatching, and Hill's illustration, which appears at the work's upper right edge, takes the place of an avalanche warning sign.[12] Johns's interest in this illusionistic image, manifested by its frequent appearance in his work at this time, indicates his dedicated and playful approach to the psychology of perception:

What interests me, in part, is that something can be seen in two different ways, and the question whether seeing it one way necessarily obliterates seeing it the other way. Or whether it is possible to see both at once…

61 OPPOSITE
*Untitled*, 1984
Encaustic on canvas
50 × 75 (127 × 190.5)
Collection of the artist

62 ABOVE
*Untitled*, 1983
Pencil and crayon on paper
6½ × 10¾ (16.5 × 27.3)
Collection of Mr. Thomas Dittmer

Sometimes I think I'm able to see two things at once, but I'm not sure, because I play with that kind of material so much that there are probably very rapid shifts of perception…Maybe it's something we do all the time. Certainly we can watch a television program and read the weather report that's being scrolled along the bottom of the screen at the same time. So what we see is made up, perhaps, of lots of things. In seeing one thing we probably see many.[13]

Johns is not interested in this stock perceptual device simply for its whimsical or didactic value. One possible reading is that the Hill cartoon leads to more complex, philosophical speculation about the world than its somewhat mundane appearance would at first suggest. Its either/or nature recalls Johns's absorption with the relationship between seeing and knowing, or what art historian E. H. Gombrich, in writing about the psychology of perception, termed the distinction between making and matching. Art is in some ways, Gombrich posits, problem-solving: distinguishing seeing from knowing; concept from percept.[14] Johns, however, seems to ask whether or not we need to choose between the two, creating work—including this trick image—that can be described in both visual and conceptual terms. "In focusing your eye or mind, if you focus in one way," explains the artist, "your actions will tend to be of one nature; if you focus another way, they will be different. I prefer work that appears to come out of a changing focus."[15] So, there is the suggestion of fluctuation, of variety and energy that expresses process and a sense of life. For Johns, this image stands as an emblem of perceptual intelligence and enquiry: understanding the process of perception is a complex and possibly incomprehensible enterprise. Yet Johns's work proposes that such exploration should lead to prolonged, focused attention and looking, and even to different perspectives. As he noted earlier, "There is always another way to see things, isn't there? It is interesting to me that the world is not the same to us."[16]

Back in 1964, when the artist made this comment, he appears to have sought in his art a gray area between seeing and knowing, percept and concept. Twenty-five years later, he considered the question again, finding that:

My interest in optical illusion is such that I like to create an image that when looked at becomes something else and there's no in between. You see the one or the other with no in between. That aspect of seeing or knowing—or whatever are the visual or mental operations responsible—offers equal access to two possibilities. I'm fascinated by that kind of thing and other kinds of material that make possible that either/or situation where things become slurred or uncertain. That's why I tend to play with that possibility. Not knowing exactly is something that I find fascinating. Whatever the basis, it probably moves one to see life in an ambiguous way. There may be an infantile foundation to it, a kind of sensitivity, a predisposition towards that way of seeing.[17]

In using these diverting but serious images, Johns examines the way sight and mind work, but appears equally taken with them as manifestations of larger issues regarding experience. As Gombrich said, such images demonstrate that we can remember one while we see the other, but cannot see them simultaneously. We *know* each is there, but we still cannot *see* them at the same time. The women here

cannot be seen as both, or as anything in between, but solely as distinct beings. For Johns, an artist often thought of as being skeptical about the human condition, these images draw attention to the mind's flexibility or openness.[18]

Johns's inclusion of these illustrations from perceptual psychology suggests he sees life as an aggregate of contradictions, also questioning the notion of a single point of view without hesitation or the possibility of change. The ideas that stem from these images link Johns's work to more expansive ideas concerning experience and the world. Johns seems preoccupied in these pictures by change and memory, by the unpredictable nature and inconstancy of life, the unavoidable and enigmatic conditions of humanity, as well as by ambiguity and shifting viewpoints.

◆

In late 1984, using the same lightened palette that appeared in the untitled paintings featuring the Grünewald ground, Johns embarked on a body of work even more compositionally spare and organic than either the untitled works with the hatched ground he made earlier that year or the densely layered compositions of the bath series. Picasso's art—in particular his work of the late 1920s and 1930s—came into focus as a prime artistic reference for Johns in these new pictures.[19] *Untitled* (fig. 58)—and the body of work that followed on from it—represents a shift in direction for Johns, in both form and iconography. This untitled drawing imparts a wide-eyed innocence at the same time that its cartoonish quality can seem oddly menacing or simply curious.

The white ground is inflected with varying lengths and tonalities of ochre pastel strokes that form a largely diagonal screen from lower left to upper right across the surface. The open composition and broad areas given over to scribbles have a freshness that recalls children's drawings. In several paintings related to this drawing, the canvas surface takes on the fleshy appearance of Caucasian skin with the eyes suggesting a rectangular face. Despite its ambiguous blend of figuration and abstraction, the work manages to evoke a deeply human aspect. Johns's interest in skin as a metaphor for sensation harks back to his four *Study for Skin* drawings of the early 1960s (see fig. 63), though the more recent works also draw on Surrealist irrationality or infantile impulse.[20] In the 1984 untitled pastel and pencil drawing, even though one could hardly deny the face's three-dimensional aspect, skin becomes identified with the paper itself, the flatness also indicative of a wall. This is a flattened, rectilinear schematized face, the colored lines on the white ground providing the only suggestion of light and space, of potential depth. At the sheet's center is a sharply demarcated hatched tracing of the Grünewald's Isenheim altarpiece plague victim (shown upside down), which Johns has treated as a small drawing pinned to the wall-like ground—or face. This disconcerting, even baffling, formal element extends Johns's interest in the identification of the picture surface with the wall of his studio or bathroom, and with the layering of surfaces that began in *In the Studio* and continued in the bathtub-view works.

Johns placed the other, fragmented, representational elements of the untitled pastel and pencil work at its periphery. At the top left corner and the middle right of the sheet are parts of two oversized eyes, with their distinctive blue irises set off by the whites and the long lashes that also appear as sperm attempting to penetrate

an egg. Double-ridged bubblegum pink lips arise at the bottom right edge; they can also be read as mountains in a sunrise landscape, or even as breasts. In the lower left corner, a curling line marks the suggestion of a schematic mouth and nose. Its stylized simplicity recalls the mustache Duchamp added to the Mona Lisa in his *L.H.O.O.Q.*, one of the first works by him that Johns was aware of (fig. 88).[21] We see one quarter of the eye at the sheet's upper left, half of the right eye, and only the upper lip, prompting us to rely on our imagination to make these images whole, and pointing to the significance of the viewer's role in completing the visual experience.

It has been noted that the eyes—and perhaps the mouth and nose—in this simplified rectangular face derive from Picasso's *Woman in a Straw Hat with Blue Leaves* (1936; fig. 64), an abstracted female bust. Through the years, Johns has turned to a number of artists whose work, for him, has opened a dialogue for exploring ideas or offered a shared visual vocabulary. The art of Cézanne, Duchamp, and Picasso, in particular, provoked Johns to experiment with new approaches to making works of art. In the case of Picasso's *Woman in a Straw Hat with Blue Leaves*, Johns explained how:

> It became extremely poetic, something that conveys many meanings at once. While looking at it, it interested me that Picasso had constructed a face with features on the outer edge. I started thinking in that direction, and it led me to use the rectangle of the paper as a face and attaching features to it.[22]

Unlike the formal character of Johns's adoption of elements of Grünewald's Isenheim altarpiece, in the case of the Picasso picture, he took an iconographic element, the eyes from the biomorphic boomerang-shaped face, and devised a composition otherwise bearing little resemblance to its model.[23] Johns's interest in the Grünewald diseased demon and Picasso's abstracted woman indicate that

during this period he was drawn to representations that display extreme examples of physical mutation or distortion, for their disturbing or ambiguous psychic impact, even if his own abstract faces of this period seem to have a gentle, benign character. Features from Picasso's *Woman in a Straw Hat with Blue Leaves*, primarily the eyes and nose, appear in at least thirty-five paintings, two prints, and sixty drawings, studies, and sketches made by Johns between 1985 and 1997.[24]

Contemplating Picasso's work, particularly his extreme Surrealist-influenced representations of the human form in his pictures of the 1930s, enabled Johns to investigate an iconographic vocabulary that included references to his childhood and to broader themes of innocence and mortality, the evocation of sensuality, and the role of the subconscious. Johns sought inspiration in Picasso's attenuated forms of that period with their distorted exaggerated scale, notably in his images of women. Not visually accurate, the figures follow some subjective, emotional inner-body logic, resulting in works that are at once haunted and tender. The "many meanings" that Johns noticed and commented on in speaking of Picasso's *Woman in a Straw Hat with Blue Leaves* may derive from the ambiguous nature of the image itself: the indeterminate sense of space or genre; the contours of the simultaneously distended and schematized face (with eyes that could be nipples) that resemble breasts; the neck-like vase that can be read as a phallus; and the collar of the dress that doubles as breasts or testicles. Johns described Picasso's piece as "very simple, arbitrary, and thoughtless, and yet it's full of interesting thoughts. It's a still life with a book and a vase, but the head can be seen as a [fruit hanging from] a branch. It's rich in a kind of sexual suggestion and extremely complicated on that level, but

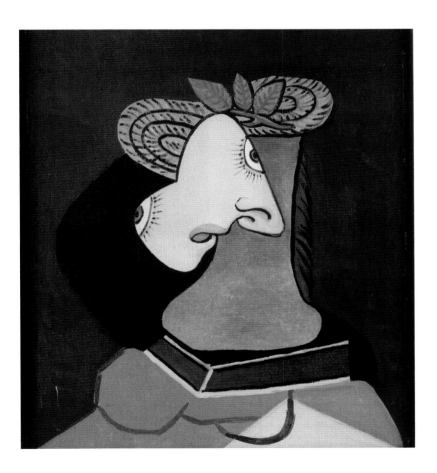

**64**
Pablo Picasso
*Woman in a Straw Hat
with Blue Leaves*, 1936
Oil on canvas
24 × 19¾ (61 × 50)
Musée National Picasso, Paris

it seems so offhand."[25] This may be true of the Picasso, but Johns's drawing with the Picassoid eyes appears more goofy than sexual in nature, as a result of the detachment of the eyes and the schematized physiognomy and landscape quality of the face, with the lips doubling as distant mountains, which give the work its surreal character.[26]

◆

Johns's latest models and the W. E. Hill illustration provided unfamiliar—yet known—imagery and a novel structure in his sustained investigations of perceptual concerns, of the relationship between seeing and thinking and how we make sense of our fragmented world. In the series of faces Johns continued to explore how various modes of picture making will trigger associations, memories, analysis, and alternate readings, by both artist and viewer. Johns's childhood references in the work of this era may extend to our universal experience of maternal nurture instead of figuring simply as deep-seated allusions to Johns's own history.

Related paintings, drawings and prints over the next five years show Johns returning again and again to this rectangular face in slightly varied forms. Some of the paintings are large (75 × 50 ins.) and, in spite of their vertical format, have airy, open, flat expanses of color that recall a landscape or beach scene. The first face painting he made, *Untitled (A Dream)* (1985; fig. 57), has particularly surreal overtones with a watch, hanging by its red strap from a trompe-l'oeil nail at the upper right, and spectacularly bulging eyes, the one at upper left seeming to shed a few tears in the form of two slight gray drips. *Untitled (A Dream)*—along with the variations that followed—shows the bottom lip as well as the top, giving them the appearance of hills in a landscape, even more than those in the untitled 1984 pastel and pencil drawing (fig. 58). In *Untitled (M.T. Portrait)* (1986; fig. 65), the ground is the hatched tracing of the Grünewald plague victim, with the rectangular face and its peripheral features appearing as a small sketch tacked to the middle of the tracing.[27] The watch hangs from a nail, with its painted cast shadow, at the upper right, as in *Untitled (A Dream)*.[28] A dark line at the right and lower edges of the rectangular face gives the illusion that the sheet is curling away from the ground.

In the encaustic and sand *Montez Singing* (1989; fig. 66) the title is stenciled along the upper border, the letters of the two words interspersed, "MONTEZ" in black and "SINGING" in light whitewashed red, the encaustic and sand dripping, as if it is washing away. Although words had appeared from time to time in Johns's work of the 1980s, in the avalanche warning sign, for instance, and in some titles and signatures, stenciling had featured only intermittently. Instead of the Grünewald tracing, a small, square schematized sketch of a sliver of a boat with red sails below a setting sun "hangs" from a nail in the center of the canvas. For Johns,

> the face redistributed, puts you in the world of Surrealism. If you put something in the middle of that you have an idea inside a head.[29]

Johns says he "thinks of [*Montez Singing*] as a portrait of my grandmother. She used to sit at the piano and sing 'Red Sails in the Sunset.'"[30] The subject of this non-figurative portrait is Johns's step-grandmother, Montez B. Johns. After his parents divorced when he was two or three, Johns lived for several years with his paternal grandfather, a farmer, and his younger second wife, Montez, in an old brick house

**65**
*Untitled (M.T. Portrait)*, 1986
Oil on canvas
75 × 50 (190.5 × 127)
Collection of Robert and
Jane Meyerhoff

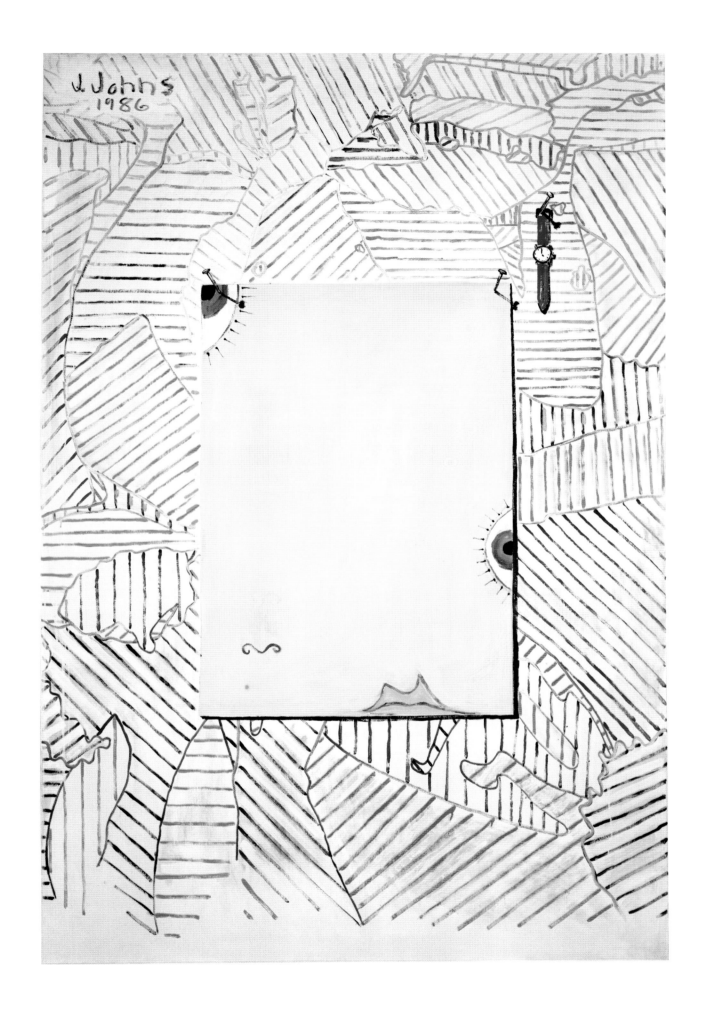

A subtle sand-textured pinkish gray border that appears whitewashed frames the central modulated light yellow-beige of the rectangular face. The rough appearance created by the combination of encaustic and sand, and the right eye that now appears slightly lower in the composition than in the first *Untitled* drawing of this series (1984; fig. 58), further the suggestion of a beachscape such as one might glimpse from Johns's Saint Martin studio or in the South Carolina of his youth and his early years as an artist.[31] The work also recalls René Magritte's pictures of faces set in landscapes.[32] A rough outline separating the face from the border has strokes emanating from its left and right edges, suggesting wispy hair framing a face. The lower border contains three circular imprints that could represent breasts, one appearing as a faint outline while another is a partially rendered bold circle under the lips, cut off by the canvas edge at lower right. They recall the two circular shapes that, with an adjoining line, form the ambiguous collar in Picasso's *Woman in a Straw Hat with Blue Leaves* (fig. 64).

**66**
*Montez Singing*, 1989
Encaustic and sand on canvas
75 × 50 (190.5 × 127)
Private collection

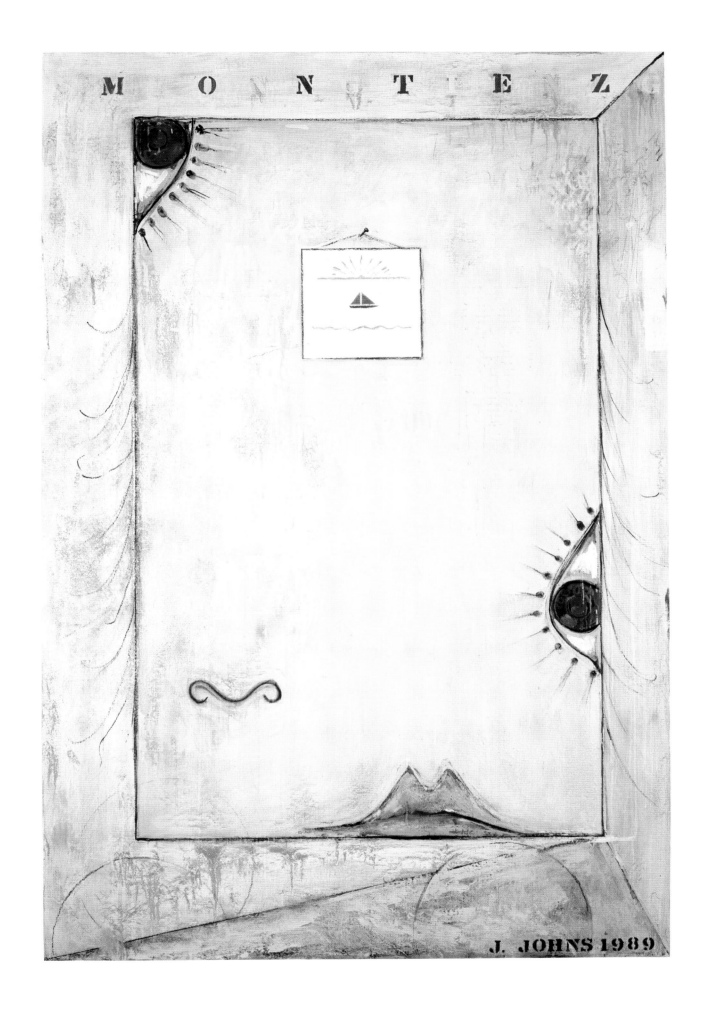

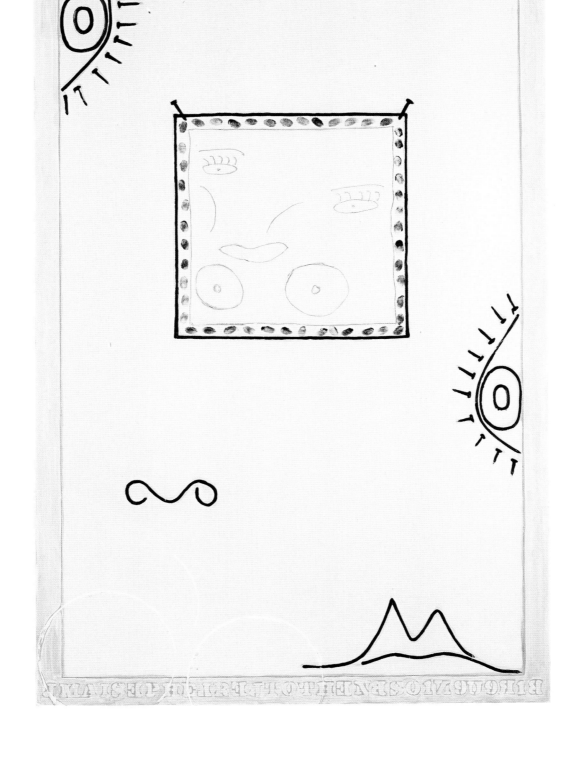

in Allendale, in southwestern South Carolina. He described this environment as "entirely Southern, small-town, unsophisticated, a middle class background in the Depression years of the thirties."[33] Johns's emblematic portrait has a precedent in the early twentieth-century portraits and poetry of Charles Demuth and William Carlos Williams among others, artists and poets often associated with the Arensberg Circle. Their non-figurative portraits were not intended to represent physical likenesses, but rather to convey something of their subject's psychological character through the use of abstract shapes and commonplace objects as "equivalents" of the thoughts or spirit of their subjects.[34]

*Montez Singing* contains the artist's first specific allusion to his childhood, with others appearing more frequently in his art in the years to follow. Much of Johns's work of this period has been characterized as autobiographical due to his inclusion of images that have personal significance for him. Yet this does not necessarily indicate that these pictures should be understood as "confessional" or as instances of "personal mythologizing."[35] Johns has chosen inventive imagery that permits him to investigate unfamiliar language and compositional structure, and allows both artist and viewer to explore visual thought and common experiences triggered by the work's affective character. It would be easy to conclude that such childlike images do indeed tell us something specific about Johns himself—his unstable childhood (moving from his parents' home to his grandfather's to his uncle's, followed by his aunt's and back to his mother's before he was out of high school),[36] or deep-seated feelings about his mother—but if they tell us anything about Johns, it is about the depth of his technical facility as an artist, and his perseverance in his myriad efforts to explore the expressive ways that we derive meaning from works of art. In describing his ideas for *Montez Singing*, Johns explained that:

> I was really working with this face in a rectangle with all these features moving about in the background and I think I was just trying to relate it to something. To make it less abstract for myself. And of course it has this infantile quality: the image of the face, features floating about... I think it's also like some infantile drawings, an infant's first drawings; but I'm not sure. I think it's an early recognition, one of the first images or forms.[37]

Eventually, the rectangular faces Johns had been making based on Picasso's *Woman in a Straw Hat with Blue Leaves* prompted a memory of a schizophrenic child's drawing of a distorted compressed face representing her mother, who died when the girl was two. The artist remembered seeing the drawing in an article in *Scientific American* (fig. 68) when he was in the army in the early 1950s.[38]

Several years later, in 1991, Johns dug up the article with the image he recalled—"The Baby Drinking the Mother's Milk from the Breast"—and established its relationship to his earlier face pictures in three new untitled paintings with a sketch based on the child's drawing pinned to the rectangular face (figs. 67 and 69). Each one is quite different. One (fig. 67) shows the child's sketch with simply outlined breasts, eyes, and nose in blue on a creamy unmodulated field, with the fingerprints that form the border in gray and the features of the rectangular face schematically rendered in black. A pale blue frame has "Jasper Johns 1991" and, in reverse, "Bruno Bettleheim," the name of the child psychologist and author

**67** ABOVE
*Untitled (Bruno Bettelheim)*, 1991
Oil on canvas
60⅛ × 40⅛ (152.7 × 101.9)
Collection of the artist

**68** OPPOSITE
Anonymous, "The Baby Drinking the Mother's Milk from the Breast", illustration from "Schizophrenic Art: A Case Study" by Bruno Bettleheim, *Scientific American*, 186:4 (April 1952), p. 33

of the *Scientific American* article, stenciled in alternating letters at the border's lower edge. It is a work that conveys pure, if mournful, innocence as well as nurture. The encaustic used in another untitled painting in the series (1991-94; Greenville County Museum of Art, South Carolina) lends a more tactile sketchy appearance that makes the facial features appear less distinct. It is a potent, offbeat ochre and has the circular imprints at lower left seen also in *Montez Singing*. A tear drips from the infant's right eye. The third, *Untitled* (1991-94; fig. 69), is loosely worked in a soulful purple, with some white underpaint emerging in the variable lines of yellow, blue, black, red and purple that form the traced ground of the Grünewald plague victim and the face based on Picasso's *Woman in a Straw Hat with Blue Leaves*, as well as two circular imprints at lower left. The child's drawing is now depicted as a square cloth draped from two trompe-l'oeil nails, the features in white, and fingerprints in grayish black. The artist saw these images as

> infantile—images of faces where features seem to float about. One tends to associate it with Picassoesque distortion. So, there's a conflation of infantile and adult, if you rank Picasso as an adult.[39]

Johns said of his unwillingness to reveal the source of the imagery in his contemporaneous *Green Angel* series (see fig. 99) that he was interested in "the extent to which knowing things influences seeing."[40] Here, it is the innocent eye—the eye without experience before we have a vocabulary or labels to organize our thoughts or questions—that Johns presents in a cartoonish, poignant, and modernist way.

The cartoonish style that is Johns's chosen mode for the works in this face series, harking back to Surrealist irrationality and to a place of cockeyed innocence, begs the question of how humorous these images really are. Do they play on the seriousness of modernist discourse? In reviewing Johns's 1996 retrospective at the Museum of Modern Art, New York, art historian Mark Rosenthal compared Johns to Cézanne, noting that "along with an art of echoes and recycled motifs and themes, both artists also have a predilection for the taciturn and melancholic."[41] Prior to these these funny/unfunny faces, Johns's work had seemed entirely serious, even when punning and witty. Even in these seriously dopey faces, Johns manages to remain somehow neutral. A pronounced uneasiness, however, sets in while viewing these works, in spite of their humor. In a 1962 essay, Leo Steinberg wrote of the disquiet associated with viewing unfamiliar works of art:

> [Modern art] is always born in anxiety, at least since Cézanne. And Picasso once said that what matters most to us in Cézanne, more than his pictures, is his anxiety. It seems to me a function of modern art to transmit this anxiety to the spectator, so that his encounter with the work is—at least while the work is new—a genuine existential predicament. Like Kierkegaard's God, the work molests us with its aggressive absurdity, the way Jasper Johns presented himself to me several years ago. It demands a decision in which you discover something of your own quality; and this decision is always a 'leap of faith,' to use Kierkegaard's famous term.[42]

Steinberg was describing his experience of viewing Johns's flags and targets, but his words seems to apply to Johns's work of twenty-five years later as well.

**69**
*Untitled*, 1991-94
Oil on canvas
60⅛ × 40⅛ (152.7 × 101.9)
Collection of the artist

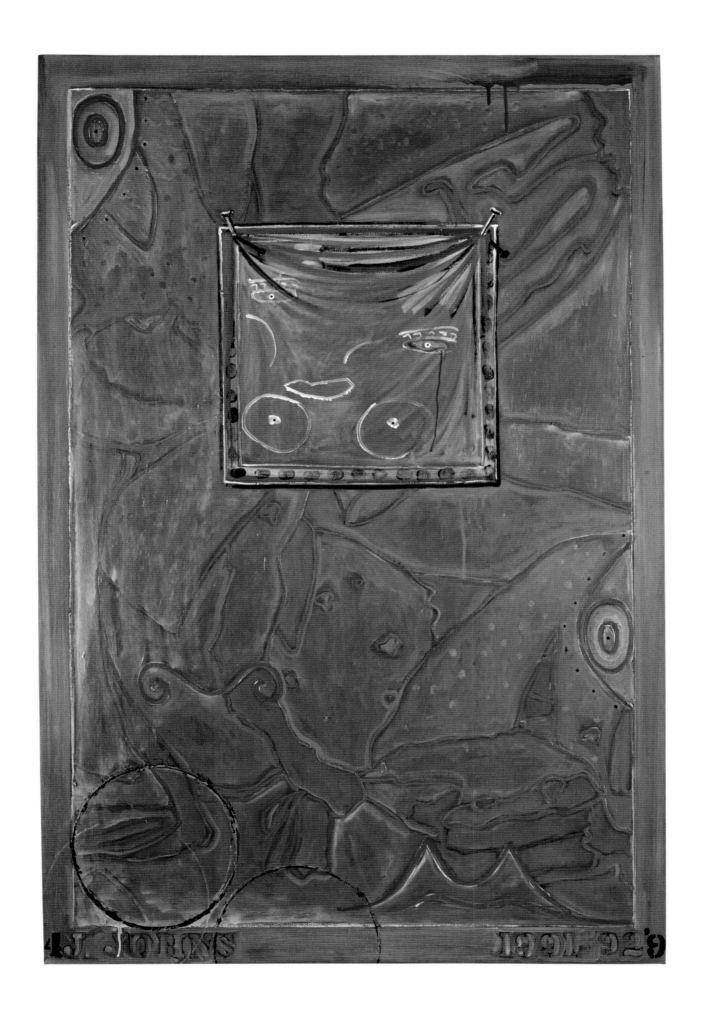

**70**
*Painted Bronze*, 1960
Bronze and oil paint (3 parts)
5½ × 8 × 4⅝ (14 × 20.3 × 11.7)
Museum Ludwig, Ludwig Donation,
Cologne

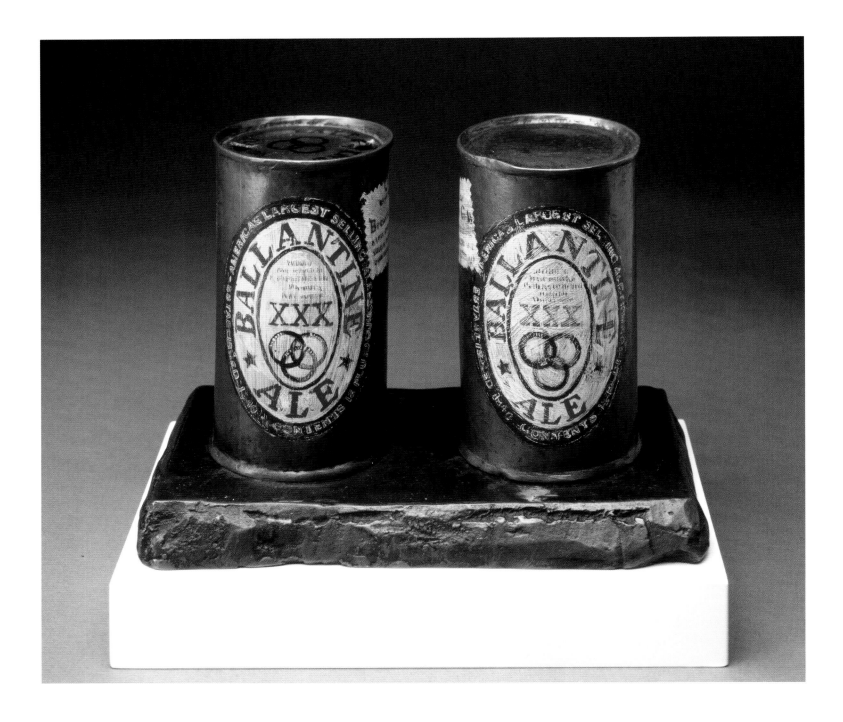

As Johns himself noted:

> Think of [Philip] Guston's late works, which have a cartoon quality, and
> they are not very amusing...I was trying to define the quality that suggests
> cartoon. I just don't know what makes something appear to be a cartoon—
> probably some kind of shorthand way of representing an image. I don't
> know the answer to that.[43]

From the acerbic *The Critic Sees* (1961; fig. 140), and tongue-in-cheek *Painted Bronze*
ale cans (1960; fig. 70), to the cartoonish play with trompe-l'oeil imagery such as
nails and their shadows or painted wood grain, humor—both cognitive and visual—
is a recurring feature in Johns's work.

The face/landscape works appear more intentionally surreal and absurd
than anything else Johns has made. When asked in the early 1990s whether he was
consciously embarking on a new body of work with the faces, Johns responded
enigmatically:

> No, what I hope to do is get rid of these images and get on to something
> else, and do what I think to do. Your thought takes a certain form and you
> have to follow it. Maybe there are devices to slip out of that pattern, I'm not
> concerned; I find it difficult, so I simply try to deal with my thought as best
> I can.[44]

Johns's description of his process at this time implies that the imagery was guiding
him rather than the other way round, as though the surreal forms surfaced from
unconscious impulses while logging time in the studio. When asked about the faces,
Johns responded, perhaps jokingly, that "I think of these things as representing
my second childhood."[45] One might conclude that this was a new feature of Johns's
work in late middle age, but even back in 1960, the painter and critic Fairfield
Porter noted that Johns "looks for the first time, like a child, at things that have
no meaning to a child."[46]

Some of Johns's faces, particularly the later ones with the child's drawing
from the Bettelheim article (see fig. 67), seem to refer to the sight of the youngest
children, the type of seeing unrestrained by knowledge. Others, such as *Montez
Singing*, seem more in the tradition of elegy, at a time when Johns claimed that
he "suddenly became very old as soon as I hit sixty."[47] The works by Guston that
Johns referred to as examples of pictures that are cartoonish but not funny were
made when Guston was around the same age and had rejected painterly abstraction
in favor of narrative figuration. Employing raw, thick lines in a sketchy, spare
style in canvases populated by monumental pointing fingers, hooded figures or
those sitting around tables deep in thought or debate, Guston expressed in a direct
but dignified way brooding anger, unleashing powerful, painterly salvos on man's
inhumanity (see fig. 71).[48]

Johns's humor in the series of faces is more akin to the absurd character
and biomorphic forms of Surrealism, as opposed to Guston's engagement with
contemporary political and social issues. The Surrealists aimed to undermine
the earnest, self-referential, rarefied nature of the contemporary art world in
nonsensical, darkly comic, or whimsical works, many of which feature illogical
or absurd imagery and are predicated on life's unpredictable or chance nature.
They endeavored to set loose the imagination and foster creative ingenuity.

Johns has long been interested in the conceptual art of the Belgian Surrealist René Magritte, and shares with him a curiosity concerning the relationship between visual and written language and representation and illusion.[49] Landscapes with melting watches, or faces disjunctively appearing in them, feature in paintings by Magritte as well as by Salvador Dalí and other Surrealist artists (see fig. 72).[50] In Johns's work, however, the Surrealist element seems to arise from the separation of facial features and their strangely humorous and ambiguous nature.

Johns explored a range of female imagery—the Hill wife/mother-in-law, and the face adapted from Picasso's *Woman in a Straw Hat with Blue Leaves*—as well as the child's drawing from the Bettelheim article in his work intermittently for a decade, beginning in the mid-1980s. To a certain extent, the original significance of the sources (including that of the male Grünewald diseased victim that he used as a ground in a number of works) became lost as Johns made the images his own. In a series of drawings, prints, and paintings in the mid-1980s that continued the shallow sense of spatial depth Johns had explored in *In the Studio* and in the bathtub pictures that followed, he included all three female images together. In an untitled encaustic and collage painting (1987; fig. 73), for instance, the ground consists of a freely worked upside-down tracing of the Grünewald diseased plague victim in a wide range of colors, tones, and textures. At the canvas's lower edge, as if on three pieces of cloth pinned to the traced ground, Johns represented three women's heads—his version of the Picasso, with the bulging eyes cleaving to the edges now on a deep blue, richly worked ground, the Picasso breast-shaped face on a blood-red ground, and the wife/mother-in-law on a light purple ground.[51] Shadows cast by the pieces of cloth lend a sense of depth, contradicted by the scumbled flatness of the traced ground, engendering the type of spatial ambiguity that has characterized Johns's work for years, forcing the viewer to question if this is a representation of a wall or an object in itself. This complex compilation of images in the untitled 1987 encaustic and collage painting—and other Johns pictures of this era that also combine the bathtub-view with images of the Hill perceptual trick image and Picasso's *Woman in a Straw Hat with Blue Leaves*—probes the persistence of memory and the certainty of change.[52] The three images of the women in their dissonant way collectively suggest modesty, innocence, flamboyance, sensuality, resilience, and mortality, embodying a full range of metaphors for human existence and vulnerability.[53]

The pronounced amplification of Johns's range of color, evident in the 1991 Bettelheim pictures, had evolved over time since the mid-1980s. Here, the result is a sketchy rawness with the encaustic rough and dripping in some places, and more lyrical and carefully worked in others, color functioning, as Ruth Fine noted in 1990, "more overtly in recent years as a distinct quality in Johns's work."[54] The colors delineate many aspects from dark, disturbing, and moody to dreamy, fantastic, and beautiful. They are alien to the purer primaries or even complementary colors characteristic of much of Johns's practice. Other work of this period was also notable for its expanded tonal range, in pictures such as an untitled 1990 painting that features bravado bubblegum colors in its depiction of the Picasso head and the Hill wife/mother-in-law, schematically rendered lime-green elements floating around in a pink field. When asked about his new use of color, Johns suggested that it was actually due to "working with color" rather than "sticking to some form of schematic organization…I don't know whether it's an

increase in skill or a change in attitude, or maybe those things are connected."
He hinted at—and the canvases belie this—a sense of color that had become
increasingly complex, sophisticated, and differentiated, adding:

> [I had gained] more sensitivity or awareness of color...Much of my early
> work was concerned with what I considered 'pure' color. [But with red,
> for instance], the recognition of it is generally just red, even though it's
> not just red. My work is gradually moving in a slightly different direction,
> but I can't describe it. It's done intuitively, so it's very hard to state what
> it is [I'm] doing...[In my earlier work] I had a different idea of clarity, what
> constituted clarity...I was concerned with the things I just mentioned,
> in terms of color. A kind of rigid idea of purity, and that's perfectly normal.
> And now, an off color seems to me just as pure as the central color in the
> spectrum, within limitations—there is not a huge range of possibilities
> presented in this way, but still, while working I am not concerned to keep
> something in the purest representation of itself, of the name red or the
> name yellow.[55]

◆

**71**

Philip Guston
*Studio Landscape*, 1975
Oil on canvas
67 × 104 (170.2 × 264.2)
The Marguerite and Robert
Hoffman Collection

**72**

René Magritte
*The Beautiful Relations*, 1967
Oil on canvas
15¾ × 12⅝ (40 × 32.1)
Scheidweiler Collection, Brussels

Johns's art, and specifically here his continual return to a few given images serves,
as Kirk Varnedoe recognized, "to pique the mind's active and reflective powers
against the silent deadening that steadily works to truncate human experience."[56]
When Johns adapted Picasso's *Woman in a Straw Hat with Blue Leaves* and Hill's
wife/mother-in-law illustration to create a substantial new body of work in the
mid- to late 1980s, alongside his simultaneous focus on the *Seasons*, Picasso's art
became a touchstone for Johns, as Duchamp's ideas about art had been for
him in the 1960s.[57] With the more obvious allusions to art history—Picasso, and
his continued interest in Grünewald—came reflections on Johns's early childhood
and the aging process, though not in an autobiographical or narrative fashion.

**73**
*Untitled*, 1987
Encaustic and collage on canvas
50 × 75 (127 × 190.5)
Collection of Robert and
Jane Meyerhoff

In his decision to focus on the eyes from Picasso's *Woman in a Straw Hat with Blue Leaves*, Johns drew attention to the significance of the innocent eye, an eye without experience, sight unencumbered by thought or prior knowledge. Similarly, his use of the wife/mother-in-law perceptual trick image suggests a skepticism concerning a single point of view, a desire to jog us out of our habitual ways of thinking. It is a metaphor for fluidity, abiding irresolution, an icon that encourages flexibility of the mind.[58]

The face-landscapes that Johns took up in the 1980s and 1990s are visually soothing yet psychically unbridled, as if Johns were, after all these years, giving in to a moment of impulsive observance of the *id*; they explore states of being that are at odds with their benign appearance. The disjunction between these pictorial elements—the cockeyed facial features, the jagged puzzle-like ground, the juxtaposition of trompe-l'oeil elements and jarring mix of colors—results in works that continue to have the "romantic melancholy" that art historian Leo Steinberg had identified as a characteristic of Johns's work in 1962.[59] The scholar Richard Field has noted (about Johns's prints, though his observations apply to all of Johns's work) that the artist's "technical mastery is placed wholly in the service of probing the endless structures of mind and language; but as with Rembrandt and Picasso, such structures are paired with a sensuosity of surface that suggests the profundity of tragic experience, of human limitations."[60] The artist's touch here results in large compositions of spare simplicity in an expanded range of uncanny colors, somehow reminiscent of the creations and unbridled innocence of children. Trompe-l'oeil illusion, experiments with a range of materials from rough sand to molten encaustic and gritty carborundum, the use of layering, and a sense of space that falls somewhere between complete flatness and shallow recession all contribute to the state of irresolution that these images engender.[61] In their themes and imagery, together with the sensuous nature of Johns's surfaces, these works point to the depth of our common experience of memory and longing.

# THE SEASONS

I HAD A BOOK WHICH YOU COULD PUT ALONGSIDE
[JAMES JOYCE'S] *FINNEGANS WAKE* AND LINE
FOR LINE IT WOULD EXPLAIN THE MYSTERIES OF
*FINNEGANS WAKE.* BUT ONCE THEY'RE EXPLAINED,
THE BOOK REMAINS JUST AS MYSTERIOUS. [LAUGHS]

JOHN CAGE, 1989[1]

**74** ABOVE, LEFT
*Spring,* 1986
Encaustic on canvas
75 × 50 (190.5 × 127)
Collection of Robert and
Jane Meyerhoff

**75** ABOVE, RIGHT
*Summer,* 1985
Encaustic on canvas
75 × 50 (190.5 × 127)
The Museum of Modern Art,
New York

**76** BELOW, LEFT
*Fall,* 1986
Encaustic on canvas
75 × 50 (190.5 × 127)
Collection of the artist

**77** BELOW, RIGHT
*Winter,* 1986
Encaustic on canvas
75 × 50 (190.5 × 127)
Private collection

Johns's output over sixty years affirms his consistent interest in exploring a range of styles and reprising forms and motifs, a practice that, while at times enigmatic, is central to his work. In the mid-1980s—in addition to the series of stretched and abstracted Picassoid faces discussed in Chapter Three—Johns expanded on the themes associated with his life and art that he had developed in *Racing Thoughts* (1983; fig. 52) and related works, making a series of four large-scale *Seasons* paintings in 1985 and 1986 (figs. 74–77). In the *Seasons*, Johns extended his connection to earlier art and to poetry, manifesting a new expressive freedom and complex re-engagement with nature and landscape, a subject Johns had not addressed in a significant way since the early 1960s.[2] During the course of his intensive investigation of the seasons theme, as well as making the four large paintings, each 75 × 50 inches, in encaustic on canvas—*Summer* in 1985, with *Winter, Fall* and *Spring* completed in 1986—he produced thirty-two *Seasons* drawings between 1985 and 1990, and close to fifty prints. Imagery from the *Seasons* has continued to feature in his work well into the mid-1990s and beyond.

In taking the *Seasons* as a subject, Johns linked his work to a cultural tradition dating back to the Romans and beyond. In art, music, and poetry, the theme of the four seasons has a rich history, providing a metaphor for the orderly course of existence.[3] The *Seasons* has more of a traditional thematic context than any of Johns's other subjects.[4] To the artist,

> [the *Seasons*] reflect a different kind of rhythm because they're fairly complicated in terms of imagery, suggesting a kind of natural abundance of detail; that they're cyclical in traditional terms. It gives them a wholeness, I guess; they have that to a degree that not much of my work has.[5]

While he had previously made monumental works, compilations of ideas, or summaries on a given theme, this was the artist's first series of paintings to take into account classical subject matter. In the *Seasons*, Johns combined two of the most significant genres in the history of art—figure and landscape—to address human connections to art and to the larger world we inhabit. While Johns's *Seasons* pictures spring from the landscape tradition, they do not immediately read as landscapes, with their unconventional vertical format and suggestion of a compressed interior space, crowded with objects.

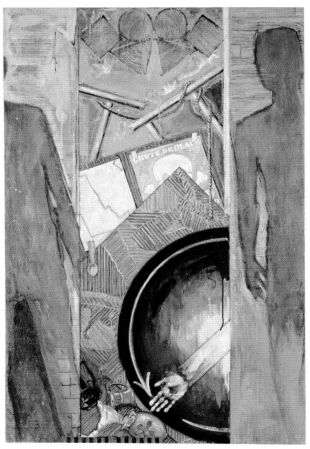

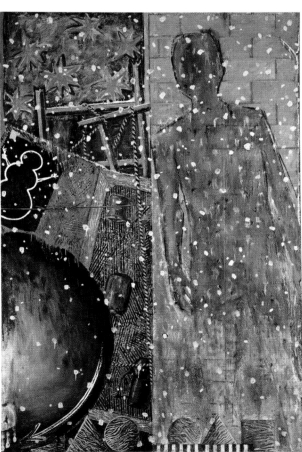

Nan Rosenthal proposed that Johns's study of Matthias Grünewald's polyptych Isenheim altarpiece may have informed his choice of a multi-panel format for the *Seasons*, or at least for the compendium of etchings and drawings on this theme that followed the paintings.[6] With its two wings and three possible configurations, the Isenheim altarpiece could be presented in a variety of ways depending on the religious calendar and the church's requirements at a given time (see figs. 48–50). The *Seasons* echoes this monumentality and flexible arrangement in a secular context. Likewise, Johns's close regard of Pablo Picasso and Paul Cézanne, who, for all their departures from tradition, chose to depict conventional subjects such as still lifes, nudes, and portraits, may have informed his choice of a traditional theme.

In each of the four paintings—*Spring*, *Summer*, *Fall*, and *Winter*—a shadow figure is placed in a bi- or tripartite compositional arrangement alongside a layering of images and references to previous art, both Johns's own and that of artists significant to him, including Picasso, Grünewald, and Marcel Duchamp. The structure is suggestive of mirroring, a man with no identity on one side or in the middle, his memories on the other side or surrounding him. The art objects are not symbols, but emblems or reminders of a creative life, forming a whole knotted together with rope and wire, yet depicted in different states of unraveling.

**78**
Jasper Johns with Leo Castelli in front of the paintings *Fall* (1986) and *Summer* (1985), Leo Castelli Gallery, 420 West Broadway, New York, 1987. Photograph by Hans Namuth

With the *Seasons*, Johns moved still further away in theme and form from both the iconic pictures of the mid-1950s and the more abstract works that followed in the 1960s and 1970s. The *Seasons* developed along the equivocal representational lines Johns had established in suggesting a shallow space or room in *In the Studio* of 1982 (fig. 44). The environment depicted in the *Seasons* pictures is neither abstract nor representational, but somewhere in between. The range of effect is compelling—grand in scale, with myriad tones and textures to convey varied states of weather and mood, and an environment in which man is subordinate to the elements of culture and nature that envelop him. In the *Seasons*, the dense collaged encaustic of the early flags and targets has been discarded in favor of a delicately applied mix of wax and pigment that, in Johns's hands, achieves careful and compelling modulations of tone and texture. The limited palette of muted colors largely adheres to fixed ideas of seasonal hues, distilling their essence: vibrant, clear colors for spring; fresh green and blue for summer; an elegant balance of yellow, green, and gray for fall; and white and gray tones for winter.

The *Seasons* were first exhibited at the Leo Castelli Gallery in New York in 1987 and again the following year at the Venice Biennale (fig. 78). While the contemporaneous pictures of abstracted faces left some critics shaking their heads—Barbara Rose, for instance, described the ones exhibited at the Leo Castelli Gallery in 1991 as "disorienting and unpleasant"—reviews of the *Seasons* tended to elicit more expansive language. John Russell, in the *New York Times*, described the group as "a four-part meditation on the mutability (as much as the multiplicity) of meaning." Michael Brenson wrote in the *New York Times* that the *Seasons* pictures were "difficult works, intense, even hermetic, loaded with personal symbols, involved with issues of mortality and fate." Jack Flam suggested in the *Wall Street Journal* that the pictures were symbolic and autobiographical; praising *Winter* as "evoking melancholy and loss;" he went on to describe it as "one of the most affecting paintings Mr. Johns has ever done." Referring to the current penchant for uncovering meaning in every Johns hatch mark, Amei Wallach groused in *New York Newsday*, "a tempting offense these days is to figure out the iconography of his paintings."[7] Critics devoted more attention to the *Seasons* than they had to any of Johns's work since his crosshatch paintings first appeared to much critical acclaim in the early 1970s. Additionally, as Wallach observed, these new pictures by Johns incited viewers to attempt to decode and ascribe meaning to, as well as determine artistic intention in, every detail.

The subject matter of the *Seasons* has encouraged a disproportionate emphasis on narrative readings over formal investigations. While seeking to redress that balance, this chapter will consider Johns's decision to turn to the age-old theme of the four seasons after thirty years of painting that had never featured this type of allegory. It will also examine how he created universal images concerning the traditional tropes of the passage of time and the four ages of man by quoting from, and referring to, his own art and that of other artists. Johns's depiction of nature is a significant feature of this body of work and will be examined through comparisons with poetry.

◆

The two series that Johns began in 1985—the *Seasons* and the paintings with the distended faces—could hardly be more different in tone, composition, form,

*Arrive/Depart*, 1963–64
Oil on canvas
68 × 51½ (172.7 × 130.8)
Bayerische
Staatsgemäldesammlungen,
Pinakothek der Moderne, Munich

structure, or subject. While the face pictures probe abstraction and Surrealist impulses, the *Seasons* follow an artistic tradition of allegorical representations of the four stages of life. Yet both draw on works by Picasso and continue Johns's exploration of issues surrounding perception. Both make some reference to Johns the person, though he has stated that the *Seasons* are "not particularly autobiographical," but rather "a clichéd tradition of representing the *Seasons*." Paradoxically, he adds,

> in a sense none of it represents me. And, in a sense, all of it represents me. It's like any other painting in that respect. You can say it does, or you can say it doesn't.[8]

While the faces refer to human perception and childlike instinct, the *Seasons* series concerns the larger world of nature and culture and man's relation to that sphere; it looks beyond the self to the natural world and the inevitability of growth, decay, and renewal.

This was not the first time Johns had directly addressed issues of transformation, the cyclical nature of existence, and the brevity of life. In 1980 and 1981, for instance, he painted three *Tantric Detail* canvases, each one a dark, hatched work featuring a coarsely depicted skull and bulbous testicles in the cartoonish style of Philip Guston, the forms based on a seventeenth-century Nepalese image of life and death agents copulating (see fig. 41). Johns said around that time that he had been looking at Tantric art, "thinking about issues like life and death, whether I could even survive."[9] A skull had featured in Johns's work as early as 1963–64 in the painting *Arrive/Depart* (fig. 79). While in that painting the skull may allude to death, it does not have the suggestion of regeneration that features in the *Tantric Detail* pictures with their Buddhist references.[10] Johns also engaged with the cycle of life in his 1979 watercolor *Cicada*, a colorful hatch composition with a number of complex doodles in the drawing's lower margin including a skull-and-crossbones, genitalia, spermatozoa, and a pyre, as well as a cicada and several other images (fig. 80). The cicada is a locust with an unusual life cycle. It burrows underground as a nymph, emerging after up to seventeen years only to mate and die within six weeks, the cycle endlessly recurring. When the cicada sheds its exoskeleton, its adult, winged body issues from its larvae. The *Seasons* extends Johns's interest in these metaphors of regeneration. In retrospect, the marginalia in *Cicada*, and the movement of imagery to the foreground in combination with abstract patterning in *Tantric Detail*, signaled the evolution of a new turn in Johns's art toward themes of life, death, sex, and regeneration that the artist continues to explore today.

Broadly speaking, the imagery of the four *Seasons* canvases has a narrative element, even if it is vague. Johns himself, speaking in 1990, was typically reluctant to posit one way of reading them:

> I don't really see that it's a narrative, in that I don't see what it narrates— unless you think that the representation of the *Seasons* is in itself a narrative.[11]

His earlier representational work—flags, numbers, and alphabet paintings, for instance—erased any sense of narrative or place, leaving the viewer unsure about the validity of the image or subject's original meaning. The *Seasons* pictures do not

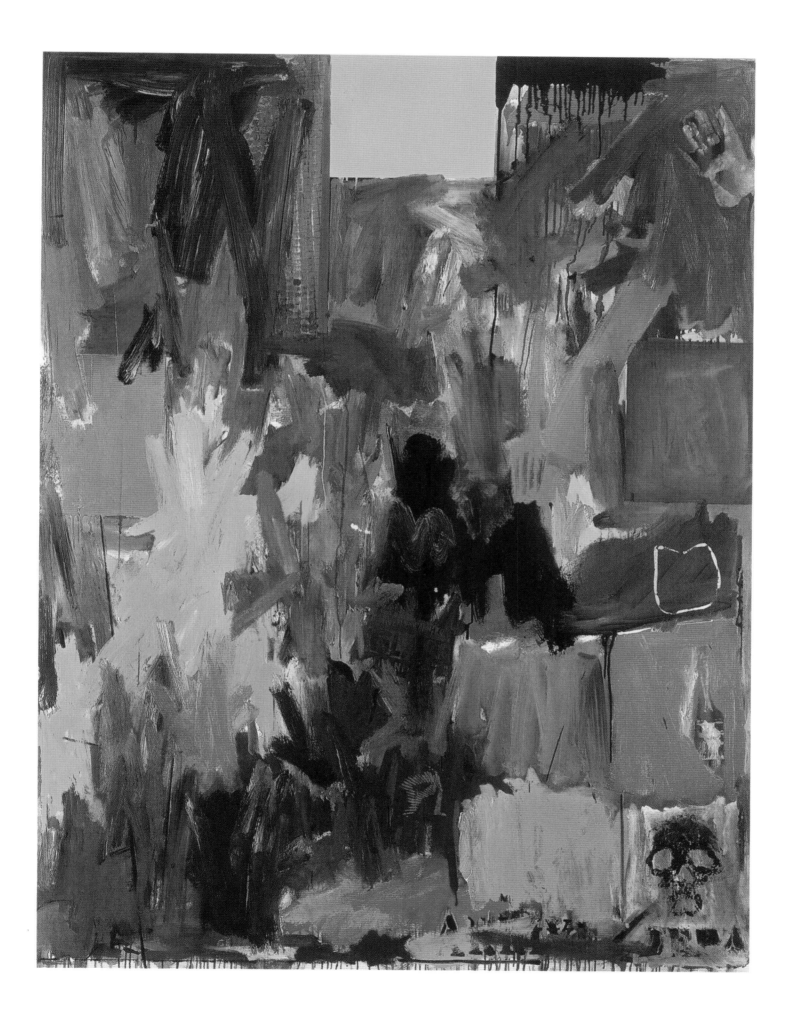

**80**

*Cicada,* 1979
Watercolor, pencil and
crayon on paper
43 × 28¾ (109.2 × 73) sheet
The Museum of Fine Arts, Houston

**81**

*Summer,* 1985
Frontispiece for *Poems* by
Wallace Stevens
Etching, aquatint and photogravure,
edition of 320
11⅝ × 8¼ (29.5 × 21)
Published by the Arion Press,
San Francisco

permit resolution any more than the earlier works do, but in them there is a sense
of place and time new to Johns's work.

When he installed the *Seasons* paintings at the Leo Castelli Gallery in 1987,
Johns hung them in their natural seasonal order, beginning with *Spring* and ending
with *Winter*. This is not, however, the sequence in which he painted them: *Spring*
was the last of the four paintings to be completed and *Summer* the first. Johns
originally conceived *Summer* as a single work, made in 1985 in his newly completed
studio on the Caribbean island of Saint Martin. Having been asked that year to
illustrate a special edition of selected Wallace Stevens poems for Arion Press
(when *Summer* was already finished but still not titled), and with Stevens's 1921
poem "The Snow Man" in mind, the artist considered elaborating on *Summer* and
making a series of prints of the four *Seasons* for that project. Ultimately, he chose
to make the 1985 intaglio print that he named *Summer* the frontispiece for Stevens's
*Poems* (fig. 81).[12] He then extended the seasons idiom in three further paintings,
closely adhering to the compositional format of *Summer*, completing first *Winter*,
followed by *Fall* and finally *Spring* in 1986.[13]

In developing the *Seasons*, Johns drew on two paintings by Picasso, one as a
compositional model, the other as an iconographic and metaphorical one. He chose
Picasso as an interlocutor, as a fellow artist whose works would forge connections
in the minds of both artist and viewer. Picasso provided a framework for the
creation of meaning, as Johns related his own visual history. Firstly, Johns based
the life-size silhouette that features in each of the four canvases, and that was
drawn from a tracing his artist friend Julian Lethbridge made of Johns's own
shadow, on Picasso's painting *The Shadow* (1953; fig. 82). He must have also
considered that work's structure in devising the composition of the *Seasons* pictures.
Secondly, Picasso's *Minotaur Moving His House* (1936; fig. 83), an autobiographical
allegory concerning a difficult time of transition in the older artist's life, provided

**82**
Pablo Picasso
*The Shadow*, 1953
Oil and charcoal on canvas
51 × 38 (129.5 × 96.5)
Musée National Picasso, Paris

**83**
Pablo Picasso
*Minotaur Moving His House*, 1936
Oil on canvas
18 × 21½ (46 × 55)
Private collection

some parallels for Johns's own peripatetic lifestyle. As Johns worked on the *Seasons*, he finished construction of his new studio on Saint Martin and was pondering moving his work and living spaces in New York, a change he would make in 1987.[14] Johns thus looked to Picasso's *Minotaur Moving His House*, which shows the artist as the Minotaur pulling a cart piled high with his possessions through a landscape, for its subject matter.

In the *Seasons*, Johns transformed Picasso's cart into a still life of fragmented, overlapping objects that populate each canvas. As Barbara Rose noted in one of the first pieces written about the *Seasons*, in each painting the shadow falls on a ground representative of one of Johns's studios: the terracotta in *Spring* from Saint Martin, brick in *Summer* from Stony Point, wooden planking in *Fall* from his Houston Street studio, and paving stones in *Winter* from the courtyard of his new townhouse in New York.[15] Johns selected imagery from *Minotaur Moving His House* to modify and make his own, including the stars, tree branch, ladder, rope, canvas, and fragments of the cart—in particular the wheel, which he transformed into an arm tracing a circle.[16] Each *Seasons* canvas features this complex grouping of objects; it requires concentrated attention on the viewer's part to define and appreciate the details and their variation across the four paintings.

Johns's irresolutely tilted gray-blue shadow, a dominant presence in all four *Seasons* canvases, is the first full figure in the artist's work.[17] Previously in his art, Johns had included plaster-cast body fragments; bitten a canvas, leaving the imprint of his mouth; pressed his oiled physiognomy on paper, fixing charcoal to the impression; imprinted his face, feet, arms, and hands in a variety of paintings, drawings, and prints; and created a surrogate self-portrait in the form of a Savarin coffee can full of paintbrushes.[18] When asked in 1980 about the expressive potential of the body parts in his work, Johns observed,

there's a kind of automatic poignancy connected with the experience
of such a thing. Any broken representation of the human physique
is touching in some way; it's upsetting or provokes reactions that one can't
quite account for. Maybe because one's image of one's own body
is disturbed by it.[19]

In the *Seasons*, however, the human presence appears in the form of the hovering
cast shadow, a spectral figure without features, but more benign than disturbing.
When asked whether he preferred indexical marks—templates or stamps, for
instance, as well as body fragments or the traced shadow in the *Seasons*—the artist
allowed that

> [I seem] to be attracted to such things and frequently work with them.
> Images that can be measured, traced, copied, etc., appeal to me, and
> I often enjoy that my finished work should contain a suggestion that
> I have used such procedures.[20]

Since the shadow first appeared in the *Seasons*, critics and writers have seen in
the figure clear and uncharacteristic autobiographical allusions, even while noting
its anonymous or ambiguous qualities. As such, these four paintings, as well as
the related works on paper, have been seen to represent a new phase of the artist's
work in which autobiography plays a larger role.[21] Reviewing the exhibition in
1987 when the *Seasons* were shown for the first time, critic John Russell commented
in his gentle commanding way on the figure's "vulnerable stance" throughout
the four canvases, adding that while the series is "full of action...the standing figure
(nowhere named, but difficult not to identify with the artist) functions throughout
as witness and victim, rather than as participant."[22] It has been called "Everyman,
but also the anonymous figure of Jasper Johns himself," as well as the divided
"watchman" and the "spy" whom Johns had mentioned in his 1965 Sketchbook
Notes.[23]

　　Roberta Bernstein observed that "Cézanne serves as a model for presenting
the figure as simultaneously a projection of the self and a universal type."[24] She
further cites Cézanne's solitary male bathers as a reference for Johns's shadow
figure. In discussing Cézanne's influence on Johns's 1963 *Diver* and related
works, Bernstein describes the "emotional vulnerability rather than heroic
monumentality" of Cézanne's figures. Citing Theodore Reff's interpretation of
the French artist's *Bather with Outstretched Arms* as "a projection of the artist,
'an image of his own solitary condition,'" she offers the view that in the 1960s
Johns may have seen in Cézanne's male bathers a model of a reticent contemplative
"figure that could be read as anonymous and at the same time enabled him to
introduce his own experiences into his work."[25] The constant figure in the *Seasons*
appears more neutral than Cézanne's vulnerable, awkwardly expressive male
bathers, but it would be hard not to characterize it as both anonymous and at the
same time suggestive of the artist, particularly as the series features elements of
Johns's own history.

　　The shadow is defined by the same roughly drawn outline that marks
Cézanne's male bathers, a line that both clarifies and exists independent of
form. Modulated contours lend Cézanne's figures the appearance of greater bulk
than Johns's shadow image, which has the stolid presence of a humbly crafted

paper doll or a chalk figure on a sidewalk. Cézanne's bathers are monumental, weighty forms, whereas Johns's shadow seems spectral and immaterial. Both manage to appear calculated and impulsive in equal measure. In choosing to depict an unclothed figure, Johns, following Cézanne, looked back to a long history in art, working with this classic type as a means of exploring form and structure, and thereby meaning. As Barbara Rose noted, in turning to the human figure Johns encountered an issue that featured significantly in Cézanne's art—how one could draw the contours of a shape (or of a figure) that could not be understood as either an illusion of three-dimensional space or as a completely flat silhouette.[26]

Just what is this remote and featureless figure doing in the *Seasons*? Johns explained that he "wanted some suggestion of a person," adding "although it is my shadow, from my point of view, the self was of no interest."[27] While it changes position from canvas to canvas, the shadow does not develop in any comprehensive manner from one to the next in a way commensurate with the overall *Seasons* theme. It has no narrative character; nor is it the overwhelming presence in Picasso's *The Shadow*, the source for Johns's figure. In the *Seasons*, the shadow figure looms, but it is ungrounded and its significance is uncertain. Johns had seen *The Shadow* and *Minotaur Moving His House* in David Douglas Duncan's coffee table book *Picasso's Picassos* (1961). In Duncan's text, which includes the artist's anecdotes, Picasso confirms that the shadow is his own, in the bedroom he shared with Françoise Gilot, who had recently left him, taking their two children, Claude and Paloma, after a ten-year relationship.[28] Considering Johns's career, it is unlikely that such an intimate incident would find a similar place in the *Seasons*. Nevertheless, whether or not Johns knew of Picasso's personal history, including, at age seventy-two, the grief and loneliness he experienced in the wake of Gilot's departure, *The Shadow* and the *Seasons* share a contemplative aspect that is at least in part due to the presence of the human figure, its passivity indicating some inherent human helplessness or exposure.

In composition and structure, *Spring* (1985; fig. 85) adheres more closely to Picasso's *The Shadow* than does any of the other *Seasons* pictures. Both works show a silhouetted figure at the center surrounded by, or superimposed on, a rectangular series of planes, parallel to the picture surface. In Johns's work, they are canvases, in Picasso's, a bed, floor, and walls. The sense of space in both is ambiguous, as the rectangular forms work to block any more than a shallow suggestion of depth across the picture plane. Johns's picture feels less claustrophobic or contained than Picasso's. While the figure in *The Shadow* appears isolated from the room in which he stands, the shadow in *Spring*, while weightless and indistinct, is moored by the surrounding works of art and the figure of the young boy below. Picasso depicts himself darkly silhouetted against a harsh light, eyeing his bed, seeing in it memories of the young lover who had broken off their relationship. To note this is not to suggest parallels in the lives of the two artists; indeed, Johns does not appear to refer to a life outside of art in the way Picasso does. Rather, in *Spring* the figure appears bolstered by the works of art that surround him rather than unsettled by external conditions.

The works of art that Johns depicts in the *Seasons* are dynamic elements that contrast with the detached colorless shadow. Accordingly, the *Seasons* affirm, art and its spirit warrant greater focus than the artist himself.[29] Johns's spectral

**84**
*Cups 4 Picasso*, 1972
Lithograph in 5 colors, edition of 39
22 × 32 (55.9 × 81.3)
Published by Universal Limited
Art Editions

shadow—perhaps the watchman or spy mentioned earlier—simply observes the passage of time expressed through the evolution of his art and accumulation of ideas and sensations. Throughout Johns's work, the human figure is only represented as a fragment or trace, or in this case, a shadow. This elegiac image is not given to specific or precise interpretation. More passive than dynamic, the shadow seems to exist as a reminder of man's presence, alongside the seasonal symbols and accumulation of objects and images that together represent the human cycle of maturation and decay. If the shadow's identity is obscure—veiled by its very nature—it is conceptually not dissimilar to other indexical ways Johns has chosen to represent himself.[30] As well as the non-figurative Savarin can or disembodied imprints of his skin, hands, and feet, in *Racing Thoughts* Johns included a pair of trousers, hanging on a bathroom door, which can be seen as a stand-in for the artist. The shadow figure in Johns's frontispiece for the Wallace Stevens *Poems* volume bears a close visual similarity to the trousers in *Racing Thoughts* (see figs. 52 and 81).[31]

Ultimately, the way that Johns makes the figure important both metaphorically and formally seems of greater significance than giving it a specific identity. The shadow changes position from one canvas to the next, revolving from *Spring* to *Winter*, as Kirk Varnedoe noted, "in sliding quarter-shifts, literally in rotation... attached to ideas of recurring cycles of beginnings, endings, and renewals."[32] The figure in *Fall* is split in two, one half at each edge of the canvas. Johns had established this type of implied cylindrical space extending beyond the picture plane in earlier works such as *Fool's House* (1961–62; fig. 12) and *Voice 2* (1967–71; fig. 23), with their stenciled split titles. In the *Seasons*, the shadow's movement is linked formally to the metaphor of the changing ages of man. As Varnedoe amplified, the shadow's varied placement in each canvas is "another of the artist's codes for a changing point of view, and for time passing."[33] Perhaps it says something that Johns's figure is centered in *Spring* and goes off-kilter after that, at left in *Summer*, fractured in *Fall,* and at right in *Winter*. The shadow's movement

The images depicted in *Spring* are, for Johns, "things the mind already knows," all having appeared in some form previously in his work.[34] Apart from a puzzle-like fragment of the hatched tracing of the plague victim from the Isenheim altarpiece, the appropriated images in *Spring* are from books on the psychology of perception: a Queen Elizabeth II Silver Jubilee vase and goblets similar to it, as well as the duck/rabbit and now familiar wife/mother-in-law image by William Hill. Johns presents the so-called Rubin's vases as a 5 × 3 grid—albeit one split in two—simply outlined and silhouetted on a black or blue ground, framed in green, with space beyond the canvas implied by the grid continuing from one edge to the other. The vases at right are partially obscured by the deep purple illustration of the wife/mother-in-law tacked to the grid and by the square canvas of the small boy, and those at left by the circle with its extended arm. There is a window-like suggestion of translucence in the ground of the grid that heightens the possibility of some type of expansive space. Only one of the vases is shown outside of the grid. It casts a synthetic blue shadow and floats, superimposed on the Hill image. Johns first used these types of perceptual puzzles in 1972, in the lithograph *Cups 4 Picasso*, which shows a pair of goblets, each of which can also be read as a mirror image of Picasso's face in profile (fig. 84); in the 1980s, such figure-ground reversals, which refer to the nature of perception and to the habits of eye and mind that develop over time and become difficult to break, appear frequently in Johns's work.[35] The young boy and the array of picture puzzles in the cart point to youth, or spring, as a key point in human development, when the ego forms, perceptual growth is stimulated, and the mind is fluid and capable of responding to changing or unpredictable circumstances.

**85**
*Spring*, 1985
Encaustic on canvas
75 × 50 (190.5 × 127)
Collection of Robert
and Jane Meyerhoff

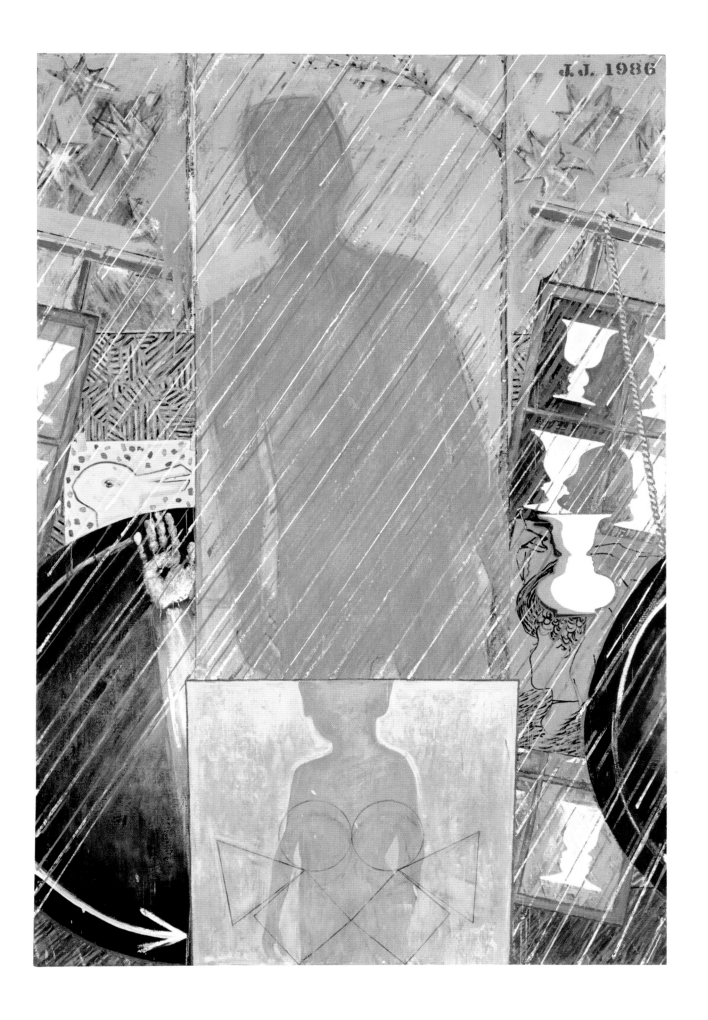

affirms the cyclical nature of life and the passage of time from youth to age, of rotation in a rhythm of evolution and regeneration.

◆

In *Spring* (the last of the *Seasons* to be completed, though thematically the first in the sequence), the shadow looms in the middle of the canvas, against a ruddy pink ground, sheltered by the blooming branches of a slender, flattened tree. Framing the shadow figure—yet divided from it by the tree at right and an indistinct reddish white line at left—is a massing of objects and works of art. The yellow stars on a ground articulated in a range of blues above fragments of a ladder, various works of art fixed to the ladder with a section of rope, and a cart wheel that can also be read as a device that records time, all clearly derive from Picasso's *Minotaur Moving His House*. A light spring rain, rendered in fine, straight chalk-like lines, covers the canvas on a diagonal from upper right to lower left. The composition has a lightness that Johns controls by his use of a range of color to affect mood. This includes the illusionistic duck/rabbit image, with its yellow ground speckled with red, yellow, and blue taped to the blue, orange, and yellow and black stripes that make up fragments of the tracing of the diseased demon from Grünewald's Isenheim altarpiece that has featured in many of Johns's pictures, as well as the shadow's pink ground and the deep purple of the wife/mother-in-law image, which featured so regularly in the face works discussed in Chapter Three. *Spring* has the richest span of color of the *Seasons* pictures, a mix not often seen in Johns's work. His manipulation of paint so that, for instance, the pink ground is allowed

**86**
Albrecht Dürer
*Melencolia I*, 1514
Engraving
9½ × 7¼ (24 × 18.5) plate
The Metropolitan Museum of Art,
New York

to seep through the shadow, gives the work a luminous character that differentiates it from the more opaque shadow and darker tones in the other three canvases.

At the bottom of the shadow figure in *Spring*, obscuring its legs, leans a lightly painted, buff-colored canvas showing an ethereal brown torso and most of the head of a small boy. Superimposed on the young figure, simply outlined in delicate black ink, is a symmetrical arrangement of squares, triangles, and circles. These objects appear in varied groupings in all four *Seasons* canvases. Johns was aware of Cézanne's dictum to "treat nature by the cylinder, the sphere, and the cone," and refers to the older artist through his inclusion of these forms. Johns has turned Cézanne's words about the underlying forms of nature into images—in their relationship to the child they can be seen as building blocks—in this series that treats nature as a metaphor for the phases of life and connects the ages of man with the development of the artist. The groupings may reflect Johns's interest in Zen Buddhism, according to which these shapes are found in everything in the universe; in Johns's work, they can be likened to his repeated use of the standard primary colors red, yellow, and blue, which are blended in the perception of all colors.[36]

In an early piece on the *Seasons*, Barbara Rose connected these geometric forms and the wheel device found in each canvas to the compass, geometrical solid, magic square, scale, and hourglass in the German master Albrecht Dürer's allegorical engraving *Melencolia I* (1514; fig. 86). Like the *Seasons*, Dürer's print depicts a host of objects with multiple meanings. At the feet of the winged personification of genius deep in thought are a variety of work implements, including measuring tools and a sphere. The objects have been shown to represent truth, judgment, and vanitas. Stumped by the conundrum of geometric proofs, is the figure working out how to reconcile theory with artistic impression? Perhaps wisdom without passion is ultimately unsatisfying, paradoxically leading to a life without meaning. Johns's *Seasons* series presents a similar type of indeterminate meditation on life, with objects full of meaning but ultimately unresolved.[37]

Johns includes many parallels to youth in *Spring*, in both content and form. He places the shadow in the center of the canvas, pointing to childhood and adolescence as a time when one is focused on the self. The ladder fragment at right continues on the canvas's left side; the wheel is split in two parts and the cart's contents could only be made whole if one could form the canvas into a cylinder. The allusion to circularity reinforces the varied placement of the shadow in each of the *Seasons* canvases and the beginning of a cycle of renewal implied in the series as a whole. Like a clock hand, the outstretched hand on the circle points up, indicating the start of life. In choosing the primary, formative colors red, yellow, and blue as a ground for the duck/rabbit, Johns pinpoints its childlike qualities rather than underlining its intellectual function as a device from perceptual psychology. The generally light palette of *Spring* adds to its overall vital character.

◆

Johns completed *Summer* (fig. 87) in Saint Martin in 1985, prior to painting the rest of the *Seasons*. As the artist finished the work and thought about naming it, he expanded its theme, from an investigation of his own experience in the context of moving house and studio, to the four seasons and the ages of man. The picture remained untitled until Johns developed the *Seasons* theme and began work on

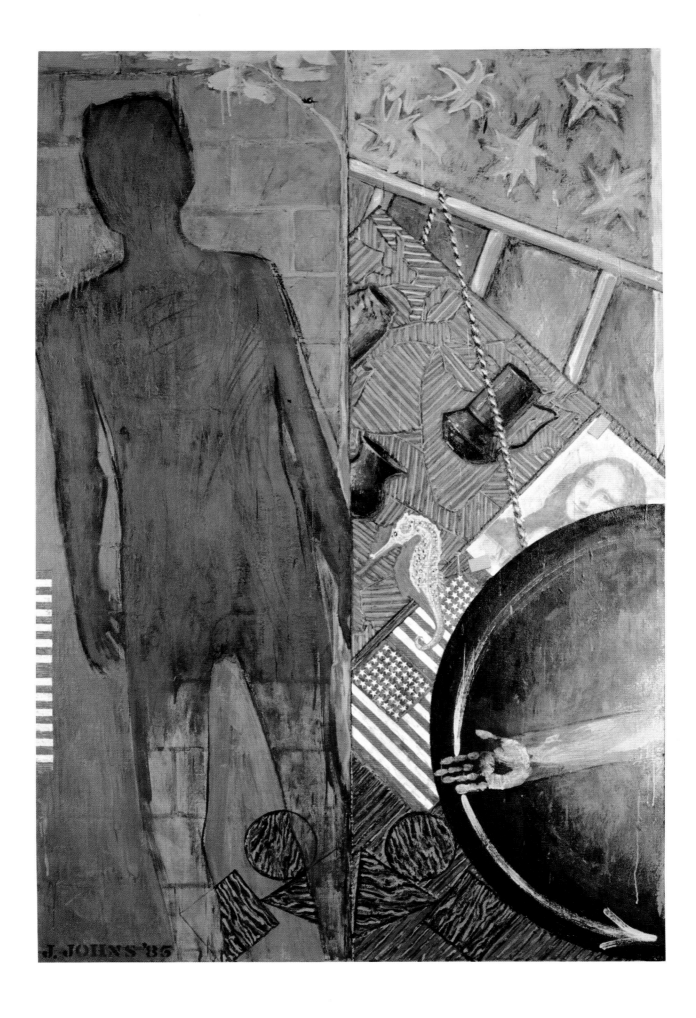

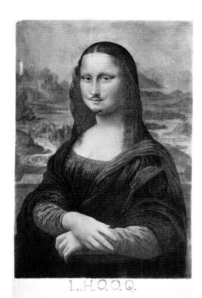

L.H.O.O.Q.

the other three paintings in 1986. In *Summer*, the artist's shadow, markedly outlined in deep black, appears against a green tile ground, the grout lines fading away at the canvas midpoint, leaving the lower half a resonant passage of painterly green over dark underpaint. The shadow is more opaque than in *Spring*, where the pale pink ground is often visible through the vertical, relatively regular strokes of the blue shadow, its insubstantial character suggesting a youth not yet fully formed. In *Summer*, the shadow is roughly painted, in deep blue and scratchy black, with patches of lighter tones on the lower legs as if, in a schematic way, light were hitting it there. As in the other *Seasons* pictures, the shadowy figure faces the viewer, knees slightly bent. Its feet are cut off by the lower edge of the canvas, and it tilts slightly to the left, giving it an elusive aspect. The figure's genitals are more distinct than in the shadow in *Spring*, suggesting a young man past childhood, a rare instance of sequential narrative in the *Seasons*.

Other elements of *Summer* include references to art and nature. Near the figure's right hand, interrupted by the picture's edge, is a small section—the red and white stripes—of a Johns flag painting. A thin tree trunk bisects the canvas. This spindly branch that bloomed in *Spring*, arching above the figure, has filled out with green leaves; a hummingbird perches in a nest on the branch. The figure's left hand extends over the tree trunk, seemingly seeking a connection with the objects on the right side of the canvas. The flattened hand bisecting the tree lends a shallow sense of depth, which does little to diminish the ambiguous pictorial space.

The right half of the canvas is filled with a jumble of objects: the ladder from Picasso's *Minotaur Moving His Cart*, and the half circle suggesting both a cart wheel and an off-kilter time-measuring device; it could suggest a type of Doomsday Clock, the symbolic model that indicates how close the world stands to midnight— that is, to some type of life-threatening catastrophe—the arrow nonetheless transcribing the arc the hand will follow in time's ceaseless cycle.[38] The rope, each knot carefully depicted to describe its round form, secures a canvas slanting perilously to the right with fragments of familiar references to Johns's work and that of other artists he appreciates: George Ohr pots, an abbreviated grouping of those depicted in *Ventriloquist* (1983; fig. 53), placed on a hatched version of the Isenheim altarpiece diseased demon; and the Mona Lisa. Depicted in red, as in the 1983 *Racing Thoughts*, the Mona Lisa image recalls Johns's admiration for both Leonardo and Duchamp.[39] Duchamp tested the tradition of high art in his readymade *L.H.O.O.Q.*, a postcard of the Mona Lisa to which he added in black pencil a mustache and goatee. The letters of the title have no meaning, but when said in French, sound out "elle a chaud au cul" or "she has a hot ass," (1919; fig. 88). Tacked below the Mona Lisa in Johns's painting is a stacked double red, white, and blue flag picture. As in all the *Seasons* works, Johns fosters a dialogue between organic and inorganic forms, a rich poetic vocabulary inherent in the variety of depicted objects. Natural elements, such as the budding tree and aspects of weather, combine with handmade items such as fragile pottery and works of art.

At the canvas's lower edge are the six geometric forms—squares, circles, and triangles—seen in *Spring*, now painted in faux bois, bisecting the middle of the canvas in a symmetrical arrangement. They lend a further sense of ambiguity to the space, as the three shapes at left appear partially covered by the shadow, while the ones at right are depicted as foreground elements set on the red and green striped ground. The stars from Picasso's *Minotaur* can be seen at top right, fluid pinwheels

**87**

*Summer*, 1985
Encaustic on canvas
75 × 50 (190.5 × 127)
The Museum of Modern Art,
New York

**88**

Marcel Duchamp
*L.H.O.O.Q.*, 1919
Pencil on reproduction of
Leonardo da Vinci's Mona Lisa
7⅝ × 4⅞ (19.4 × 12.4)
Private collection

set against a freely painted green over purple underpaint. In addition to the verdant palette and strong light that indicate summer, Johns superimposed a trompe-l'oeil seahorse and its lush blue schematic shadow over the Isenheim and flag fragments. The fish is painted with unusual attention to detail. The creature asserts itself with a clarity at odds with the more freely painted elements from the world of mankind and culture. Why? Was Johns simply playing with the idea of an Audubon-style natural specimen that suggests a temperate climate? He acknowledged that

> in a certain way, *Summer* is connected to [Saint Martin] in terms of its imagery. It was definitely this house. The hummingbird was in *that* tree, things of that sort.[40]

While the seahorse may be one element that locates *Summer* in a particular time and place, it is also open to more symbolic readings. Because the male seahorse is nearly unique among animals in its ability to bear offspring, some Johns scholars have seen it as a replacement for the miserable pregnant horse that Picasso's minotaur drags in his cart.[41] Mark Rosenthal observed a more conceptual role for the seahorse, claiming that through it and other elements in the picture that indicate a play of two- and three-dimensional space—from trompe-l'oeil tape and nail to flat flags—"Johns suggests that during the summer of his life, he became familiar with the tenets and practices of modernism."[42]

◆

The tone of *Fall* (1986; fig. 90) is more subdued than either *Spring* or *Summer*. Like *Spring*, the composition of *Fall* is divided into a tripartite structure, this time with the shadow figure split into two at the canvas's left and right, its wholeness only conceivable if the canvas were to be formed into a cylinder. The articulation of space in this work is thus linked thematically to the cycle of life manifested by the *Seasons* as a whole. Although the encaustic surface has no newsprint collage to lend it the plasticity characteristic of Johns's earlier encaustic work, it is by no means uniform. The shadow is textured with horizontal striations as well as a goosebump

**89**
*Study for Fall*, 1986
Pencil on paper
22¼ × 31⅛ (56.5 × 79.1) sheet
20⅛ × 28⅝ (51.2 × 72.7) sight
Collection of Janie C. Lee

**90**
*Fall*, 1986
Encaustic on canvas
75 × 50 (190.5 × 127)
Collection of the artist

consistency in places, the wood grain texture of the encaustic ground occasionally showing through.

In the middle of the composition, separating the fragmented figure, are the iconographic elements taken from Picasso's *Minotaur* painting, variations of which appear in all the *Seasons* canvases. As the double meaning of the title sinks in, we realize that here things are literally falling apart. The ladder has split in two, the tree branch is broken, the stars above appear muted, fragmentary, distant, and the rope has split. It hangs loose, no longer able to contain the art objects falling out of its hold. Three Ohr pots and the goblet from Johns's 1973 lithograph *Cup 2 Picasso* lie in a heap at the lower edge of the canvas (see also *Study for Fall*, 1986; fig. 89). A fraction of a Johns double flag—now green and black as opposed to the brighter red and white segment in *Summer*—appears on its side at the lower edge of the canvas. A fragment of a canvas depicting the hatched demon from the Isenheim altarpiece functions as a ground for the wheel and the jumble of objects. Unique to *Fall* is the Swiss avalanche warning sign featuring a skull and crossbones that figured in Johns's work in the early 1980s, here taped to a red striated canvas, suggesting, along with the ruptured shadow figure and scattered objects, disarray and anxiety, instability, and death lurking ahead.[43]

Tacked next to the skull is a homage to Marcel Duchamp, a painted version of the older artist's portrait, similar to Johns's earlier collage *M.D.* (1964; fig. 92) and his 1971 lithograph *Fragment—According to What—Hinged Canvas*.[44] Johns's inventive transformations and revisions of Duchamp's self-portrait are interesting examples of his complex visual and intellectual process, and specifically regarding the ideas he shares with Duchamp regarding cast shadows and silhouettes. *M.D.*, a torn-paper collage of Duchamp's silhouetted profile, was the young artist's first

visual response to Duchamp. According to Roberta Bernstein, Johns traced the
image from a 1959 Duchamp self-portrait print in his collection, one of many
examples of the artist's *Self-Portrait in Profile* (1957; fig. 91).[45] Duchamp's self-
portrait shows his silhouette made of cut and pasted paper, from a zinc template
the artist made of his profile. Johns shifted the head 180 degrees, so it faces left
instead of right, mirroring Duchamp's version. *M.D.* reflects Johns's understanding
of Duchamp's thoughts on perspective and cast shadows as articulated in *The
Green Box.*[46] His 1964 sketchbook notes indicate he was considering other ways to
work with Duchamp's self-portrait, and the same year, he included it in his major
assemblage, *According to What* (fig. 22). In that work it is only visible when the
small hinged canvas at lower left is unclasped and open to reveal the profile—
which Johns may have transferred from his collage—on its inner face.

Duchamp's self-portrait silhouette was itself most likely traced, and suggests
a possible genesis for Johns's idea for the template shadow he used in the *Seasons.*
Both can be viewed as objectified portraits, with unfixed identities. The shadow
figure in the *Seasons* recalls Duchamp's play with blurred personas in his self-
depictions as R. Mutt and Rrose Sélavy, alter egos that question the nature of identity,
how we are shaped by the views of others and by societal norms, as well as our
ability truly to know anyone, including ourselves. Curator Anne Collins Goodyear
has written that Duchamp's self-portraits "enabled the artist to demonstrate radical
multiplicity of self…Duchamp's most significant legacy is to demonstrate that one
thing, one person, can be many things at once, all depending on one's perspective.
Identity, then, is not reducible to a single convenient expression but is ultimately
unstable and multiple."[47] Duchamp was apparently fascinated with shadows
and the correspondence between positive and negative space, presence or absence.[48]

Like Duchamp, Johns has constructed an elusive figure in the *Seasons*, one not easily labeled. Johns's reference to Duchamp's self-portrait silhouette—with its ambiguity of figure and ground—seems appropriate in the context of the split figure that in *Fall* highlights issues of perception and mirroring. His inclusion of his version of Duchamp's self-portrait, adjacent to his own painted shadow (both images that evoke presence through the depiction of negative space), suggests he is acknowledging a connection across time, to Duchamp and to his own earlier work.

In *Fall*, a painted spoon hangs from a trompe-l'oeil nail tacked to the lower left edge of Duchamp's self-portrait. Cutlery has featured in Johns's work since the early 1960s. Commenting on the implements in a 1967 set of drawings, Johns articulated—in a manner indicating his reluctance to interpret his own work, laced with a modicum of humor—a link between the very real objects in his art and broader concerns they might signal: "My associations, if you want them, are cutting, measuring, mixing, blending, consuming—creation and destruction moderated by ritualized manners."[49] According to Roberta Bernstein, the spoon derives from Duchamp's *Locking Spoon*.[50] Johns first incorporated an actual spoon in *In Memory of My Feelings—Frank O'Hara* (1961; fig. 13), where it hangs, attached by a long, spindly wire to the upper edge of the canvas. At its most basic, the cutlery in Johns's work recalls Duchamp's rejection of traditional media starting around 1912, when he gave up painting in favor of radically conceptual imagery in the form of the readymade.

Extending Duchamp's idea of presenting real objects as works of art, Johns first made an object into a painting with his flags and later incorporated actual objects—rulers, thermometers, and eventually utensils—into his paintings. Not only did these devices break up the painterly surface of his work to bridge the gap between more sculptural assemblage and pure painting, they also "work[ed] on other levels" as Johns said in 1959, discussing the flag image.[51] The spoon in *Fall*, like many elements in Johns's art, has a literal character. The longer we engage with it, however, the more layers are revealed in terms of both iconography and style. Johns presents the spoon and its shadow in paint; there is evident pleasure in the painted surface, wonder at his play with illusion, and a reminder of the line between fiction and reality in the material quality of the encaustic itself. As a utensil, the spoon also triggers the territory of human feelings that remains unquantifiable, individual, and sensual, associated as it is with taste and hunger in all their metaphoric meaning. A spoon can function as a measuring device, and so can express both a rational quality and its opposite. It can be linked to all of Johns's earlier works in which spoons appear—in short, with various ideas and memories, visual, intellectual, and visceral. In the work of both Duchamp and Johns, the gap between reason and sensation is a small but subtle and significant one.

The dark, circular wheel, its extended arm pointing at seven o'clock, and an arrow indicating counter-clockwise movement, appears at the lower right of the middle segment of the canvas, superimposed on the Grünewald hatched demon. The arm has not moved far from its placement in *Summer* in its trajectory around the wheel; change is greater in youth than in middle age and afterward, this device seems to indicate. Because of its dark tonality and large, regular geometric shape, this wheel looms prominently in all four of the *Seasons* canvases. In *Fall*, however, it is notably defined, set off clearly by its sharp outline and rich, painterly black, lightened by a range of carefully applied gray and white encaustic at its center,

and enlivened by drips and smudges. It is an element that reminds the viewer of Johns's force as an abstract painter and foreshadows the expansive, luminous encaustic in the gray *Catenary* paintings he turned to in 1997.

Similar devices first appeared in Johns's work in the early 1960s, where instead of an arm, a ruler or a paint stick leaves a scraping arc of paint, seeming to mock abstraction's painterly touch and sensation. In some works of this period, such as *Diver,* the device is a hand that extends, seeking connection, but suspending resolution (fig. 21). Now, whether a more regular timepiece or a type of Doomsday Clock, the device is hauntingly rendered in rich modulations of darkness and light, its arm tracing an arc of diminishing time. The arm measures the passage of time but also evidences human activity or connection, forging a link between human life and an abstract dimension beyond time. As a measuring device, it is inexact: it appears to be falling down or off-center, unable to keep track of life's surges. Its appearance in each of the four *Seasons* canvases provides the opportunity to consider its varied representations, with Johns exploring the possibilities of a restricted black and white palette, ultimately exceeding that limitation by adding a subtle yet sweeping range of blue, purple, and gray tones that shape the character of each work.

The six geometric shapes in *Fall*—in a grisaille trompe-l'oeil wood grain— now suspended in the center at the canvas's upper edge, provide a stable element, an underlying structure that grounds the disarray below. The distinct character of each shape is rendered somewhat nebulous by paint drips and smudges, with bits of ground overlaying the wood-grain surface, as if Johns needs to keep us aware of the painting's objecthood. In *Fall*, the squares, triangles, and circles replace the now faint stars. The building blocks remain as a visual and conceptual scaffold underlying nature's variable states and attesting to a sustaining spirit in the universe.

◆

*Winter* (1986; fig. 93) is distinguished from the other *Seasons* pictures by its unremitting grayness, relieved by snowfall suggested by an allover pattern of irregular white impasto daubs. Johns said he was attempting "to establish the idea of some kind of movement that couldn't be noticed but would still be there."[52] *Winter* was the second of the *Seasons* paintings to be finished. He began work on it in Saint Martin in 1985, and completed it at his Houston Street studio in New York in 1986. Johns may have had Wallace Stevens's poem "The Snow Man" on his mind as he contemplated the imagery for *Winter*. It was around this time that he was planning the frontispiece for the Arion Press's edition of Wallace Stevens's poems; ultimately, Johns chose to use *Summer* for that project, before he went on to develop the *Seasons* series (fig. 81). *Winter* has the same diptych format as *Summer*, but the shadow has migrated from the left to the right side of the canvas. At left, under a starry sky, the tumble of objects is resecured with rope to the broken ladder as well as fixed with a trompe-l'oeil wire that horizontally bisects the middle of the left half of the canvas. It seems as if extra support is required at this juncture.

The wheel device appears superimposed on the lower left side of two painted canvases, or leaning against them, its extended arm pointing downward, the arrow now tracing a clockwise path. Even the wheel seems out of kilter in *Winter*, its arm

In terms of iconography and color, this is the most restrained of the *Seasons* works, as if such paring down is natural in the course of a long life. Its grisaille tones mute the jumble of objects, as snowfall does in a storm. As the critic Max Kozloff noted in 1968, "a Johns painting is a series of cancellations as much as it is a sequence of additions."[53] Johns once said that he used gray encaustic because "this suggested a kind of literal quality that was unmoved or unmovable by coloration and thus avoided all the emotional and dramatic quality of color." To him, "black and white is very leading. It tells you what to say or do. The gray encaustic paintings seem to me to allow the literal qualities of the painting to predominate over any of the others."[54]

**93**
*Winter*, 1986
Encaustic on canvas
75 × 50 (190.5 × 127)
Private collection

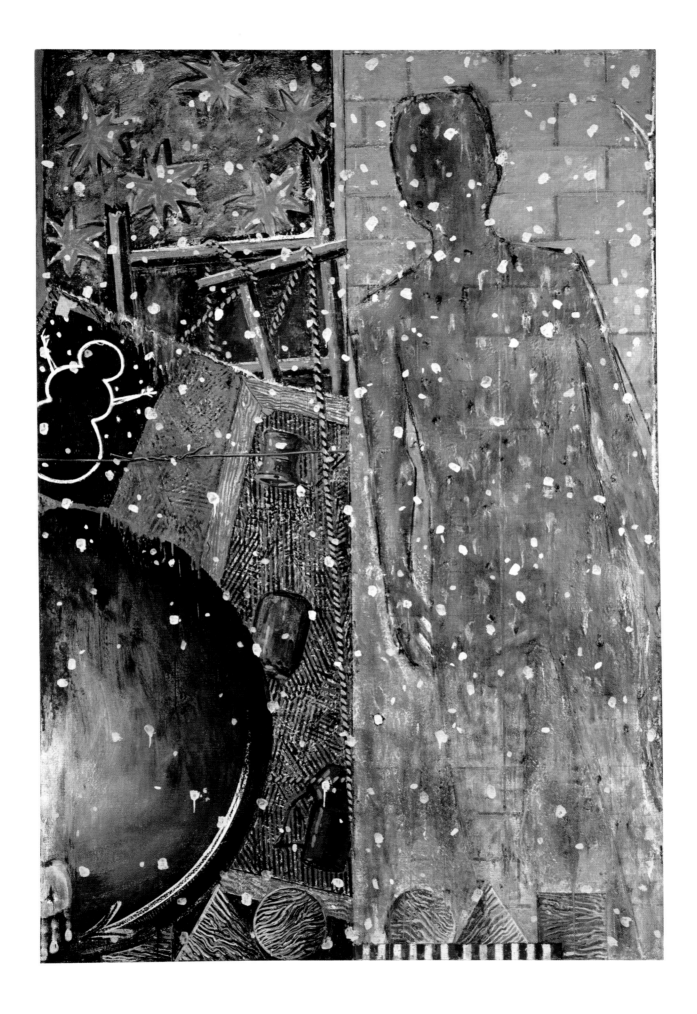

**94**
*Liar*, 1961
Encaustic, Sculp-metal
and graphite on paper
21¼ × 17 (54 × 43.2)
Collection of Gail and Tony Ganz,
Los Angeles

facing six o'clock when it should, if following the pattern established in the other *Seasons* pictures, indicate three o'clock. The arrow's reversal in *Winter* suggests that in this phase of life one looks back with greater intensity than in the constant forward push at earlier stages.

Each object is fragmented, partially hidden by the others. The canvas on the left shows against a blue, gray, and white hatched ground, a childlike white outline of a snowman on black taped to the canvas. The other canvas has been turned away from the viewer, its stretcher bars exposed. The sense of spatial disjunction created by the canvases and wheel is heightened by three upside-down George Ohr pots that either hover, defying gravity in space, or are painted on or attached to the overturned canvas. The grisaille faux bois triangles, circles, and squares, one partially obscured by the overlapping wheel device, now appear in a line at the canvas bottom, along with the striped edge of a Johns double flag painting in red and white on its side, adding to the irresolvable depiction of space.

Johns suggests that he works with gray because of its neutrality. Yet, gray is rich in suggestion, its impartial character only one of its aspects. "Gray matter" is a complex part of the brain that guides sensory perception, speech, memory, and emotions. It is fundamentally linked to the intellect, to thought and concept. A "gray area" is ambiguous. Gray as a descriptive term or metaphor can elicit a variety of responses from desolation to irresolution or indifference, loss, lack of atmosphere, anonymity, or an ascetic tendency.[55] It can imply a sense of quiet or withdrawal. It may also have no intrinsic meaning, yet simply exist as a function of process or medium. It yields the type of irresolution that Johns continuously seems to seek out. He has said on more than one occasion that gray is his favorite color.[56] Gray has featured predominantly in two distinct phases of Johns's work: during the 1950s and early 1960s, and over thirty years later in the so-called *Catenary* pictures he turned to in the mid-1990s.[57] Johns used gray only infrequently in the 1980s, in a few isolated instances, including a number of hatch paintings and one version of *Racing Thoughts* (1984). While Johns's early work in gray is too varied to generalize about, many of the pictures dating from 1959 to 1961 do have a desperate edge to them. As Kirk Varnedoe observed, "between *Thermometer* of 1959 and *Water Freezes* of 1961, a new emotional tone intervened in Johns's work, chill, dark, and bleak. Titles of negation, melancholy, or bitterness (*No, Liar, In Memory of My Feelings—Frank O'Hara*) underlined the altered mood...Gray, formerly the guise of impassive neutrality, became an expressive cast of gloom and morbidity."[58] The paint and encaustic in these works has a rough physical character, smeared, dripped, slashed, with brushwork that mimics action painting's expressionist intensity.

Paradoxically, in these early works, Johns laid down paint or encaustic with methodical care, each stroke distinct from the next. The act of painting became a key component of these pictures, as the deep, dark, unrelenting, if sensual, gray tones in works such as *No* and *Liar* (1961; fig. 94) suggested inconsolable anguish, close to the surface. Knowing basic facts of the artist's life, it is clear that *Winter* is the work of an artist at a different stage of life, in altered circumstances. Johns was in his early thirties in the early 1960s. His concentrated and extraordinary artistic relationship with Robert Rauschenberg had ended. Johns painted *Winter* in his fifties; though he was uprooting himself, there is nothing in the work that suggests the type of emotional desolation or exposure of the earlier gray paintings. The gray of *Winter* is soft, with minute gradations in tone, mirroring our infinite capacities

for range of mood, perspective, or feeling. It is a gray of absorption rather than concealment or vulnerability.

◆

While two Picasso paintings, *The Shadow* and *Minotaur Moving His House*, provided significant iconographic and structural models for the *Seasons*, the layered imagery that addresses figure-ground relationships and the nature of representation in painting recalls to some extent pictures by Cézanne even more than Picasso. In combination with the shadow figure, the tumble of canvases, wheel, and other assorted elements, the enigmatic sense of space evokes the composition of many of Cézanne's still lifes, for instance, *Still Life with Plaster Cupid* (c. 1894; fig. 95). That painting, like the *Seasons*, combines references to nature and Cézanne's own art as well as to the art of the past. It depicts the cast of an ancient Roman sculpture of Cupid set among apples and onions on a table in a studio. A group of stacked canvases at oblique angles includes one facing away, its stretcher bar exposed, another by Cézanne of a cast of a flayed man, and a Cézanne still life.

Both Cézanne's *Still Life with Plaster Cupid* and the *Seasons* cycle reflect on the nature of painting itself, one at the end of the nineteenth century, the other a hundred years later. In constructing a composition with an inconsistent sense of scale and puzzling discontinuities that limit spatial depth, Cézanne created an image that is not a realistic depiction, but instead offers a subjective sense of space based on personal experience. In *Still Life with Plaster Cupid* everything appears to shift, turn, or drift, almost as if we are viewing the objects as we move through the room; our continuous movement through space and time, and our memory of what we just saw, constantly reshapes what we see. Cézanne's pictorial revision

**95**
Paul Cézanne
*Still Life with Plaster Cast*, c. 1894
Oil on paper, laid on board
27¾ × 22½ (70.6 × 57.3)
The Courtauld Gallery, London

of space serves as a reminder that life is always in flux and that our approach to sight and experience is subjective. In much the same way, the composition and iconography of the *Seasons*—the layered imagery, spatial disorientation, and references to the past—trigger a sense of human memory constantly reinventing itself. Each time we remember something we modify it slightly, depending on the context of our recollection. Johns's layering of images, like Cézanne's, is emblematic of embedded memory, knowledge, and understanding gained through experience, the tumult of objects suggesting uncertainty and the inevitability of change.

In considering Johns's depiction of space in the *Seasons*, it is also relevant to recall his interest in Japanese culture and art. The references to nature and regular harmony of vertical divisions in the *Seasons*, as well as the shallow recession and vertical massing of objects, lend the series the appearance and feel of seasonal imagery in Japanese screens. Embedded in many aspects of East Asian cultures is a respect for the formal beauty of objects. Johns has an affinity for Japan in particular, and this sense of absorption regarding objects such as a vase or pot can be seen in his repeated use of specific objects at a time when such contemplative perspectives were diminishing during the rise of installation and identity-based art. Johns's engagement with Japanese art and culture dates to the early 1950s, when he was stationed in Sendai during the Korean War.[59] In 1977 he began a series of hatch works called *Usuyuki*, the Japanese word for lightly falling snow, suggesting the ephemeral side of nature. Johns knew the word as part of the title of a melancholy seventeenth-century epic Japanese novel, later performed as a Kabuki drama, in which the three main characters sustain deep stirring pain but have recourse to laughter in the midst of it. It takes place in cherry blossom season, the heroine, Usuyuki-hime embodying the evanescent qualities of beauty and the passage of time.[60]

Traditional Japanese artists noted the passage of time and its poignancy in carefully composed groupings of seasonal plants and birds suggesting nature's recurrence and change (see fig. 96). Johns's appreciation for the outside world and its aesthetics is well known and may reflect discrete factors such as his upbringing in rural South Carolina and his interest in the Japanese way of life, with its ancient and deep-rooted affinity with nature, embedded in its agricultural origins. Japanese poetry related to the four seasons grew naturally out of this sensitivity to climate and geography; following a cyclical model, poets found inspiration in nature to give voice to emotions and ideas, and, in turn, poetry about nature inspired in readers a greater respect for their surroundings. Nature was associated by and large with harmony, serenity, and solitude, as well as the inevitability of change and Japanese poets and artists used the passing seasons as metaphors for the nature of human experience.[61] Not only was nature meditated on and extolled, it was also subject to human emotions, such as sorrow, loss, and regret over the sense of time passing. This is seen, for instance, in the prevalence of imagery related to the beautiful but short-lived blossoming of cherry trees.[62] In the *Seasons*, Johns may have had such imagery in mind in painting the tree at different stages of development and stasis in each of the four paintings, as well as the stars and other natural forms.

Most Japanese screens, like the *Seasons*, have a common height, close to human scale, and a horizontal structure formed from a number of long, vertical panels. This format recalls Johns's 1989 horizontal intaglio print depicting the four *Seasons* side by side, this time beginning with summer and ending with spring, as well as

two intensely colored drawings in acrylic on etching. In the 1989 print and the related drawings, imagery crosses over from one vertical break to the next, as it does in many Japanese screens (see figs. 97, 98 and 111).[63] The vertical divisions within each of Johns's pictures that set the figure apart from the jumble of objects, reinforce the shadow's sense of isolation, whether detached or simply in solitude. In each canvas, however, his left hand reaches across the void, seeking to forge a connection.

Unlike the tradition of Western art since the Renaissance, most Japanese paintings and works on paper feature neither a fixed vanishing point nor a fixed viewpoint. The light tends to be uniform, with depth indicated by subtle changes in brushwork. The *Seasons* features a similar depiction of space with no consistent sense of flatness or depth. As in Japanese screens, it is Johns's range of tone, variations of light and dark, and compelling paint handling that animate each canvas with a sense of modulation in viewpoint and in the weight and depth of objects. Johns had been considering this type of shallow perspectival space indicative of a studio or interior wall since the early 1980s in *In the Studio* and related work. Following his exploration of these compact painted spaces, the *Seasons* introduced a more ambiguous environment, located somewhere between abstract and concrete, its composition defined by a dense grouping of objects, controlled collision of form, and range of color.

While the stacking of forms gives some impression of depth, Johns's mindful application of encaustic draws attention to the surface of the canvas. In his earlier work, he heightened awareness of the objecthood of his flags and targets by working in encaustic over densely applied strips of newsprint that fragment the surface and

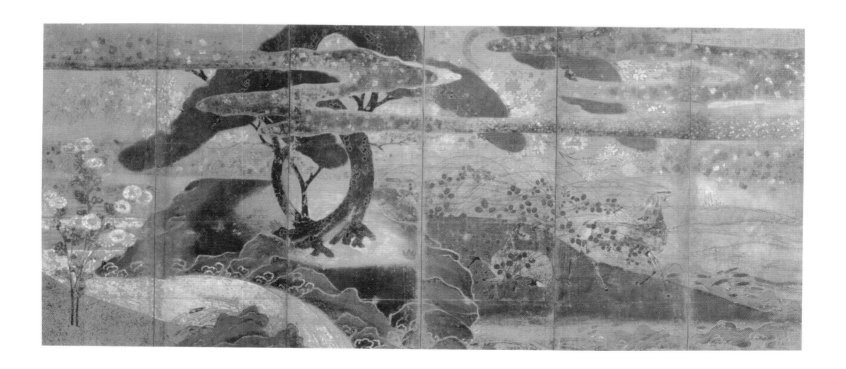

challenge illusion, lending the object texture and a three-dimensional quality that manifests gesture, action, and energy. In contrast, Johns's toned-down brushwork to depict the more traditional theme of the seasons seems correspondingly dignified. Through his dexterous handling of encaustic in the *Seasons*, Johns was able to exploit the quick-dry character of the medium to create a range of textures. In *Fall*, for instance, there are thin horizontal gray striations in the figure that approximate the texture of rough skin. The stars and geometric blocks are more sketch-like, nebulous, while the art objects rising out of this mist appear sharp and well defined. Johns's use of encaustic here is restrained, disciplined, and orderly. His brushwork has been controlled from the start, even at its most expressive, but in the *Seasons* it is exceptionally subtle and differentiated, without the torn newsprint that lends sculptural tactility to his early encaustic paintings.

◆

In its nod to the cultural tradition of its theme, its narrative references and rhythmic form, the *Seasons* series bears close comparison to lyric poetry. Johns's ideas about art—regarding the deadening effect of habit, and the relationship between thinking and seeing, as well as calling attention to things "seen and not looked at"—echo the cognitive attitudes of modernist poets.[64] Johns's regard for poetry and all literature from an early age is well known but has not received significant attention from scholars of his work, perhaps because it is difficult to evaluate or draw parallels with.[65] Johns had forged connections with poetry in his own work as early as 1962, in a series of pieces that reveal the significance for him of

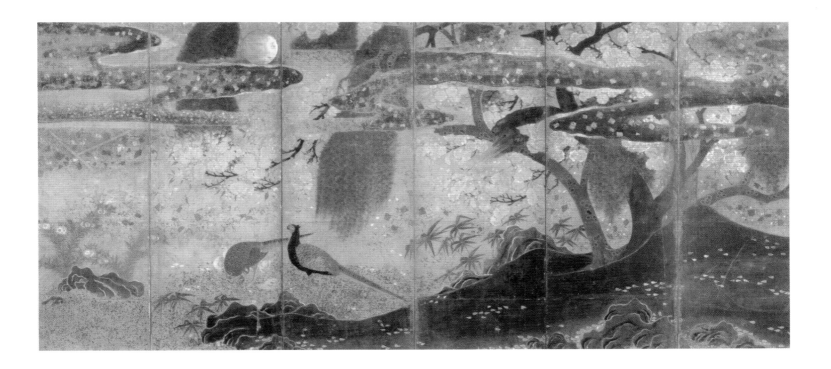

**97**

*The Seasons*, 1989
Ink on plastic
26 × 58 (66 × 147.3) sheet
20⅛ × 51⅞ (51.1 × 138.8) sight
Collection of the artist

the modernist poet Hart Crane's verse and life (1899-1932). While this was perhaps his most sustained artistic connection with poetry, it was not his last. Johns reads a wide range of prose and poetry, a fact often mentioned in interviews.[66] He has collaborated with writers and placed poems and other bits of writing—the John Cage score in *Perilous Night* (1982; fig. 46), for instance—in his work, as well as naming pictures after writers.

The tone of the *Seasons*, more than any of Johns's work to date, bears specific comparison with the poetry of Wallace Stevens (1879-1955), in the prevalence of seasonal imagery in symbolic form in Stevens's poems and in painter and poet's shared convictions about the significance of the creative spirit in our lives.[67] Johns's contribution of the frontispiece to the Arion Press publication of Stevens's *Poems* and his references to Stevens's poem "The Snow Man" demonstrate his interest in the poet's work.

For Stevens, who lived a generation and a half before Johns, poetry provided a release from his day job selling insurance in Hartford, Connecticut (he was an authority on surety bonds). His corporate life may have contributed to his celebration of the imagination in his poetry. The early poem "Gubbinal," for instance, describes a place lacking imagination, a world that is ugly, with a dejected populace, yet it affirms the potential of the human spirit to overcome a dreary outlook. Stevens's attitude to the imagination is based in British Romantic poetry. Johns's art, like Stevens's poetry, vibrates between a rich and dense sparseness and a lighter wit, taking into account "the plain sense of things," as Stevens wrote. Both have contributed in major ways to the evolution of a profound American culture, transporting us to a world dignified by creative endeavor. One of the central themes of modern poetry is the role of art in life, with the poet seen as an exemplar of the human capacity to describe or create, and the vitality of the imagination or mind as a generative force.

While Johns may at times follow in the witty, cerebral tradition of Duchamp, his work, and particularly the *Seasons*, presents an allegorical world that, like Stevens's in his poetry, is a meaningful and stimulating dwelling place. In the *Seasons*, as in many of Stevens's poems, art and the creative mind play central roles.

**98**
*The Seasons*, 1989 and 1990
Acrylic on etching on paper
26¼ × 57¼ (66.7 × 145.3)
Private collection

His poetry asks questions about the essential nature of poetic form. Stevens shows his desire for new ways—and at the same time, his reluctance to throw out the old—in the fondly despairing "The Man on the Dump", a poem he wrote during the Depression, related to his experience observing a dump site while walking to work. In it, he extols human desire as well as man's capacity for renewal and change, for seeing the world with fresh eyes. Like the *Seasons*, "The dump is full/Of images." The artist may long for something new to say, but likewise is reluctant to cast off old conventions: "The freshness of night has been fresh a long time/The freshness of morning, the blowing of day," Stevens writes, followed by an idiosyncratically rhythmic list of items one might find at the dump, including "dew, dew dresses, stones and chains of dew, heads/Of the floweriest flowers dewed with the dewiest dew." Finally, at the end of the second verse, he affirms the power of regeneration: "One grows to hate these things except on the dump." In the next stanza, Stevens celebrates spring with a list of native flowers. "One feels the purifying change," he notes. "One rejects/The trash." In the next verse, he applauds the ability to look upon the world with fresh eyes: "That's the moment when the moon creeps up/To the bubbling of bassoons."

When asked to make the frontispiece for a volume of selected poems by Stevens, Johns initially thought of the poem "The Snow Man". Instead, having recently completed the painting *Summer*, he ended up making a version of that for the book's frontispiece rather than choosing the theme of *Winter*, which would follow later in his work on the *Seasons*. When Johns turned to painting *Winter*, he incorporated a simple, childlike snowman into his composition. Stevens's "The Snow Man" offers the varied perspectives of a human being and a snowman to call attention to the significance of creative intelligence, as well as the human propensity to disregard our surroundings as we pursue our own individual agendas. Without imagination, the poem implies, we lose sight of the world around us along with our sense of humanity. Stevens advocates the qualities necessary to look at the world free of bias, beginning the poem:

> One must have a mind of winter
> To regard the frost and the boughs
> Of the pine-trees crusted with snow;
>
> And have been cold a long time
> To behold the junipers shagged with ice,
> The spruces rough in the distant glitter

It is the enigmatic oracular tone of a philosopher, bordering on pedagogy. Stevens would prefer a "mind of winter," and to "have been cold a long time," to suspend thought and judgment and live in the moment rather than the past. The watchful snowman knows that it is not the days that are frozen, but only our perception.

The human being begins the poem as a mere observer—on the sidelines—and ends up as an empathetic contemplative listener:

> For the listener, who listens in the snow,
> And, nothing himself, beholds
> Nothing that is not there and the nothing that is.

In captivatingly difficult language, Stevens addresses America's suspicion of the imagination, in the stoic recognition of unmitigated cold and misery and lack of perspective. He advocates a life of the mind, grounded in experience. While "The Snow Man" articulates a skeptical attitude toward the American acceptance of the creative imagination, it celebrates—in stripped-down symbolic abstraction—the American landscape. For Stevens, external reality is often a consoling factor, as it seems to be in the *Seasons*. Finally, in "The Snow Man" the reader becomes identified with "the listener" who "beholds/ Nothing that is not there and the nothing that is." Paradoxically, considering Stevens's stress on the imagination, feeling has been numbed, the listener resists metaphor and judgment and becomes fully aware. Winter is barren, lonely, empty, "nothing." In the confusion of inner and outer, to see like the snowman, one must recognize and challenge habits and remain open, even if it requires a capacity to suspend explanation. Stevens uses penetrating adjectives ("crusted," "shagged," "rough in the distant glitter") —like Johns's desolate range of rich, tactile gray in *Winter*—to express the snow man's clear-eyed view of nature. He contrasts this with language "of the wind," "of a few leaves," "of the land," that describes the beholder's perception of winter in straightforward human terms. Ultimately, "The Snow Man" and the *Seasons*— with its references to a range of art—point to the human need for creative activity, to a rich inner life and a stunning outer reality worthy of sustained attention.[68]

Nature and seasonal imagery play a large role in Stevens's poetry. The seasons provide a climate, circumstance, or symbol for observing our lives as human beings and a structure of recurrence and redemption.[69] Weather also figures in his poetry, expressing a vitality of place and people. His poems articulate equanimity toward nature rather than the full-blown romantic sublime of Keats or Shelley, or the exalted ethical expositions of Wordsworth. Weather, as in the *Seasons*, is for Stevens a normative backdrop, a comfort of sorts.

"Large Red Man Reading," like many of Stevens's late poems, focuses on the experience of nature, on elemental seasonal transitions and regenerative cycles. And, in much the same way that the expressive character of Johns's paint surface establishes a human connection with the viewer, Stevens's linguistic plays with alliteration and synesthesia and his fresh sense of language become metaphors for his poetry as a whole and establish creative links with his readers. "Not Ideas about the Thing but the Thing Itself" begins at the end of winter with an elemental cry that announces spring and ongoing life. The figurative language Stevens uses, the playful alliterative links joining human to cosmic and part to whole, describe original artistic endeavor. The poem becomes a metaphor for creativity.[70]

Stevens presents a tangle of inner and outer worlds (poet identified with bird, for instance), but also a clarity issuing from the common bonds we forge with nature and the imagination. As such, poetry is as organic as nature, and like it, beyond explanation. Above all, Stevens celebrates the imagination, as Johns does in making art the focus of the *Seasons*. In Johns's and Stevens's work, art and poetry exemplify the joy of expression; poetry and art represent humanity and our ongoing experience of the world. Both artist and poet explore ways to forge human connections. In his series of adages, Stevens wrote "a poem should be part of one's sense of life," just as Johns has said "one wants from painting a sense of life."[71] In their work, each makes us aware that, rather than preach or lecture, art can focus attention and heighten our sensation of the world around us.

Johns's art shares with Stevens's poetry an unusual mix of cerebral abstraction and soulful sentimentality, seen perhaps most acutely in the *Seasons*. This is not to suggest that both men's work is dictated by sentiment, but rather that in it they measure sensation—that is, wonder and the capacity for understanding—against intellect. Perhaps most significantly, the art of both Johns and Stevens takes into account the instability and doubt in our lives. A reading of their work demands an openness to multiple viewpoints, to a range of meaning, to ambiguity, and to shifting perspectives. Artist and poet share a conviction that our understanding of the world depends on our individual perception of it and that the artistic process mirrors this.

◆

The *Seasons* cycle can be seen as a metaphor for Johns's own persistence as an artist over many years, as it refers to the ages of man and the passage of time. The proliferation of images that surfaced in Johns's work in the early 1980s— for instance, in *Racing Thoughts*, a picture that suggests a man in middle age experiencing fleeting memories—quieted to a more reflective tone in the *Seasons*. Johns prefers situations and meanings that are open-ended, and the circular nature of the *Seasons* favors this type of irresolution.[72] The split or layered cluster of figure and objects in the *Seasons* implies the impossibility of a fixed view or conclusion. Johns also repeats imagery from one *Seasons* painting to the next, and borrows from varying periods of his own work; this constant recycling and reworking of images is emblematic of the artist's boundlessly curious nature and suggests an interest in relationships, fragments, parts, and wholes. It draws attention to the human capacity for sustained evolution over the course of life. Johns provides a model for thinking and working, using imagery that is not fixed but in process and constantly subject to reconsideration. The very manner in which Johns explored the four seasons in multiple paintings, drawings, and prints affirms his generatively rich imagination and capacity for inspiration and growth, echoed in the seasons theme itself. The *Seasons* series advocates the active life of the mind and of emotional experience, in all its daily ordinariness and wonder, constantly subject to reinterpretation and change.

If the lyrical narrative of the *Seasons* series sets it apart from much of Johns's work, the emotional resonance of its pictorial structure, while also new, is more characteristic. In this fractured universe is also a haunting nostalgia for the loss of what was once whole. Johns has created in the *Seasons* a redolent compilation of images built from bits of experience. The compressed nature of the *Seasons* series, with its concentrated grouping of imagery askew, in some ways intensifies the sense of loss. There is elegy, joy, and soliloquy in these pictures, a tender and pensive spirit, uncertain and skeptical, yet vital and ultimately deeply affecting.

# GREEN ANGEL AND MIRROR'S EDGE

WE ALL HAVE LIVES AND IDEAS AND RELATIONSHIPS
WITH THINGS, AND THEY SEEM TO ME TO BE
INFINITELY SHADED, NOT PRECISE...WE MAY
OR MAY NOT SEE THE SAME THING, BUT THERE'S
ALWAYS AN AREA OF UNCERTAINTY.[1]

JASPER JOHNS, 2011

During the mid-1980s, some critics dismissed what they saw as Johns's descent into narrative and autobiography in the *Seasons* series with, as one denounced, its "riddle of cryptic personal signs."[2] But by 1990, Johns had started to work in a new vein, conceiving a group of pictures, some of which he titled *Green Angel* (1990; fig. 99), that developed from the stretched rectangular faces he had begun making in 1984. The new works feature an indecipherable central traced image. Many said this horizontal white or cream-colored organic form resembled a buffalo—though in combination with a more colorful vertical form on which it appears to rest, it could just as easily represent a Pietà or other iconic image. These pictures sprang from Johns's continuing fascination with perception, specifically with the question of what effect having prior knowledge of an image has on how it is read.

In addition, Johns extended his dialogue with earlier art, creating a number of distinct groups of works each of which used imagery traced from a picture by Paul Cézanne, Marcel Duchamp and a few others (figs. 100 and 101). These paintings and works on paper hark back to the single-mindedness of the flags and targets of the mid- to late 1950s; each traced work fills the composition and none features in combination with other images. They manifest Johns's sustained reflection on, and in depth study of, imagery that intrigues him by a small group of artists.

In the early 1990s, he also initiated a new type of composition in a painting called *Mirror's Edge* (1992; fig. 102). It is a compilation of images, some familiar from earlier work, others new, such as a swirling, spiral galaxy and a ghost-like stick man based on the figure of Icarus in a Pablo Picasso mural of the 1950s. These summations, which began when Johns combined the four *Seasons* compositions into one large cruciform-shaped intaglio in 1990, seemed to foreshadow the two-floor retrospective exhibition of his work that took place at the Museum of Modern Art in New York in 1996. This chapter will explore the four distinct types of images—a group of tracings after Cézanne, the *Green Angel* series, the *Seasons* anthologies, and *Mirror's Edge*—that represent the range of Johns's work during the early 1990s.

Johns commented that he felt as if he "aged twenty years" when he turned sixty, in 1990. His reference to his rectangular face paintings of this time as suggestive of a "second childhood," however, seems to rebut this.[3] He had maintained his single-minded dedication to his art practice throughout the 1980s while a steady stream

of comprehensive exhibitions highlighted various aspects of his career to date. These included a print retrospective at the Museum of Modern Art in New York in 1986, an exhibition of work of the past fifteen years at the Venice Biennale and the Philadelphia Museum of Art in 1987–88, and a drawing retrospective at the National Gallery of Art in Washington, DC in 1990. Accompanied by a comprehensive catalogue, this last included over one hundred works on paper dating from 1954 to 1989. The show traveled to Switzerland and England before its final stop at the Whitney Museum of American Art in New York in 1991. It coincided with a one-person exhibition at the Leo Castelli Gallery of twelve paintings and eighteen drawings from the previous five years.[4] On view were the pictures of rectangular flattened faces based on Picasso's *Woman in a Straw Hat with Blue Leaves* and the new, indecipherable central image in several works that reviews of that show referred to as "more a mummy than an island" and a "bison in a blanket."[5] Shows of Johns's sculptures were held at the Centre for the Study of Sculpture at the Henry Moore Institute in Leeds, and at the Menil Museum in Houston. These surveys were capped in 1996 by the forty-year retrospective at the Museum of Modern Art in New York, Johns's most in-depth show since a 1977 exhibition at the Whitney Museum of American Art. The Museum of Modern Art show featured more than 225 paintings, works on paper and sculptures. It is hard to say if or how these surveys affected Johns's work at this time, but his continual use of previous imagery in new pictures and themes around memory suggest some reflective connection.

In addition to dividing his time between New York, Stony Point and Saint Martin, Johns traveled abroad more than customary. In an interview in 1988 in Venice, where he was installing his work for the American pavilion at that year's Biennale, he described how "I feel some dislocation when I'm away from my working space, and…I'm anxious to get home and be in a place where I can work."[6] He had already moved on to Basel, Switzerland at the time of the Biennale's official opening, and it was there that he learned he had won, at the age of fifty-eight, the Golden Lion, the Biennale's grand prize. In Basel, he visited an exhibition of drawings by the German Renaissance master Hans Holbein from the collections of the Basel Kunstmuseum and Windsor Castle. The following year, Johns drew on Holbein's *Portrait of a Young Nobleman Holding a Lemur* (c. 1541)—which had featured on the poster for that exhibition—for three new paintings, five drawings and three prints. The colors in these are among the boldest in any of Johns's work, using jewel-like tones, some on a black ground, as in *After Holbein* (1994; fig. 101).

In the fall of 1989, the artist returned to Basel to view an exhibition of Cézanne's bathers, which included two works lent from his own collection. He also traveled to London for the opening of *Dancers on a Plane: John Cage, Merce Cunningham, Jasper Johns* at the Anthony d'Offay Gallery. The next year, he was in Colmar, France, visiting Grünewald's Isenheim altarpiece, with his friends the collectors Robert ("Bob") and Jane Meyerhoff, having been there once before in 1979, with Teeny Duchamp and others. In 1993, he returned to Tokyo for the first time since a brief trip in 1978. He had not spent a significant amount of time in Japan following his service in Sendai in 1952–53 during the Korean War, when he was in a Special Services Unit of the U.S. Army, and a two-month visit in 1964. These experiences—which that included visits to a Surrealist-themed exhibition in Tokyo, as well as Kyoto's temples and gardens and Kabuki theater—cemented his lasting absorption in Japanese culture.[7]

In the large *Green Angel*, a scumbled mint green ground in rough encaustic and sand frames a group of interlocking forms. A creamy marble horizontal shape at center, with various drips animating its skin-like texture, is thickly outlined in black. This makes it appear to rest—albeit shallowly, if not completely flat—on a larger vertical form, painted in organic puzzle-like shapes of blue, orange, yellow, red, and purple. It seems strangely familiar, if unrecognizable. The flattened biomorphic face—olive eyes, nose, lips— derived from Picasso's *Woman in a Straw Hat with Blue Leaves* (1936; fig. 64), first seen in Johns's work in the mid-1980s, reappears here as the ground. Johns explored the *Green Angel* imagery through the mid-1990s and beyond in various combinations and media, the central forms reversed, mirrored, or separated into parts and recombined in different ways.

**99**
*Green Angel*, 1990
Encaustic and sand on canvas
75⅛ × 50¼ (190.5 × 127.5)
Walker Art Center, Minneapolis

**100**

*Untitled*, 1986
Ink on plastic
25⅞ × 18 (65.8 × 45.7) sheet
Whitney Museum of American Art,
New York

**101**

*After Holbein*, 1994
Lithograph in 7 colors, edition of 42
32¼ × 25 (81.9 × 63.5)
Published by Universal Limited
Art Editions

AP ½

In 1994 Johns purchased a large gray nineteenth-century stone house surrounded by 130 acres of fields and woods in rural Litchfield County, Connecticut, about 100 miles from New York City. He lives there in what Calvin Tomkins aptly described as "monastic luxury,"[8] with a carefully chosen group of works by him and other artists that hang in his home and in a large sitting room above his studio.[9] The house is stately yet simple and comfortable, and his studio in a converted coach barn is a stone's throw away. Johns continued to spend a small part of each year in Saint Martin. Whether intentional or not, his move to northwestern Connecticut placed him at a greater distance from the center of the art world in New York than he had been for years. His work as artistic adviser to the Merce Cunningham Company had ended in 1978, when he made the sets and costumes for Cunningham's *Exchange*.[10] He remains on the board of directors of the Foundation for Contemporary Arts, an organization that encourages pioneering work in the arts and provides support to artists at critical junctures and which he established with John Cage and others in 1963. Even though he stays well informed about contemporary culture, his visual language since the early 1980s increasingly suggests he favors a dialogue with Cézanne, Picasso, and Duchamp rather than aligning himself with artists working today.[11]

◆

The use of traced imagery, through the scrutiny of works by a few specific artists, became a dominant focus for Johns during the early to mid-1990s. Why this concentrated attention on traced work? Was it simply another instance of Johns turning to "things the mind already knows"?[12] Johns's first direct transcription of an entire work of art was in 1977 in an ink on plastic drawing aptly entitled *Tracing* (fig. 103) which was taken from Cézanne's *Bathers* (c. 1894–1905; The National Gallery, London). Johns based his work on a postcard of *Bathers* in the exhibition *Cézanne: The Late Work* that he had seen that year at the Museum of Modern Art in New York. Johns had included traced or imprinted elements in pictures since the early 1960s,[13] but *Tracing* was his first specific and complete reference to Cézanne, whose work he did not revisit in detail until over fifteen years later.[14]

In 1994, he drew six works in ink on translucent supports (figs. 105–110) based on another of Cézanne's late works, *The Large Bathers* (1895–1906; fig. 104). Though Johns had seen the painting years before, he was inspired to use it by its inclusion in the exhibition *Great French Paintings from the Barnes Foundation* at the National Gallery of Art, Washington, DC, in 1993. His source was a poster of the painting published to coincide with the exhibition.[15] Like Cézanne, Johns's practice has been to work with and revisit a range of themes in order to explore structure and paint handling and how these formal characteristics contribute to a picture's meaning. Perhaps even more importantly, Johns took up Cézanne's commitment to the study of nature or, more broadly speaking, of the world around us. Cézanne approached nature as a means to record how the eye and mind perceive the world; in Johns's language this involves drawing attention to "things which are seen and not looked at."[16] Both artists explore the process of perception, whether in the concrete depiction of pictorial puzzles or in the sophisticated application of markings suggestive of mutability.

Cézanne's work, and in particular his bathers and other figures, has been influential for Johns since at least 1952, when he first saw an exhibition of the French painter's work at the Metropolitan Museum of Art in New York.[17] A serious collector of Cézanne's art, Johns has placed the pictures he owns in such a way that he can view them often; Cézanne's small painting *Bather with Outstretched Arms* has hung over the fireplace in his living room, with drawings by Cézanne propped on nearby shelves.[18]

As early as the 1960s, Johns had thought of copying Cézanne's *The Bather* (*c*. 1885; Museum of Modern Art, New York), but could not find a way to reproduce it that would satisfy his indexical approach to representation.[19] Roberta Bernstein has speculated that it was at this time that Johns started to develop the large drawing *Diver* (1962–63; fig. 21), conceiving his own abstracted version of a figure rather than tracing or copying one by Cézanne.[20] Johns's later tracings after Cézanne fulfill more closely his purely conceptual dictate to employ traced, measured or copied forms and to show clear evidence of the process of their making in the finished work; at the same time, they affirm his commitment to visual sensation, to the qualities and characteristics of a gestural handworked surface, suggestive of the human presence. For Johns, tracing an artwork sets up a dialogue with his own art: "sometimes contact with works you have sympathy with refreshes your attitude towards your own work."[21]

The six tracings after Cézanne (1994; figs. 105–110) show Johns's affinity for absorbed study through drawing. Each one is unique, its mood emanating from the energy generated by the ink, whether laid down in striations akin to thumbprints or clamshells, loose pooling swirls, patches animated by inky sediment, or delicate splatters applied as if by the flick of a brush. In one (fig. 105), the eight figures have little of the solidity of Cézanne's frieze-like grouping, the diluted ink rendering them immaterial or unstable. Another (fig. 107) shows more exposed paper than ink, with the merest hint of landscape, the eight figures outlined in ink lines of varied thickness. Here, the figures lounge. They appear static, with beady eyes. In other drawings, figure and ground blend together in whorls and swishes of loose ink. The darkest (fig. 108) shows more sculpted, solid figures. This work also has the most variegated tones, a range of light to dark, with a broader application of ink. The ground is dense, active, loose, and the tree at right splayed and wild. It is the most natural and explosive of the six. In another (fig. 109), the tones are even though the wash is loose, with the bathers outlined in a range of linear contours. The figures appear more static, generalized due to the uniform application of ink, lending them a distant, inaccessible aspect. In yet another (fig. 110), the tree at right is light, nearly feathery. The effect of the whole is clear black-and-white with none of the muddiness of some of the other versions. The bathers here are so freely articulated that it is difficult to make out eight of them, with figure and ground blending together into swirls of inky tones.

Using just black ink, Johns achieves rich modulations of darkness and light, managing to describe Cézanne's picture—with its flowing landscape, luminous sky, puffy clouds, and groupings of individualized trees framing the monumental figures—and make six distinctive images of his own in the process. Intense, deep colors featured frequently in Johns's work of the early to mid-1990s; he explored a range of drawing media at this time, from watercolor to pastel, aquarelle crayon, graphite, collage, charcoal, acrylic, and pencil. While not an anomaly,

**103**

*Tracing,* 1977
Ink on plastic
10⅞ × 13 (27.6 × 33) sheet
4⅛ × 5⅞ (10.5 × 14.9) sight
Collection of David Shapiro,
New York.

**104**
Paul Cézanne
*The Large Bathers (Les Grandes baigneuses)*, 1895–1906
Oil on canvas
52⅛ × 86¼ (132.4 × 219.1)
The Barnes Foundation, Philadelphia

**105**
*Tracing after Cézanne*, 1994
Ink on mylar
18¾ × 30⅜ (47.6 × 77.2)
Collection of the artist

**106**
*Tracing after Cézanne*, 1994
Ink on mylar
20⅛ × 28 (51.2 × 71.1)
Collection of the artist

his adherence to black ink in these drawings focuses attention on his study of differentiated form and underscores the breadth of tones Johns fosters using minimal materials. Working on plastic, the ink medium appears particularly challenging to control; it is a manifestation of the unbridled nature of our world. The ink's vitality and unstable character in Johns's tracings after Cézanne seem at odds with the discrete placement of marks with which Cézanne built up his canvases, though both ink on plastic and paint in the hands of these artists have an independence that allows form to dominate. For Johns,

> one of the beautiful things about [ink on mylar] is that it can have a life that seems clearly independent of me. I seem to have almost nothing to do with it, to be an observer. But of course one does learn, and skills do develop, and innocence is compromised.[22]

In the literature on Cézanne's late bathers, several writers relate them to the theme of memory, to experiences of youth, whether of sensual pleasure or erotic coming-of-age, and artistic endeavors such as sketching in the Louvre or outdoors.[23] Curator Mary Louise Krumrine, in her analysis of Cézanne's *The Large Bathers*, suggested that an early version of the striding figure at left was a Cézanne self-portrait and that these three major late paintings concern "the sexual identity of the artist, of both the female and male characteristics of his nature."[24] Johns, in making his tracings after Cézanne, turned the female figure—which he came to see as a "dreaming" bather "fantasizing" the others[25]— leaning against the tree at right, into an aroused male bather. One way to look at the newly male figure, who is clearly detached from the group of female bathers and involved in some type of reverie, is as a portrayal of the artist. To Johns scholar Roberta Bernstein, it was the erotic nature and issues of sexuality, life, and death that came up in the *Tantric Detail* works of 1980–81 (see fig. 41) that prompted Johns's absorption with Cézanne's bathers.[26]

The majority of the identifiable tracings Johns has used in his work involve the human figure, but none more straightforwardly than those after Cézanne's

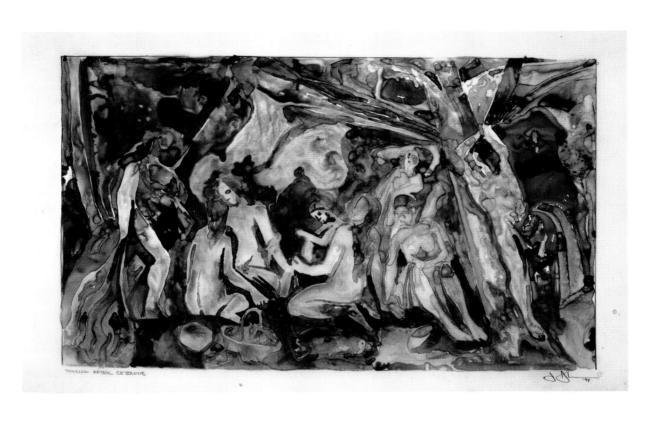

TRACING AFTER CEZANNE

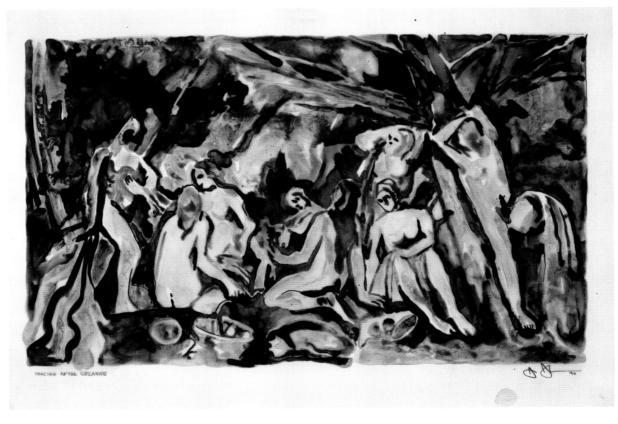

TRACING AFTER CEZANNE

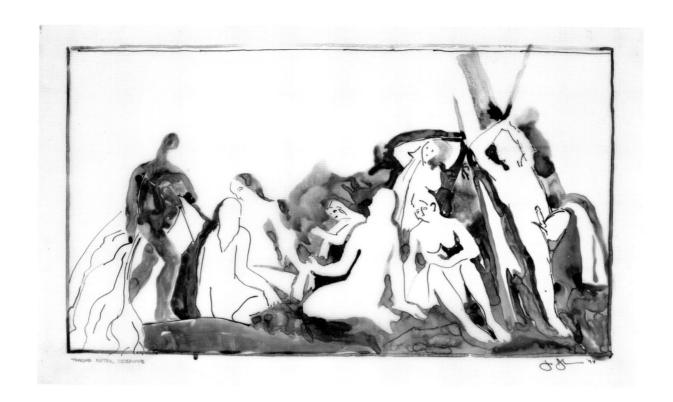

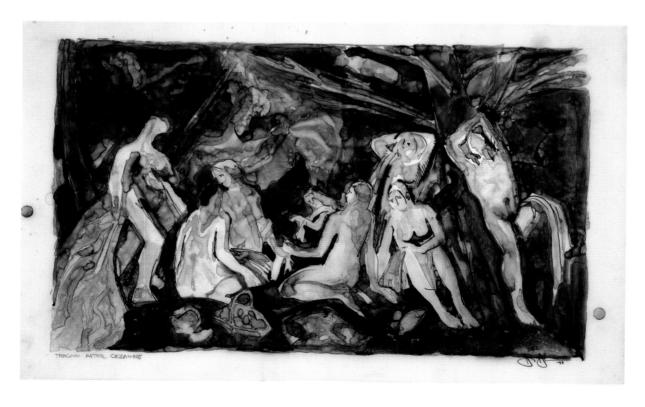

107 TOP
*Tracing after Cézanne*, 1994
Ink on mylar
17½ × 28¼ (44.6 × 71.6)
Collection of the artist

108 ABOVE
*Tracing after Cézanne*, 1994
Ink on mylar
18⅛ × 29½ (46 × 74.8)
Collection of the artist

109 OPPOSITE, ABOVE
*Tracing after Cézanne*, 1994
Ink on mylar
18 × 28⅛ (45.7 × 71.4)
Collection of the artist

110 OPPOSITE, BELOW
*Tracing after Cézanne*, 1994
Ink on mylar
18⅛ × 28⅜ (46 × 72.1)
Collection of the artist

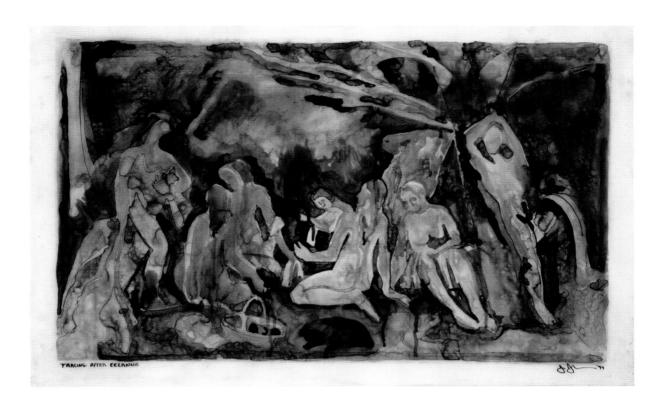

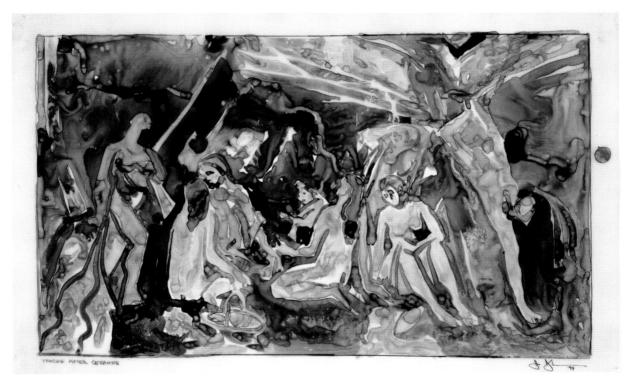

bathers. They are universal types, some with simplified facial features, their affecting nature deriving more from formal means than from the specific character of the figures themselves. They often manifest a poignant sense of anxiety and melancholy. Johns's figurative focus in the mid-1990s, in these inky drawings where the expressive character of the medium prevails over any sense of flesh and bone, echoes contemporary concerns surrounding the body at the time of the AIDS crisis in the United States. The poignant attention to figurative imagery in the early 1990s by such varied artists as Kiki Smith and Robert Gober reflects the significance of the body in art at this time. As Smith noted in a 1991 interview: "I think AIDS has had a lot to do with people's consciousness of the body as a political and social weapon or landscape. It has really pushed the body forward in people's minds in a way that it became more than something they were simply stuck in, freaked out about, or having pleasure with. We've become aware of the body as a social organism."[27] While Johns has recognized that viewers may see a reference to the AIDS virus and the fragility of human life in his use at this time of the traced figure of the diseased demon from the Isenheim altarpiece, with its numerous skin lesions, he has said he did not have that idea in mind when he began tracing it.[28]

The six tracings after Cézanne, with their variations and elaborately worked surfaces, reflect Johns's affinity for the painterly discourse of early modernism practiced by Cézanne. Whether his focus was more on figuration or on the private opportunity drawing affords to study is hard to say. The serial nature of the six—with the chance to compare the transformations in, and links between, the drawings—enhances absorption. While Johns chose a figurative work to trace, his variations on it suggest he was just as interested in exploring the ink on mylar medium as he was in Cézanne's original image. His stress on the character of the medium and surface indicates a modernist concern for tactile form. In the details from the Isenheim altarpiece that Johns incorporated into his work, he claimed,

> there was some aspect that seemed to be 'underneath' the meaning—
> you could call it composition—and I wanted to trace this, and get rid of
> the subject matter, and find out what it was.[29]

While there is some possible iconographic significance to Johns's altering the sexuality of one figure, these six fluid works relate more to the act and effects of mark making than to figurative representation.

◆

Five years before he made the six tracings after Cézanne, in the so-called *Green Angel* pictures of 1990 and 1991, Johns employed a traced image in such a way as not to reveal its source. He has said he was not being purposely obtuse;

> the idea was not to create a mystery about the derivation of an image but
> to free the image from that other thing. I was trying to find out something
> about how our minds and eyes work, and what creates a new or original
> image.[30]

This led to an interesting dichotomy between artist and viewer, for he, unlike the observer, could not look at this image with an unknowing eye. According to Johns, he

got tired of people talking about things that I didn't think they could see in my work—from some of the Grünewald tracings. It interested me that people would discuss something that I didn't believe they could see until after they were told to see it. And then I thought, what would they have seen if they hadn't been told about these things, because the same painting is there. And when I decided to work with this new configuration, I decided I wasn't going to say what it was or where it had come from. One of the things that interested me was that I knew that I couldn't see it without seeing it, seeing *that,* because I knew, and I knew that someone else wouldn't know and wouldn't see, and I wondered what the difference was in the way we would see it. And, of course, I'll never know...

Johns elaborated:

what interested me was that you can come to see something through language that you couldn't have come to see through looking. That and the extent to which knowing things influences seeing. That has always interested me and continues to.[31]

In the large *Green Angel* (1990; fig. 99) the forms are strangely familiar yet unrecognizable. In addition, viewers accustomed to the more limited palette of Johns's earlier works, which had gradually extended and intensified throughout the 1970s and 1980s, found the extraordinary range of green tones, mixed with brassy golds and rusts, odd and unsettling. So, too, was the perplexing imagery, forlorn eyes, and the title that had no discernible context. Johns had become famously irked that viewers seemed disproportionately focused on an academic decoding of his traced imagery. He did not want the expressive thrust of his paintings to be determined by our itch to grasp and puzzle out the sources of the tracings. Beginning in the mid-1980s, responding to the embedded images in Johns's work, many critics had concentrated their full attention on identifying these derivations at the expense of viewing the works as independent, unified compositions. Jill Johnston and other critics focused on the labeling of the Grünewald tracings in a manner that suggested iconographic code-breaking.[32] Even though visitors to the first exhibition of such work at the Leo Castelli Gallery in 1987 were made aware of the subject and source of the tracings,[33] to Johnston, they remained esoteric. Johns "got annoyed that pictures were being discussed in terms of imagery that could not be perceived—though once something is said to be something, then everyone accepts it."[34] Johns himself had affirmed his belief that meaning accrues through the creative process itself and is modified over time when he told David Sylvester in 1965 that

whatever idea one has it's always susceptible to doubt, and to the possibility that something else has been or might be introduced into that arrangement which would alter it. What I think this means is that, say in a painting, the processes involved in the painting are of greater certainty and of, I believe, greater meaning, than the referential aspects of the painting. I think the processes involved in the painting in themselves mean as much or more than any reference value that the painting has.[35]

In 1994, author Barbaralee Diamonstein-Spielvogel and Johns had the following exchange about the *Green Angel* imagery:

> BLDS: What was the image meant to be?
> JJ: Meant to be? It's meant to be exactly what it is. It was only withheld out of annoyance with all of the gobbledygook that was being suggested about imagery.
> BLDS: And what, therefore, is it?
> JJ: It's what you see. Do you mean what's it based on? I'm not going to tell you. And I haven't told anyone—except the person who gave me the image, who didn't recognize what it was, either.

Finally, after further questions, Johns observed:

> of course it's interesting that one thing leads us to think of something else and that having a bit of information, or a name, may stop our curiosity about what we are looking at.[36]

Johns's approach to exploring issues of perception with an unknowable image seems at odds with his easily recognizable early flags, numbers, and targets and his fondness for pre-existing images. Yet the flags, numbers, and alphabet pictures also erase any sense of context; their original meaning is no longer given, and we are left unsure and contemplative regarding their significance. The *Green Angel* image can thus be said to extend Johns's curiosity regarding the nature of perception, of our willingness, or unwillingness, to acknowledge the ambiguous, enigmatic essence of these mysterious forms without seeking specific narrative explication.

◆

In addition to the *Green Angel* works of this period, in 1990 Johns turned again to the theme of the four seasons that had preoccupied him during the mid-1980s. As he told Michael Crichton, "I would like to be rid of it, but I continue to think of things to do. Often it seems to me I have worked with it for too long, but something keeps popping up."[37] In 1990, Johns transformed the four *Seasons* paintings into a large compendium print (fig. 113). Already in 1989, in addition to the many prints that feature each of the *Seasons* in various iterations, he had made two compilations, one intaglio in rich black and gray tones depicting the four side by side starting with summer (fig. 111), the other in more muted black and white, vertical in format, with summer at the upper left and the other seasons following clockwise in seasonal order (fig. 112). After the artist completed these, the plates were cut into irregular pieces and reformed into a cross shape.

The resulting 1990 intaglio is more complicated visually than the earlier *Seasons* prints, yet also straightforward in its black-and-white clarity. The collection of objects in the *Seasons* can be seen as a metaphor for the aggregate of stuff—art and other objects—that perpetually accumulates over the course of life, as man takes in more of his past. In this cruciform print Johns distilled the imagery to its essence, subtracting and turning it upside down, creating an intrinsic inflection that corresponds to the notions of change, growth, and decay apparent in the *Seasons* paintings. Johns placed the young boy from the painting *Spring* just above

**111**
*The Seasons*, 1989
Intaglio, edition of 54
26¾ × 58¼ (67.9 × 148)
Published by Universal Limited
Art Editions

**112**
*The Seasons*, 1989
Intaglio, edition of 59
46¾ × 32½ (118.7 × 82.6)
Published by Universal Limited
Art Editions

**113**
*The Seasons*, 1990
Intaglio in 1 color, edition of 50
50¼ × 44½ (127.6 × 113)
Published by Universal Limited
Art Editions

Pablo Picasso
*The Fall of Icarus*, 1958
Mural
358 × 417 (910 × 360)
UNESCO Headquarters, Paris

the center, with imagery from *Summer*, *Fall*, and *Winter* following clockwise in each of the four arms of the cross. Fragments of the ladder that appears in each of the paintings feature in each arm of the cross, lending a skeletal structure to the composition. In simplifying the imagery in this new configuration, Johns set aside much of what had filled the paintings.

He also added a few new elements, quoting from Picasso's *Fall of Icarus*, a mural commissioned by UNESCO for its Paris offices (1958; fig. 114).[38] In the 1990 print, Johns's version of Picasso's charred Icarus bisects fall and winter. The large rag-doll-like stick figure is inverted so that it faces up instead of plummeting headfirst to earth, forming a spidery overlay on the artist's shadow that had appeared in the *Seasons* paintings. Johns was intrigued with Picasso's ability to make a stick figure so expressive and this spectral Icarus figure turns up in his work on and off during the following years.[39] At the lower edge of the large *Seasons* print, he included three smaller elementary stick figures that he had earlier depicted in the margin of the drawing *Perilous Night* (1982; fig. 46). Some scholars have interpreted them as artists at work, since they hold brush-like implements.[40] They resemble the schematic figures on charts that represent semaphore signals.[41] Compositionally, the small, elongated figures inject a disorienting shift in scale. Sculptor John Newman described them as "mountain climbers in [Johns's] invented territory."[42] To the left of the cross's lower arm, Johns introduced the suggestive spraygun blob that has figured significantly in his past work, perhaps most notably near Duchamp's profile on the small canvas hinged to the lower left of *According to What* (1964; fig. 22). While associated with the ejaculatory splatters in Duchamp's *Large Glass*, it can also stand for the type of expressionist mark making dictated by the effects of chance.[43]

Johns added a wide X to the left of the stick figures, perhaps signaling the end of his use of these plates. It is customary to mark finished plates or stones with an X to cancel them and ensure that no further printing takes place once an edition

is complete. According to his printer, John Lund, when Johns cut up the plates to create this new configuration, "it was Jasper's intention to alter the plates so decisively that we would effectively cancel them."[44] An X featured in Johns's work as early as 1971 in the lithograph *Hinged Canvas* from *Fragments—According to What*, and two years later in the margin of *Untitled (Skull)* and in several more works of the mid-1970s (see fig. 117). Apart from the act of cancellation, Johns scholars have suggested several ways of considering the X. It is variously used to mark an incorrect answer, indicate a location on a map, or to show a place to sign one's name.[45]

The fan-like form of the *Seasons* intaglio reinforces the circular nature of evolution implicit in the theme. The cruciform shape freed Johns from the linear structure of the seasons' natural rhythm, allowing for a cyclical approach with no beginning or end. The print stresses the relational character of the four images, in a spare schematic style. Johns cloaked the imagery in an airy, luxurious expanse of open space on the page, heightening the work's ethereal character. Its spare style signals a change in his work and anticipates the pared-down compositions that would come with the gray *Catenary* pictures later in the 1990s.

◆

During this period, Johns further explored overlapping accumulations of images in a second group of works, called *Mirror's Edge*. Since *In the Studio* of 1982 (fig. 44), with the parallelogram canvas at its lower edge, along with the yardstick jutting out into the viewer's space, fictive nails, and the cast arm attached to the canvas, Johns had dedicated himself to examining issues of two-dimensional representation and perspective, while developing a complex core of images. The works of the fifteen years that followed, from *Racing Thoughts* through the *Seasons* and beyond, signaled Johns's exploration of this more traditional type of pictorial space with an increasingly dense layering of images, after ten years committed largely to abstraction in the crosshatch works of the 1970s. The inclusion of perceptual tricks, tracings, and a mix of familial imagery, with more expansive references to art history and the natural world in layered compositions, reached its peak in the early to mid-1990s, with the *Mirror's Edge* series and several other untitled pictures. The prevailing view among Johns scholars is that these are transitional works that mark a stylistic or formal break in the artist's practice and represent a summation at the time that Johns had his major retrospective at the Museum of Modern Art, New York, in 1996. [46]

Visually, these works appear as among the most baroque in Johns's oeuvre. Many of the canvases are remarkably large with complex and bold forms, presenting several layers of overlapping images. There are references to the artist's childhood home and to his previous work, as well as to art history and the cosmos. In *Mirror's Edge* (1992; fig. 102), Johns questions the nature of representation, renewing the format of the studio wall with its pinboard group of images first seen in his work of the early 1980s, its painted illusion now significantly more complex. Collectively the *Mirror's Edge* works continue his exploration of the expressive and perceptual character of space, while presenting a range of familiar and new imagery. Johns made two *Mirror's Edge* paintings in the early 1990s—an oil version in 1992 (fig. 102) and one in encaustic in 1993 (fig. 115)—as well as several related drawings and a print.

The imagery in *Mirror's Edge 2*, a rough encaustic of raw, expressive energy, is similar to that in the earlier oil *Mirror's Edge* (1992; fig. 102), though Johns has reoriented some of it. The cross-shaped intaglio of the *Seasons* has spun 130 degrees to the right and the wood strip runs along the right side of the canvas. The large stick figure at left drifts earthward as it did in Picasso's *Fall of Icarus*, and the spiral galaxy appears more distilled and atmospheric. The page with the curling corners depicts Grünewald's diseased demon from the Temptation of St. Anthony panel (see fig. 50) instead of the awed soldiers. The soldiers appear in a gray-blue tracing as part of the ground, largely obscured by the floor plan of Johns's grandfather's home and the rest of the imagery. This tracing stops short of the canvas's upper edge, and this, combined with the angled tip of the wooden stick, lends a slight sense of depth, which the black line that defines the edge of the faux-bois stick contradicts. Johns signed the work with two trompe-l'oeil "J" stencils representing his initials and the date, "93," the "3" overlapping the black line at the edge of the wood strip, further confounding the spatial paradoxes.

**115**
*Mirror's Edge 2*, 1993
Encaustic on canvas
66 × 44⅛ (167.6 × 112.1)
Collection of Robert and
Jane Meyerhoff

The earlier oil version has bold contrasts and distinct contours. The ground is a blueprint of the floor plan of Johns's grandfather's South Carolina home, where the artist lived for several years as a child (fig. 116). Johns drew it from memory.[47] The house plan is largely obscured by painted images overlapping in the form of a trompe-l'oeil collage. Superimposed on the ground at upper right is a simplified fragment in reverse of the 1990 *Seasons* intaglio, rotated 45 degrees to the left, its cruciform shape cut off at the top and right sides by the canvas edge, and at left by a faux-bois painted wooden strip. Most of the *Seasons* imagery has been dissolved, leaving a vaporous gray-blue passage of paint and the figure of the boy at center with the finely drawn geometric blocks layered over him, the ladder, the Icarus figure, the three stick figures, and a suggestion of the artist's shadow.

A boldly colored, traced detail of the soldiers guarding Christ's tomb from the *Resurrection* panel of the Isenheim altarpiece, rotated to the right and reversed, is taped at the painting's center, its corners illusionistically curling. On the lower right edge of the Grünewald detail is the Silver Jubilee vase on the wicker hamper familiar from the painting *Racing Thoughts* (1983; fig. 52) and other pictures. Two black-and-white drawings by Barnett Newman in Johns's collection feature at the upper edge of the Grünewald tracing, reversed, the left one also flipped vertically.[48] The drawings, part of a large group associated with Newman's series of fourteen paintings called *The Stations of the* Cross (1958–66), teamed with the Grünewald tracing, offer contrasting visual expressions of spiritual experience. Taped to the bottom edge of the Grünewald tracing is an image based on a photograph of a spiral galaxy. Johns described how the stars in the *Seasons* paintings morphed into small spirals as he worked on the *Seasons* intaglio prints, which led to this more pronounced astral allusion.[49] The spiral galaxy expands—in a more ethereal organic manner—on Johns's interest in celestial imagery, beginning with the stars he depicted in his flags at the very start of his career. The picture is signed at the bottom in gray in Johns's characteristic stencil, the letters of the title

alternating with his name and the date in reverse. The imagery in *Mirror's Edge 2* (1993; fig. 115), a rough encaustic of raw, expressive energy, is similar to that in the earlier oil, though Johns has reoriented some of it.

Johns's highlighting of issues of space in the *Mirror's Edge* pictures both iconographically—from the grounded floor plan to the cosmic spiral galaxy— and formally—in the layering of forms and play with illusion—ties them to other work with similar concerns dating back to the early 1960s. These works, perhaps more than any, evoke Johns's long interest in the nineteenth-century American trompe-l'oeil tradition.[50] In layering inherently flat imagery in a trompe-l'oeil manner, Johns sustains his exploration of non-illusionistic ways to navigate between the three-dimensional world and a flat canvas. This took early form in the painting *Liar* of 1961 (fig. 94) where the inferred stamped mirroring of the title both acknowledges the process of its making and proposes a space beyond the canvas. The split title of the 1961–62 *Fool's House* (fig. 12) is another example, as are the many scraped half circles and diptych formats throughout Johns's pictures since the 1960s that imply cylindricality and mirroring.

Johns's attention to non-illusionistic means of representing space in his art and the potential in it for related metaphorical meanings regarding human nature and the inevitability of change continued in the 1970s, for instance, in *Corpse and Mirror* (1974; fig. 117).[51] According to Michael Crichton, Johns, with the Surrealist game of folded paper called "Exquisite Corpse" in mind and its resulting chance images, painted the hatched groups on the left side of *Corpse and Mirror* somewhat randomly.[52] The right side, a mirrored variation, has been altered to a dense, rimy state of evanescence. This could describe the variations from *Mirror's Edge* to *Mirror's Edge 2*, the crisp contours breaking down to forms suggestive of decay in the later work.

Several Johns scholars have seen in the mirroring and variations a tie to his consistent activity as a printmaker.[53] The artist has acknowledged this link, remarking:

> I suppose painting and printmaking contribute to each other in largely
> unnoticed ways. That the print is the reverse of the image drawn
> on the stone must impress even novice printmakers. In the shop, one
> is always conscious of these mirror images, and this awareness
> has influenced my paintings in which images are sometimes mirrored
> or deliberately reversed. The procedures of painting and printing
> are different, part of the life of any painting being in the weight
> of the paint, its unique thickness or thinness.[54]

As well as this process of mirroring, Johns's title for this group of works points in a concrete way to the trompe-l'oeil wooden strip at the edge of each canvas. According to the artist, it represents a section of a mirror's frame, reinforcing the falsehood of the picture's complicated illusion.[54] Such devices have featured often in Johns's work, though not necessarily in relation to a mirror. The frame of a mirror also marks the edge of reality. With their many references to illusion and spatial constructs, the *Mirror's Edge* works present the suggestion of an experience extending beyond the dimensions of time and space. As with his earliest flags and measuring devices, in presenting a range of elements from

**117**
*Corpse and Mirror*, 1974
Oil, encaustic, and collage
on canvas (2 panels)
50 × 68⅛ (127 × 173)
Private collection

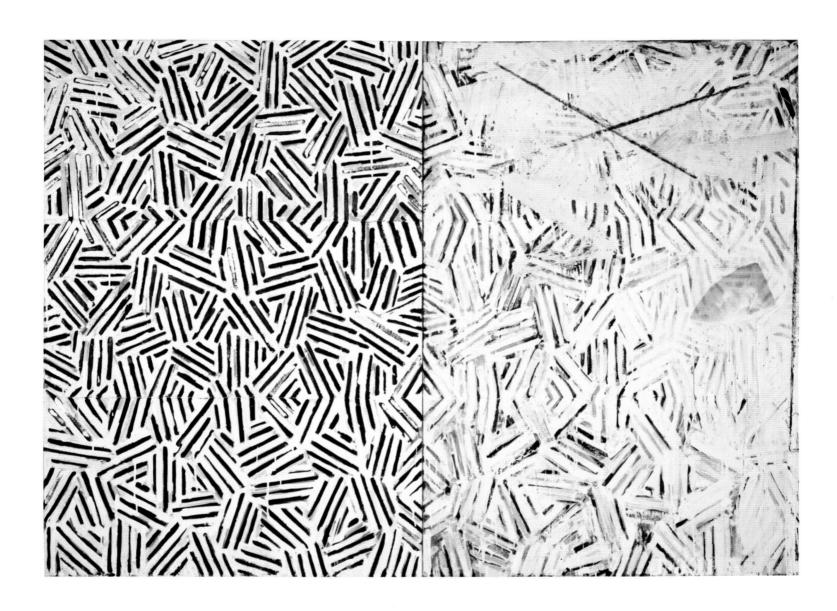

the quotidian to the cosmic, Johns questions how things are measured and time marked; he makes what is habitual or familiar seem somehow uncertain.

◆

While the visible references to art history in Johns's work at this time reflect his absorption with the visual and conceptual language of a small group of artists, including Grünewald, Holbein, Picasso, Cézanne, and Barnett Newman, these pictures also show him reconsidering his own earlier imagery and incorporating it into increasingly complex compositions. Johns's working method, emphasizing exploration and renewal, plays an active role in generating meaning in his pictures. His process of adapting imagery, techniques, or structure from one work to another—or picking up something he had developed years before—shows how he engages past and present, visually linking one work or idea to another. His reuse of imagery can be seen as a metaphor for the fragmentary, organic nature of life.

The artist also included in these pictures specific references to his own past: the blueprint of his grandfather's home, where he himself had lived as a child; beginning in 1993, an old family photograph; and later, a piece of a Chinese costume he wore one Halloween as a small boy, among others. While memory as a theme seems present in much of his practice, in the 1980s and 1990s these references proliferate in works whose character seems overtly self-reflective. Johns's tone in these works is poetic in nature. In form and theme, their expansive compositions offer wide-ranging associations. The approach—a comprehensive view in which art, creativity and a spiritual element play central roles—evokes that of Wallace Stevens in his late poems, especially "The Auroras of Autumn" where, in his seventies, the poet establishes change as a key element in the world. The poem starts with three myths presented in sequence, one replacing the next in a form akin to Johns's visual layering. Stevens initially identifies the imagination as the creator or agent of myth. He moves from describing a cosmic serpent overseeing the heavens, to it transforming into a terrestrial serpent, and then becoming a local one. Finally, with a simple, "Farewell to an idea…," he sheds the serpent-myth metaphor, turning to seasonal shifts, in which summer gives way to the auroras of autumn:

> With its frigid brilliances, its blue-red sweeps
> And gusts of great enkindlings, its polar green,
> The color of ice and fire and solitude.

The long poem proceeds in this fashion, ideas regarding grand myths shifting to seasonal imagery and back again. Often, the poem keeps its momentum with a gentle, reassuring image yielding to some threat:

> Still-starred. It is the mother they possess,
> Who gives transparence to their present peace.
> She makes that gentler that can gentle be.

> And yet she too is dissolved, she is destroyed.
> She gives transparence. But she has grown old.
> The necklace is a carving not a kiss.

The soft hands are a motion not a touch.
The house will crumble and the books will burn.
They are at ease in a shelter of the mind.

Stevens's poem affirms human creativity and the power of myth, while contemplating the possibility of some greater cosmic imagination that generates seasonal recurrence, the Aurora Borealis, and the rest of creation. The poem jumps from universal references to more human ones, presenting a comprehensive view of the world, where art—in the form of the imagination, the creative mind—plays a central role. There is no climax. Instead, he expresses contrary ideas, from abstract to concrete, fragment to whole, universal to local, white to color, reassurance to threat, summer to winter, and youth to old age and death. The heavens, however, are ubiquitous, and the seasons provide a structure for recurrence and recovery. He uses simple if sometimes bewildering language to describe the most complex aspects of human life.[56]

Johns and Stevens share a style rooted in abstraction, but full of affecting imagery. They present myriad perspectives, a range of voices that overlap to provide a stir of sensation and cerebral challenge. Neither artist nor poet seems to have, or even to seek, answers, but their work is grounded in questioning the relationship between our individual perceptions and the world we live in, the correlation of mind and reality that is uniquely human. An investigation of their art form's own rules is an integral part of their visual and verbal language, with experimentation as a guiding principle.

Starting in 1992, then in his fifth decade as an artist, Johns elaborated on the *Mirror's Edge* works, expanding still further the layered compositional format and play with illusion in two very large untitled paintings (figs. 118 and 119). Made over a number of years, these paintings are compendiums that integrate allusions to art and personal history. The amplified trompe-l'oeil images float in a dreamlike fashion, while incongruously appearing completely grounded. The imagery and style of these sweeping ruminations generate a range of ideas regarding shifting perceptions, connections to place, and the function of memory. Johns may have had in mind Grünewald's Isenheim altarpiece as he considered the scale and overlapping forms of these major works, as well as their cinematic breadth. Johns noted of the altarpiece: "It's very impressive, very big, it seems to explode through the space. It has a quality that is very glamorous, sort of like a movie."[57] In their synthesis of his visual vocabulary, the imagery and ideas in these two major paintings provide a retrospective amalgam of Johns's work of the previous forty years. Symphonic in scope, the two untitled pictures bear comparison to a few other extremely large works that Johns has made during the course of his career. These, including *According to What* of 1964 and *Untitled* of 1972 (figs. 22 and 29), both 16 feet wide, can be characterized as congregations of the artist's visual and conceptual ideas at a given moment, summations of past images and ideas that lead on to new ones. Discussing what she sees as both the expansive and circular nature of these composite works, the art historian Barbara Rose concluded that "Johns is not interested in closure: he clearly wants his engagement with the spectator to continue, and so he connects work in an open-ended chain of repeating, inverting and recycling images that reemerge from consciousness and refuse to be forgotten."[58]

118
*Untitled*, 1992–94
Encaustic on canvas
78 × 118⅜ (198.1 × 300.7)
The Broad, Los Angeles

119
*Untitled*, 1992–95
Oil on canvas
78 × 118 (198 × 299.7)
The Museum of Modern Art, New York

**120**
*Untitled (Red, Yellow, Blue)*, 1984
Encaustic and charcoal on canvas
(3 panels)
55¼ × 118½ (140.3 × 301) overall
55¼ × 39½ (140.3 × 100.3) each panel
The Museum of Fine Arts, Houston

Johns conceived the 1992–95 untitled oil painting (fig. 119) to replace a 1984 picture that had hung in his Saint Martin home for ten years.[59] He integrated a reversed version of the imagery of the earlier painting, the three-panel encaustic *Untitled (Red, Yellow, Blue)* (fig. 120), into the new work, in which layers of trompe-l'oeil images appear to emerge from it. A spatially complex architectural engraving by Piranesi figured as a model for the illusionistic folded and rolled paper edges of the pictures-within-a-picture. Johns told Mark Rosenthal in 1993 that "at first glance the Piranesi seemed to represent architectural studies. Later, I saw another level of representation, suggesting that the studies were on several unrolled sheets or pages. This complication, this other degree of 'reality' or 'unreality,' interested me."[60] In Johns's sometimes punning way, the layering and confounding spatial ambiguities can prompt questions about what it means to have perspective. In these two large works, Johns retreated from the idiosyncratic palette of intense colors he explored in the mid-1980s and early 1990s in the paintings with the Picassoid faces and the works after the Holbein portrait, as well as in the *Green Angel* pictures. In the two large untitled paintings, a more sober blue-gray palette is animated with green circles on a freely applied light purple ground, as well as earth tones, ranging from rust and brighter red to dark yellow.

On the left side of the untitled oil, Johns included the floor plan of his grandfather's home. It appears illusionistically taped to the ground, its ends folded up as in Piranesi's study. At the lower right is the 1990 *Seasons* cross-shaped intaglio, including Picasso's Icarus, the three stick figures, and the wide X. Propped at the middle of the bottom edge is a cropped canvas that appears to be resting against the circular patterned ground of the 1984 untitled work. The smaller image shows the upper part of the *Green Angel* form combined with a rectangular face from Johns's works of the mid-1980s, the paint laid on as if through a grid-like screen. Projected over and under this amalgam of images is a linear tracing of two soldiers in awe at the sight of Christ from the *Resurrection* panel of the Isenheim altarpiece. This, combined with the large cross, offers a spiritual aspect rendered with characteristic ambiguity, though the visceral experience is undeniable. The sense of suffering, wonder, and fear carried in the Isenheim tracing seems unavoidable, in spite of its abstract character. This experience is heightened in the untitled painting's large size and strange, spatial beauty. It can trigger in the viewer a disconcerting sense of diminution in relation to the imagery's expansive scale.

Like most summations, these two untitled works of the mid-1990s refer to the act of reflection, looking back to Johns's past work and experiences and, by extension, to our own histories and memories, at the same time that they anticipate the pictures he turned to next. Johns reminds viewers of the subjectivity of perception, even while exploring universal themes. The images he brings together are meaningful to him in some mysterious way; his paintings impel us to conjure up recollections and images that are significant for us. In stimulating the life of the mind, these soaring inner views capture the germination of curiosity, creativity, and understanding that develops over time and space.

# CATENARIES

I FIND ALL USE OF SPACE EMOTIONALLY AFFECTIVE...
BUT THERE'S NO INTENTION ON MY PART TO ACHIEVE
THAT—THEN YOU LEAD PEOPLE ON. THERE'S A
LEONARDO DRAWING THAT SHOWS THE END OF THE
WORLD, AND THERE'S THIS LITTLE FIGURE STANDING
THERE, AND I ASSUME ITS LEONARDO. FOR ME,
IT'S AN INCREDIBLY MOVING PIECE OF WORK—BUT
YOU CAN'T SAY THAT, IN ANY WAY, WAS AN INTEREST
OF LEONARDO'S.[1]

JASPER JOHNS, 1977

I n 1992 Johns completed a large work on paper (fig. 121) using the same plan images of both floors of his childhood home that figured in the two untitled paintings considered at the end of Chapter Five (1992–95; figs. 118 and 119), though now they were more freely arranged on the page than in the earlier trompe-l'oeil blueprint format. This graphite drawing heralded a direction Johns's art would later take after his retrospective at the Museum of Modern Art, New York, in 1996, in a large group of so-called *Catenary* paintings and works on paper. The drawing, entitled *Nothing at All Richard Dadd*, is built from a dense layering of lines and biomorphic shapes that form representational images and abstract passages. It is freely worked, with long vertical strokes and thick nests of markings, manifesting Johns's extraordinary versatility with paper and pencil. The drawing's active surface—sketch-like yet clearly finished, organic without overstimulating—animates the composition. Its form and iconography mark an unassuming human presence, demonstrated by the artist's touch and indicated by the domestic floor plans and the young boy from Johns's painting *Spring*, carefully framed at the central hole of a spiral nebula like Icarus flying too close to the sun. Johns had included this swirling form in the 1992 version of *Mirror's Edge* (fig. 102) discussed in Chapter Five, and from 1993 onwards it appeared in several paintings and works on paper. The galaxy's arms are modeled by a concentration of curving lines, and a massing of lighter plasmic blobs of varied sizes and shapes, to suggest stars hurtling out of a light center. Small bursts of celestial light within each of the floor plans are manifestations of some animating force contained within.

The bottom part of the spiral galaxy is somewhat obscured by a group of layered images: the blueprint depicting the lower story of the home Johns grew up in and a cut up and reconfigured version of Johns's 1990 cruciform-shaped *The Seasons* intaglio print (fig. 113). The ladder, snowman and Icarus figure, with its attenuated body and star-shaped hand—all fragmented—reinforce the sense of human presence. This imagery, along with the windmill-like cross suggesting

**121**
*Nothing at All Richard Dadd*, 1992
Graphite on paper
41¼ × 27½ (104.8 × 69.9)
The Museum of Modern Art,
New York

the cyclical nature of life and evolution, revisits the themes Johns had explored in the *Seasons* paintings of the mid-1980s. From the blueprint to the spiral galaxy, and the suggestions of Greek mythology to the biblical overtones of the cruciform shape, *Nothing at All Richard Dadd* draws on anecdotal sources as well as aspects of the cosmos, classical and sacred traditions, and poetry. In incorporating this referential range, Johns exploits the vital and expressive character of drawing to convey at once fragility and dynamism, infinite space and the circumscribed confines of childhood experience. The richly modulated gray lines suggest atmospheric sheets of rain as much as enveloping shelter; in places, the graphite appears rubbed by hand, further expanding the subtle differentiation in values, the raised dots of the paper also adding to the variations in surface.

Johns stenciled the curious title, *Nothing at All Richard Dadd*, across the drawing's upper edge, echoing the letters four times. Richard Dadd, a nineteenth-century British artist, began his career as a portraitist, history painter, and book illustrator before turning to strikingly detailed fairy paintings in the early 1840s. He traveled to the Middle East in 1842, hired as an artist to make documentary sketches for a tourist expedition. Returning from this trip, he demonstrated increasingly psychotic behavior, and, claiming he was carrying out orders from the "great god Osiris," stabbed his father to death in 1843.[2] Dadd was deemed insane and, after trial, committed to two of England's most infamous lunatic asylums, first Bethlem and later Broadmoor, where he remained, continuing to paint and draw, until his death in 1886.[3] Dadd's miniature paintings teem with imaginary figures and Shakespearean allusions. With its fantastical subjects, deviations in scale and compulsive detail, his work was an anomaly in its time. His allover style—the grasses veiling the scene and the various rounded forms that enliven the surface

**122**
Richard Dadd
*The Fairy Feller's Master-Stroke,*
1855–64
Oil on canvas
21¼ × 15¼ (54 × 39.4)
Tate, London

of his best-known work, *The Fairy Feller's Master-Stroke* (1855–64; fig. 122), from nuts and fruits to details of clothing—permits only a limited suggestion of depth, echoed by Johns's dense web of lines in *Nothing at All Richard Dadd*.

Johns's title may derive from part of a long poem Dadd wrote about *The Fairy Feller's Master Stroke*. In it, Dadd describes the imagery in complex punning language full of double meanings and then rejects his own interpretive authority regarding his work.[4] The poem ends with the following verse, inviting the viewer's opinion of his picture:

> And needs not now that I instill
> Into your mind, what here I've said from fancy's wing
> A sense supporting at my need
> You may deny—say—no such thing
> Tis all wrong every bit indeed.
> Well, to your judgment I must bow
> Freely its exercise allow you perhaps to such
> Are more inured. Your notions may be more endured
> But whether it be or be not so
> You can afford to let this go
> For nought as nothing it explains
> And nothing from nothing nothing gains.[5]

In much the same way, Johns recognized the key role played by the viewer in determining meaning in his work. Dadd's final line, "And nothing from nothing nothing gains," may also have resonated with Johns considering his longstanding practice of working with found images and his incorporation of past art into his own work. Johns favors appropriated imagery, "things known" rather than invented. As Roberta Bernstein observed, Dadd's perseverance as an artist in his extreme circumstances is indicative of the power of art, both for the artist and for society.[6]

Even though it includes many of the same iconographic elements that appear in Johns's two large untitled paintings of the same era that teem with images and floating spatial disparities, the achromatic aspect of *Nothing at All Richard Dadd* sets it apart. The gray tones lend it silent energy; it is elegant and reserved, even pensive. The number of images is reduced, the composition simplified. If the two paintings give the dreamy sensation of off-kilter bewilderment, the subtle gray, sonorous insistence of *Nothing at All Richard Dadd* provides a visual transition between the works of the previous twenty years, with their ever-increasing range of imagery depicted within a cloistered space, and the atmospheric compositions of the predominantly grisaille pictures that followed five years later.

The gray works Johns began in 1997 extend his long-held interest in the polysemous potential of gray, both in formal and iconographic terms. In these new paintings and works on paper, Johns explored the sober, meditative possibilities of a reduced color scheme and, in addition, the stirring pictorial potential of an insubstantial piece of string curving across a canvas, combined with modest relief implied by framing wood slats and cast shadows. In this new series, the pictures have been emptied out, the slate wiped clean.[7] Recognizable imagery has largely been sidelined in favor of gray passages of mysterious silence. After Johns's focus

Henri Monnier
*Untitled, c.* 1835
From a series of 12 hand-colored
lithographs in a sequence entitled
*Fantaisies Erotiques (Erotic Fantasies)*
4¾ × 3¾ (12.1 × 9.5)
Dopp-Collection, Frankfurt

**124**
*From Henri Monnier,* 2000
Ink on plastic
26 × 20 (66 × 50.8)
Private collection

on perceptual play and shallow illusion in pictures full of images, these new works
seem to encompass the legacy of abstract painting, to ask questions about how
a non-representational object conveys meaning.

Johns worked on the so-called *Catenary* group—the title taken from the
term for the type of arc traced by a suspended piece of string—from 1997 to 2003.
Encompassing eighty works, nineteen of them paintings, it is one of the largest
series he has completed.[8] Sixteen of the paintings are largely gray in value. All
feature some type of wood-slat framing device, either painted in trompe l'oeil or
physically hinged to the canvas. Despite the emphasis on gray, the works on paper
introduce a comprehensive range of color, imagery, and techniques. Carried over
from Johns's earlier work, some *Catenary* pictures contain flag fragments, the
spiral galaxy, or the three stick figures that first appeared in the 1982 ink on plastic
*Perilous Night* (fig. 46). Johns also inserted in some of the drawings a portrait
photograph of his grandmother, Evaline, an artist who died before Johns was
born, with his aunts and uncle, and Johns's father, William Jasper Johns, as a
small boy seated on his father's lap. New to Johns's vocabulary are images of the
Big Dipper constellation and a colorful handmade lantern, as well as a multihued
diamond-shaped pattern and a Halloween costume featuring a Chinese dragon
that Johns wore as a young child. Some of these images also appear in several
of the paintings, although nearly half of them are devoid of figuration.

Two paintings from this period, as well as a group of related works on paper
(see fig. 124), include an image derived from a print by the nineteenth-century
French satirical writer and cartoonist Henri Monnier. Monnier's lithograph shows
a young man in the foreground, back to the viewer, peeping—through a folding
screen that conceals him—at the entwined legs of a couple in bed (*c.* 1835; fig. 123).
The voyeur's shadow on the screen at right reveals his erection. The image features
hinged screens, folds of rumpled bedcovers and curving curtains—the type of

FROM HENRI MONSTER                                    J. JOHNS 2000

illusionistic play that has long fascinated Johns—and provides a vision of both connection and detachment.⁹

Given this shift in style and tone, many critics wondered what effect Johns's 1996 retrospective had had on him, with the opportunity it provided him to consider his previous work, as he turned to these new pictures. To Amei Wallach, writing in the *New York Times* in 1999 about the change from the pictures "crowded with emblems of the brutal abandonments of the artist's childhood" to those he began following the retrospective, "it seems, [Johns] has emerged from this attic of memory and loss into a more metaphysical atmosphere of reconciliation between eternal truths and personal history."¹⁰ While never tiring of his masterful touch and tone, many critics had assailed Johns's work of the late 1980s and early 1990s for featuring some type of hidden language that required more decoding than looking. One review had referred to the works' "oppressive claustrophobia," while another had described Johns's "self-mythologizing and preening obscurantism." Nevertheless, the same critic related how once "bored, you can suddenly find yourself snapped back to attention by the unexpected, almost reckless freedom he brings to a work."¹¹ The new pictures appeared more open to direct visual appreciation. The structure of these new *Catenary* compositions, affectingly wistful and nuanced, has in most cases been reduced, though personal references remain and many feature evocative titles.

◆

This chapter will consider four large *Catenary* paintings, each representative of different aspects of the series. *Bridge* (1997; fig. 127) was the first *Catenary* picture Johns made. By the next year, when he completed the encaustic *Catenary (I Call to the Grave)* (1998; fig. 131), he had nearly eliminated recognizable imagery, apart from the vestige of a colorful diamond-shaped pattern. This work, and *Catenary (Manet-Degas)* (1999; fig. 132), regardless of their pronounced abstraction, refer distinctly to past art. Finally, the arcing string's painted echoes and the pieces of attached canvas in the oversize vertical painting *Near the Lagoon* (2002; fig. 134), as well as in related drawings, such as *Untitled* (2002; fig. 125), bring to mind classical drapery folds and early Renaissance polyptych altarpieces.¹² Each of the four paintings shows Johns drawing on and extending the artistic language of his previous work.

*Bridge* is extraordinarily large, nearly 7 by 10 feet. The number of canvases of this size that Johns had completed before this can be counted on the fingers of one hand. *Catenary (I Call to the Grave)* and *Near the Lagoon* are similarly sweeping in scale. *Bridge* has the appearance and feel of an old-fashioned chalkboard with a trompe-l'oeil wood frame. It is a broad expanse of gray, actively painted in slightly varied shades that inflect the canvas surface. The right side of the composition is framed by a plywood slat attached near the picture's lower edge that tilts out into the viewer's space, seemingly attempting to establish some connection. Elsewhere, the faux-bois edge is interrupted on the upper left side by gray strokes that spill over from the contained expanse, and also on the top left, adjacent to the image of a small photo screenprint of a spiral galaxy made to look as if it is adhered to the faux-bois frame. On the upper right, also apparently affixed to the canvas, is an illustration of the Big Dipper on a deep blue ground, a white line drawn between its seven points. The nebula is an unfathomable and mysterious element in the

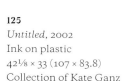

**125**
*Untitled*, 2002
Ink on plastic
42⅛ × 33 (107 × 83.8)
Collection of Kate Ganz

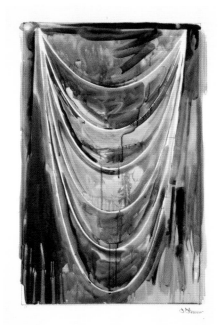

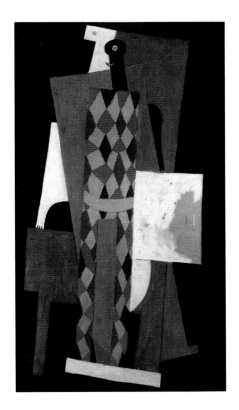

larger world we inhabit, nearly impossible for humanity to see or fully grasp, while the Big Dipper is a type of map that has long interested Johns, a constellation we recognize from a young age that helps establish our place in the cosmos as we seek to understand our connection to the wider universe. At the left edge of the gray field is the painted pinned handkerchief that first made its appearance in Johns's 1982 *Perilous Night* (fig. 30), based on a 1937 *Weeping Woman* print by Picasso (fig. 47). These images provide a sense of scale in the midst of the expansive gray ground.

Overlapping the framing edge and the gray at right is a vertical strip depicting a colorful diamond pattern that dissolves into abstraction as it approaches the lower edge, seemingly resting on the point of a light gray pyramidal form. The diamond-shaped colors are reminiscent of the traditional dress of Harlequin, a stock character in *commedia dell'arte* plays, who throughout art history has been read as a surrogate for the artist, beginning in the sixteenth century and continuing through Picasso and beyond (see fig. 126).[13] When curator Richard Field asked Johns why the handkerchief appears in *Bridge*, the artist replied, drawing a relationship between the harlequin motif and the handkerchief:

> I think that the suggestion of the handkerchief form was a way to indicate that there was the possibility that the work had meaning...the connection with comedy and tragedy. They are often thought of as a pair.[14]

As the series progressed, Johns incorporated two new images, one a schematic depiction of the Chinese costume featuring a dragon he had worn as a boy, the other a simple lantern such as is made by cutting shapes out of cardboard and filling them in with thin plastic sheets of various colors.[15] In a vertical encaustic of 1998 (fig. 129), the costume and harlequin pattern appear side by side, the wood slat at left. These two abstract references to the figure—the harlequin and the Chinese costume—provide a playful contrast of styles: the bold linear elements of the stylized costume, with its gold frog enclosures, toothy fire-breathing dragon, pigtail, and the hat and slippers indicated by gray outlines on a black field; and the loosely applied encaustic of the harlequin pattern against a light gray ground. Johns's mastery of encaustic allows him to suggest freely painted passages of floating diamonds, and at the same time the most carefully articulated lines of embroidery set into the black ground of the costume, along with buttons in wax relief that extend into the viewer's space. In this vertical painting, a string hangs from the top of the projecting slat at left creating an arc down to a screw eye affixed to the lower right edge of the canvas. The exposed and fragile string unites the references to costumed child and mature artist within its sweep.[16]

The *Catenary* pictures have a physicality that harks back to Johns's early assemblage practice. As curator Scott Rothkopf has stressed, the *Catenaries* also affirm Johns's longstanding impulse to question the nature of painting and its status as an object.[17] In them, Johns explores non-illusionistic means of resolving the discrepancy between the flat picture plane and the sophisticated perspective of the real world. He had previously flipped canvases over to reveal their stretchers and so draw attention to the space behind, as well as leaving unpainted strips at the edge of pictures to accentuate the conceit of paint on canvas to suggest pictorial space. The title *Bridge* invokes the way in which Johns's consistent engagement with these central formal preoccupations spans the course of his career.

126
Pablo Picasso
*Harlequin*, 1915
Oil on canvas
72¼ × 41⅜ (183.5 × 105.1)
The Museum of Modern Art,
New York

In *Bridge*, the right side of the composition is framed by a plywood slat attached near the picture's lower edge that tilts out into the viewer's space, seemingly attempting to establish some connection. On the canvas under the projecting slat is a painted version of it with the work's title stenciled sideways along its upper edge. This was the first time since 1982, when the cast arms were incorporated in *In the Studio* and *Perilous Night*, that Johns had affixed an object to canvas. The hinged stick that had first surfaced in *In the Studio*, a picture in which Johns reintroduced shallow painted illusion while using relief to intrude into the space occupied by the viewer, returned here in a work that addresses different but similarly complex issues of the relationship of art to the visible world. Attached to a screw eye at the top of the slat is a string, the other end of which is screwed to the faux-bois frame at the lower left, creating a gradual arc loosely suspended between two points, one real, the other painted. The cord is a line in three dimensions, formed by the weight of gravity, yet with the latent potential for flux.

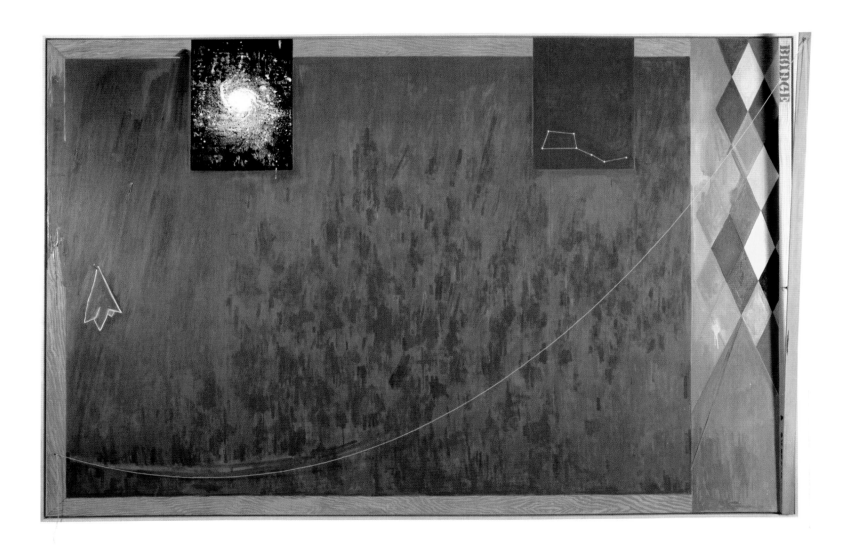

**127**
*Bridge*, 1997
Oil on canvas with objects
78 × 118 (198.1 × 299.7)
Collection Helen and Charles Schwab

**128**
*Bridge,* 1997
Graphite and ink on paper
42 × 28 (107 × 71.1)
Collection of Helen
and Charles Schwab

**129**
*Untitled,* 1998
Encaustic on canvas
with objects
44⅛ × 22½ (112.1 × 57.2)
overall
Whitney Museum of
American Art, New York

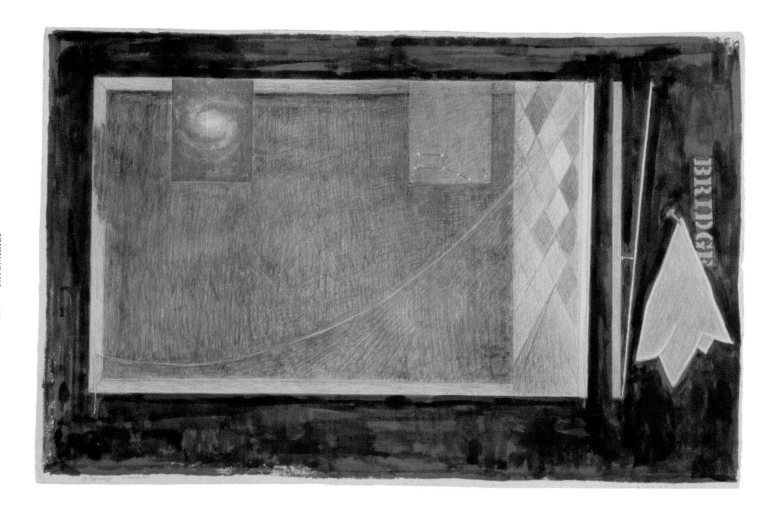

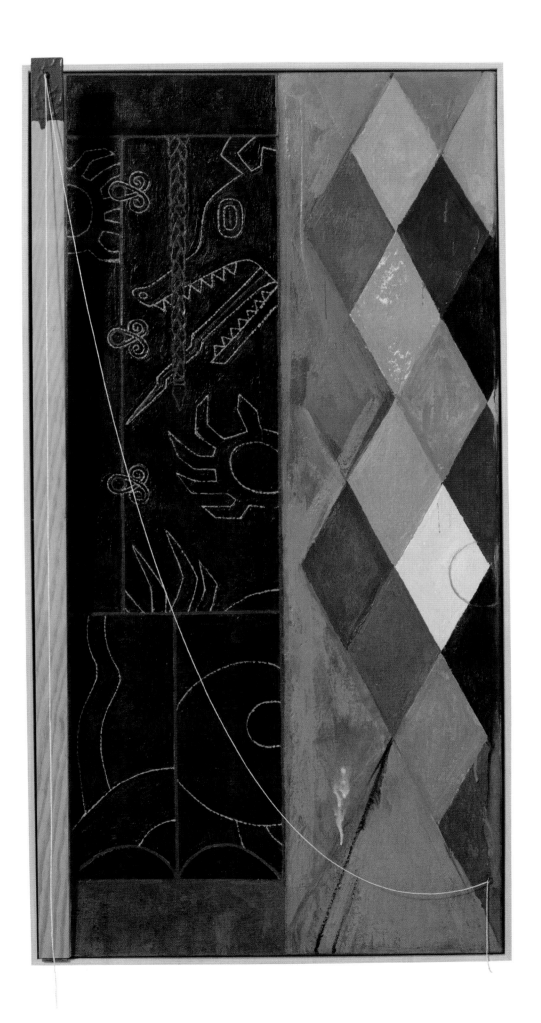

In the *Catenaries*, he set aside the suggestion of the flat surface as a wall with images illusionistically hung, taped, or nailed to it that had been his focus in the 1980s in works such as *Racing Thoughts*, in favor of simplified expanses of atmospheric gray, with superimposed wood slats and string.

The *Catenaries* manage to suggest planarity and depth at the same time. The physical character of the encaustic, with its carefully placed drips and layered marks, forms a somewhat impenetrable skin; on the other hand, Johns establishes atmospheric space through the layering of strokes of varied grays and a profusion of diagonal inflections. Much like the playful visual illusions Johns employed in the 1980s of the duck/rabbit and wife/mother-in-law, the space in the *Catenaries* can be interpreted in more than one way. In one of the drawings, also called *Bridge* (1997; fig. 128), a graphite version of the painting is framed by a large black ink border, the slat, hook, and handkerchief depicted to its right. The edge and hatches that form the *Bridge* image indicate spatial recession, as do the pronounced lines marking the inset compositions of the spiral nebula, Big Dipper and harlequin. The pyramid at the lower right, its three-dimensional character enhanced by dark lines at its edges, affirms the illusion. Johns also plays with space in the Halloween costume. In his schematic depiction of it, he manages to indicate both the front of the jacket and pants, with shoes facing forward, and the back of the hat and pigtail. It is a sophisticated notion of perspective that circumvents the traditional goal of painting to create illusion, encompassing instead "the rotating point of view" for which the artist expressed admiration in his studies of cubism and the work of Cézanne.[18]

Johns learned the term for the type of arc the suspended string in *Bridge* traces—catenary—from a friend, Henry Cortesi, who visited him at his home in Saint Martin, where the painting was hanging on a wall apparently reserved for new work. Eventually, Johns sent *Bridge* to his studio in Connecticut and replaced it with *Catenary (I Call to the Grave)*. Akin to his own thought process, Johns explained the way a series can develop physically:

> I don't know where ideas come from, but somehow the fact that the painting was going to go on the wall in that place made me think of it as a kind of object, and then I thought, well, it would be nice if this object expressed the idea that it was an object, and that's how I started thinking of things happening in the physical space, like the stick and the string.

Cortesi told Johns, who claimed not to have known the term "catenary," of the curve's name and its significance for the engineering of suspension bridges. "I became very interested that there is a name for that," Johns continued. "And I don't know if I would have painted this series without Henry having said that."[19]

Coincidentally, the artist had chosen the title *Bridge* for the picture seen by Cortesi, without yet understanding the real link between the curve he had made and its specific structural use in the building of bridges. He related how,

> [The title] seemed appropriate to me...obviously, the painting has to do with, in a sense, connections, doesn't it? So that in itself is a bridge, whether they are connections among the various ideas we have of space, of connections of thought, or what.[20]

The title also evokes Hart Crane's 1930 poem "The Bridge," his ode to both the Brooklyn Bridge and America, a resolutely personal poetic journey through time

and space in which the Brooklyn Bridge becomes an emblem of inspiration and hope. This poem (and Crane's poetry in general) has been an important source for Johns's work over many years.[21]

A 1996 photograph on the front page of *The New York Times* (fig. 130) may have prompted Johns to include the arcing string in these pictures. The image shows a Rwandan refugee at left holding up a plastic bag used to intravenously feed her daughter, seated at right. The umbilical-like IV cord has a striking and unexpected poignancy as it forms a catenary curve connecting the two figures. Johns had this photo tacked to his studio wall in Connecticut around the time he worked on the *Catenary* series.[22] In attaching the string to eyehooks, Johns projected it into the viewer's space, bridging observer and painted canvas.[23] In several of the *Catenary* works, Johns treated the string as a device, placing it on the canvas in an arc, painting over it, and pulling it off once the paint or encaustic hardened. The raw trace echoes the actual line of the string above, implying some kind of intrinsic yet fragile relationship.

The *Catenary* series extends Johns's embrace of the role of chance in his images as it is gravity, and not the artist's hand, that determines the final form the curve will assume. The slender cord mediates between picture and viewer, tempting our interaction. We can gently blow on it and it moves about, casting varied shadows on the paint surface; cast shadows become confused with painted ones, reality with illusion. When asked about the variable shadows the strings would cast when exhibited in different locations, Johns observed: "I assume that will take care of itself and they will encounter different situations, just like the rest of us."[24]

As the series progressed, the harlequin, Halloween costume and astronomical references disappeared, while the arcing shadows assumed a larger role. The 1998 *Catenary (I Call to the Grave)* is framed by wood slats on the sides and, while the harlequin pattern is present at right, its colors are muted. What is distinctive is the stirring field of gray, the encaustic laid down in vertical strokes, passages, and drips issuing from the upper right, the picture's tactility articulated by subtle shifts in tone from blue-gray to grayish white, with individual marks knitting together to form a sfumato-like membrane. The painting has the appearance of rain at night beating down in sheets on a car windshield, or possibly of a well-used blackboard, wiped repeatedly but not washed. The white drip mark depicted as more of a blob

**130**
A Hutu refugee from Rwanda helps her daughter with an intravenous (IV) drip at a hospital in Goma, Democratic Republic of Congo, *New York Times*, November 18, 1996

**131**
*Catenary (I Call to the Grave)*, 1998
Encaustic on canvas with objects
78 × 118 (198.1 × 299.7)
Philadelphia Museum of Art

in *Bridge*, and seen in many of Johns's works, appears on the lower edge of the diamond-shaped pattern as two carefully placed linear drips.[25] While the string is still fastened at upper right and lower left, it is now attached at both ends to wooden slats, thus only touching the picture at these points, and freer as a result than the one in *Bridge*.

Johns's *Catenary* pictures took on an increasingly introspective character as he eliminated imagery and reconsidered the possibilities of allover abstraction that had characterized pictures of the early 1960s such as *No* (1961) and *Disappearance II* (1961). With its heightened abstraction, the parenthetical phrase in the title *Catenary (I Call to the Grave)* intensifies the work's effective resonance, amplifying its allusions to human faith and frailty. A literary dimension—or play of word and image—is nearly always present in Johns's work, whether as the germ of an idea or part of a title, or as a stenciled or written word with literal or metaphoric significance. The title refers to a passage in the Book of Job (17:14).[26] It is a dark verse, in which Job questions whether his belief in God is pointless if his fate is to die.[27] Job's faith is severely tested, as the result of a challenge from Satan to God, when he suffers one catastrophe after another. Job mourns his losses but keeps his faith while longing for deeper self-knowledge. Eventually, his life stabilizes as his defeats are overturned. The Book of Job is unusual in biblical literature in its poetic style of discourse, in which Job and others, including God and Job's wife and friends, question, argue, and change their minds. Given Johns's interest in poetry, his reference is perhaps not surprising. Ultimately, the passage concerns the human inability to comprehend why God would permit people to suffer.

Johns continued work on the *Catenaries* over the next four years. In 1999 he painted *Catenary (Manet-Degas)* (fig. 132). He had been asked to contribute a work to the exhibition *Encounters: New Art from Old* held at the National Gallery in London in 2000, for which artists were to make a piece in response to a work in the Gallery's collection. While initially doubtful about coming up with a project following the somewhat constrained guidelines, Johns ultimately chose to participate, taking Édouard Manet's *The Execution of Maximilian* (1867–68; fig. 133) as his point of departure.[28] Manet's painting, rare in his oeuvre as an instance of contemporary history, has a poignant and complicated provenance that ultimately altered the work's physical structure and composition. These factors, in addition to his regard for Manet's working methods and touch, may have piqued Johns's interest.

Manet's canvas shows the execution by firing squad of Austrian archduke Maximilian, who Napoleon III had made Mexico's puppet emperor in 1864. While political themes are alien to Manet's art, he must have felt strongly enough about Napoleon III, and his misguided imperial ambitions in Mexico, to take this as his subject. Briefly told, a small group of wealthy landowners and clergy in Mexico had sought France's help in overtaking the government there and Napoleon complied, sending an invading army in 1862. When the French army was defeated, Napoleon talked Maximilian into the role of emperor. Eventually, Maximilian was arrested. Mexican army forces killed him along with two of his generals in 1867 in a harrowingly drawn out execution. Manet made a group of paintings on this theme, relying on patchy news coverage, but tellingly depicting the Mexican firing squad in uniforms worn by French soldiers, the pointed political implication of which would not have been lost on contemporary viewers.

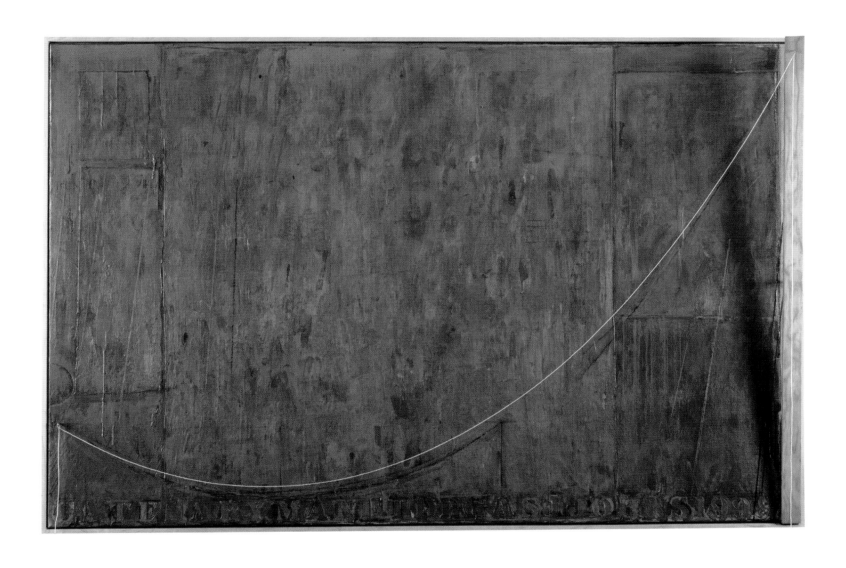

**132**
*Catenary (Manet-Degas)*, 1999
Encaustic and collage on
canvas with objects
38 × 57⅜ (96.5 × 145.7)
Private collection

133
Édouard Manet
*The Execution
of Maximilian*, 1867–68
Oil on canvas
76 × 111¾ (193 × 284)
The National Gallery, London

The National Gallery picture, the second painting in Manet's series, had been damaged by water in Manet's studio. At the artist's death, the work was cut into pieces, which were sold individually. In the 1890s, Manet's friend, the artist Edgar Degas—like Johns, a discerning and intuitive collector of contemporary art— searched all over Paris for the parts, eventually finding four of them. He rejoined them on one large canvas, aligned in their original configuration, with the missing fragments marked by blank areas of canvas. The fractured result is disquieting. Only the left hand of the Emperor Maximilian can be seen, clasped firmly with the hand of the Mexican General Mejia, at the moment these two, plus a third, General Miramon, are executed at close range.[29] The National Gallery purchased the work in 1918 at the posthumous auction of Degas's collection. At this point, the fragments were separated yet again and framed individually. It was only in 1992 that the National Gallery reassembled the pieces on a single canvas, which Johns chose as the inspiration for his painting.[30]

*Catenary (Manet-Degas)* is a relatively small gray encaustic. Where Johns had previously chosen to include the work of other artists in the form of traced or reproduced images, he now appropriated the physical structure of his model instead and, in doing so, its complicated history. Johns assembled his painting out of four pieces of canvas, each relatively the same size as the ones cut from Manet's picture, and attached them in the same configuration as the National Gallery work. In Johns's picture, a cord falls across the surface in an arc, seemingly uniting the disparate fragments.

In 2002, Johns made the final picture in the *Catenary* series, the large encaustic *Near the Lagoon* (fig. 134). Painted in nearly monochromatic gray, it is among the most pared-down of Johns's *Catenary* compositions, if not of his entire output. He made the painting in Saint Martin and, after completing it, hung it there in his home overlooking a nearby lagoon and the sea beyond.[31] *Near the Lagoon* is unusual in the artist's practice in that it was preceded by an untitled drawing (2001; The Art

Institute of Chicago); more commonly, Johns makes works on paper in response to or independent of his paintings. The painting is oriented vertically, unlike the majority of the *Catenary* works. Where the horizontal ones suggest expansive abstracted landscapes obscured by drenching drizzle, deep fog, or even night, *Near the Lagoon*, despite its referential local title, alludes in its structure and form to historical artistic precedents. Its scale and hinged wooden side wings—a single one at left and double-hinged section on the right—follow the conventions of large Northern Renaissance altarpieces, such as the Isenheim altarpiece that Johns has drawn on in his work since 1981, which have wings that can be left open or closed depending on the liturgical calendar.[32]

A string hangs in an asymmetrical curve from a point at the upper edge of each of the side wings in *Near the Lagoon*. Its curve falls slightly right of center, as the string is attached on the right to the outer of the two wooden slats. Instead of affixing the string with screw eyes, Johns ran each end through a hole at the top of each wing, the ends dangling freely behind the wings to the canvas's lower edge. Johns formed two arcs on the surface using another string embedded in wet pigmented encaustic, removing it as it hardened to leave two shorter catenary traces in the paint above the actual curving string. A third arc, made in the same way, gives the illusion of being a shadow of the actual string. Together, they call to mind the ornate drapery folds in classical history painting.[33]

Four canvas patches are attached to the surface of *Near the Lagoon*, fragmenting it and providing a suggestion of relief. Their arrangement was determined by the relationship of the joined canvas sections in *Catenary (Manet-Degas)*, itself based on Degas's reconstruction of Manet's painting. *Near the Lagoon* provided an opportunity for Johns to explore this structure on a larger canvas, now vertical with dimensions slightly exceeding the National Gallery reconstruction. Johns's picture has been the subject of thorough examination and thoughtful documentation by two conservators at the Art Institute of Chicago. Their examination, along with the artist's words, makes it possible to describe Johns's process in detail. He first applied a restrained red pigment to the canvas, which had been prepared with a layer of unpigmented wax, as a ground. Then he tacked to the canvas with knotted thread four pieces of linen the same size and configuration as the Manet fragments, and painted them a muted red similar to that of the ground. With a pale yellow corresponding to the sections of bare canvas in the Degas reconstruction, he worked over the ground, in some cases freely painting over the attached canvas as well. He framed the red and yellow with a blue edge.[34] Finally, a gray "skin," a mix of chromatic tones, was applied over the whole composition. Johns described how,

> thinking of my work and its references to Degas's attempt to reassemble Manet's painting, I divided the surface into three categories—my canvas, the ground provided by Degas to contain the Manet fragments, and the Manet fragments themselves. I indicated each of the three categories with a subdued primary color, a sort of underpainting…I thought to distinguish these three things, one from the other, as a beginning.[35]

While Johns has long considered the relation of part to whole in his work, as well as the use of mirroring and fragments, both literally and metaphorically, his interest in the *New York Times* image of the two Hutu women (fig. 130), in which a line down

Johns's experience with encaustic over nearly half a century results here in a rigorous and pensive work, quite unlike the unsettled nature and rough surfaces of early grisaille pictures such as *No* (1961) or *Liar* (1961; fig. 94). Johns, speaking with Nan Rosenthal, recalled the emphatic objecthood of these earlier canvases: "In these early works, a feeling of reality was being stressed; through the use of gray, the object nature of the materials would come forward, their physical existence isolated or intensified. I don't know what it is that color does to a work, but, in a sense, gray drained the work of the excitement that color afforded. One was left with what I must have thought of as reality. It's hard to recover the sense that one had then, such a long time ago."[43] Where these pictures are dark and mercurial, *Near the Lagoon* has a ruminative and wistful subtlety.

**134**
*Near the Lagoon*, 2002
Encaustic and collage on canvas
with objects
118¼ × 78⅛ (300.4 × 198.4)
The Art Institute of Chicago

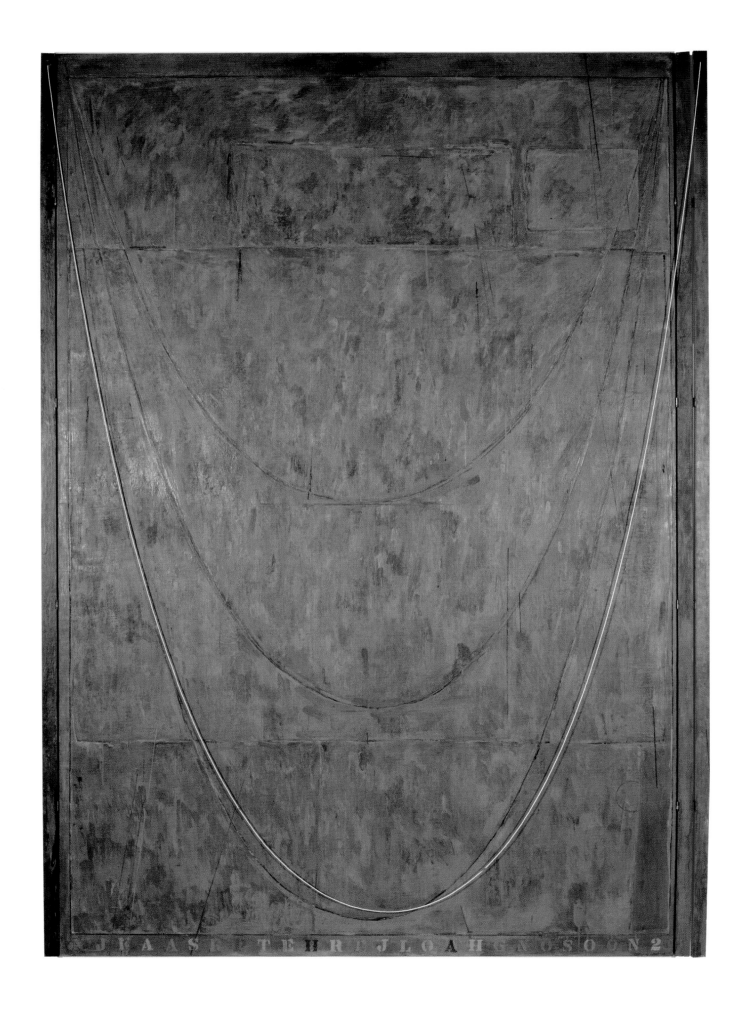

the middle of the wall behind them clearly bisects the composition into two parts, may have prompted the linear divisions in *Near the Lagoon*.[36] The gray that covers the surface is complex and elegant, no longer a stark mix of black and white as in some of his earlier gray works, but a blend that includes more than one black as well as variations of red, yellow, and blue.[37] Notable is the nuanced physicality of the brushwork, applied in several directions, vertically toward the large central section, with a buildup of strokes at the fragment and impressed curve edges, as if to accentuate the relief or impression of those lines. This is where the red and yellow are most likely to show through the gray, as a fissure or a raw line of lacerated, exposed tissue. A particularly thinly applied gray encaustic at the work's lower right reveals luminous red underpaint, a texture approximating some natural element like the coarse bark of a tree.[38] The overall effect is more atmospheric, however, one of peering into a deep dark pool, its surface gently modulated. As conservators Kelly Keegan and Kristin Lister noticed, *Near the Lagoon* impels the viewer to eye closely as well as to take a broader perspective, to repeatedly change focus.[39]

In *Bridge* and other *Catenary* works, the inserted images on the modulated grisaille ground—including the spiral nebula, the Big Dipper, and the string and stick that extend out into the viewer's field—play with various types of space, from the infinite, to shallow relief, and relatively planar or two-dimensional.[40] In addition, the framing slats that appear in the majority of the *Catenary* pictures can be read as wooden stretcher bars, raising the indeterminate question of whether we are looking at the canvas's front or back. To Rothkopf, the *Catenaries* provide opportunities for physical interaction (the viewer may, for instance, unhook a slat or blow on a string), thus challenging the ways in which we experience and interact with artworks.[41] Viewed close up, the gray in *Near the Lagoon* seems purposefully abraded in places to reveal some raw state buried beneath. The canvas remnants also imply something broken, lost, or hidden, even some kind of bodily wound or decay. The framing relief lines, suggestive of open lesions, underscore the fragments' shallow illusion, as if one could expose the underside of each piece by lifting it up at its edge. The patches hint at something veiled yet also stripped. The string provides a further organic allusion: it is movable, casting shadows that change with the light and bringing to mind the inevitability of change and the unpredictability of life.

Gray expresses many of the qualities intrinsic to Johns's art, encapsulating its reserve. Neither black nor white, it remains open to interpretation. The *Catenaries* are lyrical as well as austere works that mark Johns's evolution from the guarded yet heady, fresh, and effusive gray pictures of the late 1950s and early 1960s. Where the animated pseudo-Abstract Expressionist brushstrokes in paintings such as *Jubilee* (1959; fig. 135) can be seen as metaphors for the precarious spirit of human nature, the *Catenaries* suggest a full spectrum of life experience, the cosmic space of the spiral nebula, the Big Dipper map and wooden stick acting as metaphors for humanity's attempts to measure or name the world.

These finely nuanced gray tones imbue all the *Catenary* pictures with a grave dignity, intensified by Johns's awareness of gray's potential to elicit a broad range of meanings. While the gray in the *Catenaries* is suggestive of weather, the pictures invoke more of an emotional spectrum than that which John Cage observed when describing the experience of looking at Johns's work in in 1964: "Finally, with nothing in it to grasp, the work is weather, an atmosphere that is heavy rather

**135**
*Jubilee*, 1959
Oil and collage on canvas
60 × 44 (152.4 × 111.8)
Private collection

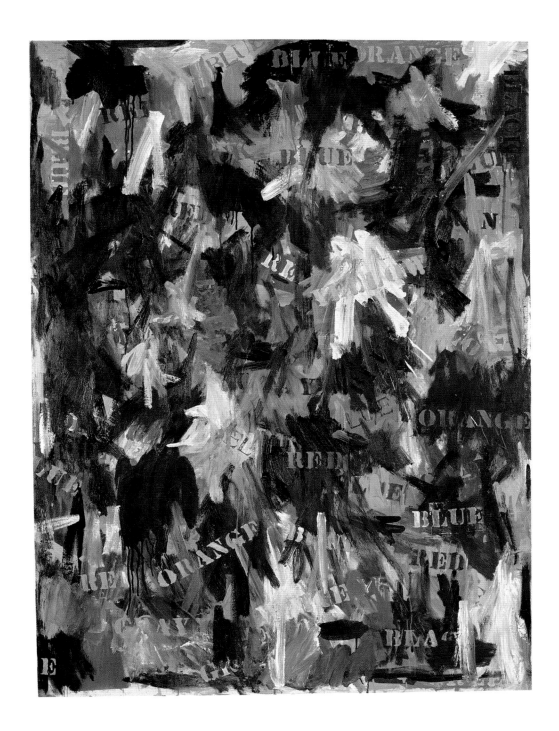

than light (something he knows and regrets); in oscillation with it we tend toward our ultimate place; zero, gray disinterest."[42] Comparing the *Catenary* pictures to the gray works of 1961 and 1962, one sees that the youthful energy and stimulation of Johns's early work, its vulnerable assertiveness, has deepened to a subtle, penetrating resonance that can, at times, assume a sepulchral tone. The expansive space and gravity of these pictures signal Johns's turn to the metaphysical topics of life and death, flux and eternity.

# 0-9 AND **REGRETS**

LATE STYLE, TO ME, STARTS WITH AN IDEAL OF
A SIMPLE, SUBDUED, UNORNAMENTED LANGUAGE
AND A CONCENTRATION ON QUESTIONS OF REAL
IMPORT, EVEN QUESTIONS OF LIFE AND DEATH.[1]

J.M COETZEE TO PAUL AUSTER, 2009

Now in his eighties, Johns's absorption in his art practice remains vital. Since 2000, he has investigated a range of styles and forms in paintings, works on paper, and sculpture, exploring familiar themes as well as new iterations (see figs. 137 and 138). Two large and cohesive bodies of work stand out. Between 2007 and 2012 he concentrated intensively on a group of relief sculptures, some large in scale and some more intimate. Later, from 2012 to 2016 he created two series of paintings and works on paper, each triggered by a different photograph of a tragic male figure.

Since the 1980s, Johns's focus has been on issues of physical and represented space, as well as imagery that refers to his own art and life and to the work of artists who interest him. These continue to be essential concerns. Late critic John Russell's prescient words regarding the flags and numbers in a 1977 review remain relevant to the artist and his work today: "Johns could have gone on painting those primary images forever—and indeed he does occasionally allow himself a luxurious reprise—but in general he prefers to sire a whole new family of images every year or two and go back to them from time to time to see how they are getting on."[2] With a career spanning over sixty-five years, Johns abides by the same creative impulse that fostered his auspicious beginnings: to explore what happens when he takes up given materials or constraints.

◆

From 2007 to 2011, Johns had his most concentrated period of working with sculpture, making thirty-seven reliefs—both unique and editioned—in bronze, as well as in aluminum and silver (see figs. 136, 143 and 150). The theme of the majority of these sculptures is numbers, a subject that he has revisited often and across a range of media since the mid-1950s.[3] In 2011 Johns exhibited nine sculptures at Matthew Marks Gallery in New York and thirteen at the same gallery in Los Angeles the following year. Though Johns has worked on sculpture intermittently throughout his career, sometimes completing editions of objects begun years before,[4] it had been fifty years since he had made it his primary focus. As a child he made casts and "recalls a fascination with plaster of Paris."[5] He produced his first sculpture in 1958 and, while working in other media, sculpture remained a major preoccupation over the next three years. Early on, Johns turned to Sculp-metal, a type of aluminum putty, to model small sculptures of everyday

**136**
*Numbers*, 2007
Bronze
107½ × 83 × 2¾ (273.1 × 210.8 × 7)
Kravis Collection

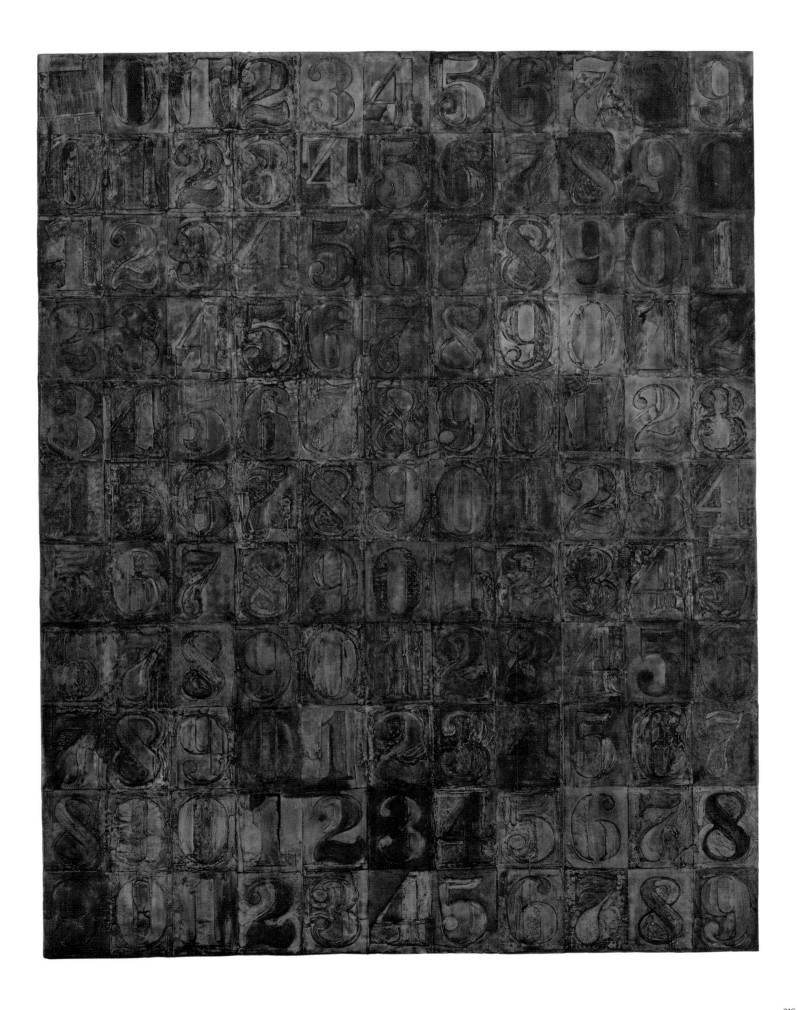

**137**

*Usuyuki*, 2002–04
India ink and acrylic on paper
54¾ × 24 (139.1 × 61)
Seibert Collection

**138**

*Bushbaby*, 2003
Watercolor and graphite
pencil on paper
22¾ × 13⅝ (57.8 × 34.6)
Private collection

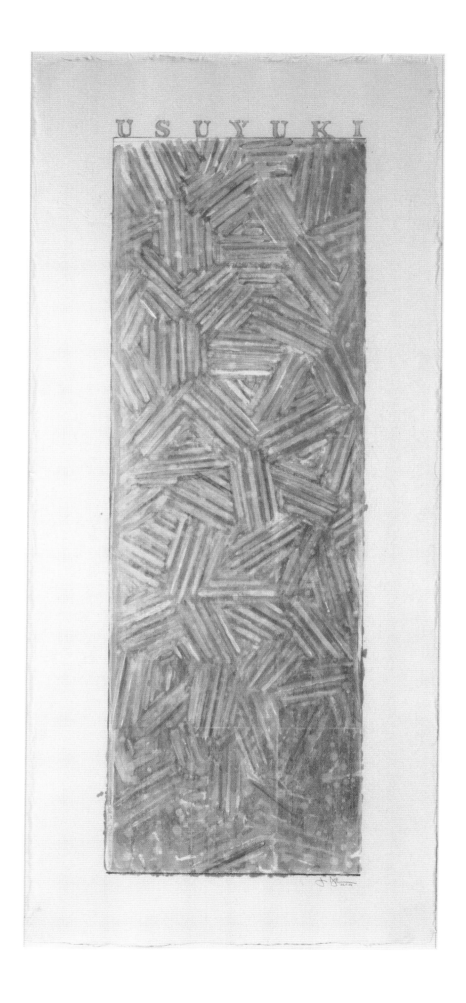

**139**
*Flashlight III*, 1958 (cast 1987)
Bronze, glass, and aluminum paint
5⅛ × 8⅜ × 3¾ (13 × 21.3 × 9.5)
Private collection

**140**
*The Critic Sees*, 1961
Sculp-metal on plaster with glass
3⅛ × 6½ × 2⅛ (7.9 × 16.5 × 5.4)
Private collection

**141**
*The Critic Smiles*, 1959
Sculp-metal (2 parts)
1⅝ × 7⅝ × 1½ (4.1 × 19.4 × 3.8)
Collection of the artist

objects: numbers, a lightbulb and a flashlight, among others (fig. 139). Because Sculp-metal is liquid, it can be applied with a brush, palette knife or by hand before it hardens, making it a versatile material for free modeling.[6] Johns also used Sculp-metal to paint on collaged canvas, crossing the conventional boundaries of painting and sculpture. The small-scale objects that Johns modelled by hand seem to have, as Fred Orton has noted, a "mainly private purpose."[7] Some, such as *High School Days* (1964), concern memory. Others—the flashlights and lightbulbs—consider aspects of studio practice, chiefly the significance of light and vision.

Johns's sense of visual punning is particularly barbed in some of these works, especially in two objects that consider the role of the art critic: *The Critic Sees* (1961; fig. 140) and *The Critic Smiles* (1959; fig. 141). While the former shows two open mouths instead of eyes projecting behind the critic's spectacles—a satire on the nature of art criticism and preconceived ideas about art—the latter substitutes bristles for teeth in the critic's 'smile'. In *The Critic Sees*, Johns correlates speech and sight, highlighting the significance of language in his work and the relationship between vision and concept.[8] This work, as with much of Johns's sculpture, carries traces of the artist's long-term interest in the work of Marcel Duchamp. Not only did Johns, like Duchamp, begin with common objects, but, as Johns wrote in eulogizing Duchamp shortly after his death in 1968, he "moved his work… into a field where language, thought, and vision act upon one another."[9] Johns met Duchamp in 1959 and had also begun to collect and write about his work.[10] Reviewing Duchamp's *Green Box* in 1960, Johns pinpointed some of the key characteristics that he admired in the older artist:

> Duchamp's curious frugality…wit and high common sense ('Limit the no. of readymades yearly'), the mind slapping at thoughtless values ('Use a Rembrandt as an ironing-board'), his brilliantly inventive questioning of visual, mental and verbal focus and order.[11]

Johns's early sculpture embodies this "frugality," and shares with Duchamp's readymades a visual wit and enigma, raising questions about the nature of the work of art.

Beginning in the early 1960s, Johns also experimented with other materials, including aluminum, bronze, silver, wood, and plaster, as well as making relief casts from one flag and five different number paintings in Sculp-metal and collage on canvas. During this time, he cast two artfully rendered and painstakingly finished trompe-l'oeil painted bronzes, one of two beer cans (fig. 70), the other of a Savarin coffee can filled with paint brushes (fig. 15). The latter falls within a tradition of paintbrushes and other tools acting as allegorical representations of the artist. Johns made the bronze ale cans—one closed, solid and heavy, the other open, hollow and light—after hearing artist Willem de Kooning's assertion that Johns's longtime art dealer, Leo Castelli, could sell anything, even two beer cans.[12] Johns's exploration of materials and techniques had also been stimulated by his introduction to printmaking in 1960.[13] Making prints involves complex reversals, repetitions, and transformation of imagery over time. Johns's growing understanding and appreciation of this medium and its processes triggered new developments across his practice, for example, the six embossed *Lead Reliefs* (1969–70) that he made using a printing press at the technically innovative printmaking workshop Gemini G.E.L. in Los Angeles.[14]

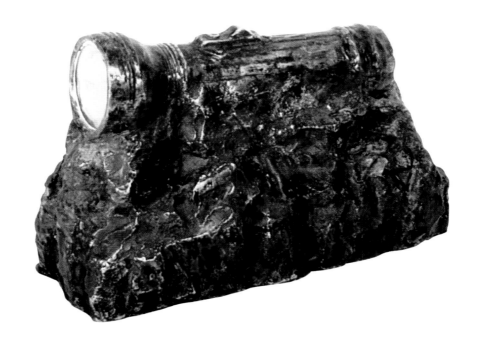

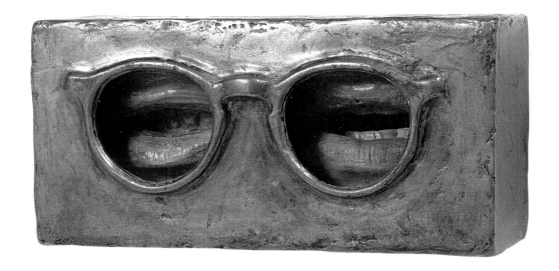

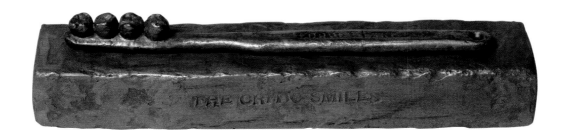

*Numbers*, 1964
Sculp-metal and collage on canvas
with Sculp-metal on wood frame
(121 panels)
110½ × 85½ (280.7 × 217.2)
including frame
David. H. Koch Theater at Lincoln
Center, New York

Johns's earliest exploration of sculpture preceded by just a few years a vital decade of sculptural creativity that saw artists, from Lee Bontecou and Claes Oldenburg to Donald Judd and Dan Flavin, working in many styles, emphasizing process, using unconventional materials, and, in some cases, seeking ways to blur the boundaries between art and life. Robert Rauschenberg, for instance, challenged the norms of sculpture and painting by inserting found objects into his large *Combines*. In 1957, sculptor John Chamberlain began using scrap metal from old cars to create colorful, elegantly mangled forms that conflated painting and sculpture. Around the same time, Oldenburg started fashioning objects from plaster-soaked canvases over chicken-wire forms, finished with enamel paint, making lumpy, molten oversized clothes, food, and everyday goods that he hung in market-like displays.

While the images and ideas that Johns developed in his early sculptural practice continued to inform his work of the next four decades across all media, and he frequently chose to incorporate objects into his paintings, it was not until 2007 that he put aside painting for a period of time to concentrate again on sculpture. According to Johns, when he was young and starting out as an artist, he did not distinguish between painting and sculpture. He also thought of his early low-relief Sculp-metal sculptures as paintings, as many had been modeled with a brush, until he subsequently began casting them in bronze and other metals.[15] More recently, he used wax to model his relief sculptures, a material familiar to him from his long-term experience working with encaustic in painting. It becomes clear, then, that Johns's painting is informed by a sculptural vision, and that similarly his sculpture is closely linked to his painting. "A lot of people," he posits, talking about his late relief works, "might associate the low relief and the kinds of detail that are in these pieces more with painting than with sculpture."[16]

The sculptures that Johns began in 2007 relate to his only public artwork, the 1964 Sculp-metal *Numbers*, commissioned for the lobby of what is now the David H. Koch Theater at Lincoln Center, New York (fig. 142). Around the turn of the twenty-first century, Johns realized that the Koch Theater had installed Plexiglass protection in front of his piece and segregated it from the public with a velvet rope. He had the idea to make a cast of the 'painting', as Johns refers to the relief, giving it its own protection, but Lincoln Center refused.[17] He therefore decided to create some new pieces on the same theme, employing the age-old indirect lost-wax casting process. Rather than the direct lost-wax method, in which the artist's original wax model melts away, the choice of the indirect lost-wax technique allowed Johns to re-use the same model more than once for a group of sculptures. The first of these was the aluminum *Numbers* (2007; fig. 143), which he later cast in bronze (2007; fig. 136).

These sculptures required a wide range of techniques and types of hand work, starting with sheets of wax, some torn or cut out, some imprinted with silkscreened newsprint, as well as collage elements. Unlike the earlier Sculp-metal works, fashioned largely with a brush, the process of casting from wax allows for rigorous detail in these reliefs. This is especially notable in the legible characters of the newsprint. To achieve this readable text, which appears raised in some places and incised in others, Johns "made a kind of fake newspaper from thin sheets of wax onto which the image of the text was silkscreened in very low relief.

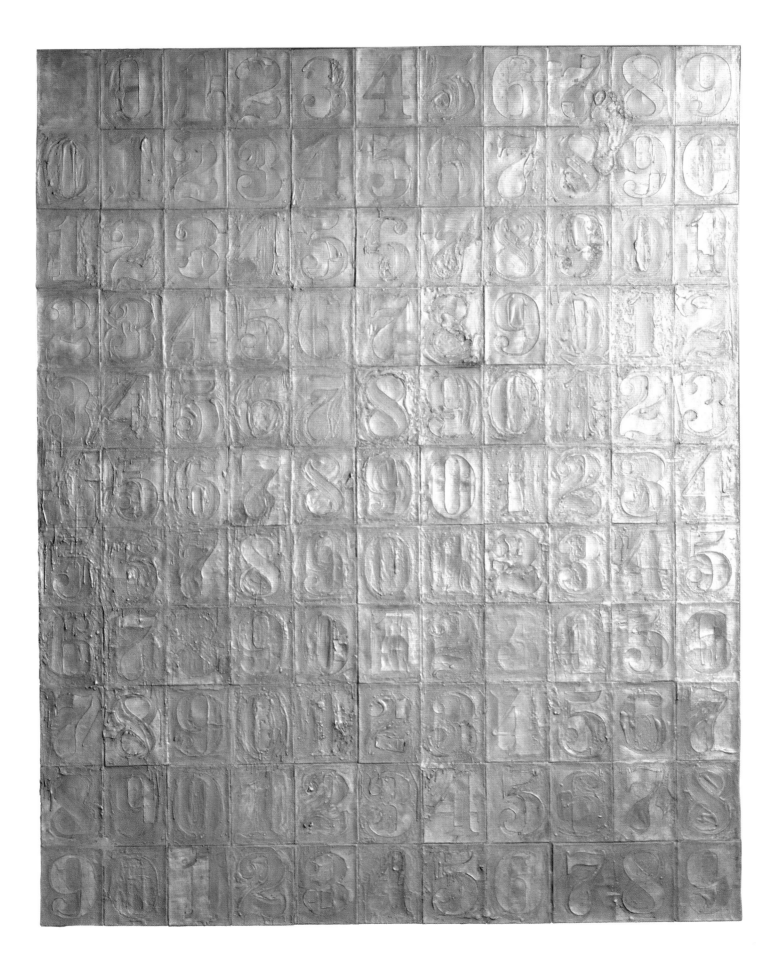

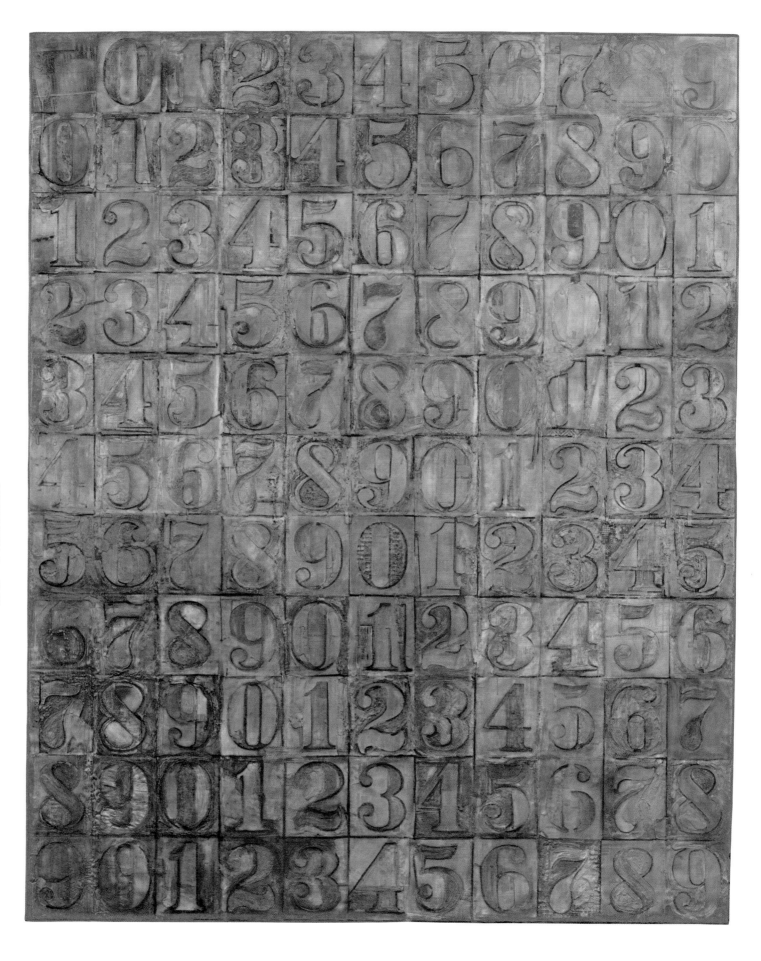

**143**
*Numbers*, 2007 (cast 2008)
Aluminum
107¾ × 83 × 2¼ (273.7 × 210.8 × 5.7)
Glenstone Museum, Potomac,
Maryland

**144**
Jasper Johns's study, Sharon,
Connecticut, 2011

Other sheets were imprinted by pressing blocks of raised metal type into them."[18] Johns completed as much of the work as possible himself, from building the wax to sanding and applying patina, lending the sculptures a handmade aspect that counteracts the apparent inflexibility of the materials and the impersonality of those most fundamental abstractions, the numbers themselves. Working closely with the foundry, Johns asked that "they do nothing to 'finish' the casts...The imperfect detail that I want kept is not something they're accustomed to being concerned with."[19] For Johns, both "chance and deliberation" were important in the final appearance of the bronze, the various chemical reactions inherent in the process of applying the patina creating "another level of information or noise." The unpredictable nature of some of these processes appeals to Johns,

> playing with materials and not being certain what they will do, and basing decisions on what you see happen...in some way, it's knowing what you want; and in another way, it's not knowing what you want, and so it's something that can't be said before it happens. There is no way to say exactly what I'm going to do before I do it.[20]

Working toward a solution, Johns seeks to "modulate the legibility of the form, to make the character of each work more particular, clearer."[21] The finish in the bronze version of the *Numbers* relief casts a deep, golden-brown glow that recalls the patina of some refined ancient object. Johns's piece falls into the tradition of seminal bronze reliefs such as those that the early Italian Renaissance sculpture Lorenzo Ghiberti (*c.* 1378–1455) made to decorate the massive doors for the east portal of the Baptistery in Florence, three of which were shown in 2007 at the Metropolitan Museum of Art in New York.

Johns's sculptural approach to describing numbers in his reliefs is markedly varied. Some of them have softened edges that become embedded in the rectangular ground; others appear in sharper relief, yet it is rare to find a digit that has solid contours around its entire edge. Sometimes, in the 1, for instance, a part of the ground seems to cross the edge of a number, while in another part it appears to be under it (fig. 136: see the numerals 1 and 2 in the fifth row). At times either the figure or the ground is partially defined by a layering of materials in the wax model, lending a mottled sense of shallow depth; the finished cast is a complex combination of drawing, painting, collage, and assemblage, as well as printmaking. In these reliefs Johns indicates form and space through a variety of drawn and painted gestures—from a clean straight edge to a broad stroke in the ground abutting a number, as in the left edge of the 2 (fig. 136, same detail as above) —as well as indentations and contrasts of light and dark. The finished works assert the primacy of process and indicate its continued importance in Johns's art and thought. The markings and collage elements assert their independence, while at the same time they describe the grid and numbers that give the composition its formal structure.

After making the two large *Numbers* reliefs, Johns tore and reassembled the wax left over from the models to make casts for a group of smaller works, each containing stenciled numbers in order, from zero to nine, in a grid. Johns cast the works in bronze, aluminum, or luminous silver and then chased and patinated them, each material slightly modulating the character of the piece. He also molded some of the leftover wax into a cylinder, creating a vase (2007; fig. 145) that recalls his earlier investigations of implied volumetric space in two-dimensional works such as *Voice 2* (1982; fig. 34) and the Usuyuki crosshatch paintings (see fig. 32).[22]

Some of these smaller reliefs are designed to hang on the wall, stressing their relationship to painting, while others are freestanding and sit on a base. Johns included hanging devices on all of them, however, and treated the back of each sculpture "with the same degree of thought" as the front.[23] Although less apparently worked than the fronts, the backs of the recent sculpture reliefs have the same grid structure, with the digits reversed and appearing as ghost images that disappear into the ground. In some works, 0–9 of 2008, for instance, the verso has the wrinkled appearance of canvas (fig. 150). Johns had started investigating alternative ways of representing two and three dimensional space in the mid-1950s, with works such as *Canvas* (1956), for instance, which has a reversed painting stretcher attached to the front of the picture, drawing attention to the space behind the canvas, as well as to its properties as an object in itself.[24]

In most of Johns's early sculpture the base was an important component of the work. Typically, he would have formed this from the same material as the object, either suspending the object from its stand with wire or merging the sculpture with its support, treating it as an integral part of the work. In most cases, the ironically organic form of the common manufactured object contrasted with the more angular, finished appearance of the base, though sometimes, as in *Flashlight III* (fig. 139), for instance, the base anthropomorphically cradles the intimate object. In contrast, the later small 0–9 bronzes slide into simple matching metal frames that sit on a plain wooden base (see fig. 150).

Apart from a bronze called *Fragment of a Letter* (2009)—partly based on a letter from Vincent Van Gogh to his friend, the painter Émile Bernard, about

*Vase*, 2007
Bronze
28¾ × 8 (diameter) (73 × 20.3)
Collection of the artist

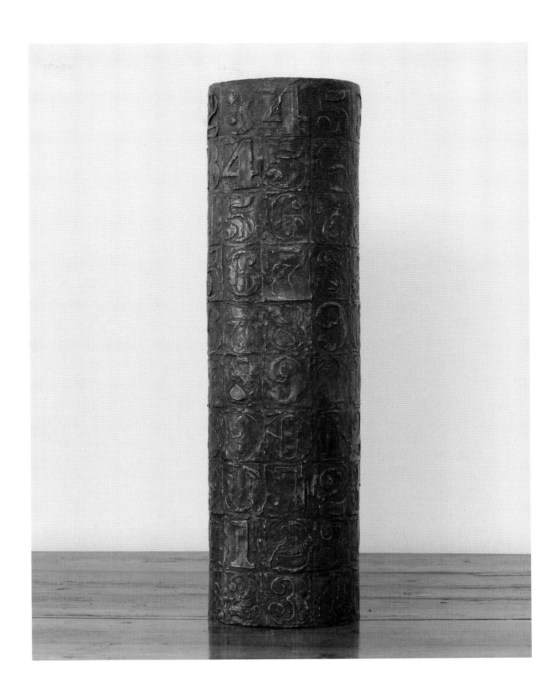

artistic kinship—all of Johns's recent sculptures depict either numbers or other meaningful symbols such as sign language. Johns had first used numbers in his work in 1955 in four white encaustic and collage paintings, each depicting a digit, or 'figure' as Johns referred to them, punningly suggesting that they were his version of 'figure' painting. Assuming most of the space in their individual squares, the numbers have a monumental character that reinforces their relationship to the body. Numbers recur in Johns's work more than any other subject.[25] Already, by 1960, he had established the four specific configurations and titles for his numbers compositions—"Figures", "Numbers", "0-9", and "0 through 9"—that have served as the foundation for hundreds of paintings, drawings, prints, and sculptures.

Johns's first use of a grid was in the painting *Gray Alphabets* (1956; fig. 8), where it was used as an organizing principle to arrange the twenty-six letters of the alphabet. The following year, Johns made *Numbers* (1957; fig. 147), a grid painting

Some of the *Numbers* reliefs have a straightforward solidity that manifests their character as objects. Others have a more lyrical aspect, underscored by the massing of emblematic elements within their surface. Brushstrokes and drips blur the sculptures' contours, masking the distinctions between solid and void and leaving reminders of the artist's process. The sculpture of these later years has the sensuous tactility of the most richly worked of Johns's encaustic paintings. Some bear the impressions of screens, hand and fingerprints, parts of news articles, house keys, and even the cast foot of dancer and choreographer Merce Cunningham, the imprinting manifesting Johns's long experience as a printmaker. For Johns, the keys, foot, and newsprint provide a sense of scale, while also lending context to the more abstract character of the grid and numbers.[26]

**146**
*0-9 (with Merce's Footprint)*, 2009
Bronze
19⅛ × 37⅛ × 1¼ (48.9 × 94.3 × 3.2)
Private collection

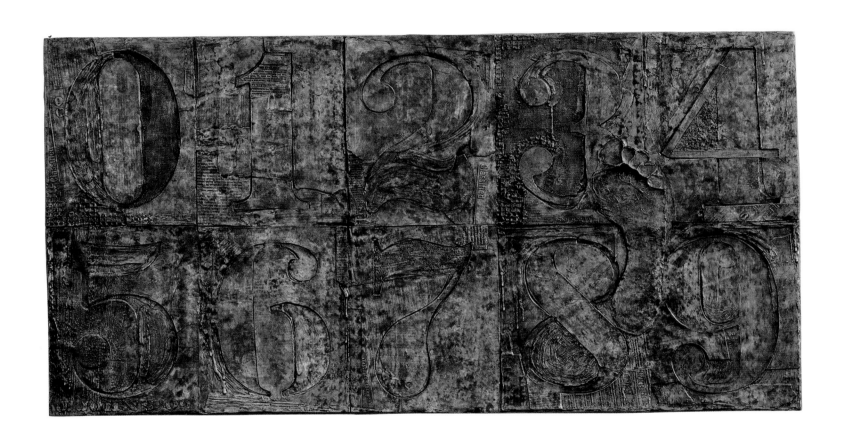

using the numbers 0 to 9, leaving the upper left unit blank and repeating the numbers twelve times from left to right in sequence. Apart from the first, each row starts and ends with the same number. This establishes a diagonal pattern of odd and even numbers read one way and repeating figures in the other direction. Johns has recycled this matrix often in his work, including both the aluminum and bronze *Numbers* reliefs of 2007.[27] In this arrangement, each number asserts its individuality in the context of the others. At the same time, the stream of numbers and allover pattern challenges our habit of fluid reading from left to right, requiring targeted attention to define the progression. In 1958, Johns started to make paintings in which the numbers 0 to 9 were arranged in two rows, the same format he employed in the relief series *0-9* and *Numbers (0-9)* dating from 2008 to 2011 (see fig. 148). He elaborated on the early *Numbers* paintings in numerous works on paper in which the numbers appear in two rows on a single sheet, or on separate sheets that can be hung in one row or two (see fig. 149).[28]

Like reciting the alphabet, the practice of learning to count to ten is a common building block of childhood. Johns's numbers are invested with an innocent purity; they provide the viewer with the opportunity to experience a well-known sign anew.[29] Johns told David Sylvester in the mid-1960s that he worked with flags, targets, maps, letters, and numbers because they were "preformed, conventional, depersonalized, factual, exterior elements."[30] The preassigned pattern of the numbers, always in the repeating established sequence of 0 to 9, left Johns room to allow process to take over and for the abstract to collide with literal representation. For Johns, process can be of "greater meaning than the referential aspects of [a] painting."[31] In choosing to repeat subjects, he also speaks of "tone of voice that can change from picture to picture."[32] Early on, Johns identified a vocabulary or structure that allowed for variation and repetition. The sequence and infinite character of numbers in particular, even within the confined system of 0 to 9, provided an apt metaphor to match Johns's serial approach to making art.

In his recent *Numbers* sculptures, Johns deliberately marks both figure and ground through texture, scraping, cutting, indentations, gesture, hand and foot prints, and other surface elements, as well as added items such as keys and newsprint. The patinas lend further individuality, in both tone and degree of polish. Even the character of the matrix changes from one to the next. In the silver relief *0-9* of 2008 (fig. 150), as well as the white bronze version of 2009 (fig. 151), Johns has added additional lines that bisect the digits and further emphasize the grid structure. Johns varies the relationship between figure and ground through this use of allover patterning and surface articulation. Using drips, smudges, fingerprints, gestural brushwork, and the textures of newsprint, cardboard, linen or canvas, screens, wood grain, and what looks like stone, often in overlapping collaged layers, Johns's surfaces confound our expectations of the properties of bronze, lending it a handmade character (see figs. 146 and 150-53). These elements play against the rationality of the numbers and the grid. Discipline and coherence coexist with extempore riffs. The sculptures are worked to an extent that—and this is especially true of the small reliefs—the nominal subject can seem to disappear in the buildup of surface; their character is informed by the convergence of these two elements. Melding free-form experimentation with age-old modeling techniques, Johns encourages the viewer to consider his recent

**147**
*Numbers*, 1957
Oil on cardboard
8¼ × 6 (21 × 15.2)
Private collection

**148**
*0-9*, 1959 and 1962
Acrylic on canvas
20½ × 35½ (52.1 × 90.2)
Collection of Martin Z. Margulies

**149**
*0-9*, 2013
Monotypes on 10 separate sheets
of hand-torn Kurotani Kozo paper
8 × 6¼ (20.3 × 15.9) each sheet
Collection of the artist

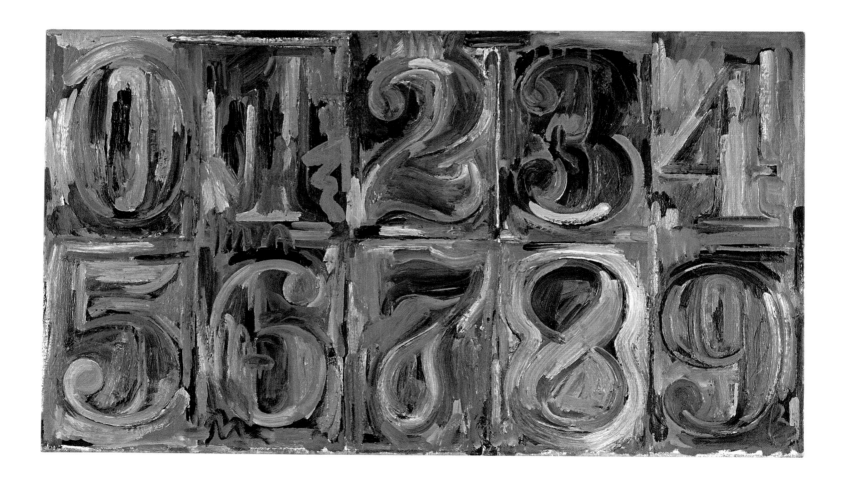

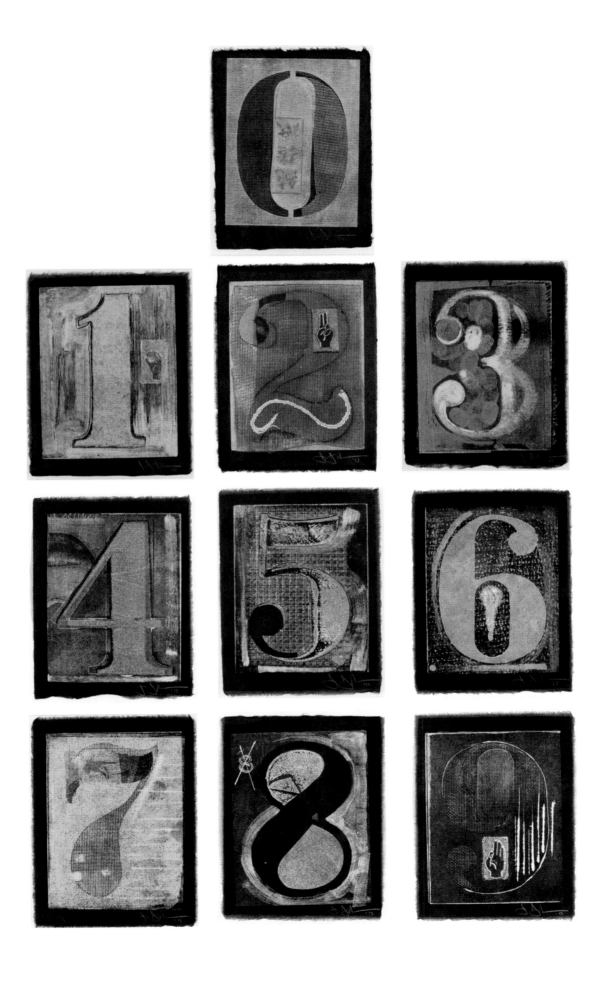

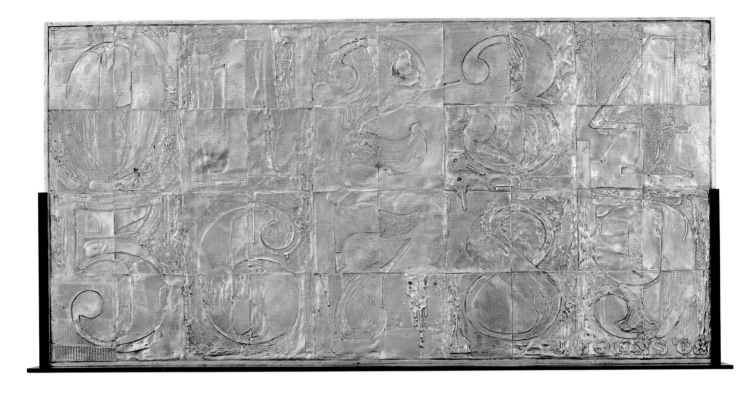

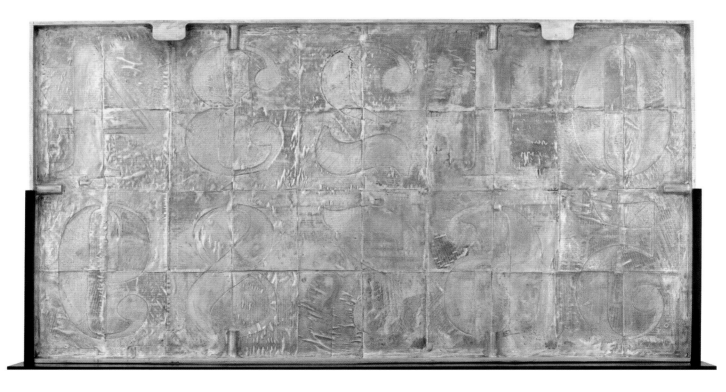

**150** TOP AND ABOVE
0–9 (front and back), 2008
Silver
20⅛ × 37⅞ × 1¼ (51.1.2 × 96 × 4.4)     OPPOSITE
Private collection                      0–9 (detail of front), 2008

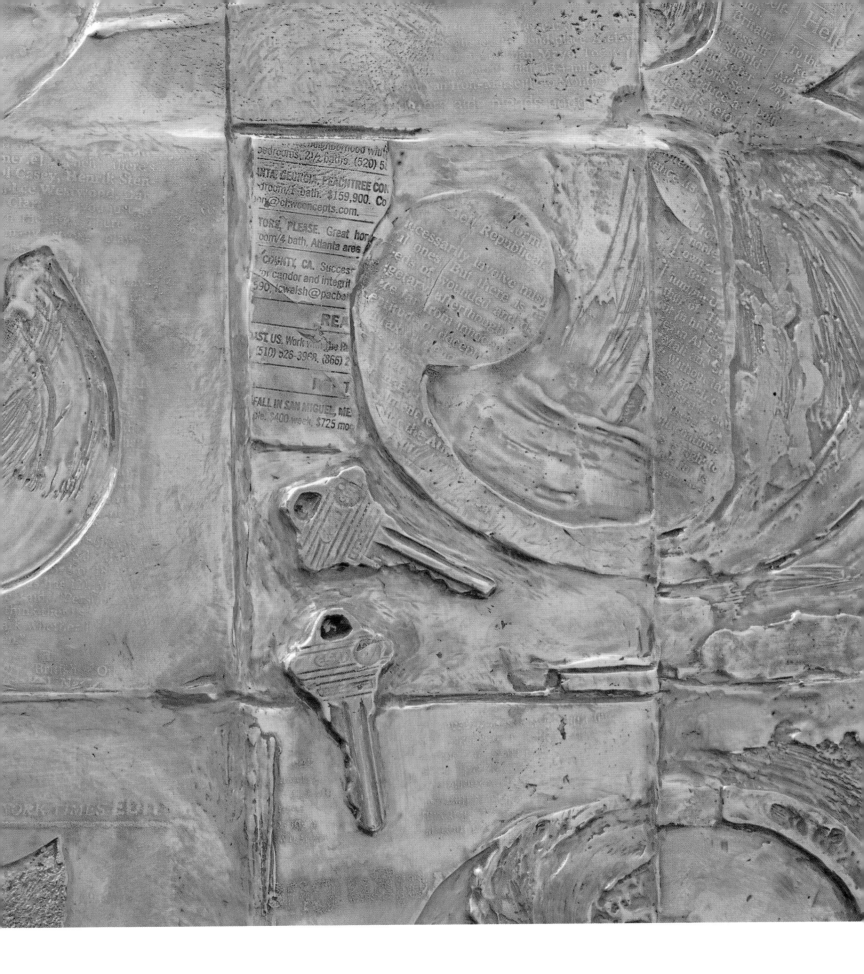

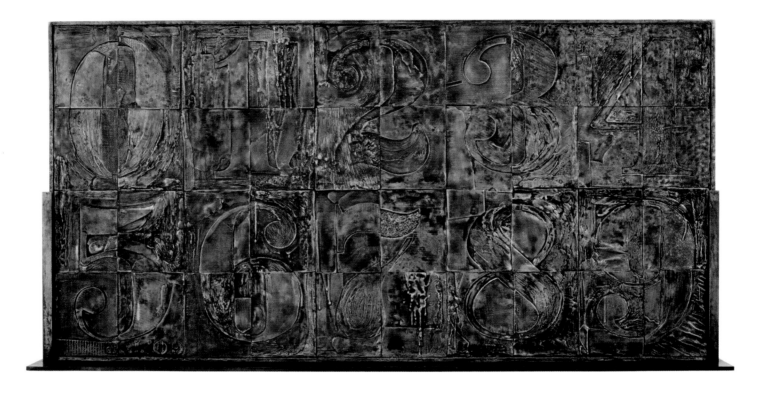

**151**
0-9, 2009
White bronze
20⅛ × 37¾ × 1⅜ (51.1 × 95.9 × 3.5)
Private collection

OPPOSITE
0-9 (detail), 2009

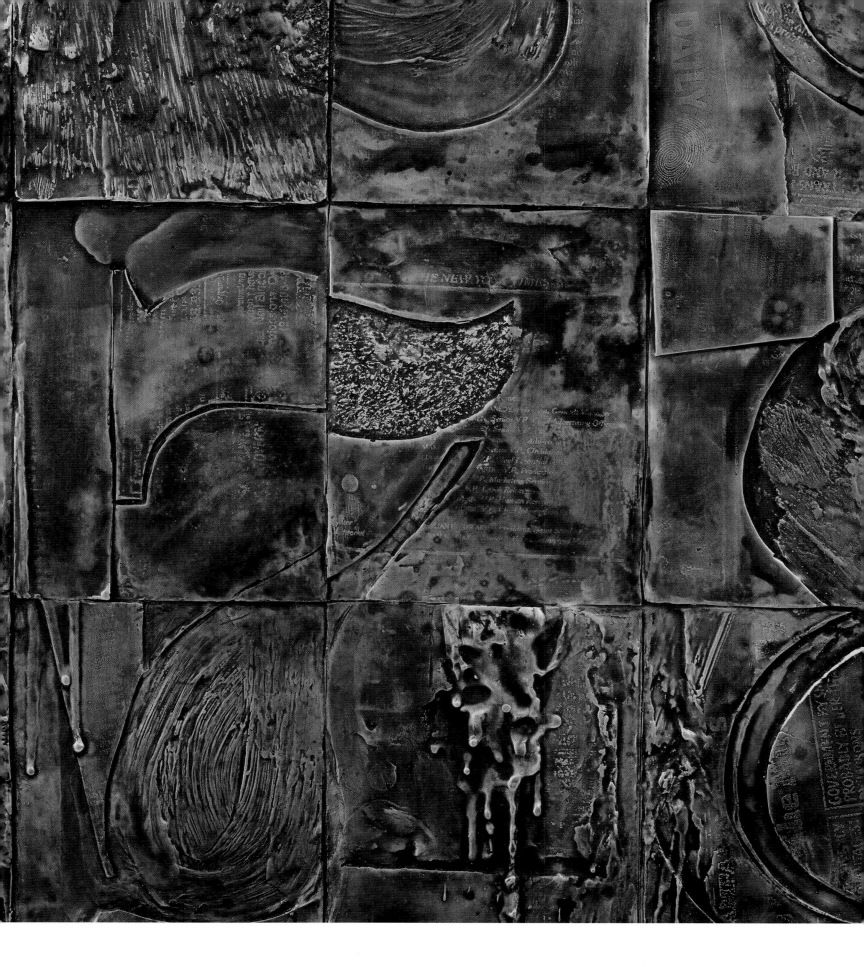

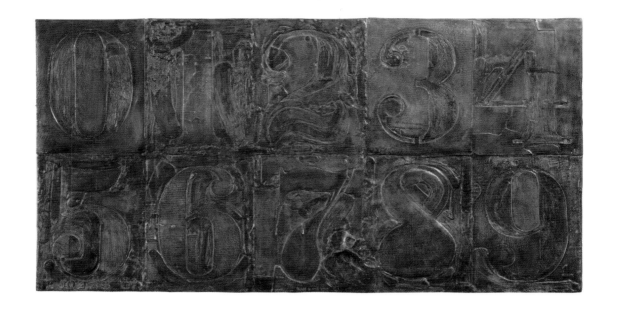

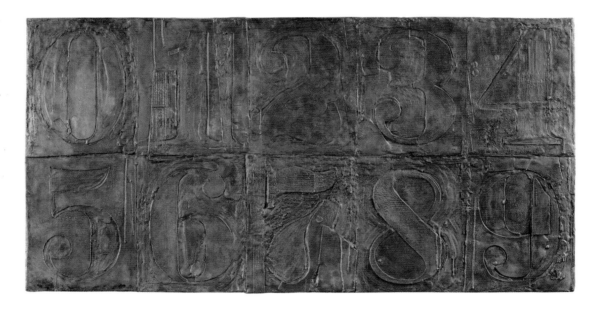

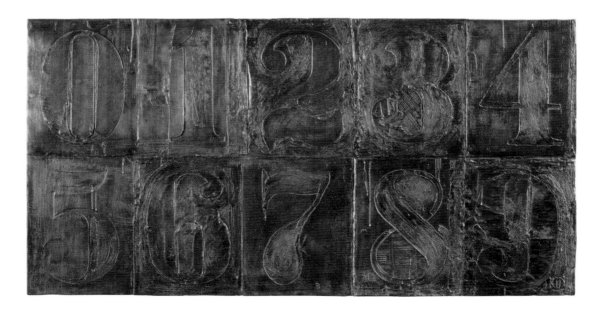

sculpture as part of a long continuum, pushing the limits with new approaches and a judicious measure of wit.

◆

In 2014, Johns exhibited two paintings, ten drawings and two etchings at the Museum of Modern Art in New York (see fig. 160).[33] Referred to as *Regrets*, the series evolved when Johns noticed in the summer of 2012 a reproduction of a tattered photograph (fig. 156) in an auction catalogue announcing the sale of Francis Bacon's *Study for a Self-Portrait* (1964). As with other seemingly random moments in the artist's life—his dream of painting a flag, catching a glimpse of a crosshatch pattern on a passing car, or a childhood memory of a Halloween costume—the photograph spurred a new series of work. It is this body of work, as well as a second group of pictures triggered by a different photograph, that are discussed here.

Around 1964, Bacon asked the photographer John Deakin to take some pictures of his close friend, the younger figurative painter Lucian Freud. Bacon often used photographs as a starting point for his portraits. In Deakin's photograph, perching on a quilt at the edge of a small brass bed, his forehead resting in his right hand, a pondering Freud appears drained or sorrowful. Bacon combined Freud's pose in this photograph with another one Deakin took the same day and used them as a reference for *Study for Self-Portrait*, unifying Freud's body and his own head into one tormented figure. In the process of making the painting, Bacon completely mangled the photograph. It remained in his famously cluttered studio at his death in 1992, paint-stained, creased, and scratched. Part of the image had been torn and folded, creating a dark void.[34] The Christie's sale catalogue included several of the photographs Deakin had taken of Freud; the one that caught Johns's eye, and apparently Bacon's too, was the only one in which Freud appears overwrought.[35]

Johns tore the reproduction of the photograph from the auction catalogue and began transforming the image, embarking on an intense eighteen-month stretch in which he created a cohesive group of fourteen works. Tracing the photograph and photocopying his tracing, Johns extended Deakin's vertical image in *Study for Regrets* (2012; fig. 157) in a firm hatch of bright-colored pencils, using all six primary and secondary colors. A sharp, thin black ink line borders each color. Figure merges with ground through Johns's division of the image into organic patterns of small, irregular shapes, reminiscent of those in a paint-by-numbers set. Johns turned Deakin's vertically oriented image into a horizontal composition, creating a mirror image to the left of it in a wash of gray watercolor. With the image doubled, the void—the result of the original photograph being torn and folded at the bottom and lower left edge—assumes a dominant frontal presence. The missing sections of the photograph become just as significant for Johns in the description of space as the image itself. He adhered to the mirroring here, too, coloring the left side in red, the other in green. Above this bifurcated vertical rectangle, a plasmic sphere forms, shaped by four creases in the photo, each one filled in a different color: yellow and gray watercolor and red and blue pencil.

At the upper right, Johns used a preformed stamp to add title and signature to each work. While suggesting a misgiving or setback, "Regrets/Jasper Johns" was in fact a stamp the artist had initially made as an efficient means of declining the many requests and invitations he receives. This approach to signing takes Johns's

**155**
Francisco de Goya
Plate 43 from *Los Caprichos: The Sleep
of Reason Produces Monsters* (*El sueño
de la razón produce mostruos*), 1799,
published 1908-12
Etching and aquatint on wove paper
8½ × 6 (21.6 × 15.2) plate
12 × 8⅜ (30.4 × 21.3) sheet
The Metropolitan Museum of Art,
New York

**156**
John Deakin
Photograph of Lucian Freud, *c.* 1964
From Francis Bacon's studio. Dublin
City Gallery The Hugh Lane

**157** OPPOSITE
*Study for Regrets*, 2012
Acrylic, photocopy collage, colored
pencil, ink, and watercolor on paper
11⅜ × 17¾ (28.9 × 45.1)
Private collection

**158** OVERLEAF, LEFT
*Untitled*, 2012
Pencil on paper
19¾ × 14⅜ (50.2 × 36.5)
Collection of Janie C. Lee

**159** OVERLEAF, RIGHT
*Untitled*, 2012
Watercolor and pencil on paper
22⅝ × 15½ (57.5 × 39.4)
Private collection

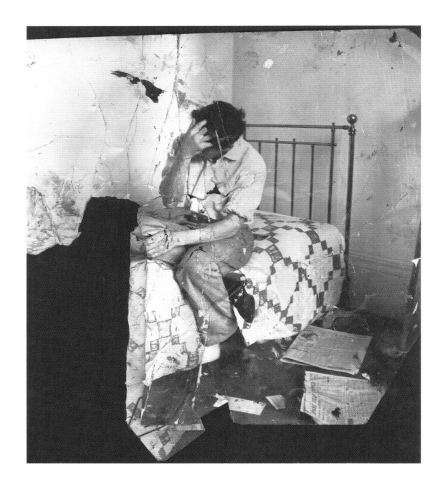

common use of letter stencils and other non-autographic forms to a new extreme, offering the artist's signature but, ironically, in a non-original form.

Two small vertical untitled drawings of 2012 —one in pencil (fig. 158), the other in watercolor and pencil (fig. 159)—further elaborate Johns's alteration of Deakin's photograph. In the monochrome version, parallel lines and masses of hatching lend definition, while sharp lines delineate creases in the photograph and suggest volume. Johns has left some segments of the composition blank, filling others with gray tones ranging from very light to dark. The missing section of the photo at the lower and left edges is compelling here, as it is the most densely worked area and an important part of the composition that foregrounds the image of Freud seated on the bed. Freud's head appears as an amorphous flat crest shape and, did we not know the source of Johns's tracing, it would not be obvious in the massing of irregular geometric planes and skeins of lines that form the composition.

A notation at the bottom of the sheet that reads "GOYA? BATS? DREAMS?" and a lighter one just above that says "Goya?" indicate the direction of Johns's thoughts. Spanish painter Francisco de Goya (1746–1828), like Johns, was a master printmaker. His etchings and lithographs present a clear, vivid and powerful vision of man's inhumanity to his fellow man. In 1799 he published *Los Caprichos*, a portfolio of eighty allegorical etchings, including the well-known *The Sleep of Reason*

*Produces Monsters (El sueño de la razón produce monstruos)* (fig. 155). In this print Goya depicts a fanciful and terrifying image of a mind in a dream state, running amok. Highlighting the role of the creative unconscious in inspiration, alongside reason, it shows an artist asleep at his drawing table, head in hands, surrounded by an ominous if fanciful group of bats, owls, and a lynx. There is a clear resemblance between Freud's expression in Deakin's photograph and the slumped figure in Goya's print.

In the watercolor version of this drawing, the missing part of the photograph assumes less importance. Instead, Johns plays with ideas of doubling and the type of reversal usually associated with printmaking. As Bacon did in conflating several images into one, Johns has doubled Deakin's portrait of Freud, reversing and superimposing one image of Freud on top of the other. In this version, Freud appears to hold his head in both hands, with another two hands crossed in his lap. Layered forms and differentiated harlequin patterns in watercolor serve to define the space, with a slight recession into depth on the left side. The suggestion of space is arrested by a delicate net-like hatching in pencil that forms on the surface as a stippled screen, toning down the intensity of the watercolor. Centrally framed by the double bedsteads, this drawing accentuates the now amorphous Freud, the lighter colors of figure and bed bathed in a dappled light set off from the surrounding darker geometries. Johns inscribed "LUCIAN FREUD" at the lower right, calling attention to his source, just as he had questioned its kinship with Goya's print in the related monochrome drawing.

A large painting Johns made in 2013 includes aspects of each of the three drawings he made the previous year. In *Regrets* (fig. 160), Johns built on the central form, now whole instead of bifurcated, as well as the mirroring that he had explored in the horizontal *Study for Regrets*. *Regrets* is a gray painting, yet with a rich range of color, including orange, pink, green, purple, and blue in addition to black, brown, gray, and white. The repeated and reversed figure has dissolved into a mass of planes of varied sizes, defined by lines and paint more broadly applied. There are squiggles and more angular forms, as well as cylinders that subtly articulate space. The two sides have different qualities, the left showing a greater independence of form and color, the right a more tightly rendered mix of geometric and organic elements that outline the figure and bed, its frame now a strong structural feature of the composition. Johns included his signature spraypaint blob, here a dark drip at the lower right.[36]

The conflation of abstract and more representational elements in this work permits a range of possible readings. The canvas calls to mind a satellite map of some dystopian world, a mass of variegated pixels in wash and hatchings, separated by lines of varying widths, many broken up, the gray mass above abutting a dark sea below. Johns made his first map painting in 1961 and maps have featured in his work on and off since then. Satellite imagery has become widely available in the twenty-first century and has many applications, but is perhaps most associated with its use in intelligence gathering and warfare. Equally macabre, the central abstracted orb that appeared in *Study for Regrets*, knitting together the mirrored images, has materialized as a skull in *Regrets*, with eye sockets, nostrils, and jaw. Skulls have appeared periodically in Johns's work since he first included one in *Arrive/Depart* (1963–64; fig. 79). In this context, the dark shape below assumes the vulnerable presence of a human torso without arms or a neck.

It is a mere suggestion of a figure, however, and in this it also proclaims a fathomless void. The lost area of the photograph emerges in *Regrets* as a muted crypt-like form.[37]

Altering his signature to an appropriate scale, Johns signed *Regrets* as he had the study. To this end, he asked his friend Bill Goldston, director of the print workshop ULAE, to enlarge the stamp as a screenprint to a proportion befitting the size of the larger works in the series, and the artist then inscribed it on most of the works in the series.[38] Not only does the silkscreen include the title and signature, but it also indicates Johns's specifications for the change in scale. Johns seems intrigued by such potential disruptions in his pictures. Forty-five years earlier, he had included similar information in his work at a time when he was also experimenting widely with technique and format, employing screenprinting and photo reproduction, as well as exploring scale and proportion (see fig. 163). Suggestions of scale and space in a painting usually come from the relationships between depicted forms, not from a written instruction. Johns's combination of word and painted form works to challenge ideas about ways that space can be represented on a two-dimensional surface, taking on a conceptual implication as well as offering an added element that enlivens the composition.

Johns subsequently made one painting, seven drawings and two prints in the *Regrets* series, each of which follows the composition of the 2013 painting with subtle alterations (see, for instance, *Untitled*, 2013; fig. 162). The photograph that prompted the series presented an image of Freud but also a trace of a creative life and community. Bacon's treatment of the photograph provides an added narrative; embedded in its tears and creases and paint splatters is a sense of time, age, memory, abuse, and, ultimately, care. Johns's series concludes a complex progression of artistic recycling that casts light on the ties between artists, their creative lives, and their work.[39] The *Regrets* series also carries vestiges of Johns's previous work, for example, the use of mirroring in *Between the Clock and the Bed* (1982–83; fig. 42), a large, hatched abstraction itself based on a self-portrait by Edvard Munch (fig. 43).[40] Munch's portrait shows the artist in his studio, the small bed with a patterned quilt beside him implying solitude and mortality, the subject matter resonating with Deakin's photograph of Freud. In addition, the colorful patterns of red, yellow, and blue that contrast with more somber grays and blues in three of the *Regrets* works refer to Picasso's grieving and forlorn *Harlequin* (1915; fig. 126)—the artist as loner, living on the edge.

Over ten years before he made the *Regrets* series, in 2002, Johns had already appropriated a photograph with a composition remarkably similar to Goya's *The Sleep of Reason Produces Monsters*, and to Deakin's image, using it to make some drawings (figs. 165 and 166), before putting it aside. The photograph that triggered these earlier drawings was a black-and-white documentary image shot by the distinguished British photojournalist Larry Burrows during the Vietnam War (fig. 164). Published in *Life* magazine in the spring of 1965, it shows U.S. Marine Lance Corporal James C. Farley alone in a supply shed, collapsed on a trunk, head in hands, after a failed helicopter mission during which Farley watched two fellow Marines perish at close range.[41] Johns recognized parallels between this image and Deakin's portrait of Freud. As he related to Julie Belcove, "a similar mood is conveyed, and it also has to do with the face being buried, I think in the arm, but nothing to do with the art world."[42] The photograph of this broken-down and solitary young soldier radiates a piercing bleakness; in the foreground stenciled

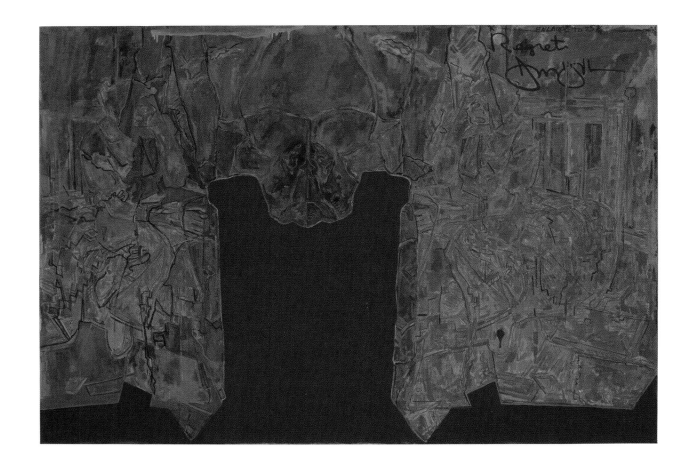

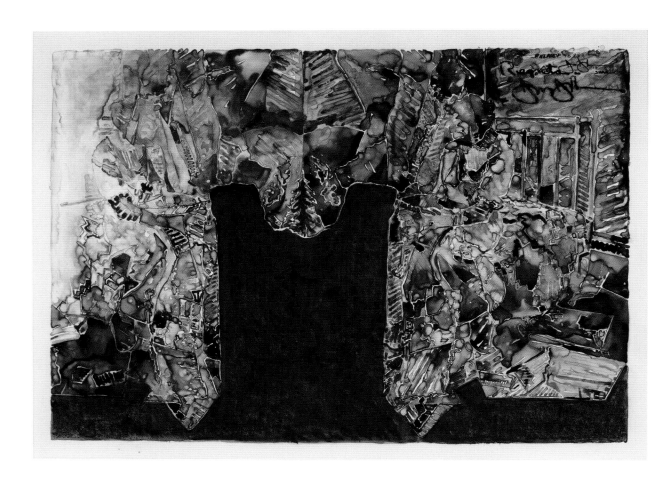

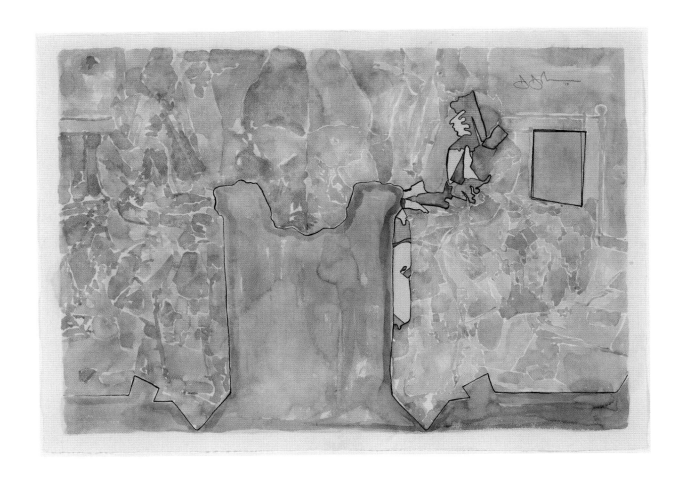

**160**
*Regrets,* 2013
Oil on canvas
67 × 96 (170.2 × 243.8)
The Museum of Modern
Art, New York

**161**
*Untitled,* 2013
Ink on plastic
27½ × 36 (69.9 × 91.4)
The Museum of Modern
Art, New York

**162**
*Untitled,* 2013
Watercolor on paper
22¼ × 31 (56.5 × 78.7)
Anne Dias Griffin

**163**
*Screen Piece 3*, 1968
Oil on canvas
72 × 50 (182.9 × 127)
Nerman Museum of Contemporary
Art, Johnson County Community
College, Overland Park, Kansas

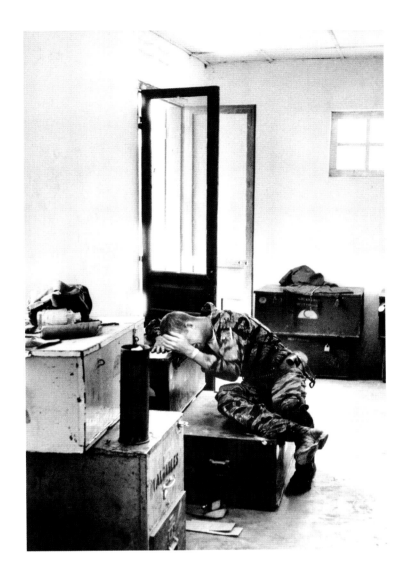

**164**
Larry Burrows
Marine Lance Corporal
James C. Farley, a helicopter crew
chief, crying in a supply room after
a tragic and frustrating mission,
Da Nang, Vietnam, March 31, 1965

**165** OVERLEAF, PAGE 252
*After Larry Burrows*, 2002
Ink on plastic
12½ × 10½ (31.8 × 26.7)
Collection of the artist

**166** OVERLEAF, PAGE 253
*After Larry Burrows*, 2002
Ink on plastic
17½ × 13⅛ (44.5 × 33.3)
Collection of the artist

**167** PAGE 254
*Farley Breaks Down—
after Larry Burrows*, 2014
Ink and water-soluble
encaustic on plastic
31⅞ × 24 (81 × 61)
Private collection

**168** PAGE 255
*After Larry Burrows*, 2014
India ink and water-soluble
encaustic on plastic
32 × 24 (81.3 × 61)
Anne and Joel Ehrenkranz

on a wooden box is the word "VALUABLES." With its raw, formal power and narrative poignancy, the image is a study in contradictions that encapsulates one man's deep sorrow as well as the sweeping devastation of the Vietnam War.

While working on the *Regrets* series, Johns decided to revisit the group of earlier drawings he had made based on this image. These ink on plastic drawings from 2002 are small and humble, on the scale of intimate portraits or figure studies. In them, Johns investigated both the formal qualities of Burrow's photograph and its subject, following the vertical orientation of Burrows's image, yet rendering it highly abstract with no anecdotal detail. Through the seepage of a range of molten gray and black ink, he reduced Burrows's composition to an amorphous environment, with little distinction between figure and ground. The figure, described in a tapering black outline, appears dwarfed amid the atmospheric aqueous ink; the hand-drawn quality of the mark-making brings attention to the materials used as much as to the subject.

When Johns returned to this subject in 2014, having worked on *Regrets* for two years, he included more distinct traces of Lance Corporal Farley in a further group of ink drawings and monotypes (figs. 167–169). Interior details of the supply shack are also more clearly articulated, from the stacked trunks to the casement doors and window. Whether the figure dissolves into the pooling ink, or emerges

2002

FARLEY BREAKS DOWN    AFTER LARRY BURROWS

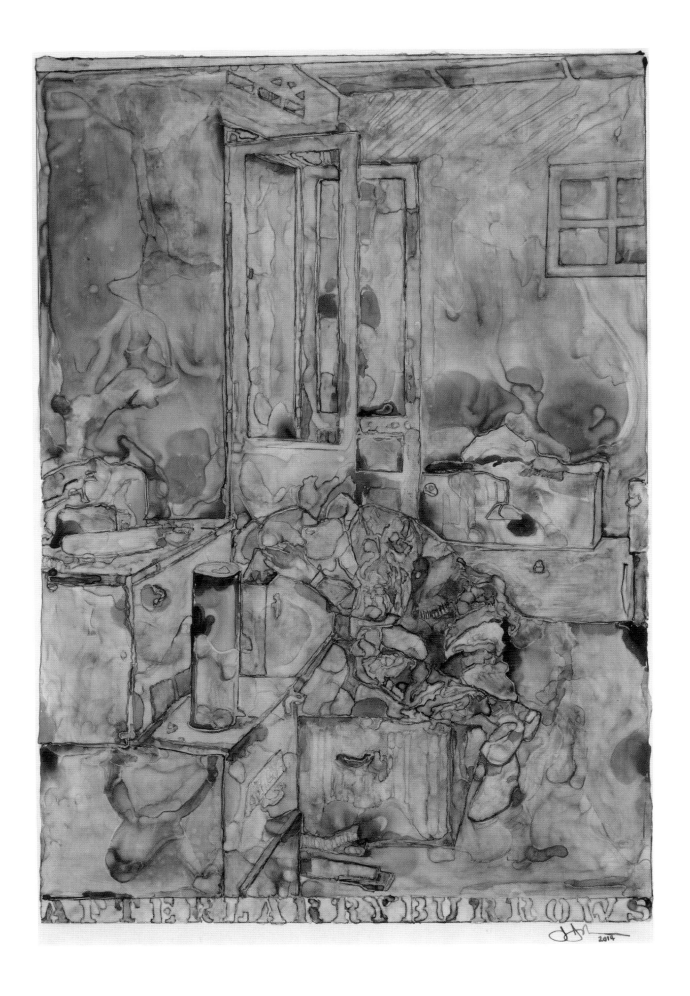

AFTER LARRY BURROWS

In 2015, Johns made several monotypes triggered by the Burrows photograph (fig. 164), unique prints made by applying ink and watercolor directly to a sheet of mylar plastic, which was then run through a press to transfer the image onto paper. The freedom of the monotype technique lends a sense of immediacy to the resulting print. As in most of the works in the *Regrets* series, in these monotypes Johns has doubled and mirrored Burrows's composition, while adhering to its vertical format. The composition is bisected off-center to the left, the fulcrum provided by the artillery shell in the foreground, which Johns has extended vertically into a long passage of pooling and broken-up bister. Where the mirrored shapes at the top of the *Regrets* works joined to form a skull, here, the space between the cylinder and the figure forms a muted if distinct heart shape. The composition is simple, the wash a translucent, ethereal range of tones— now the colors of war camouflage and black-edged mourning—to suggest a thinned atmosphere. Any roughness has been eradicated, smoothed, and abstracted. There are no diversions here; only a directness, as if to ask, "How can we correlate visual beauty with abject desolation?"

**169**
*Untitled*, 2015
Monotype on paper
37⅜ × 29⅞ (94.9 × 75.9)
Kravis Collection

in the softness of bleeding passages of black and red or the groovy colors of the psychedelic 1960s, there is a tender fragility that distinguishes this group of works from the more disquieting *Regrets* series. In these images, Johns makes explicit reference to his source, through stenciled letters at the bottom of the page or hand-written ones in the margin.

In addition to mirroring, in these works Johns explores the effects of conjoining two compositions, both the cropped version of Burrows's photograph that appeared in *Life* and the uncropped original. In the published version, the expended shell sitting on a foreground cabinet is bisected by the crease of the page fold. Johns makes this division the linear axis of his own image, placing the shell off-center to the left in a configuration similar to the one in the magazine. In most of the works, it becomes a thin, vertical rectangular element. He also includes the French doors to the right of this axis and, in some works in the series, the window at the upper right that Burrows shot but that was cropped from the *Life* spread. In appropriating the Burrows photograph—fifty years later—as well as the cropped version that appeared in *Life* two weeks after the photographer shot it, Johns's work provides a conceptual metaphor for exploring the passage of time and how memory can alter our understanding of events.

Johns's virtuosity persuades us to linger with his art. We are not necessarily taken in—at least not initially—by the source of his appropriations, but rather with the absorption with which he depicts them. It is his stirring visual language that encourages us to immerse ourselves in the work. In the group based on the Burrows photograph, Johns's freely applied tones and broken outlines respond as much to the angularity of the walls, and to the delicate glass-paned doors and window of this French colonial structure, as to the characteristics of the slumped figure and the range of light. In spite of the essential unity of surface, the figure stands out as a measure of wholeness—even if a vulnerable one—in the midst of a broken world.

◆

Whether working in gray, the primary colors, or more off-base pinks and purples in paintings and works on paper, or in sculpture with varied patinas, Johns continues to engross viewers with the visual allure of his sensuous surfaces. Over the past half century, he has deliberately explored abstraction and representation in his work in an expansive range of techniques, forms, and compositions, with process being as important as any referential element. Johns's art continues to confound expectations, as he changes it by degrees and reconsiders earlier variations. After six decades, he persists in affecting his viewers in his reserved yet resolute way. Johns's recent work persuades us that accumulated experience begets wisdom. Maintaining his independence, and marrying a rigorous conceptual foundation with elegiac markings, Johns has stuck with a notably consistent approach to making art. At the start of the twenty-first century, he perseveres in making work that communicates surface and interior, the inner spirit that guides external conditions, and the conditional, fugitive mutability of life that gives humanity its extraordinary poignancy. At the same time, he continues to plunge into uncharted territory, taking risks and remaining open to new approaches.

Like all his art, Johns's work since 1980 demands the viewer's active engagement in the construction of meaning, as if to recall our common experience of, and

equivocation about, the world. Yet his audience has often found meaning elusive in the search for one answer. Instead, at the heart of Johns's work is its multivalent aspect. There simply is no single explanation. His art asks us to look carefully, and to realize ambivalence rather than seek resolution.

When a full human figure (the artist's shadow) appeared for the first time in the *Seasons* (figs. 172 and 173), many saw it as a mark of sentimentality or an autobiographical reference that jibed with our understanding of Johns's art up to that time. Yet there has only been one distinct period in his sixty-year career— from 1956 to 1960—when the figure has not been present in some form, even if fragmented.[43] Roberta Bernstein observed in 1977 that the figure "infuses his work with a disturbing, emotionally charged quality."[44] In 1993, Barbara Rose postulated that perhaps Johns's autodidact nature inspired in him a lack of confidence in figure drawing that he only first addressed directly in the *Seasons*.[45]

Perhaps Johns's depiction of a traced figure in the *Seasons*, and his attention to it since then, is the natural outcome of an artist who from early on explored unconventional ways of figuration and has appreciated the reflective poignancy of this human element in his work all along. Take, for instance, the cast faces in *Target with Four Faces* (1955; fig. 45), each one's expression slightly different. Johns, describing the process of casting the face over time, told artist Terry Winters, "my model relaxed more each sitting, so, left in order, it would have seemed that she was going to open her mouth and say something."[46] There is the implied figure in the large drawing *Diver* (1962–63; fig. 21) as Johns described to Richard Shiff,

**170**
Paul Katz
Jasper Johns with *Periscope*
*(Hart Crane)*, Front Street studio,
New York, 1963
National Gallery of Art Library,
Washington, DC

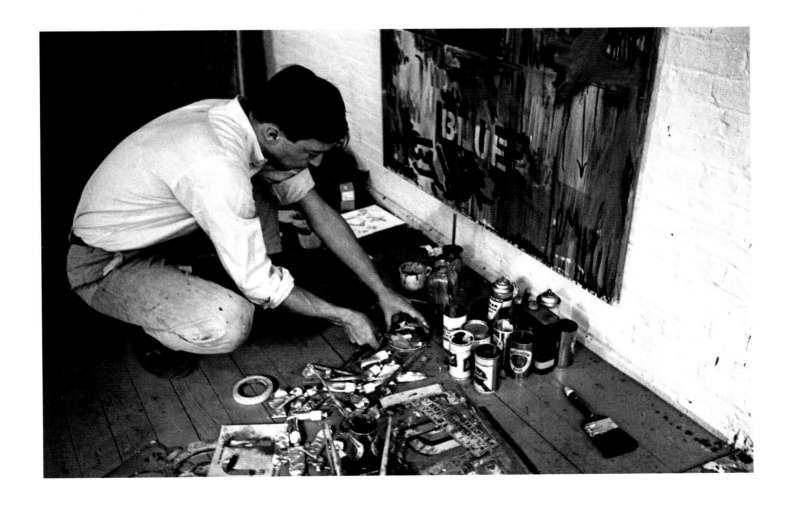

**171**
*Skin*, 1975
Charcoal and oil on paper
41¾ × 30¾ (106 × 78.1)
Collection of Richard Serra
and Clara Weyergraf-Serra

"made in the scale of the human body while I was trying to determine how I might represent a swan dive in a large painting."[47] During this time, Johns experimented with technique and ways to depict the figure by imprinting his own body on various surfaces (see fig. 171). He also cast Merce Cunningham's foot for the 1964 Sculp-metal *Numbers* commissioned by Philip Johnson for Lincoln Center and again, more than half a century later, included it in his 2007 *Numbers* relief. Of the early cast, Johns told Winters:

> At the time, I thought it an amusing idea to get Merce's foot into Lincoln Center. And, shortly before he died, I cast his foot again, for the aluminum piece. I wanted to connect the two works with some, I suppose, personal detail.[48]

More recently, Johns has explored repetition and mirroring, working with two different photographs, each one of a broken-down male figure.

Both touch and vision manifest the "sense of life" instilled in his art.[49] Embedded in this sense of life, and in Johns's evolution as an artist, is his absorption in the activity of making art. Speaking in 2011, he remarked:

> So much of the meaning to me is in the making. While that's going on, there are shifts of thought and associations and paths of development you want to follow and you want to avoid. Somehow the viewer can have a similar experience of determining. It sounds corny, but you have a sense of being alive when you encounter the thing.[50]

Johns's affinity for experimentation is the prolonged act of a restless imagination. One of the fundamental lessons of his art is in the merits of persistence. Speaking to Calvin Tomkins in 2006, he explained:

> Part of working, for me, involves anxiety. A certain amount of anxiety, or hesitation, or boredom. Frequently, I think for a long time before I do something, even though I've decided over the years that this is absolutely pointless. Actually, when one works, one comes to a solution much more quickly than when one sits and thinks. But I can't avoid it. I just sit and wonder. I don't *think* that used to happen, but I'm not sure.[51]

Sculptor Richard Serra describes Johns as "a feast of colliding thoughts, a huge, continual, revolving process, picking up the pieces and dovetailing as it moves along, an evolution that like Brancusi can go back to the same problem twenty years later, a person who hasn't closed the sequence."[52]

Throughout his career, Johns's process—the way a work of art evolves—seems to have been remarkably consistent. He once remarked that what he does "is closer to a laborer than to a Chinese poet."[53] Some of his descriptions of his methods, while giving the unconscious a significant role, are simply practical. He told Winters:

> Well, I'm never sure what work is. At its best it seems unconscious. There are no questions, you proceed. You do what you have to do, and it gets done...there seem to be two extreme possibilities. One imagines something that could exist, and then sets out to make that thing, to bring

**172**

*Winter,* 1986
Charcoal on paper
42 × 29 ¾ (106.7 × 75.6) sheet
Collection of Robert and
Jane Meyerhoff

**173**

*Summer,* 1985–86
Ink, watercolor, and pencil on paper
30⅝ × 17½ (77.8 × 44.5) sheet
24¼ × 16⅛ (61.6 × 41) sight
Ryobi Foundation

it into existence. Or one imagines that there is something to be done, and one engages in that activity and observes what happens. I suppose the extremes blend in some way...One may proceed in a way that allows the work to come into being without a preconception of what it will be. And at other times one may have an image of the final work in mind but no clear idea of how to achieve it...And I guess there may be some center in us from which these thoughts and impulses arise. Sometimes in the middle of work one thinks, "This is all wrong." But what is responsible? I mean, one did things as well as one could. [*Laughs.*] And sometimes things happen gracefully and seem to have nothing to do with any decision one has made. You're grateful that it happens that way, as opposed to, say, "This is all wrong." You have something that you believe shows some quality or life that you appreciate but don't feel particularly responsible for.[54]

While such descriptions may be revealing, the question of how various events in his life have affected his work is another issue. Of particular interest to critics and viewers has been Johns's relationship with Robert Rauschenberg, and Johns's admittedly painful childhood. Johns has been circumspect regarding the nature of his relationship with Rauschenberg, and says his childhood "had no stability at all." For Johns, John Cage, Merce Cunningham, and Rauschenberg, who he met in New York in 1954, were the "kin" who provided a sense of family that he lacked growing up and drew him into a creative community at a moment he was primed to absorb it.[55] "We called Bob and Jasper 'the Southern Renaissance,'" Cage recounted. "Bob was outgoing and ebullient, whereas Jasper was quiet and reflective. Each seemed to pick up where the other left off. The four-way exchanges were quite marvelous. It was the *climate* of being together that would suggest work to be done for each of us."[56]

Johns's Southern upbringing has been overlooked in studies of his work. His references to his own past and to memory recall similar concerns in the writing of another Southerner who dwelled on the past, William Faulkner. Barbara Rose has also observed that Johns's Southern background may figure, for instance, in his approach to time (customarily associated with a leisurely pace in the South), his carefully built up surfaces and choice of the encaustic medium that articulates each stroke, compelling viewers to linger and sustain perception.[57] Such an approach can be seen to be at odds, for instance, with the more spontaneous attitude of the New York school artists. Rose also compares Johns to Faulkner, both men bringing new ideas to traditional forms.[58] Faulkner's sharp prose intricately described the changes affecting small Southern towns in the first half of the twentieth century. His regional themes drew on the moral implications of history in the shadow of slavery and the Civil War, whereas Johns's turn to the past has none of Faulkner's distinctive southern imagery. Rather, both artist and writer rely on a richly textured language that causes reader and viewer to decelerate and closely consider form and its relationship to meaning.

Johns's expressive but impersonal style and wide-ranging iconography—"things the mind already knows"[59]—allow viewers to construct extended associations. Indeterminacy is central to Johns's work and imbedded in his style. Duchamp voiced the idea that the viewer's participation is essential to the completion of a work of art in his 1957 lecture, "The Creative Act." While perhaps

not a radical view today, Duchamp's attitudes had a profound effect on Johns and his approach to making art.[60] Johns counts on the viewer to take part in the accrual of meaning. Sometimes, the viewer's observations and ideas even stimulate Johns to make new work or a series and, in this manner, more associations form. Witness his artistic response to the viewer who brought to Johns's attention the term "catenary," defining the curve of his 1997 painting *Bridge* (fig. 127), which seems, at least in part, to have initiated the large series of *Catenary* paintings and works on paper that followed. Often, even sustained viewing of a work by Johns results in uncertainty, but also invokes John Cage's attitude that art should be "an affirmation of life—not an attempt to bring order out of chaos nor to suggest improvements in creation, but simply to wake up to the very life we're living."[61]

Johns denies intentionality. He resists fixed interpretations, preferring the type of indeterminacy that leaves his work open to new readings. In spite of the multivalent character of Johns's work, there remains one incontrovertible aspect of the observer's response to it: all critical endeavors seem to reveal more about the viewer than about the art itself. Johns is the first to embrace this. Speaking in 1980 to Calvin Tomkins, he remarked with a laugh:

> Don't you think that all of our interpretations of other people's work sound like us? That's what's interesting—you get to see yourself another way.[62]

Bibliographical references in abbreviated form in the Notes are given in full in the Selected Bibliography.

## INTRODUCTION  PAGES 10–47

**1**  Johns, in Jespersen 1969, p. 14, in *Writings* 1996, p. 136.

**2**  Rondeau and Druick 2007.

**3**  Rosenthal 1988; Garrels 1999; Rothfuss 2003b.

**4**  Cherix and Temkin 2014.

**5**  Ravenal 2016.

**6**  A healthy dose of skepticism seems expedient in considering the complete accuracy of Johns's words in these interviews, as they almost never indicate whether or not they were recorded.

**7**  Johns, in Jespersen 1969, p. 14; in *Writings* 1996, p. 136.

**8**  Tomkins 2006, p. 80.

**9**  See Kirk Varnedoe's illuminating essay, "Fire: Johns's work as seen and used by American artists," on Johns's deep-seated artistic influence in Varnedoe 1996, pp. 93–115. This is a topic that deserves revisiting given that Varnedoe wrote his seminal text on this subject over twenty years ago.

**10**  Varnedoe 1996, p. 21.

**11**  Raynor 1973, p. 21.

**12**  Crichton 1977, p. 75. On these contradictions as they relate to Johns's art, see Herrmann 1977.

**13**  Holland Cotter, "Bull's-eyes, body parts, and Jasper Johns," *New York Times*, February 2, 2007, p. E37. The poet Hart Crane, who Johns cites in his work, wrote admiringly of Donne in 1917, in a letter that could describe Johns; see epigraph, p. 74.

**14**  In D. R. Rickborn, "Art's Fair-Haired Boy: Allendale's Jasper Johns Wins Fame with Flags," *The State* (Columbia, SC), January 15, 1961, p. 20, in Tone 1996, p. 119. Unless otherwise indicated, the biographical information here is in Tone 1996.

**15**  Glueck 1977, in *Writings* 1996, p. 162.

**16**  According to Johns, "in the early fifties, I was going to be an artist, and I kept meeting all these people who were artists, and I thought, 'Here I am, still going to be an artist.' What was different? What needed to be changed, so that I would be, rather than going to be? It was then I decided I would only allow myself to do what I couldn't not do, and whatever I did would have to represent myself as an artist. There was a change in my spirit, in my thought and my work, as well as some doubt and terror." In Raynor 1973, p. 22.

**17**  Steinberg 1969/1972, p. 31. See Robert Morris's essay that touches on the influence of military culture and American capitalism on Johns's early work; Morris 2007.

**18**  Hopps 1965, in *Writings* 1996, p. 34.

**19**  Rosenthal and Fine 1990, p. 70.

**20**  Vaughan 1990, pp. 138–39.

**21**  Diamonstein-Spielvogel 1994, in *Writings* 1996, p. 296.

**22**  Johns, quoted in Mark Stevens with Cathleen McGuigan, "Super artist: Jasper Johns, today's master," *Newsweek* 90:17 (October 24, 1977), pp. 66–79, in *Writings* 1996, p. 165.

**23**  Bernstein 1985, pp. 60–61. Bernstein considers specific influences of Duchamp's views and work on Johns beginning in 1959; ibid., pp. 64–68.

**24**  Johns 1969, in *Writings* 1996, p. 22.

**25**  On the Foundation for Contemporary Arts, see ed. Eric Banks, *Artists for Artists: 50 Years of the Foundation for Contemporary Arts* (New York, 2013); and www.foundationforcontemporaryarts.org/.

**26**  On Johns's first published print and his introduction to printmaking, see Sheila McGuire's entry on Johns in Elizabeth Armstrong, *First Impressions: Early Prints by Forty-six Contemporary Artists*, exh. cat. (Walker Art Center, Minneapolis, 1989), pp. 26–29.

**27**  Tone 1996, p. 192.

**28**  Neither Johns nor Rauschenberg (1925–2008) wanted to speak about their relationship. As Johns once countered to a writer, "How is it relevant?" Belcove 2014, p. 5. Some critics have urged greater openness in discussing Johns's sexual identity. See, in particular, Caroline Jones, "Jasper's dilemma," *Art Journal* 56:3 (Autumn 1997), pp. 88–90; Jonathan Katz, "Jasper Johns' alley oop: on comics and camouflage," www.queerculturalcenter.org/Pages/KatzPages/Katzoops.html; Mark Joseph Stern, "Did MoMA closet Jasper Johns and Robert Rauschenberg?," www.huffingtonpost.com/2013/02/26/did-moma-closet-jasper-johns-and-robert-rauschenberg_n_2766032.html. See also, the references in Varnedoe 1996, p. 35, note 35. To attempt to read into Johns's work details regarding a relationship we know little about seems unnecessary and irresponsible. There is a marked difference between discussing sexual identity in Johns's work and taking a broader look at it in the context of human sexuality. As Johns said early on, "I'm interested in things which suggest the world rather than suggest the personality." Sylvester 1965, in *Writings* 1996, p. 113.

**29**  Robert Rauschenberg had given Johns a map of the United States the size of a school notebook in 1960 that Johns had painted over in gray encaustic and used as reference for his later map paintings; Crichton 1977, p. 45.

**30**  Cage 1964, p. 25.

**31**  According to Crichton, Johns had several dreams about Marcel Duchamp at this time, including one in which he changed his perspective of the older artist, and this different view became a feature of *According to What*, which, like Duchamp's final painting *Tu m'* (1918), catalogues types of representation, dissecting the process of image-making itself; Crichton 1977, pp. 52–53.

**32**  Crichton notes that while Johns made the decision soon after to use this motif in his next painting, it wasn't until weeks later that he went back to try to find the wall, searching for it in vain. According to Crichton, Johns was displeased at not being able to find it, as he had hoped to make "an exact copy of the wall. It was red, black, and gray, but I'm sure that it didn't look like what I did. But I did my best." Johns's insistence in making the original his starting point—at least—is notable, and it would be interesting to know what these works would be like if he had indeed been able to start with that "exact copy." Crichton 1977, p. 55.

**33**  Smith 1984, in Brundage 1993, n.p.

**34**  See, for instance, Eleanor Heartney, "Jasper Johns," *Artnews* 83:5 (May 1984), p. 157; David Rimanelli's flippant "Jasper Johns," *Artforum* 29:9 (May 1991), pp. 141–42; and later, Steven Henry Madoff, "Jasper Johns: a seasonal lull at Castelli," *Artnews* 86:5 (May 1987), p. 158. In discussing the duality between object and image in a 1964 interview, Johns noted that "it is the gray area between these two extremes that I'm interested in—the area [where it] is neither a painting or a flag. It can be both and still be neither. You can have a certain view of a thing at one time and a different

view of it at another. This phenomenon interests me."
Tono 1964, in *Writings* 1996, p. 98.

**35** Schjeldahl 2005, p. 96; Kimmelman 2005, p. B32.

**36** Interview with the artist, Sharon, CT, May 8, 2012.

**37** Raynor 1973, in *Writings* 1996, p. 144; *U.S.A. Artists 8: Jasper Johns*, 1966, 30-minute film produced and directed by Lane Slate, written by Alan R. Solomon, narrated by Norman Rose. TV documentary produced by N.E.T. and Radio Center, in *Writings* 1996, p. 124.

**38** In Fine and Rosenthal 1990, p. 76.

**39** Hindry 1989, in *Writings* 1996, p. 231.

**40** Interview with the artist, Sharon, CT, May 8, 2012.

**41** Raynor 1973, p. 22.

**42** Tomkins 2006, p. 85.

## ONE PAGES 48–73

**1** Sozanski 1988, in *Writings* 1996, p. 225.

**2** On the crosshatch format and its relationship to the work of contemporary artists focusing on numerical and grid systems, see Varnedoe 1996, pp. 105–06.

**3** Sozanski 1988, in *Writings* 1996, p. 225.

**4** Johns, in Crichton 1977, p. 55. Johns used the same approach with the flagstone pattern, first seen in *Harlem Light* (1967), which he had noticed on a wall in Harlem in New York City while riding in a taxi.

**5** Crichton 1977, p. 59.

**6** Kent 1990, in *Writings* 1996, p. 259.

**7** In a seminal article on Johns's crosshatchings, Barbara Rose referred to them as "pseudo abstractions— impersonations of an abstract style," to distinguish them from the type of quickly communicated retinal art that seems uncharacteristic of Johns's "difficult, hermetic art demanding time as well as effort to be comprehended." Rose 1977, p. 149.

**8** See Fitzgerald 2006, p. 287. On the Ganzes and their collection, see *A Life of Collecting: Victor and Sally Ganz*, ed. Michael Fitzgerald (New York, 1997).

**9** On Johns and Picasso, see Fitzgerald 2006, p. 279ff. and Bernstein 1996, p. 49ff.

**10** Francis 1984, p. 90. Bernstein charts various interpretations of Johns's *Weeping Women*; Bernstein 1996, pp. 49 and 71, notes 56–57.

**11** See Rosenthal 1988, pp. 34–36, with its plan and diagram of *Usuyuki*; on Johns's working method and the crosshatchings, see Crichton 1977, pp. 60–62. Johns describes the combination of hatchings and grid in *Writings* 1996, pp. 206–08.

**12** See, for instance, Degas's *Place de la Concorde (Vicomte Lepic and his Daughters)* (1875) or *Dancers in Green and Yellow* (c. 1903), both setting individuals amid collective forces. See also his *The Orchestra at the Opera* (c. 1870) or *Women with Chrysanthemums* (1865), montages of still life and portraiture in off-centered croppings that suggest the restlessness and dynamism of modern life. Degas, foreshadowing Johns, reminded viewers to jettison habit and "re-experience" the world with fresh eyes. On this aspect of Degas's work, see: Kirk Varnedoe, "The Artifice of Candor: Impressionism and Photography Reconsidered," in eds. Peter Walch and Thomas Barrow, *Perspectives on Photography: Essays in Honor of Beaumont Newhall* (Albuquerque, 1986), pp. 99–123; and Varnedoe, *A Fine Disregard: What Makes Modern Art Modern* (New York, 1994).

**13** Geelhaar 1980a, in *Writings* 1996, p. 193. Johns refers to music David Tudor composed for the ballet *Exchange* (1978). The active contemplation engendered by the repetition of groups of clusters in Johns's crosshatch paintings also recalls the intense reiteration in Philip Glass's music.

**14** On Darwin's views on dynamism and flux, see: Gertrude Himmelfarb, *Darwin and the Darwinian Revolution* (Garden City, NY, 1959); Jonathan Weiner, *The Beak of the Finch: A Story of Evolution in Our Time* (New York, 1995); Adrian Desmond, *The Politics of Evolution* (Chicago, 1989).

**15** On fractals, see B. B. Mandelbrot, *The Fractal Geometry of Nature* (San Francisco, 1982), and Nigel Lesmoir-Gordon et al., *The Colours of Infinity: The Beauty and Power of Fractals* (London, 2011). I am grateful to Bill Ehrlich for patiently discussing fractals, topology, chaos theory, and tessellation with me in June 2014.

**16** Rose 1977, p. 149.

**17** See ULAE 1994, cat. nos. 229–33.

**18** On this aspect of Johns's work, see in particular Bernstein 1977.

**19** In Geelhaar 1980a, p. 51.

**20** Varnedoe 1996, p. 15.

**21** Rosenthal and Fine 1990, p. 73.

**22** Bernstein 1985, p. 67; Rosenthal and Fine 1990, p. 269; Rosenthal 1988, p. 58.

**23** Smith 1984, in Brundage 1993, n.p.

**24** Phone conversation with the author, July 11, 2005.

**25** "A tortoise among hares," *Newsweek*, February 27, 1984, in Brundage 1993, n.p.

**26** Rose 1977, p. 153.

**27** See Bernstein 1996, pp. 48–51. She also cites Dada and Surrealist precedents. Rose cites Picasso's titles referring to friends and others close to him that lend an emotional element even to his analytical cubist pictures; Rose 1993, p. 59.

**28** See Bernstein 1996, p. 50.

**29** Grace Glueck, "'Once established,' says Jasper Johns, 'ideas can be discarded'," *New York Times*, October 16, 1977, sec. 2, pp. 1 and 31, in *Writings* 1996, p. 162.

**30** The Savarin can has featured in many guises in Johns's work since 1960; see Goldman 1982, n.p.; Ravenal 2016, pp. 10–15. On the crosshatch and the handprint in Johns's work, see Cuno 1987, p. 205.

**31** According to Johns, "At one point—I don't remember exactly when—I began to read Céline…I was in some odd state of mind and it was the only writing I was able to concentrate on. There was something very special about the relationship between me and it at the time. There were *Journey to the End of Night* and *Death on the Installment Plan* and others whose titles I can't think of right now. But those two are the most astonishing. Something hallucinatory about them held my attention. I made my painting *Céline* then." Hindry 1989, in *Writings* 1996, p. 228. See also, Francis 1984, pp. 93–94.

**32** On the relation of dance and music to Johns's crosshatch works, see Rose 1993, pp. 51–54.

**33** Welish 1996; http://bombmagazine.org/article/1983/jasper-johns.

**34** See Bernstein 1996, pp. 50–51 and fig. 51, p. 84; and Rose 1993. Johns had been interested in Tantric art when he began the first version of *Dancers on a Plane*. As he told Michael Crichton, he had been "thinking about issues like life and death, whether I could even survive. I was in a very

gloomy mood at the time I did the picture, and I tried to make it in a stoic or heroic mood." Crichton 1994, p. 62.

**35** Varnedoe 1996, p. 301.

**36** Kent 1990, in *Writings* 1996, p. 259.

**37** In Raynor 1973, in *Writings* 1996, p. 145.

**38** In Bernard and Thompson 1984, in *Writings* 1996, p. 217.

**39** Varnedoe 1996, p. 303. Crichton 1994, p. 63 says it was in 1981. See also Ravenal 2016 for details regarding the sender and date. Johns would have seen the painting when he visited the exhibition *Edvard Munch: Symbols & Images* at the National Gallery of Art, Washington, DC, in the late 1970s (Ravenal 2016, p. 33).

**40** See also Ravenal 2016, pp. 52-63; and Rosenthal 1988, pp. 50-54.

**41** Rosenthal 1988, p. 29 suggests that *Weeping Women* may refer to the three Marys and the Crucifixion. Johns referred to Buddhist traditions in *Cicada* (1979), the series of *Dancers on a Plane* (1979-82), and the *Tantric Detail* works (1980-81), all in various ways relating to Tantric art, meditations on the relationship between transformation, sexuality, and death; see Bernstein 1996, pp. 50-51. On the *Tantric Detail* paintings, see Orton 1996, pp. 57-58.

**42** On Johns and Munch, see Ravenal 2016 and Bernstein 1996, pp. 50-51 and the accompanying footnotes; and Goldman 1982, n.p. On Munch, see *Edvard Munch: Signs of Modern Art*, exh. cat. (Foundation Beyeler, Basel, 2007). On Munch's late self-portraits, see Ragna Stang, "The aging Munch: new creative power," trans. Solfrid Johansen, and Arne Eggum, "Munch's self-portraits," trans. Erik J. Friis, in *Edvard Munch: Symbols and Images*, exh. cat. (National Gallery of Art, Washington, DC, 1978).

**43** Bernstein 1996, p. 49.

**44** "Jasper Johns returns," *Art in America* (March/April 1976), in Brundage 1993, n.p.

**45** In Varnedoe 1996, p. 106.

**46** On Johns's titles, see Bernstein 1996, p. 48.

**47** "Jasper Johns stretches himself—and us," *New York Times*, February 1, 1976, in Brundage 1993, n.p.

### TWO PAGES 74-97

**1** Sylvester 1965, in *Writings* 1996, p. 113.

**2** Crane to William Wright, October 17, 1921, in *Hart Crane: Complete Poems and Selected Letters*, ed. Langdon Hammer (New York, 2006), p. 255. See also Colm Tóibín, "A great American visionary" (review of *Hart Crane: Complete Poems and Selected Letters*), *New York Review*, April 17, 2008, p. 38.

**3** Diamonstein-Spielvogel 1994, in *Writings* 1996, p. 297. In the same interview, Johns further observed that "autobiography isn't necessarily an exposure of feelings. It can be."

**4** *Jasper Johns: Ideas in Paint*, 1989, in *Writings* 1996, p. 222.

**5** Ibid., pp. 222-23.

**6** Johns's studio assistant, Mark Lancaster, explained to Mark Rosenthal in 1987 that Johns made the casts before he had a purpose in mind for them; Rosenthal 1988, p. 106, note 11.

**7** Bernstein 1981, in *Writings* 1996, pp. 201-02.

**8** The casts were taken from a boy called John Huggins, the son of a friend of the artist, at three-year intervals; Rosenthal and Fine 1990, p. 280.

**9** See Rosenthal and Fine 1990, cat. 90, pp. 282-83.

**10** *Untitled*, 1982; ink on watercolor on 2 sheets of paper framed together; top sheet 19½ × 24½ in.; bottom sheet 22 × 24 in. (49.5 × 62 cm; 56 × 61 cm)

**11** See, for instance, *Fool's House* (1961-62; fig. 12), *M* (1962), *Wilderness I* and *Wilderness II* (both 1963-70) and *Field Painting* (1963-64). On these works, see Bernstein 1985, chap. 6.

**12** Johns's and Picasso's studio pictures fall within the tradition of earlier pictures such as Velàzquez's *Las Meninas* (1656), Vermeer's *The Art of Painting* (1666) and Courbet's *The Painter's Studio: A Real Allegory Summing Up Seven Years of My Life as an Artist* (1855).

**13** See Michael Fitzgerald, *Picasso: The Artist's Studio*, exh. cat. (Wadsworth Atheneum, Hartford, CT, 2001).

**14** Varnedoe 1996, p. 319.

**15** Varnedoe 1996, p. 29; see further, pp. 25-29.

**16** Rosenthal and Fine 1990, p. 282. Johns also made a richly worked pastel and graphite pencil drawing in deep layers of green and pink. The arm in this work is more synthetic or rigid, but white highlights give it the texture of wax. See Rosenthal and Fine 1990, cat. 91, pp. 284-85. In a richly expressive, fluid ink on plastic drawing also titled *Perilous Night* (1982; fig. 46), Johns inserted an impression of his own arm in dark ink in place of the wax casts. Johns included in the drawing's lower right margin three enigmatic stick figures that he used in subsequent work.

**17** In addition to this interpretation, Mark Rosenthal has suggested the cast arms may symbolize the Trinity; Rosenthal 1988, p. 65. In a 1982 interview, discussing the work that would become *Perilous Night*, Johns related how he made the first cast "six years ago, the second one three years ago, and now another one. I thought it would become a large painting, but the casts are really very small. I hadn't realized how small a child's arm is. So it won't be a large painting, but it is nevertheless one of the most important things I will use in a painting. I just don't know how yet;" Simons 1982, in *Writings* 1996, p. 214.

**18** Interview in Rosenthal 1993, in *Writings* 1996, p. 283. In 1974 and 1975, Johns spent several weeks in Paris, working at Aldo Crommelynck's print workshop Atelier Crommelynck, where he saw Picasso's 1937 etching *Weeping Woman*.

**19** Cage described how "I was at the point of divorce between Xenia when I wrote it, and it was the dark side of the erotic. It presents a situation where the extremes become rough, where things work together, where they go far apart." John Cage in the television documentary *Jasper Johns: Ideas in Paint* 1989.

**20** Calvin Tomkins, *The Bride & the Bachelors* (New York, 1965), p. 97.

**21** Of Cage, Johns has said: "He was generous in his willingness to explain connections [between different ideologies] and seemed happy to convince others of the usefulness of his ideas. At some point, he began to teach at the New School and younger artists attended his classes. I think many of us felt that ideas in one medium could trigger ideas in another medium—and that mediums could be mixed in new ways;" Vaughan 1990, pp. 138-39. On Cage and *The Perilous Night*, see Tomkins, *The Bride and the Bachelors*, p. 97 and David Revill, *The Roaring Silence. John Cage: A Life* (New York, 1992/2011), pp. 99 and 103. Both books give fascinating accounts of Cage's life, work, and significance.

**22** Laurinda S. Dixon, "Bosch's 'St. Anthony Triptych'—an apothecary's apotheosis," *Art Journal* 44: 2 (Summer 1984), pp. 11-31, 121-22. Although not known at the time, St. Anthony's fire was caused by ingesting molded grain,

so it struck people of all ages randomly and relentlessly. The symptoms were described as either gangrenous or convulsive or both. There was no cure, but the Antonites seemed more capable than others of containing the disease. They employed the finest doctors and paid them well. Infirmaries that served as hospices for those with St. Anthony's fire were an integral part of Antonite monasteries.

**23** Johns saw the altarpiece in its installation at the Musée Unterlinden in Colmar in 1976 and 1979 and again in 1990; Rosenthal 1990, p. 36; and Tone 1996, p. 360. In the summer of 1980, Düsseldorf dealer Wolfgang Wittrock sent Johns Ostar Hagen's folio, *Grünewalds Isenheimer Altar in neun und vierzig Aufnahmen* (Munich, 1919); in Rosenthal 1990, p. 45, note 37. Nan Rosenthal's 1990 essay includes an in-depth close reading of Johns's incorporation of the Isenheim altarpiece imagery in his own work; Rosenthal 1990, pp. 34–41.

**24** Cork 1990, in *Writings* 1996, p. 258.

**25** Rosenthal and Fine 1990, p. 82. While the formal comparison is intriguing, it would be overstating its significance to suggest a direct iconographic correlation. Johns has said, for instance, that he understands that viewers may draw connections between his references to the Isenheim diseased demon in the 1980s and the AIDS virus that first came to public notice in 1981 and devastated the creative community, but that this was not his intention.

**26** Rosenthal 1990, p. 34. John Yau first wrote about the soldiers in *Perilous Night* in "Target Jasper Johns," *Artforum* 24:4 (December 1985), pp. 84–85. Jill Johnston identified the traced demon in "Tracking the shadow," *Art in America* 75:10 (October 1987), pp. 128–43. It is interesting that while Johns worked with the detail of the soldiers as given in Hagen's folio, he determined the cropping of the demon himself. There is no plate focused only on the demon in Hagen's folio; Varnedoe 1996, p. 34, note 6.

**27** On the altarpiece's iconography, see Ruth Mellinkoff, *The Devil at Isenheim: Reflections on Popular Beliefs in Grünewald's Isenheim Altarpiece* (Berkeley, 1988). On its compositional and iconographic integrity, see Andrée Hayum, *The Isenheim Altarpiece: God's Medicine and the Painter's Vision* (Princeton, 1989). See also Rosenthal 1990, pp. 37–38.

**28** Diamonstein-Spielvogel 1994, in *Writings* 1996, p. 296.

**29** Rosenthal 1990, p. 40.

**30** Robertson and Marlow 1993, in *Writings* 1996, pp. 287–88.

**31** Johns initially made the ink on plastic *Tracing* (1981), a detail from the *Crucifixion* panel of John the Evangelist comforting the Virgin.

**32** Shiff 2006, p. 277.

**33** Sketchbook Notes, S-39. Book B, *c.* 1968, in *Writings* 1996, p. 64. Judith Goldman referred to *Racing Thoughts* as a "cheerful rebus;" Goldman 1987, n.p.

**34** Olson 1977, in *Writings* 1996, pp. 168–69. Richard Shiff's essay, "Johns Metanoid, Metanoid Johns," focuses on process as a key element in Johns's practice; Shiff 2007. Richard Field has written extensively about how Johns's practice informs the meaning of his work; Field 1994, n.p.

**35** Varnedoe 1996, p. 17. Varnedoe suggests Johns's ideas regarding the function of art may have developed from his familiarity with modern poetry's goals, for instance, of "making it new," as Ezra Pound incanted; Varnedoe 1996, p. 34, note 10.

**36** Johns made nine paintings that featured his Stony Point bathroom wall, three in 1983, three in 1984, and three in 1988. He made nine drawings in 1983 (including several studies for *Ventriloquist*), seven in 1984, one in 1986, and three in 1988. Only works that include a faucet (tap) feature in this count; there are other drawings from these years that do not include a faucet and that one could also describe as studies or pictures of an imaginary wall.

**37** Winters in Varnedoe 1996, p. 108. The first web browser only emerged in 1991, eight years after *Racing Thoughts*.

**38** Explaining the title, Johns described how he "had a period of a kind of anxiety, I suppose, where when I was trying to go to sleep, images, bits of images, and bits of thought would run through my head without any connectedness that I could see. And I was having dinner with…a psychologist that I had met, and I explained that I had been having this [situation] for a week…and he said: 'Oh, we call those racing thoughts.' And I was very pleased that there was a name for my condition;" *Jasper Johns: Ideas in Paint* 1989, in *Writings* 1996, p. 224. The compositional idea came in part from an experience Johns had watching television; Rosenthal 1988, p. 85.

**39** In comparing the pants to Johns's spectral self-portrait, *Skin* (1975; fig. 171), Varnedoe described the pants image as a "melancholy, hollow husk of the self that in shape and in self-vilifying implications offers a distant echo of Michelangelo's self-portrait as a flayed sack, in the *Last Judgment* fresco of the Sistine Chapel;" Varnedoe 1996, p. 30. The cream color khakis are the only non-grisaille element in the other version of *Racing Thoughts* (1984). Apparently, Johns took as a model a work by Jean-Auguste-Dominique Ingres and his workshop with the same coloration, *Odalisque in Grisaille* (1824/34); Druick 2007, p. 105, note 101.

**40** "All these objects are signs of the past. Which doesn't necessarily mean they are souvenirs. I am not sure what their connection to memory is…All these things have a psychological character;" Davvetas 1984, in *Writings* 1996, p. 218.

**41** Johns had earlier inserted the Mona Lisa decal, with its reference to Leonardo and to Duchamp's pun on the Mona Lisa in his own *L.H.O.O.Q.* (1919; fig. 88) in his *Figure 7* lithographs; Bernstein 1996, p. 54. See also p. 70, note 31. In 1969, Johns related that the "Mona Lisa is one of my favorite paintings, and da Vinci is one of my favorite artists. Duchamp is also one of my favorite artists and he painted a mustache on a reproduction of the Mona Lisa. Also just before I came to Gemini [the print workshop where he made the *Figure 7* prints] someone gave me some iron-on decal 'Mona Lisas' which you would get from sending in something like bubble gum wrappers and a quarter. With all the decals all one has to do is iron the decal on cloth and one makes his own 'Mona Lisa.' I had some of these decals when I came to Gemini, and I thought I would use the Mona Lisa decal because I like introducing things that have their own quality and are not influenced by one's handling of them;" Young 1969, in Bernstein 1996, p. 70, note 31.

**42** Hindry 1989, in *Writings* 1996, p. 234.

**43** Sketchbook Notes S-33, Book B, *c.* 1979, in *Writings* 1996, p. 67.

**44** Sketchbook Notes S-65. Book E, *c.* 1992–93 and S-66. Book E, *c.* 1993–94, in *Writings* 1996, p. 76.

**45** Tono 1964, in *Writings* 1996, p. 98.

**46** Kent 1990, in *Writings* 1996, p. 258.

**47** French linguists and semioticians described the conditions of postmodernism. See, in particular, Roland Barthes's 1968 essay, "The death of the author;" Jacques Derrida's *Of Grammatology* (1974; original in French, 1967); Jean Baudrillard's *Simulation and Simulacra* (1994; original in French, 1981); Jean-Francois Lyotard's *The Postmodern Condition* (1984; original in French, 1979), as well as Guy Debord's *The Society of the Spectacle* (1994; original in French, 1967).

**48** A stylistically diverse group of artists emerged in the 1980s, drawing on popular culture, graffiti, and art history as well as history and current news. It is impossible to summarize this work. It went in myriad directions: Jeff Koons's polished sculptures of iconic yet fragile basketballs mysteriously suspended in a tank, for instance, embody ideas about human aspiration and consumer culture; and Ashley Bickerton's non-figurative self-portraits comment on the ubiquity of branding and how we define ourselves through consumerism. Some artists addressed the prevalence of the all-male art canon and gender stereotypes: Cindy Sherman photographed herself in various guises, focusing on artistic identity to stress the role of women as the producer rather than the object of the male gaze.

**49** Clements 1990, in *Writings* 1996, p. 243.

**50** Rosenthal 1988, p. 61.

**51** Rosenthal 1988, p. 86. On Manet's portrait, see Theodore Reff, "Manet's portrait of Zola," *Burlington Magazine* 117:862 (January 1975), pp. 35-44.

**52** Matisse's view of the function of art as providing rest and rehabilitation may have derived from his interest in Dutch interiors. As he famously said, "What I dream of is an art of balance, of purity and serenity devoid of troubling or depressing subject matter, an art which might be for every mental worker, be he businessman or writer, like an appeasing influence, like a mental soother, something like a good armchair in which to rest from physical fatigue;" Matisse, "Notes of a painter," 1908, in Herschel B. Chipp, *Theories of Modern Art: A Source Book by Artists and Critics* (Berkeley, Los Angeles, and London, 1968), p. 135.

**53** Varnedoe 1996, p. 107.

**54** Bernstein 1996, p. 54.

**55** Robertson and Marlow 1993, in *Writings* 1996, p. 286.

**56** Referring to what some consider the private language of *Racing Thoughts*, Johns noted how "everybody has a private language. So on some level, even that idea is a shared thought, a shared experience." Welish 1996, p. 50.

## THREE   PAGES 98-123

**1** Interview with the author, Sharon, CT, May 8, 2012.

**2** For a discussion of this work, see Chapter Two.

**3** Tone 1996, p. 361. In 2011, President Barak Obama presented Johns with the Presidential Medal of Freedom, the country's highest civilian honor, the first visual artist since Alexander Calder was so honored (posthumously) in 1977.

**4** The 1983 Biennial included *In the Studio* (fig. 44), the 1985 Biennial featured *Racing Thoughts* (fig. 52) and *Untitled*, 1984 (The Broad), while the 1991 Biennial showed three untitled paintings from 1990 and a *Green Angel* picture.

**5** Tone 1996, pp. 342 and 364.

**6** For a history of the Foundation see ed. Eric Banks, *Artists for Artists: 50 Years of the Foundation for Contemporary Arts*, New York, 2013; and www.foundationforcontemporaryarts. org/about/history.

**7** Tone 1996, p. 304. Johns's *Out the Window* (1959) sold at auction for $3.63 million in November 1986, also breaking the record for the work of a living artist. Other records at that time included: *Diver* (1962; fig. 21), selling in May 1988 for $4.18 million and *False Start* (1959; fig. 11), in November 1988 for $17 million; Tone 1996, p. 395, note 13.

**8** See Chapter Two, note 21. By Nan Rosenthal's estimation, Isenheim altarpiece imagery features in more than seventy of Johns's works between 1981 and 1989; Rosenthal 1990, p. 34.

**9** This illusion has become known as the "Boring figure" due to Harvard Professor Edwin Boring's introduction of it in one of the first major studies of the psychology of visual perception in the 1930s; *Puck* (London) 78 (November 6, 1915), p. 11, reprinted in E. G. Boring, "A new ambiguous figure," *American Journal of Psychology* 42:3 (1930), pp. 444-45. See also Tone 1996, p. 322.

**10** Rosenthal 1990, p. 20.

**11** Interview with the artist, Sharon, CT, May 8, 2012.

**12** See Rosenthal and Fine 1990, cat. 97 and figs. 97a and 97b, p. 296. See also *Untitled*, 1983 (fig. 24), which includes the avalanche sign.

**13** Rosenthal 1993, in *Writings* 1996, pp. 283-84.

**14** Ernst Gombrich, *Art and Illusion* (London and New York, 1960), chap. 9. For Gombrich, artists must see other art to be able to make it themselves, a belief Johns must surely share given his continual references to the pictures of fellow artists.

**15** Swenson 1964, in *Writings* 1996, p. 92.

**16** In Mattison 1995, p. 35. See pp. 34-35 on the relationship between Johns's work and Gestalt psychology.

**17** Weatherby 1990, in *Writings* 1996, p. 257.

**18** See Tomkins 2006, p. 85.

**19** Bernstein 1996, p. 49 and pp. 57-60, and Fitzgerald 2006 consider with great insight Johns's relationship to Picasso.

**20** On Johns's interest in skin and body parts, see Bernstein 1977 and Varnedoe 1996, pp. 23-24 and pp. 29-30.

**21** "I probably had heard about the mustache on the Mona Lisa when I was in college. I think the idea was well known. But I hadn't encountered his work." Hindry 1989, in *Writings* 1996, p. 227.

**22** Johns quoted in Crichton 1977, p. 70.

**23** Johns has also made works based on the whole image, not just the eyes, of Picasso's *Woman in a Straw Hat with Blue Leaves*. He continued to draw on this painting in his work throughout the 1990s and beyond. See Fitzgerald 2006, p. 289.

**24** Varnedoe 1996, p. 338, and thumbnail images of paintings and drawings by the artist supplied to the author by Jasper Johns's studio.

**25** Interview with Wallach 1988, slightly revised (in consultation with the artist) in Bernstein 1996, pp. 59-60.

**26** Bernstein 1996, p. 59, cites precedents for the Surrealist qualities of Johns's rectangular woman's faces of this period in works by Magritte and Man Ray.

**27** According to Michael Fitzgerald, the collector Jane Meyerhoff suggested to Johns the addition of "M.T." to the title. It refers, at least partially, to Picasso's mistress Marie-Thérèse Walter; Fitzgerald 2006, p. 327, note 139.

**28** See Bernstein 1996, p. 73, note 112, on possible associations between the watch and references to Johns's

childhood. It figures in a number of these untitled works, always the same type and with the same time indicated.

**29** Interview with the artist, Sharon, CT, May 8, 2012.

**30** In *Writings* 1996, p. 258.

**31** Mattison, calling these "Seascape/Faces," relates the tonality and space of this imagery to Johns's view from his Saint Martin studio; see Mattison 1995, pp. 36-38. According to Bernstein, Johns stated that the face "can be a landscape as well as a seascape, and notes that he made his first image of it not in Saint Martin but in Stony Point;" Bernstein 1996, p. 73, note 107.

**32** Bernstein 1996, p. 59. She mentions as examples Magritte's *Every Day* (1966) as well as Man Ray's *Observatory Time—The Lovers* (1932-34). See also Mattison's discussion of Surrealism as it relates to Johns's faces; Mattison 1995, pp. 38-39. In 1988, Johns made two untitled drawings showing the Picasso boomerang head on a cloth with the Grünewald demon as a ground pinned to a blue cloud-filled sky that recalls Magritte's skies in, among others, *La Mémoire* (1938) and *The Empire of Light, II* (1950).

**33** Johns, quoted in Roberta Brandes Gratz, "After the Flag," *New York Post*, December 30, 1970, p. 25; Tone 1996, pp. 118-19.

**34** On non-figurative portraiture and the Arensberg Circle, see Francis Naumann, *Making Mischief: Dada Invades New York* (New York, 1997).

**35** Feinstein 1997, p. 87; Kimmelman 1991.

**36** Tone 1996, pp. 118-20. Johns gave the valedictorian address at his high school.

**37** Johns to Wallach 1991, in *Writings* 1996, p. 260.

**38** Bernstein 1996, p. 60. Johns has stated that the illustration in Bettelheim's article was "in the back of his mind from the very first;" Bernstein 1996, p. 73, note 114. The article is Bruno Bettelheim, "Schizophrenic art: a case study," *Scientific American* 186 (April 1952), pp. 31-34.

**39** In Paul Clements, "The artist speaks," *Museum & Arts Washington* 6:3 (May/June 1990), p. 117; Tone 1996, p. 396, note 3.

**40** Amei Wallach, "Jasper Johns and his visual guessing games," *New York Newsday*, February 28, 1991. Reprinted in Brundage 1993, n.p.

**41** "Jasper Johns," *Burlington Magazine* 139 (January 1997), 66.

**42** Leo Steinberg, "Contemporary art and the plight of its public," in *Other Criteria: Confrontations with Twentieth-Century Art* (London, Oxford, New York, 1972), p. 15.

**43** Johns to Wallach 1991, in *Writings* 1996, p. 261. Johns says "he thinks of" his sculptures *The Critic Sees* and *The Critic Smiles* "as cartoons;" Fuller 1978b, in *Writings* 1996, p. 184.

**44** Wallach 1991, in *Writings* 1996, p. 261.

**45** Ibid., p. 266.

**46** Fairfield Porter, *Art International* (September 1960), p. 75.

**47** Wallach 1991, in *Writings* 1996, p. 266.

**48** On Guston's late work, see ed. Clark Coolidge, *Philip Guston: Collected Writings, Lectures, and Conversations* (Berkeley, 2011); Robert Storr, *Philip Guston* (New York, 1986); and Joanna Weber, *Philip Guston: A New Alphabet, The Late Transition* (New Haven, CT, 2000).

**49** Johns first saw Magritte's pictures at the Sidney Janis Gallery in New York in 1954 and started collecting them in the 1960s; Bernstein 1985, pp. 4, 44, and 92. On Surrealism and Johns, see Bernstein 1996, pp. 47-49, 55, and 59-60.

See also Robert Mattison's discussion of Surrealist works as they relate specifically to Johns's face paintings; Mattison 1995, pp. 38-39.

**50** See, for instance, Magritte's *Les Belles relations* (1967); and his *Les Recontres naturelles* (1945) and the examples in Bernstein 1996, p. 59.

**51** See Bernstein's discussion of parallels between Johns's cloth representations and the seventeenth-century Spanish artist Francisco de Zurbarán's *Veil of St. Veronica* images, two of which Johns saw at a show at the Metropolitan Museum of Art in 1987; Bernstein 1996, p. 61 and note 117. Johns's interest in these images most likely resulted more from Zurburán's finesse with trompe l'oeil than the subject's iconography. In Christian legend, Veronica's veil was the cloth that Veronica used to wipe Christ's face as he carried the cross on the road to Calvary. It miraculously took on his image.

**52** The disintegrating Picassos result from the artist's causing the waxy encaustic to melt. Apparently, two stories Johns heard about Picasso prompted him to break down these images. See the amusing anecdotes in Fitzgerald 2006, p. 293 and Bernstein 1996, p. 61.

**53** Kirk Varnedoe suggested a relationship between these and the three "Draft Pistons" of cloth at the upper part of Duchamp's *The Bride Stripped Bare by Her Bachelors, Even (The Large Glass)* (1915-23), which Johns traced in a suite of ink drawings in 1986; Varnedoe 1996, p. 337.

**54** Fine 1990, p. 65.

**55** Wallach 1991, in *Writings* 1996, pp. 263-64.

**56** Varnedoe 1996, p. 21.

**57** On Johns and Duchamp, see: Jasper Johns, "Duchamp," *Scrap* (New York) 2 (December 23, 1960), p. 4, in *Writings* 1996, p. 20; Jasper Johns, "Marcel Duchamp (1887-1968)," *Artforum* 7:3 (November 1968), p. 6, in *Writings* 1996, p. 22; Jasper Johns, "Thoughts on Duchamp," in ed. Cleve Gray, "Feature: Marcel Duchamp 1887-1968," *Art in America* 57:4 (July-August 1969), p. 31; and Bernstein 1996, pp. 43-46 and especially Bernstein 1985.

**58** See Varnedoe 1996, p. 21, on the broader manifestations of these ideas in Johns's work.

**59** Steinberg 1962/1972, pp. 52-53.

**60** Field 1994, n.p.

**61** See Tone 1996, p. 341 on Johns's experiments with carborundum prints. It is interesting to note that Picasso—who inhabited the sandy French Riviera as Johns did Saint Martin—often mixed sand with paint to build texture.

## FOUR   PAGES 124-61

**1** *Jasper Johns: Ideas in Paint* 1989.

**2** See, for instance, *By the Sea* (1961) and *Land's End* (1963) and related works that evidence a vivid reconsideration of Abstract Expressionism not addressed in his earlier work.

**3** Notable examples of this theme can be found in late antique Roman frescos and mosaics and in the Western painting tradition from Nicolas Poussin to Jackson Pollock. Early in his artistic career, Cézanne—an artist particularly important to Johns—painted four vertical paintings of the *Seasons*, each one depicting an allegorical woman with seasonal attributes, to hang in his parents' dining room. The subject also has an extensive history in Japanese art, pastoral poetry, and music. It is the theme of a ballet choreographed by Merce Cunningham with a musical score

by John Cage and sets by Isamu Noguchi first performed in 1947. See David Vaughan, "Merce Cunningham's 'The Seasons'," *Dance Chronicle* 18:2 (1995), pp. 311-18. See also, James Pritchett, *The Music of John Cage* (Cambridge and New York, 1993),

pp. 40-45.

**4**  Barbara Rose suggested a link between the *Seasons* and Johns's "calendar" pages, one for each month in a calendar published by Anthony d'Offay, relating these to the Northern Renaissance tradition of Books of Hours. See *Jasper Johns: A Calendar for 1991.*

**5**  *Jasper Johns: Ideas in Paint* 1989, in *Writings* 1996, p. 224.

**6**  Rosenthal 1990, p. 41.

**7**  Rose 1991, in Brundage 1993, n.p.; John Russell, "The *Seasons*: forceful paintings from Jasper Johns," *New York Times*, February 6, 1987, pp. C1, 30, reprinted in Brundage 1993, n.p.; Michael Brenson, "As Venice Biennale opens, Jasper Johns takes the spotlight," *New York Times*, June 27, 1988, p. C15; Jack Flam, "Jasper Johns: new paintings," *Wall Street Journal*, February 27, 1987, p. 12, reprinted in Brundage 1993, n.p.; Amei Wallach, "The *Seasons* of Jasper Johns," *New York Newsday*, February 21, 1987, part 2, p. 10, reprinted in Brundage 1993, n.p.

**8**  Taylor 1990, in *Writings* 1996, pp. 251-52.

**9**  Johns, quoted in Crichton 1994, p. 62.

**10**  On the *Tantric Details*, *Cicada* and related work, see Barbara Rose's comprehensive study; Rose 1993. See also Varnedoe 1996, p. 301.

**11**  Taylor 1990, in *Writings* 1996, p. 252.

**12**  On Johns's decision to use *Summer*, see master printer John Lund's description of the work on the plates for the intaglios *Summer* and *Winter* in Lorence 1996, pp. 49-50.

**13**  Bernstein 1991, p. 10; Tone 1996, p. 338.

**14**  Bernstein 1996, p. 58; Tone 1996, pp. 338 and 340.

**15**  Rose 1987, in Brundage 1993, n.p.

**16**  On the *Seasons* and Picasso, see Bernstein 1996, pp. 57-59; and Fitzgerald 2006, pp. 287ff.

**17**  There is some suggestion of a full-length figure in the middle panel of *Between the Clock and the Bed* (1981, Museum of Modern Art, New York) as well as other crosshatch triptychs of the mid- to late 1970s and early 1980s (see, for instance, fig. 42, where the allusion is slightly less pronounced).

**18**  See, for example, *Target with Plaster Casts* (1955); *Painted Bronze* (1960; fig. 15); *Painting Bitten by a Man* (1961); *Study for Skin*, a series of four drawings (1962; fig. 63).

**19**  Bernstein 1981, in *Writings* 1996, p. 201.

**20**  Interview in Rosenthal and Fine 1990, p. 70.

**21**  See, for instance, Goldman 1987, n.p.; Rose 1987, reprinted in Brundage 1993, n.p.; Rosenthal 1988, pp. 89 and 94; Cuno 1990, p. 84; and Bernstein 1991, p. 10.

**22**  "The *Seasons*: forceful paintings from Jasper Johns," *New York Times*, February 6, 1987, C1, 30, reprinted in Brundage 1993, n.p. In his analysis of the *Seasons* drawings in the Meyerhoff Collection, Robert Mattison suggests alternately that the shadowy form represents the artist's determination not to expose himself: "It is deliberately anonymous;" Mattison 1995, p. 42.

**23**  Fitzgerald 2006, p. 301. John Yau, "Jasper Johns: The *Seasons*," *Artforum* 25:9 (May 1987), pp. 142-43.

**24**  Bernstein 1996, p. 57.

**25**  Bernstein 1996, p. 42. Bernstein cites Theodore Reff, "Cézanne's Bather with Outstretched Arms," *Gazette des Beaux-Arts*, 6th series, no. 59 (March 1962), p. 174. On the influence of Leonardo, Cézanne, and Duchamp on Johns's figures and body fragments, see Bernstein 1996, pp. 41-42.

**26**  Rose 1991, p. 16, in Brundage 1993, n.p.

**27**  In Mattison 1995, p. 42.

**28**  Bernstein 1996, p. 57. On Johns's familiarity with and adaptation of Duncan's *Picasso's Picassos* (New York, 1968), see Fitzgerald 2006, pp. 287-89 and 299-301. Further details of this incident and a thorough examination of Picasso's role in Johns's work are in Fitzgerald 2006, pp. 301 and 270-315.

**29**  Mattison 1995, p. 42, draws a similar conclusion.

**30**  On the history of Johns's enforced absence in his work—and, by extension, his presence—see Goldman 1982 and Goldman 1987.

**31**  See Cuno 1990, p. 86, on the varied appearance of the shadows in the *Seasons* series.

**32**  Varnedoe 1996, p. 337.

**33**  Ibid.

**34**  "His heart belongs to Dada," *Time* 73 (May 4, 1959), p. 58, in *Writings* 1996, p. 81.

**35**  On *Cups 4 Picasso*, see Fitzgerald 2006, p. 287.

**36**  Rose 1987. I am grateful to Bill Goldston for pointing this out.

**37**  Dürer, like Johns, was a formidable printmaker who developed a system for reproducing tone through line to achieve a painterly effect. Erwin Panofsky attempted to identify a theme unifying three Dürer engravings. To him, *Night, Death and the Devil* of 1513 depicted a man of action, *Melencolia*, the artist himself or an intellectual, and the 1514 *St. Jerome* a spiritual man who looks to the greater good; these formed a trilogy that summarized the theory and practice of art in the service of humanist learning. On this print and Panofsky's theory, see Erwin Panofsky, *The Life and Art of Albrecht Dürer* (Princeton, 1971). One could perhaps forge other connections between *Melencolia* and the *Seasons*.

**38**  Created in 1947, and set then at 7 minutes to midnight, by a group of leading scientists and security experts, at its inception it was considered an indicator of the prospect of nuclear conflict. It now takes into account other potentially disastrous risks, such as climate change, cyber warfare, and biological weapons. It is updated annually. During the 1980s, a time when fears of an arms race between the United States and the Soviet Union were raging, the clock was set at 3 minutes to midnight. See http://thebulletin.org/overview.

**39**  Johns had first used the Mona Lisa image in *Figure 7*, a color lithograph published by Gemini G.E.L. in 1969.

**40**  Hindry in *Writings* 1996, p. 232. Goldman 1987, n.p., posits matter-of-factly that the seahorse locates "the painting's site as Saint Martin." Mark Rosenthal noted following a 1987 interview with the artist, that while at work on *Summer*, Johns "was most interested in depicting the seasonal effects of summer in Saint Martin;" Rosenthal 1988, p. 107, note 71.

**41**  Johns affirmed that he did use the seahorse as a substitute for Picasso's horse in a 1987 interview; Rosenthal 1988, p. 107, note 74. To Rosenthal (p. 95), the seahorse "balances the female Mona Lisa (if the seahorse is male), giving the double nature of the human being." See also, Rose 1987. She links the male seahorse and its procreative powers to "the artist's creation of himself through art." Roberta Bernstein, interpreting Picasso's horse as a reference to Picasso's lover and the birth of their daughter, links it to the relationship between "sexuality [and] creativity in both life and art." Given the male seahorse's rare ability to bear

offspring, she sees that "Johns's visual pun immediately throws into question gender-based stereotypes about creativity;" Bernstein 1991, p. 10.

**42** Rosenthal 1988, p. 96.

**43** Bernstein 1996, p. 59, more firmly posits that the skull and crossbones are "warning of death." On skulls in Johns's work, and specifically in his *Tantric Detail* series, see Rose 1993.

**44** *Fragment—According to What—Hinged Canvas* is one of six in the series *Fragments—According to What*, each focused on a detail or details from Johns's large 1964 assemblage, *According to What*. On the lithographs, see Coplans 1972.

**45** Bernstein 1996, p. 46. There are many versions of Duchamp's *Self-Portrait in Profile*. The artist tore 137 self-portraits by hand, mounting them on velvet-covered paperboard as the frontispiece for Robert Lebel's deluxe edition of *Sur Marcel Duchamp*. Bernstein offers a cogent comprehensive consideration of the influence of Duchamp's *Self-Portrait in Profile*; Bernstein 1996, pp. 45-46.

**46** Goodyear 2009, pp. 238-40.

**47** Ibid., p. 85.

**48** Ibid., p. 222.

**49** Interview in Rosenthal and Fine 1990, p. 82.

**50** Bernstein 1996, p. 59.

**51** In "His heart belongs to Dada," *Time* 73 (May 4, 1959), p. 58, in *Writings* 1996, p. 81.

**52** Sozanski 1988, in *Writings* 1996, p. 225.

**53** Kozloff 1968, p. 24.

**54** Young 1969, in *Writings* 1996, p. 129.

**55** For a fuller exploration of gray's symbolic tones, see Rondeau 2007, pp. 31-35.

**56** Rondeau 2007, p. 27. According to the artist, gray is "self-effacing." He has also likened the consistency of it in the later *Catenary* paintings to a "school uniform." Johns in Cherix and Temkin 2014, p. 19 and Rosenthal 2007, p. 160.

**57** Rondeau and Druick 2007 is an intensive study of Johns's work in gray. These curators' ambitious 2007 exhibition and catalogue *Jasper Johns: Gray* held at the Art Institute of Chicago and the Metropolitan Museum of Art, is a testament to Johns's extended commitment to focused monochromatic experiments in a range of media, technique, and subject.

**58** Varnedoe 1996, p. 191.

**59** Tone 1996, p. 122.

**60** A summary of the tale is in: Arendie and Henk Herwig, *Heroes of the Kabuki Stage* (Amsterdam, 2004), pp. 138-43.

**61** Haruo Shirane, *Japan and the Culture of the Four Seasons* (New York, 2012), p. xi. On nature and the *Seasons* in Japanese screens see: Oliver Impey, *Art of the Japanese Folding Screen: The Collections of the Victoria and Albert Museum and the Ashmolean* Museum (Oxford, 2007); and ed. Janice Katz, *Beyond Golden Clouds: Japanese Screens from the Art Institute of Chicago and the Saint Louis Art Museum* (New Haven, 2009).

**62** Japanese art and literature that focuses on the outside world has a spiritual character linking it to Shinto teachings on the generative force of nature and man's place in the natural world.

**63** Some examples include: Artist Unknown, *Flowers and Birds of the Four Seasons with the Sun and Moon* (first half of the fifteenth century; Idemitsu Museum of Arts, Tokyo); Ogata Kōrin, *Red and White Plum Blossoms* (1710/16; MOA Museum of Art, Atami, Japan); and, Attributed to Kano

Takanobu, *Pheasants and Cherry Trees* (1614; Freer Gallery of Art, Smithsonian Institution, Washington, DC).

**64** Varnedoe 1996, p. 17. Johns is quoted in Hopps 1965 in *Writings* 1996, p. 108.

**65** "Throughout his early education (during which he also developed a strong affinity for poetry), Johns aimed at becoming an artist;" Varnedoe 1996, p. 117. The relationship of Johns's work to poetry was the subject of three lectures given during the 2007 exhibition *Jasper Johns: Gray* at the Art Institute of Chicago, co-sponsored with the Poetry Foundation. They are: Helen Vendler, "Wallace Stevens: the poet as painter," Marjorie Perloff, "Avoid a polar situation: Johns, Cage, and O'Hara in the sixties," and Langdon Hammer, "Hart Crane and Jasper Johns." See also Langdon Hammer, "Lost at sea: Jasper Johns with Hart Crane," *Yale Review* 97:4 (October 2009), pp. 34-53. On Hart Crane and Johns, see also Pissarro 1999. Crane is the poet most closely linked with Johns in studies of his work. Some writers, taking after Thomas B. Hess, have related the structure of Johns's hatchings to that of sonnets; see Hess 1976.

**66** See, for instance, Hindry 1989, in *Writings* 1996, p. 228.

**67** On Stevens's poetry, see Vendler 1984. Vendler compares Stevens's appropriations to those of modernist painters and sees a strong connection between Stevens's poetry and the visual arts; Vendler 1984, pp. 49-50 and Vendler 2007.

**68** Vendler 1984, pp. 47-50.

**69** Stevens wrote a sequence of major *Seasons* poems, starting with "Notes toward a Supreme Fiction," (1942), followed by "The Credences of Summer" (1946) and "The Auroras of Autumn" (1948).

**70** On Stevens's inventive poetic language, see Borroff 1976.

**71** Sylvester 1965, in *Writings* 1996, p. 118.

**72** Johns expanded on this sense of the open-ended in a group of related intaglios where the order encourages a more flexible reading as one season bleeds into another and new imagery is added. See, for example, figs. 111-13.

## FIVE   PAGES 162-93

**1** Winters 2011, p. 155.

**2** Steven Henry Madoff, "Jasper Johns: a seasonal lull at Castelli," *Artnews* 86:5 (May 1987), p. 158.

**3** Wallach 1991, in *Writings* 1996, p. 266.

**4** Tone 1996, pp. 361-62.

**5** Faye Hirsch, "Jasper Johns," *Arts* 65:9 (May 1991), p. 77; and Kimmelman 1991, both in Brundage 1993, n.p.

**6** In Sozanski 1988, in *Writings* 1996, p. 224.

**7** Tone 1996, pp. 122, 225-26, 278, 341-43, 360, and 364.

**8** Tomkins 2006, p. 81.

**9** When asked in conversation with Richard Shiff about the nature of his collecting interests, Johns responded, "I choose things that I like. Chance is often involved… There may be an unconscious attraction, something kinetic or even kinesthetic in nature. And there may follow a rationalization, 'I like this because…' Artists grow in sophistication, make many distinctions, break things into pieces, or join things across gaps. There are also technical interests and surprises: 'How was this done?'" Shiff 2006, p. 275.

**10** Tone 1996, p. 278.

**11** Asked in 1993 if there was any "contemporary American art which strikes a chord with you," or that he finds new,

Johns responded: "I see things I like, that interest me, but I don't see anything completely new. I think one may become insensitive to that sort of thing as one gets older. There's a tendency to be more self-preoccupied, and usually your work has developed to a point where it absorbs your own interest. When you get older, you become content to be on your own more and to explore your own work." Robertson and Marlow 1993, in *Writings* 1996, p. 290. In 2005, Johns told Julie Belcove that to a certain extent he missed regular contact with the art world: "I'm interested in other artists' work as a stimulus for my work...Even noting how someone is not like you, who is an artist, that reinforces you in your individuality or loneliness. You see they have an equal possibility for isolation." Belcove 2005, p. 68.

**12**  Johns quoted in "His heart belongs to Dada," *Time* 73 (May 4, 1959), p. 58, in *Writings* 1996, p. 82.

**13**  Johns's first appropriation of another artist's work was his small pencil and graphite *Litanies of the Chariot* (1961), the "Litanies" musings from Duchamp's *Green Box* on the construction and various erotic and emotive states of the "Chariot" in Duchamp's "Bachelor Apparatus" in *The Large Glass*. From this first instance of his careful study of another artist's work—and one completely committed to the conceptual in art—Johns showed his appreciation of Duchamp's conceptual framework while calling attention to the expressive possibilities of a worked-up surface, in his rich modulations of line and tone. Johns imprinted Duchamp's bronze sculpture *Female Fig Leaf* (1961) in *No* (1961) and other works of the 1960s, as he experimented with various approaches to marking his picture surfaces; see Bernstein 1996, p. 44ff.

**14**  Even though Johns did not refer explicitly to Cézanne in his work before the 1977 *Tracing*, scholars of his early career have noted Cézanne's influence in Johns's approach to the human figure in his pictures of the early to mid-1960s. The tracings after Cézanne with the figurative theme from the *Large Bathers* extend Johns's interest in the figure that originated in the early 1960s with the four Study for *Skin* drawings and *Diver*. Continued signs of the human presence in Johns's work include imprints of hands and feet, arms extending and tracing semicircles, as well as skulls, genitals, and cast body parts, and the Grünewald tracings, extended faces, and the shadow in the *Seasons*. One does not necessarily think of Johns as a figurative artist until considering such a group. See Bernstein 1996, pp. 41–42; Geelhaar 1990, p. 298; and Tuma 2007.

**15**  Tone 1996, p. 364.

**16**  Johns quoted in Crichton 1977, p. 28. Cézanne wrote frequently in his letters about the importance of intense observation. For example, he wrote to the French painter and writer Emile Bernard in 1905, "The Louvre is the book in which we learn to read. We must not, however, be satisfied with retaining the beautiful formulas of our illustrious predecessors. Let us go forth to study beautiful nature, let us try to free our minds from them, let us strive to express ourselves according to our personal temperaments. Time and reflection, moreover, modify little by little of our vision, and at last comprehension comes to us;" in Herschel B. Chipp, *Theories of Modern Art: A Source Book by Artists and Critics* (Berkeley and Los Angeles, 1968), p. 21.

**17**  Tone 1996, p. 122. Roberta Bernstein's authoritative scholarship considering Johns's longstanding response to Cézanne's work appears in several perceptive essays; see Bernstein 1996, p. 41ff. and Bernstein 2009. On Johns and Cézanne's bathers, see Bernstein 2009, pp. 468–72; and Geelhaar 1990, pp. 297–98.

**18**  Johns started collecting Cézanne's work in 1981 and his collection currently includes more works by Cézanne than by any other artist; Bernstein 2009, p. 560, note 3.

**19**  Geelhaar 1990, pp. 297–98. Johns did not want to sit in the museum and work before Cézanne's canvas nor could he find a reproduction of the work. Johns has noted about this work that it has "a synesthetic quality that gives it a great sensuality—it makes looking equivalent to touching;" in Glueck 1977, p. 87.

**20**  Bernstein 1996, p. 42.

**21**  Hindry 1989, in *Writings* 1996, p. 227.

**22**  Johns, quoted in Shiff 2006, p. 290. Johns told Christian Geelhaar that it was likely that he began using ink on plastic following his experience with washes on lithography stones and plates. He added: "Lithography has affected all of my thought, of course;" Geelhaar 1980a, p. 189.

**23**  See summary of scholarship on Cézanne's bathers in Krumrine 1990, pp. 33–36.

**24**  Krumrine 1990, p. 241; also in Bernstein 1996, p. 64.

**25**  Bernstein 1996, p. 63.

**26**  Ibid.

**27**  Kiki Smith, Interview with Carlo McCormick, *Journal of Contemporary Art* 4:1 (1991), pp. 81–95, 90, www.jca-online.com/ksmith.html.

**28**  Rosenthal and Fine 1990, pp. 40 and 82.

**29**  Bernstein 2009, pp. 469 and 472.

**30**  Johns quoted in Tomkins 2006, p. 80.

**31**  Wallach 1991, in *Writings* 1996, pp. 260 and 264. See also Rothfuss 2003a, p. 28ff.

**32**  Jill Johnston, "Tracking the shadow," *Art in America* 75 (October 1987), pp. 128–43; Johnston, "Jasper Johns' artful dodging," *Artnews* 87 (November 1988), pp. 156–59.

**33**  See, for instance, John Ashbery, "A tortoise among hares," *Newsweek* 103 (February 27, 1984), p. 81.

**34**  Johns, quoted in Crichton 1994, p. 72.

**35**  Sylvester 1965, in *Writings* 1996, p. 117.

**36**  In Diamonstein-Spielvogel 1994, pp. 114–20, in *Writings* 1996, p. 297.

**37**  Crichton 1994, pp. 69–70.

**38**  Bernstein was the first scholar to identify this figure. See Bernstein 1996, p. 66. Johns initially drew the image in the ink on paper *Sketch for Montez Singing* of 1988 (12¼ × 19¾ in.; 31 × 50.5 cm).

**39**  Bernstein 1996, p. 66.

**40**  Rosenfeld and Fine 1990, cat. 89, p. 280. Bernstein 1991, p. 12.

**41**  Conversation with Bill Goldston, November 26, 2012.

**42**  Conversation with John Newman, February 2, 2013.

**43**  Varnedoe 1996, p. 33, note 1. Varnedoe speculated that the mark's spray blob appearance could relate to the paint-dipped matchsticks that Duchamp fired from a toy cannon at *The Large Glass* to indicate the Bachelors' impotent shots at the upper realm of the Bride. Their spurts miss and the Bride is left hanging.

**44**  Lorence 1996, p. 54. It was not, however, the end of Johns's absorption with the *Seasons* imagery, which has continued into the twenty-first century. In 1998, he made two haunting drawings featuring outlines of the figures and the ladder from *Spring* in the 1990 *Seasons* intaglio on a Christian cross set against a loosely brushed inky ground.

45  See, in particular, Judith Goldman, *Foirades/Fizzles*, exh. cat. (Whitney Museum of American Art, New York, 1977), n.p. Richard Field posited that the X in *Hinged Canvas* and *Untitled (Skull)* questions Johns's authorship; Field 1987, pp. 110-11. See also Rosenthal 1988, pp. 25-26, who stresses X as a symbol of negation.

46  Feinstein 1997, p. 88; Rosenthal 1997, p. 67. Roberta Bernstein has compared the *Seasons* to Gustave Courbet's large painting *The Painter's Studio: A Real Allegory of Seven Years of My Life as an Artist* (1854-55), suggesting it "can be read as a complex allegory of an artist's life." Bernstein 1991, p. 9.

47  Johns's description of the house and plan is interesting as it sheds light on his thought process. When asked in an interview if he had the image and idea of his grandfather's house in mind for a long time, he responded: "The plan of the house? No. Because I'm having such trouble remembering it. I don't know what triggered my trying to reconstruct the plan, but I had decided I wanted to use it. And when I began to draw it, I realized that certain parts didn't exactly go together, and so I consulted my cousins, to see if they could remember. They remembered some things— other things they remembered less well than I." The house had recently been torn down, according to Johns, so they had to rely on their memories. Interview with Diamonstein-Spielvogel 1994,
in *Writings* 1996, p. 290.

48  Bernstein 1996, p. 65.

49  Rosenthal 1993, in *Writings* 1996, p. 282. Mattison provides an in-depth consideration of Johns's spiral galaxy and points to the source of Johns's image as Timothy Ferris, *Galaxies* (San Francisco, 1980), p. 82; Mattison 1995, pp. 47-48.

50  As early as his 1962 painting *4 the News*, Johns had linked himself to one of the masters of this detailed style of visual punning, John Frederick Peto, stenciling alongside the title of his work, "PETO JOHNS". Johns's picture refers to Peto's work *The Cup We All Race 4* (c. 1900). On trompe l'oeil in Johns's work, see Kenneth E. Silver, *Jasper Johns and Roy Lichtenstein: Walls*, exh. cat. (Leo Castelli Gallery, New York, 2014).

51  See Varnedoe 1996, p. 27, on Johns's investigation of "direct, nonillusionistic ways of mediating between a fully dimensional world and a flat plane."

52  Crichton 1977, pp. 60-61.

53  See Field 1994, and Varnedoe 1996, p. 27.

54  Robertson and Marlow 1993, in *Writings* 1996, p. 288.

55  Bernstein 1996, p. 67. Bernstein intriguingly suggests Johns has taken up in a twentieth-century version Leonardo's theories regarding the picture being a mirror of nature. See also Mattison 1995, p. 46, who views the strip as a trompe-l'oeil wooden stretcher of a picture seen from the side.

56  Vendler 1969, pp. 231-32, 245-48 and 264-68.

57  Quoted in Crichton 1994, p. 64. See also the in-depth discussion of the influence of these elements of the Isenheim altarpiece on Johns's work in Rosenthal 1990, p. 36ff.

58  Barbara Rose, "Mapping the mind," pp. 142-55, in Rondeau and Druick 2007, p. 150.

59  Varnedoe 1996, p. 13, offers a particularly insightful and inventive inventory and analysis of this picture.

60  Rosenthal 1993, in *Writings* 1996, p. 282. The engraving is by Gian Battista Piranesi, *Del Castello Dell'Acqua Giulia* (1761).

1  In Mark Stevens with Cathleen McGuigan, "Super artist: Jasper Johns, today's master," *Newsweek* 90:17 (October 24, 1977), p. 78.

2  Dadd, quoted in Nicholas Tromans, *Richard Dadd, The Artist and the Asylum* (London: Tate Publishing, 2011), p. 61.

3  Patricia Allderidge, *The Late Richard Dadd, 1817-1886* (London: The Tate Gallery, 1974), pp. 18-27.

4  See Allderidge, cat. 190, pp. 125-26. For the poem, see pp. 127-29, cat. 193. The poem (titled *Elimination of a Picture & its subject—called The Feller's Master-Stroke*) is reproduced, exactly as in the twenty-four leaves of a notebook now in Bethlem archives, in Tromans, op. cit., pp. 186-93.

5  Dadd quoted in Tromans, p. 193.

6  Bernstein 1996, p. 68.

7  Scott Rothkopf described how "Johns wiped the slate clean," after the dense work that preceded the *Catenary* pictures; Rothkopf 2005, p. 5.

8  According to Johns, "this work more than anything I've done before is a definite series;" Belcove 2005, p. 67.

9  See Rothkopf's formal analysis of Johns's 2000 ink on plastic *Untitled* in Rothkopf 2005, p. 18 and cat. 24, detailing Johns's use of Henri Monnier's lithograph. Johns saw Monnier's image in the *Times Literary Supplement* and began working with it soon after, Walter Redfern, "Try a taboo," *Times Literary Supplement*, issue 4971 (July 24, 1998), p. 32.

10  Wallach 1999, p. 29.

11  Kimmelman 2005; Kimmelman 1996.

12  See James Rondeau's detailed consideration of these art historical references; Rondeau 2007, p. 68. Rondeau also relates the drapery folds in *Near the Lagoon* to Johns's works of the late 1980s featuring faces on trompe-l'oeil fabrics tacked to the picture surface.

13  Joachim Pissarro discusses the multiple metaphoric associations of Harlequin as it relates to Johns's *Catenary* pictures; Pissarro 1999, pp. 51-53.

14  Field 1999, p. 30. Field writes a wonderful brief history of the harlequin in twentieth-century art as well as the clown who enforces laughter to mask the intensity of his feelings and earnest outlook; Field 1999, pp. 31-32.

15  Johns first depicted the Halloween costume in 1997 in an untitled ink on plastic drawing on two sheets. Johns says the costume derives from a "Halloween costume I wore when I was five or six." Yau 1999, p. 125. As a child, Johns made lanterns out of cardboard cartons and colored paper. With a candle inside, and a string attached, he pulled one along at night, providing a beacon; Garrels 1999, p. 12.

16  See Garrels 1999, pp. 10-12, for a cogent discussion of the relationship between the Chinese and Harlequin costumes and the figures in Johns's earlier work.

17  Rothkopf's insightful essay focuses on Johns's continual questioning of the nature of painting in his work. See in particular, pp. 16-18; Rothkopf 2005.

18  "Statement," in ed. Dorothy C. Miller, *Sixteen Americans*, exh. cat. (Museum of Modern Art, New York, 1959), p. 22; in Bernstein 1996, p. 41.

19  Wallach 1999, p. 29.

20  Ibid.

21  In a 1963 interview, Robert Rauschenberg described to Calvin Tomkins how Johns "read a lot, and he wrote poetry. Jasper would read Hart Crane to me in the studio. I loved it—I just didn't have the patience to read it myself;" Rauschenberg, quoted in Tomkins 2006, p. 82. On the

multiple related themes in Crane's poem and Johns's painting, see Pissarro 1999, pp. 42-46.

**22**  See Field 1998, p. 26; and Livingstone 2000, p. 181. The photograph ran in the *New York Times* on November 18, 1996. When Field queried Johns about the photo's potential influence, Johns said that while he wasn't aware of a direct influence, it was possible that he had indeed had a "subconscious reaction" to it. He further described it as "an extraordinary photograph...those two panels and everything. But it reminded me of a Frida Kahlo painting...in which there are two of her and she is connected...or maybe it is he [Diego Rivera] and she...I saw the painting in Mexico City. It's an extraordinary picture. It has the suggestion of things connected by tubing which is sending energy, as it were;" Field 1999, p. 26. The Kahlo painting Johns refers to is *The Two Fridas* (1939).

**23**  Field observed that the string stands as a mark of the integral relationship between viewer and work of art in the creation of meaning; Field 1999, p. 18.

**24**  Johns, quoted in Livingstone 2000, p. 185.

**25**  On these ejaculatory drips, see Varnedoe 1996, p. 33, note 1.

**26**  Field first noted the reference to Job. Most versions of the text read: "if I call the grave my father..." but in a conversation between Field and art historian Ruth Fine, she noted that in 1990 (eight years before Johns incorporated it into a title) her husband sent Johns a version of the passage that read "I call to the grave..." No one has yet found the source of this text; see Field 1999, pp. 21 and 35, note 35.

**27**  Catherine Craft interprets this reference in the context of other *Catenary* pictures, suggesting that these gray paintings evoke a broad expanse from the heavens to the grave, with a mere frail cord keeping us suspended somewhere in between; Craft 2009, pp. 233-34.

**28**  Livingstone 2000, p. 180.

**29**  On the history of Manet's Maximilian series, see John Elderfield, *Manet and the Execution of Maximilian*, exh. cat. (Museum of Modern Art, New York, 2006).

**30**  Livingstone 2000, pp. 180 and 188, note 8.

**31**  Rondeau 2007, pp. 67-68.

**32**  Johns first worked with a detail of the *Crucifixion*, seen when the altarpiece is closed, showing John the Evangelist catching the stupefied Virgin, in the ink on plastic *Tracing* (1981).

**33**  Druick 2007, p. 100, relates the folds to the cloth in depictions of the Passion of Christ, including the veil St. Veronica used to wipe Christ's brow on the road to Calvary as well as Christ's loincloth and shroud covering his body in the Deposition. Johns would have had the opportunity to see such sumptuously painted drapery when he viewed the exhibition of the work of the Spanish master Francisco de Zurbarán at the Metropolitan Museum of Art in New York in 1987; see Rondeau 2007, p. 68. Artist Carroll Dunham described how "it was somewhat jarring, after studying [Johns's] painting for several minutes, to realize that its opaque monumentality was giving way to the sensation of standing before the chest and necklace of a gray female giant." Dunham 2008, p. 285.

**34**  Keegan and Lister 2007, pp. 165-67. Keegan and Lister provide a fascinating and detailed technical examination and interpretive analysis of Johns's process in *Tennyson* and *Near the Lagoon*.

**35**  Rosenthal 2007, p. 159.

**36**  Ibid., p. 161.

**37**  On the split in this photo in relation to Johns's *Catenary* pictures, see Field 1999, pp. 25-26. Regarding his interest in fragments, Johns told Fred Orton in 1978 that the relationship of part to whole is "so stressed in my work that I imagine it has a psychological basis." Orton 1994, p. 17. In another interview the same year, Johns commented, "My experience of life is that it's very fragmented. I would like my work to have some vivid indication of those differences." Fuller 1978a, in *Writings* 1996, pp. 173-74.

**38**  Keegan and Lister 2007, p. 169. Keegan and Lister refer to the grays in *Near the Lagoon* as "colored grays."

**39**  Keegan and Lister infer that in creating *Near the Lagoon*, Johns may have used many tools in addition to a brush, possibly including (but not limited to) a mezzotint rocker to make the textured crosshatch pattern or a heat gun to indent, as well as a screen that creates a surface impression and a squeegee to skim some parts of the encaustic surface; Keegan and Lister 2007, pp. 167 and 171.

**40**  Keegan and Lister 2007, p. 168.

**41**  On Johns's varied spatial references in the *Catenary* pictures, see the thorough analysis in Pissarro 1999, pp. 46-51, and Livingstone 2000, p. 182.

**42**  Rothkopf 2005, p. 10ff.

**43**  Cage 1964, p. 22.

## SEVEN   PAGES 218-65

**1**  In Paul Auster and J. M. Coetzee, *Here and Now: Letters 2008-2011* (New York, 2013), p. 97.

**2**  John Russell, "Art: Jasper Johns packs them in," *New York Times*, October 21, 1977, p. C21.

**3**  On Johns's use of numbers, see Bernstein and Foster 2003.

**4**  See, for instance, *Flag* (1960, cast 1987; Silver, $12\frac{3}{4} \times 19\frac{1}{4} \times 1\frac{1}{2}$ in.; $32 \times 49 \times 3.5$ cm) and *Figure 3* (1961, cast 2001; Bronze, edition of 4, $25\frac{5}{8} \times 19\frac{3}{8} \times 1\frac{1}{4}$ in.; $65 \times 49.5 \times 3$ cm). Johns also revised one of two aluminum casts made from his Sculp-metal *Numbers* (1963) several years later, further activating the surface by painting on it in colored oils. See, *Numbers*, 1963-78, aluminum with oil paint, $57\frac{1}{8} \times 43\frac{3}{8}$ in ($145 \times 110.5$ cm).

**5**  Winters 2011, p. 141.

**6**  On Sculp-metal, see Orton 1996, pp. 25-27.

**7**  Orton 1996, p. 19. See also, Roni Feinstein, "New thoughts for Jasper Johns' sculpture," *Arts* (April 1980); www.ronifeinstein.com/book/new-thoughts-for-jasper-johns-sculpture/.

**8**  Max Kozloff, *Jasper Johns* (New York, 1969), p. 10; and Roni Feinstein, "New thoughts for Jasper Johns' sculpture," *Arts* (April 1980), n.p.

**9**  *Writings* 1996, p. 22.

**10**  Bernstein 1985, p. 60; Tone 1996, p. 127. See *Writings* 1996, pp. 19-23 passim.

**11**  Jasper Johns, "Duchamp," *Scrap* (New York) 2 (December 23, 1960), p. 4, in *Writings* 1996, p. 21.

**12**  Johns inscribed the top of the slightly smaller open can with the three-ring emblem of the Ballantine Brewing Company, Florida. The other lid has no writing, apparently manufactured in the company's brewery in the North. Here Johns refers to his Southern roots and Northern present. This and the open and closed cans suggest the

human presence and the passage of time.

**13** Tone 1996, p. 168.

**14** The reliefs are: *High School Days* (1969), *The Critic Smiles* (1969), *Flag* (1960–69), *Light Bulb* (1969), *Bread* (1969) and *0 through 9* (1970). Johns printed them in editions of sixty. On the Lead Reliefs, see John Yau, "Encaustic and lead in the work of Jasper Johns," in ed. Elizabeth Armstrong, *Jasper Johns: Printed Symbols*, exh. cat. (Walker Art Center, Minneapolis, 1990), pp. 31–47.

**15** Winters 2011, pp. 141–42.

**16** Ibid.

**17** See Winters 2011, pp. 142–43. Among several articles published in 1999 about the possibility of Lincoln Center selling *Numbers*, see, Carol Vogel, "Lincoln Center drops plan to sell its Jasper Johns painting," *New York Times*, January 26, 1999. www.nytimes.com/1999/01/26/nyregion/lincoln-center-drops-plan-to-sell-its-jasper-johns-painting.html, and an opinion piece: www.nytimes.com/1999/01/13/opinion/numbers-at-lincoln-center.html.

**18** Winters 2011, pp. 142.

**19** Ibid., pp. 154–55.

**20** Ibid., p. 155.

**21** Ibid., p. 153.

**22** See chap. 1.

**23** Winters 2011, p. 146.

**24** See also Chapter Five.

**25** Bernstein 2003, p. 12.

**26** Winters 2011, p. 146.

**27** Bernstein 2003, p. 18. For *Gray Alphabets*, Johns drew on a chart he saw in a book.

**28** Ibid., p. 20.

**29** For a comparison of Johns's use of numbers with those of other artists and a discussion of his influence, see Bernstein 2003, pp. 26–29.

**30** Interview with David Sylvester, 1965, in *Writings* 1996, p. 113.

**31** Ibid., p. 117.

**32** Rosenthal and Fine 1990, p. 80.

**33** The Museum of Modern Art catalogue by the exhibition curators, Christophe Cherix and Ann Temkin, delineated in a clear, thoughtful manner Johns's work, ideas and imagery, including a wealth of technical and narrative detail.

**34** Photographs of Bacon's studio at the time of his death show a dense layering of photographs, papers and other objects littering the floor. See Martin Harrison, *In Camera— Francis Bacon: Photography, Film and the Practice of Painting* (London, 2005); and Cherix and Temkin 2014, p. 12.

**35** See Christie's auction catalogue for the sale, *Francis Bacon: Post-War & Contemporary Art* (London, June 27, 2012), p. 16 onwards. Johns did not know Freud, who was eight years older and died in 2011. Deakin's photograph is evidence of a creative and emotional friendship between these two major modern British painters during the 1950s and 1960s, that subsequently dissolved. Bacon and Freud, like Manet and Degas, had been close friends before rivalries and other factors caused friction. Their bond recalls Johns's own with Robert Rauschenberg and the friendship they shared with John Cage and Merce Cunningham. Those four creative spirits were major twentieth-century innovators and their rapport is a testament to the force of the exchange of ideas and the strength of the artistic community; Cherix and Tempkin 2014, pp. 16–17; Belcove 2014. On Freud, see David Sylvester, *Looking Back at Francis Bacon* (London, 2000).

**36** On these drips, see p. 182 and note 43.

**37** Cherix and Temkin discuss the missing figure as an extension of those that have appeared in Johns's work since the early 1960s; Cherix and Temkin 2014, p. 23.

**38** Ibid., p. 24.

**39** It is perhaps worth mentioning another side of the art world that Johns may have found consuming at this time: James Meyer, who had worked as Johns's studio assistant for twenty-five years, was arrested in 2013 for selling twenty-two works on paper by Johns that he pulled from files in the artist's studio. Over the next two years, Meyer was tried, fined, and sentenced to eighteen months in prison. In 2014, Johns also appeared in court to give evidence against a foundry owner who was eventually charged with fraud for making and attempting to sell an unauthorized cast of a Johns *Flag*. See: www.nytimes.com/2014/08/28/arts/design/former-assistant-to-jasper-johns-pleads-guilty-in-thefts-of-artworks.html and www.wsj.com/articles/sentencing-in-jasper-johns-fraud-case-1413488793.

**40** See also Chapter Five, on Johns's use of mirroring in his *Mirror's Edge* series.

**41** On Burrows, see Larry Burrows, *Vietnam*, intro. by David Halberstam (New York and London, 2002).

**42** Julie L. Belcove, "Artist Jasper Johns on the process behind his monotypes," *WSJ. [Wall Street Journal] Magazine*, Feb. 9, 2016; www.wsj.com/articles/artist-jasper-johns-on-the-process-behind-his-monotypes-1455033251.

**43** A key article on various types of body imprints in Johns's art is Bernstein 1977. Barbara Rose noted that there is a very small stick figure at the bottom of the 1979 drawing *Cicada*; see Rose 1993, p. 69.

**44** Bernstein 1977, p. 42.

**45** Rose 1993, p. 70.

**46** Winters 2011, p. 144.

**47** Shiff 2006, p. 294.

**48** Winters 2011, p. 144.

**49** Field 1999, p. 15.

**50** Julie Belcove, "Meaning in the making," *Financial Times*, April 30/May 1, 2011, Life and Arts, p. 13.

**51** Tomkins 2006, p. 85.

**52** Varnedoe 1996, p. 111.

**53** Shiff 2006, p. 297.

**54** Winters 2011, pp. 157–58.

**55** Tomkins 1980, p. 108. Belcove 2014. Johns gives a sense of the life they lived in the 1950s in a 1989 interview with David Vaughan; Vaughan 1990.

**56** John Cage, 1987 interview, quoted in Mary Lynn Kotz, *Rauschenberg: Art and Life* (New York, 1990), p. 89.

**57** Rose 1993, pp. 49–50.

**58** Ibid., p. 49.

**59** "His heart belongs to Dada," *Time* 73 (May 4, 1959), p. 58.

**60** Johns remarked in 2005 "I feel that works of art are an opportunity for people to construct meaning, so I don't usually tell what they mean. It conveys to people that they have to participate;" Belcove 2005, p. 66.

**61** Tomkins 1980, pp. 69–70.

**62** Ibid., p. 78.

Belcove 2005: Julie L. Belcove, "String fellow", *W* (July 2005), pp. 65-69

Belcove 2014: Julie L. Belcove, "Jasper Johns: 'Regrets belong to everybody, don't they?'," *FT [Financial Times] Magazine*, February 14, 2014; www.ft.com/cms/s/2/65e763c8-9444-11e3-a0e1-00144feab7de.html

Bernard and Thompson 1984: April Bernard and Mimi Thompson, "Johns on...," *Vanity Fair* 47:2 (February 1984), p. 65. Reprinted in *Writings* 1996, pp. 214-17

Bernstein 1977: Roberta Bernstein, "Jasper Johns and the figure: part one: body imprints," *Arts* 52:2 (October 1977), pp. 142-44

Bernstein 1981: Roberta Bernstein, "An interview with Jasper Johns," *Fragments: Incompletion and Discontinuity*, ed. Lawrence D. Kritzman, *New York Literary Forum* 8-9 (1981), pp. 279-90. Reprinted in *Writings* 1996, pp. 200-04

Bernstein 1985: Roberta Bernstein, *Jasper Johns' Paintings and Sculptures 1954-1974: The Changing Focus of the Eye*, Ann Arbor, MI, 1985

Bernstein 1991: Roberta Bernstein, *Jasper Johns: The Seasons*, exh. cat. Brooke Alexander, New York, 1991

Bernstein 1995: Roberta Bernstein, "*Winter* by Jasper Johns," *Sotheby's Preview* (New York) 7:6 (November 1995), pp. 12-14

Bernstein 1996: Roberta Bernstein, "Seeing a thing can sometimes trigger the mind to make another thing," in Varnedoe 1996, pp. 39-91

Bernstein 2003: Roberta Bernstein, "Jasper Johns's Numbers: uncertain signs," in Bernstein and Foster 2003, pp. 12-32

Bernstein and Foster 2003: Roberta Bernstein and Carter E. Foster, *Jasper Johns: Numbers*, exh. cat., The Cleveland Museum of Art, 2003

Bernstein 2009: Roberta Bernstein, "Cézanne and Johns: 'At Every Point in Nature There is Something to See'," in Joseph J. Rishel and Katherine Sachs, *Cézanne and Beyond*, exh. cat. Philadelphia Museum of Art, 2009

Borroff 1976: Marie Borroff, "Wallace Stevens's world of words, II," *Modern Philology* 74:2 (November 1976), pp. 171-93

Brundage 1993: Susan Brundage (ed.), *Jasper Johns: 35 Years, Leo Castelli*, Leo Castelli Gallery, New York, 1993

Cage 1964: John Cage, "Stories and ideas," in Solomon 1964, pp. 21-26

Cherix and Temkin 2014: Christophe Cherix and Ann Temkin, *Jasper Johns: Regrets*, exh. cat., Museum of Modern Art, New York, 2014

Clements 1990: Paul Clements, "The Artist Speaks," *Museum and Arts Washington* 6:3 (May-June 1990), pp. 76-81, 116-17. In *Writings* 1996, pp. 242-44

Coplans 1972: John Coplans, "Fragments according to Johns: an interview with Jasper Johns," *Print Collector's Newsletter* 3:2 (May-June, 1972), pp. 29-32. Reprinted in *Writings* 1996, pp. 138-41

Cork 1990: Richard Cork, "The liberated millionaire is not flagging," *The Times* (London) (November 30, 1990). Reprinted in *Writings* 1996, pp. 257-59

Craft 2000: Catherine Craft, "New Haven and Dallas: recent works by Jasper Johns," *Burlington Magazine* 142:1166 (May 2000), pp. 329-30

Craft 2009: Catherine Craft, *Jasper Johns*, New York and London, 2009

Crichton 1977: Michael Crichton, *Jasper Johns*. exh. cat., Whitney Museum of American Art, New York, 1977

Crichton 1994: Michael Crichton, *Jasper Johns*, New York, 1994. Revised and expanded edition of 1977 catalogue

Cuno 1987: James Cuno (ed.), *Foirades/Fizzles: Echo and Allusion in the Art of Jasper Johns*, exh. cat., The Grunwald Center for the Graphic Arts/Wight Art Gallery, University of California, Los Angeles, 1987

Cuno 1990: James Cuno, "Reading the seasons," in *Jasper Johns: Printed Symbols*, exh. cat., Walker Art Center, Minneapolis, pp. 77-89

Davvetas 1984: Demosthène Davvetas, "Jasper Johns et sa famille d'objets," *Art Press* (Paris) 80 (April 1984), pp. 11-12. Reprinted in *Writings* 1996, pp. 217-19

Diamonstein-Spielvogel 1994: Barbaralee Diamonstein-Spielvogel, *Inside the Art World: Conversations with Barbaralee Diamonstein*, New York, 1994. Reprinted in *Writings* 1996, pp. 290-99

Druick 2007: Douglas Druick, "Jasper Johns: gray matters," in Rondeau and Druick 2007, pp. 80-107

Dunham 2008: Carroll Dunham, "Jasper Johns: Gray," *Artforum* (February 2008), pp. 283-85

Feinstein 1997: Roni Feinstein, "Jasper Johns: the examined life," *Art in America* 85 (April 1997), pp. 78-88ff

Field 1976: Richard S. Field, "Jasper Johns' Flags," *Print Collector's Newsletter* 7:3 (July-August 1976), pp. 69-77

Field 1987: Richard S. Field, "The making of *Foirades/Fizzles*," in Cuno 1987, pp. 99-126

Field 1994: Richard S. Field, "Introduction," in ULAE 1994, n.p.

Field 1999: Richard S. Field, "Chains of meaning: Jasper Johns's *Bridge* paintings," in Garrels 1999, pp. 15-36

Fine 1990: Ruth Fine, "Making marks," in Rosenthal and Fine 1990, pp. 46-67

Fine and Rosenthal 1990: Ruth Fine and Nan Rosenthal, "Interview with Jasper Johns," in Rosenthal and Fine 1990, pp. 69-83

Fitzgerald 2006: Michael Fitzgerald, *Picasso and American Art*, exh. cat., Whitney Museum of American Art, New York, 2006

Francis 1984: Richard Francis, *Jasper Johns*, New York, 1984

Francis 1989: Richard Francis, et al., *Cage, Cunningham, Johns: Dancers on a Plane*, exh. cat., Anthony d'Offay Gallery, London, 1989

Francis 1990: Richard Francis, "If Art is not Art, then what is it?", in Francis 1989, pp. 25-32

Freeman 1994: Judi Freeman, *Picasso and the Weeping Women—The Years of Marie-Thérèse Walter & Dora Maar*, exh. cat., Los Angeles County Museum of Art, 1994

Fuller 1978a: Peter Fuller, "Jasper Johns interviewed, part I," *Art Monthly* (London), 18 (July-August 1978), pp. 6-12. Reprinted in *Writings* 1996, pp. 173-82

Fuller 1978b: Peter Fuller, "Jasper Johns interviewed, part II," *Art Monthly* (London), 19 (September), pp. 5-7. Reprinted in *Writings* 1996, pp. 182-88

Garrels 1999: Gary Garrels, et al., *Jasper Johns: New Paintings and Works on Paper*, exh. cat., San Francisco Museum of Modern Art, 1999

Geelhaar 1980a: Christian Geelhaar, "Interview with Jasper Johns,"

in Geelhaar 1980b, pp. 37-56. Reprinted in *Writings* 1996, pp. 188-97

Geelhaar 1980b: Christian Geelhaar (ed.), *Jasper Johns Working Proofs*, exh. cat., Kunstmuseum Basel and Tate, London, 1980

Geelhaar 1990: Christian Geelhaar, "The painters who had the right eyes: on the reception of Cézanne's Bathers," in Krumrine 1990, pp. 275-303

Glueck 1966: Grace Glueck, "No business like no business," *New York Times* (January 16,1966), section 2, p. 26. Reprinted in *Writings* 1996, p. 128

Glueck 1977: Grace Glueck, "The 20th-century artists most admired by other artists," *Artnews* 76:9 (November 1977), pp. 78-103. Excerpts in *Writings* 1996, pp. 162-66

Goldman 1982: Judith Goldman, *Jasper Johns: 17 Monotypes*, West Islip, NY, 1982

Goldman 1987: Judith Goldman, *Jasper Johns: The Seasons*, exh. cat., Leo Castelli Gallery, New York, 1987

Goodyear 2009: Anne Collins Goodyear, "Constructing a 'made-up' history: self-portrayal and the legacy of Marcel Duchamp," in Goodyear and McManus 2009, pp. 80-99

Goodyear and McManus 2009: Anne Collins Goodyear and James W. McManus (eds.), *Inventing Marcel Duchamp: the dynamics of portraiture*, exh. cat., National Portrait Gallery, Smithsonian Institution, Washington, DC, 2009

Greenberg 1962: Clement Greenberg, "After Abstract Expressionism," *Art International* 6:8 (October 1962), pp. 24-32

Hammer, 2007: Langdon Hammer, "Lost at Sea: Jasper Johns and Hart Crane," public lecture at the Art Institute of Chicago, December 13, 2007. www.artic.edu/aic/resources/resource/677?search_id=1&index=0

Herrmann 1977: Rolf-Dieter Herrmann, "Jasper Johns' ambiguity: exploring the hermeneutical implications," *Arts* 52:3 (November 1977), pp. 124-29

Hess 1976: Thomas B. Hess, "On the scent of Johns," *New York*, February 9, 1976, p. 67

Hindry 1989: Ann Hindry, "Conversation with Jasper Johns/ Conversation avec Jasper Johns,"

*Artstudio* 12 (Spring 1989), pp. 6-25. Reprinted in *Writings* 1996, pp. 227-34

Hopps 1965: Walter Hopps, "An interview with Jasper Johns," *Artforum* 3:6 (March 1965), pp. 32-36. Reprinted in *Writings* 1996, pp. 106-13

*Jasper Johns: A Calendar for 1991*: Anthony d'Offay Gallery, London, 1990

*Jasper Johns: Ideas in Paint* 1989: Television documentary directed by Rick Tejada-Flores, narrated by Polly Adams. Produced by WHYY Inc. Productions (Philadelphia) in association with WNET/New York, for the "American Masters" series on PBS. Excerpted in *Writings* 1996, pp. 222-24

Jespersen 1969: Gunnar Jespersen, "Møde med Jasper Johns," *Berlingske Tidende* (Copenhagen), February 23, 1969, p. 14. Excerpts in *Writings* 1996, pp. 134-37

Johns 1959: Jasper Johns, "Artist's statement," in *Sixteen Americans*, Dorothy C. Miller (ed.), exh. cat., Museum of Modern Art, New York, 1959, p. 22. Reprinted in *Writings* 1996, pp. 19-20

Johns 1968: Jasper Johns, "Marcel Duchamp (1887-1968)," *Artforum* 7:3 (November 1968), p. 6. Reprinted in *Writings* 1996, p. 22

Johns 1969: Jasper Johns, "Thoughts on Duchamp," in Cleve Gray (ed.), "Feature: Marcel Duchamp 1887-1968," *Art in America* 57:4 (July-August 1969), p. 31. Reprinted in *Writings* 1996, p. 22

Joselit 2012: David Joselit, "Profiles," in *Jasper Johns: Numbers, 0-9, and 5 Postcards*, exh. cat., Matthew Marks Gallery, Los Angeles, 2012

Karmel 2010: Pepe Karmel, *Jasper Johns: Drawing Over*, exh. cat., Leo Castelli Gallery, New York, 2010

Keegan and Lister 2007: Kelly Keegan and Kristin Lister, "A shifting focus: process and detail in Tennyson and Near the Lagoon," in Rondeau and Druick 2007, pp. 162-73

Kent 1990: Sarah Kent, "Jasper Johns: strokes of genius," *Time Out* (London) (December 5-12, 1990), pp. 14-15. Reprinted in *Writings* 1996, pp. 258-59

Kimmelman 1991: Michael Kimmelman, "Jasper Johns, cool and/or confessional," *New York Times*, March 1, 1991. www.nytimes.com/1991/03/01/arts/

reviews-art-jasper-johns-cool-and-or-confessional.html

Kimmelman 1996: Michael Kimmelman, "Sifting among the icons for the key to Johns," *New York Times*, October 18, 1996, pp. C1, C32

Kimmelman 2005: Michael Kimmelman, "Jasper Johns: Catenary," *New York Times*, May 27, 2005, p. B32

Klüver 1963: Billy Klüver, "Interview with Jasper Johns" (March 1963). Reprinted in *Writings* 1996, pp. 22-25

Kozloff 1968: Max Kozloff, *Jasper Johns*, New York, 1968

Krauss 1965: Rosalind Krauss, "Jasper Johns," *Lugano Review* 1:2 (1965), pp. 84-113

Krauss 1996: Rosalind Krauss, "Split decisions, Jasper Johns in retrospect: whole in two," *Artforum* 35 (September 1996), pp. 78-85

Krumrine 1990: Mary Louise Krumrine, *Paul Cézanne: The Bathers*, exh. cat., Kunstmuseum Basel, 1990

Lewis 1990: Jo Ann Lewis, "Jasper Johns, personally speaking," *Washington Post*, May 16, 1990, pp. F1, F6. Reprinted in *Writings* 1996, pp. 240-42

Livingstone 2000: Marco Livingstone, "Jasper Johns," in *Encounters: New Art from Old*, Richard Morphet (ed.), pp. 177-89, exh. cat., National Gallery, London, 2000

Lorence 1996: Susan Lorence with Susan Brundage (eds.), *Technique and Collaboration in the Prints of Jasper Johns*, exh. cat., Leo Castelli Gallery, New York, 1996

Mattison 1995: Robert Saltonstall Mattison, *Masterworks in the Robert and Jane Meyerhoff Collection*, New York, 1995

Morris 2007: Robert Morris, "Jasper Johns: the first decade," in Weiss 2007b, pp. 208-33

Olson 1977: Roberta J. M. Olson, "Jasper Johns: getting rid of ideas," *Soho Weekly News*, November 3, 1977. Reprinted in *Writings* 1996, pp. 166-69

Orton 1994: Fred Orton, *Figuring Jasper Johns*, Cambridge, MA, 1994

Orton 1996: Fred Orton, *Jasper Johns: The Sculptures*, exh. cat., Centre for the Study of Sculpture, Henry Moore Institute, Leeds, U.K., 1996

Pissarro 1999: Joachim Pissarro, "Jasper Johns's *Bridge* paintings

under construction," in Garrels 1999, pp. 37-55

Pohlen 1978: Annelie Pohlen, "Interview mit Jasper Johns," *Heute Kunst* (Milan) 22 (May-June 1978), pp. 21-22. Translated in *Writings* 1996, pp. 170-73

Porter 1964: Fairfield Porter, "The education of Jasper Johns," *Artnews* 62:10 (February 1964), pp. 44-45, 61-62

Ravenal 2016: John B. Ravenal, *Jasper Johns and Edvard Munch: Inspiration and Transformation,* exh. cat., Virginia Museum of Fine Arts and Yale University Press in partnership with the Munch Museum, 2016

Raynor 1973: Vivien Raynor, "Jasper Johns: I have attempted to develop my thinking in such a way that the work I've done is not me," *Artnews* 72:3 (March), pp. 20-22

Robertson and Marlow 1993: Bryan Robertson and Tim Marlow, "Jasper Johns," *Tate: The Art Magazine* (London) 1 (Winter 1993), pp. 40-47. Reprinted in *Writings* 1996, pp. 285-90

Rondeau 2007: James Rondeau, "Jasper Johns: gray," in Rondeau and Druick 2007, pp. 22-79

Rondeau and Druick 2007: James Rondeau and Douglas Druick, *Jasper Johns: Gray,* exh. cat., The Art Institute of Chicago, 2007

Rose 1964: Barbara Rose, "New York Letter," *Art International* 8:1 (February 1964), pp. 40-41

Rose 1970a: Barbara Rose, "The Graphic Work of Jasper Johns, Part I," *Artforum* 8:7 (March 1970), pp. 39-45

Rose 1970b: Barbara Rose, "The Graphic Work of Jasper Johns, Part II," *Artforum* 9:1 (September 1970), pp. 65-74

Rose 1976: Barbara Rose, "Decoys and doubles: Jasper Johns and the modern mind," *Arts* 50 (May 1976), pp. 68-73

Rose 1977: Barbara Rose, "Jasper Johns: pictures and concepts," *Arts Magazine* 52:3 (November 1977), pp. 148-53

Rose 1987: Barbara Rose, "Jasper Johns: The Seasons," *Vogue* (New York) 177: 1 (January 1987), pp. 192-94, 199, and 259-60. Reprinted in Brundage 1993

Rose 1991: Barbara Rose, "Jasper Johns: this is not a drawing," *The Journal of Art* 4:4 (April 1991),

pp. 16-17. Reprinted in Brundage 1993, n.p.

Rose 1993: Barbara Rose, "Jasper Johns: the Tantric Details," *American Art* 7:4 (Fall 1993), pp. 46-71

Rosenblum 1960: Robert Rosenblum, "Jasper Johns," *Art International* 4:7 (September 1960), pp. 74-77

Rosenthal 1988: Mark Rosenthal, *Jasper Johns: Work Since 1974,* exh. cat., Philadelphia Museum of Art, 1988

Rosenthal 1990: Nan Rosenthal, "Drawing as rereading," in Rosenthal and Fine 1990, pp. 13-45

Rosenthal 1993: Mark Rosenthal, "Jasper Johns," in *Artists at Gemini G.E.L.: Celebrating the 25th Year,* New York and Los Angeles, 1993, pp. 58-67

Rosenthal 1997: Mark Rosenthal, "Jasper Johns, New York," exhibition review, *Burlington Magazine,* 139:1126 (January 1997), pp. 66-67

Rosenthal 2007: Nan Rosenthal, "A conversation with Jasper Johns," in Rondeau and Druick 2007, pp. 156-61

Rosenthal and Fine 1990: Nan Rosenthal and Ruth E. Fine, *The Drawings of Jasper Johns,* exh. cat., National Gallery of Art, Washington, DC, 1990

Rothfuss 1993: Joan Rothfuss, "'*Foirades/Fizzles*': Jasper Johns's ambiguous objects," *Burlington Magazine* 135:1081 (April 1993), pp. 269-75

Rothfuss 2003a: Joan Rothfuss, "What do you see: Jasper Johns' *Green Angel,*" in Rothfuss 2003b, pp. 28-39

Rothfuss 2003b: Joan Rothfuss (ed.), *Past Things and Present: Jasper Johns Since 1983,* exh. cat., Walker Art Center, Minneapolis, 2003

Rothkopf 2005: Scott Rothkopf, *Jasper Johns: Catenary,* exh. cat., Matthew Marks Gallery, New York, 2005

Schjeldahl 2005: Peter Schjeldahl, "String theory: Jasper Johns's new work," *New Yorker* (May 30, 2005), pp. 96-97

Shapiro 1984: David Shapiro, *Jasper Johns, Drawings: 1954-1984,* New York, 1984

Shiff 1987: Richard Shiff, "Anamorphosis: Jasper Johns," in Cuno 1987, pp. 147-66

Shiff 2006: Richard Shiff, "Flicker in the work: Jasper Johns in conversation with Richard Shiff,"

*Master Drawings* 44:3 (Autumn 2006), pp. 275-98

Shiff 2007: Richard Shiff, "Metanoid Johns, Johns Metanoid," in Rondeau and Druick 2007, pp. 120-41

Simons 1982: Riki Simons, "Gesprek met Jasper Johns: Dat ik total niet begrepen word, is interessant," *NRC [Niewe Rotterdamse Courant] Handelsblad,* April 23, 1982. Reprinted in *Writings* 1996, pp. 211-14

Smith 1984: Roberta Smith, "Jasper Johns's personal effects," *Village Voice,* February 21, 1984. Reprinted in Brundage 1993, n.p.

Solomon 1964: Alan R. Solomon, *Jasper Johns,* exh. cat., Jewish Museum, New York, 1964

Solomon 1988: Deborah Solomon, "The unflagging artistry of Jasper Johns," *New York Times Magazine,* June 19, 1988, pp. 20-23, 63-64, and 66. Reprinted in *Writings* 1996, pp. 220-21

Sozanski 1988: Edward J. Sozanski, "The lure of the impossible," *Philadelphia Inquirer Magazine,* October 23, 1988, pp. 25-31. Reprinted in *Writings* 1996, pp. 224-26

Sparks 1990: Esther Sparks, *Universal Limited Art Editions: A History and Catalogue: The First Twenty-Five Years,* The Art Institute of Chicago, 1990

Steinberg 1962/1972: Leo Steinberg, "Jasper Johns: the first seven years of his art," *Metro* (New York) 4/5 (May 1962); revised and reprinted in *Other Criteria: Confrontations with Twentieth-Century Art,* Oxford, 1972, pp. 17-54. Excerpted in *Writings* 1996, pp. 83-84

Stevens 1954: Wallace Stevens, *The Collected Poems of Wallace Stevens,* New York, 1954

Stevens 1985: Wallace Stevens, *Poems,* selected and with an introduction by Helen Vendler, Arion Press, San Francisco, 1985

Swenson 1964: Gene R. Swenson, Gene R. "What is Pop Art? Part II," *Artnews* 62:10 (February 1964), pp. 40-43, 62-67. Reprinted in *Writings* 1996, pp. 92-96

Sylvester 1965: David Sylvester, Interview with Jasper Johns recorded for the BBC in June 1965, broadcast the following October. Excerpted in *Writings* 1996, pp. 113-21

Sylvester 1997a: David Sylvester, "Johns-II," in *About Modern Art:*

*Critical Essays 1948-1997*, New York, 1997, pp. 463-76

Sylvester 1997b: David Sylvester, "Shots at a moving target," *Art in America* 85:4 (April 1997), pp. 90-97, 127

Taylor 1990: Paul Taylor, "Jasper Johns," *Interview* 20:7 (July 1990), pp. 96-100, 122-23. Reprinted in *Writings* 1996, pp. 244-53

Tomkins 1980: Calvin Tomkins, *Off the Wall: Robert Rauschenberg and the Art World of Our Time*, New York, 1980

Tomkins 1986: Calvin Tomkins, "Passage," *New Yorker* (August 4, 1986), pp. 72, 75-76

Tomkins 1996: Calvin Tomkins, "The changing picture: a retrospective reveals Jasper Johns," *New Yorker* (November 11, 1996), pp. 120-23

Tomkins 2006: Calvin Tomkins, "The mind's eye," *New Yorker* (December 11, 2006), pp. 76-85

Tone 1996: Lilian Tone, Chronology, in Varnedoe 1996, pp. 119-336, passim

Tono 1964: Yoshiaki Tono, "I want images to free themselves from me," *Geijutsu Shincho* (Tokyo) 15:8 (August 1964), pp. 54-57. Translated in *Writings* 1996, pp. 96-101

Tuma 2007: Kathryn A. Tuma, "The color and compass of things: Paul Cézanne and the early work of Jasper Johns," in Weiss 2007b, pp. 170-87

ULAE 1994: Universal Limited Art Editions, *The Prints of Jasper Johns, 1960-1993: A Catalogue Raisonné*, West Islip, NY, 1994

Varnedoe 1996: Kirk Varnedoe (ed.), *Jasper Johns: A Retrospective,* exh. cat., Museum of Modern Art, New York, 1996

Vaughan 1990: David Vaughan, "The fabric of friendship; Jasper Johns in conversation with David Vaughan," in Francis 1990, pp. 137-42

Vendler 1969: Helen Vendler, *On Extended Wings: Wallace Stevens' Longer Poems*, Cambridge, MA, 1969

Vendler 1984: Helen Vendler, *Wallace Stevens: Words Chosen Out of Desire.* Knoxville, TN, 1984

Vendler 2007: Helen Vendler, "Wallace Stevens: the poet as painter," public lecture at the Art Institute of Chicago, October 18, 2007. www.artic.edu/aic/resources/resource/685?search_id=1

Wallach 1988: Amei Wallach, "Jasper Johns at the top of his form," *New York Newsday*, October 30, 1988, part 2, pp. 4, 33. Reprinted in *Writings* 1996, p. 155

Wallach 1991: Amei Wallach, "Interview with Jasper Johns," February 22, 1991, in *Writings* 1996, pp. 259-66

Wallach 1999: Amei Wallach, "A master of silence who speaks in grays," *New York Times*, September 5, 1999, pp. AR29, 31

Weatherby 1990: W. J. Weatherby, "The enigma of Jasper Johns," *The Guardian* (London), November 29, 1990, p. 29. Reprinted in *Writings* 1996, pp. 256-57

Weiss 2007a: Jeffrey Weiss, "Painting bitten by a man," in Weiss 2007b, pp. 2-56

Weiss 2007b: Jeffrey Weiss (ed.), *Jasper Johns: An Allegory of Painting, 1955-1965*, exh. cat. National Gallery of Art, Washington, DC, 2007

Welish 1996: Marjorie Welish, "Jasper Johns," *Bomb* 57 (Fall 1996), pp. 46-51

Winkfield 1996: Trevor Winkfield, "The artists' artist," *Modern Painters* 9:4 (Winter 1996), pp. 22-25

Winters 2011: Terry Winters, "Jasper Johns in the studio: a conversation with Terry Winters," *Jasper Johns: New Sculpture and Works on Paper*, exh. cat., Matthew Marks Gallery, New York, 2011

*Writings* 1996: *Jasper Johns: Writings, Sketchbook Notes, Interviews*, Kirk Varnedoe (ed.), compiled by Christel Hollevoet, Museum of Modern Art, New York, 1996

Yau 1999: John Yau, "Enter the Dragon," *Artnews* (September 1999), pp. 124-25

Yau 2007: John Yau, "Jasper Johns with John Yau," *Brooklyn Rail* (February 2007), pp. 20-22

Yau 2008: John Yau, *A Thing Among Things: The Art of Jasper Johns*, New York, 2008

Young 1969: Joseph E. Young, "Jasper Johns: an appraisal," *Art International* 13:7 (September 1969), pp. 50-56. Reprinted in *Writings* 1996, pp. 129-34

## ACKNOWLEDGMENTS

My interest in Jasper Johns's art, and particularly in his work since 1980, germinated during my first post-college job in the early 1980s at the Leo Castelli Gallery. Twenty-five years and more passed before the idea for a book on this topic emerged, after I saw two exhibitions of Johns's recent work at Matthew Marks Gallery in New York, and hoped to present it to a wider audience. From the beginning, my research and writing proceeded with Jasper Johns's encouragement. I am deeply appreciative of his generosity of spirit, as well as his patient and engaging consideration of my ongoing queries. I am also grateful for his willingness to provide access to images and to spend time showing me new work. I will not soon forget the good conversation and delicious, civilized lunches shared with him and his staff during several congenial visits. Johns's studio staff—ably led by Maureen Pskowski and including Lynn Kearcher, John Delk, Ryan Smith, and John Lund, as well as Sarah Taggart Picton, who helped at the start of this project—have been invaluable to me. Always courteous, this exceptional group made works of art available for me to see, and shared information, advice, and ideas, as well as countless images. My utmost thanks to each of them for their consistent professionalism, attention to detail, and good humor. It has been tremendously gratifying to work with them on a project that has stretched over nearly a decade.

Dodie Kazanjian's unflagging enthusiasm and belief in this project gave rise to its publication, through her introduction to my persistent and insightful agent, Jeffery Posternak. I am forever appreciative of Dodie's encouragement and friendship. Jeff had a sixth sense about where this book belonged and found a felicitous home for it at Thames & Hudson. My thanks also to Savannah Lake at the Wylie Agency for assisting with an array of procedural details.

In addition to the artist's work, this book's foundation lies in the many interviews Johns has generously given over nearly sixty years. I am indebted to the artists, art historians, scholars, curators, and journalists who guided these conversations that illuminate Johns's art, his practice and ideas, perspective, and life. Scholars and anyone curious about Johns's practice can be most grateful for the collected interviews, as well as Johns's writings and transcribed notebooks that appear in a substantial anthology edited by the late Kirk Varnedoe, published on the occasion of the 1996 exhibition *Jasper Johns: A Retrospective* at the Museum of Modern Art, New York.

Libraries have long been important sanctuaries, though perhaps even more so in recent years, providing spaces for contemplation and writing, and open access to books and online resources. Among the libraries that facilitated research for this project are the Watson Library at the Metropolitan Museum of Art, New York, and the New York Society Library. Portions of this book were also written at the Virginia Center for the Creative Arts, a nurturing artists' residency program where my writing was enriched by the rare opportunity for quiet focus as well as interactions with artists, musicians and fellow writers under the amiable and discerning care of Sheila Pleasants.

I would like to acknowledge the artists who were willing to discuss Johns's work and share their compelling perspectives, including Lesley Dill, Mark Fox, Edward Henderson, Robert Kushner, John Newman, and Terry Winters. I have benefited from the advice of scholars and Johns experts who took time to read my manuscript. Michael Fitzgerald devoted much care to reviewing and commenting on the manuscript. Susan Lorence kindly and judiciously reviewed my text. I greatly appreciate their time and thoughtful guidance.

Life in the early twenty-first century is inevitably dependent on digital communication. During the preparation of this book, I realized just how feasible it is to foster friendships through e-mail with individuals I already know, as well as to establish ones with those who I may never meet. One of the great pleasures of this project has been communicating with a wide range of people to gather information, arrange to see works of art, and secure images and rights. At the remarkable and innovative print publisher, Universal Limited Art Editions (ULAE) I had the privilege to view prints and discuss Johns's work with Bill Goldston on several occasions. He and Jill Czarnowski went out of their way to provide reproductions of prints and images of Johns at work. I am most appreciative of Ariel Fishman and Jacqueline Tran at Matthew Marks Gallery for contributing several images and caption information. Thanks to Frederick Courtright for securing text permissions. Margaret McKee and Joseph Newland at the Menil Collection worked to provide state-of the-art digital files of works on paper that I was unable to source anywhere else. Joseph is a rare e-mail poet, who enlivens that normally quotidian form of communication with peerless bons mots. Among rights and reproductions experts, there is no one more knowledgeable, efficient and delightful to collaborate with than Anita Duquette at the Whitney Museum of American Art. My gratitude to her for her willingness to spend time clarifying rights issues for me and for supplying knockout files in a timely manner.

At Thames & Hudson in London, it has been my pleasure to work with Sophy Thompson. Her insightful suggestions and comments on matters large and small have improved and focused the book. My interactions with the rest of the team at Thames & Hudson, which has the familial feel that distinguishes its longstanding tenure as a family-run company, have only increased the satisfaction of the publication process. For any errors of fact or omissions, only I am to blame.

Throughout this project, friends, colleagues, and family have challenged me, cajoled, and provided sustenance as well as keen observations. The enduring affection of my mother, Flora Biddle, has been a continual source of good cheer and contentment. With grace and enthusiasm, she has encouraged me to amplify and deepen my thoughts and given me the confidence to keep going. She always puts aside whatever she is doing for a conversation, inspiring me with her wisdom and goodness and the perfect pithy comment. My dreamy daughters, Flora, Tess, and Lucy, have been inquisitive and animated advocates every step of the way, provoking and amusing, and standing by for technical assistance. Finally, and most significantly, I am fortunate to have in Mark Donovan a marvelously devoted, irresistible spouse and a discriminating editor, who has contributed to every phrase of this book, while persistently hatching captivating diversions. Always my first reader, his penetrating eye and magnanimous edits, typically delivered with a dash of spirited banter, encouraged me to write with increased clarity and focus for an expanded audience. His high standards and abiding care have contributed immeasurably to this book.

New York City, February 2017